viewfinder
100 top locations for great
travel photography

A RotoVision book

Published and distributed by RotoVision S.A.
Route Suisse 9
CH-1295 Mies
Switzerland

RotoVision SA
Sales & Editorial Office
Sheridan House, 112/116a Western Road
Hove, East Sussex BN3 1DD, UK

TEL: +44 (0)1273 72 72 68
FAX: +44 (0)1273 72 72 69
EMAIL: sales@rotovision.com
WEBSITE: www.rotovision.com

10 9 8 7 6 5 4 3 2 1

ISBN 2-88046-793-4

Designed by Balley Design Associates
Art director Luke Herriott
Project editors Kylie Johnston & Nicola Hodgson

Reprographics in Singapore by Provision Pte. Ltd
Tel: +65 6334 7720
Fax: +65 6334 7721
Printing and binding in Singapore by Provision Pte. Ltd

viewfinder
100 top locations for great *travel photography*

RotoVision

Contents

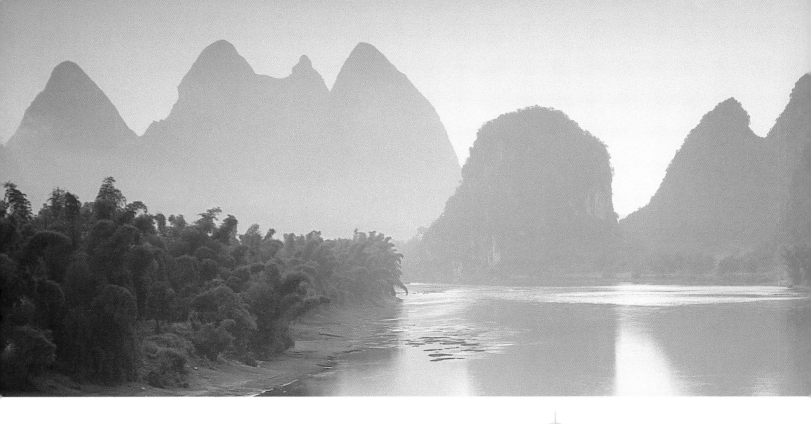

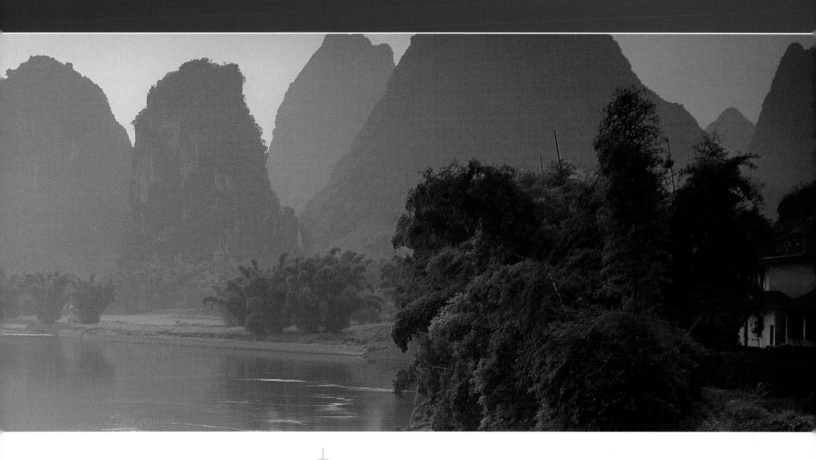

This well-known quote by the great Scottish nineteenth-century author Robert Louis Stevenson (1850–94) speaks for an age when overseas travel of any kind was a time-consuming and often hazardous adventure, pursued only by the affluent. To journey to the exotic destinations that Stevenson went to, such as Hawaii, Tahiti, Australia, and Western Samoa, was even rarer—in that era, to contemplate a journey around the world was more the stuff of a Jules Verne fantasy than a realistic undertaking.

How times have changed. Since the 1950s, the growth of mass tourism and long-haul air travel has turned Stevenson's quote on its head. For the 21st century, a more appropriate saying would be: "To arrive in certainty is a better thing than to travel."

What matters to many people today is getting to a chosen location quickly so that they can spend as much time as possible there. This is understandable when you consider what extraordinary places can now be reached within a day's traveling time from our homes. Photography has helped to stimulate the desire to venture to parts of the world that we might otherwise never have considered.

The locations featured in this book have been chosen for their tremendous photographic potential. They include cities and towns that are well-known to most of us, as well as distant landscapes that take more than a flight and a taxi to get to. You will find more than just the familiar places however; there are plenty of alternative views too, along with detailed information about where and when to go in order to relive the experience of what is printed on these pages.

In compiling this list of "greatest" photographic locations, I have drawn on the experience of some of the world's best-traveled photographers, and I am indebted to their knowledge. I have no doubt that there are omissions from this book that will raise eyebrows (San Francisco, Mt Kilimanjaro, Mont St Michel, to name a few)—people respond to places in different ways, after all.

For all of his own intrepid journeys, what would Robert Louis Stevenson have given to see what lies ahead on these pages?

Keith Wilson

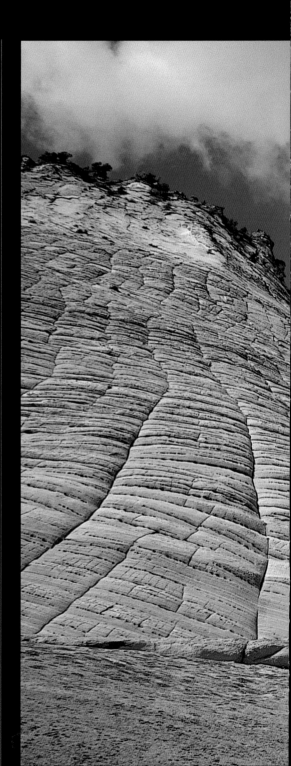

"To travel hopefully is a better thing than to arrive."

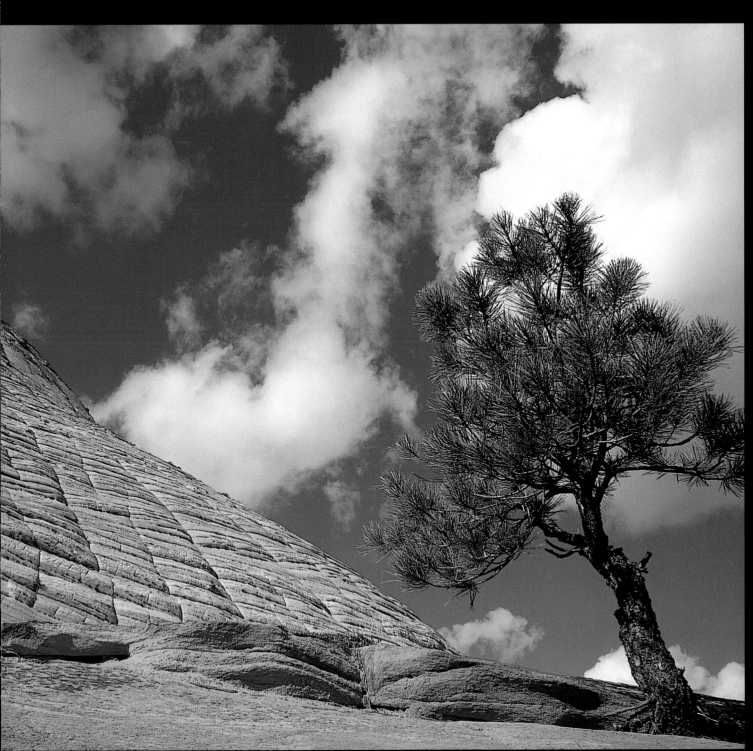

Map

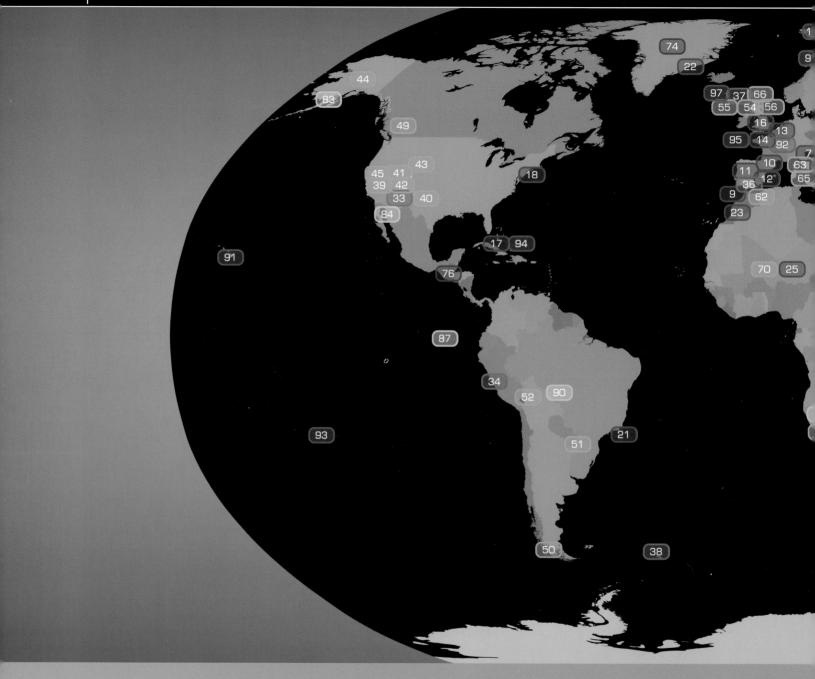

1	Calcutta	12	Barcelona	23	Marrakesh	34	Machu Picchu	45	Death Valley
2	Kathmandu	13	Amsterdam	24	Cape Town	35	Great Wall of China	46	Dead Vlei
3	Pushkar	14	Paris	25	Timbuktu	36	Alhambra Palace	47	Uluru and Kata Tjuta
4	Kashgar	15	Prague	26	Angkor Wat	37	Callanish	48	Empty Quarter
5	Hoi An	16	Westminster	27	Potala Palace	38	Grytviken	49	Lake Moraine
6	Istanbul	17	Havana	28	Taj Mahal	39	Yosemite Valley	50	Torres del Paine
7	Venice	18	Manhattan	29	Ephesus	40	Monument Valley	51	Iguacu Falls
8	Florence	19	Sydney Harbour	30	Abu Simbel	41	Bryce Canyon	52	Lake Titicaca
9	Seville	20	Hong Kong	31	Great Pyramid of Giza	42	Grand Canyon	53	Fiordland
10	Segovia	21	Rio de Janeiro	32	Petra	43	Yellowstone	54	The Cuillins
11	Toledo	22	Ammassalik	33	Canyon de Chelly	44	Denali	55	Glen Coe and Rannoch Moor

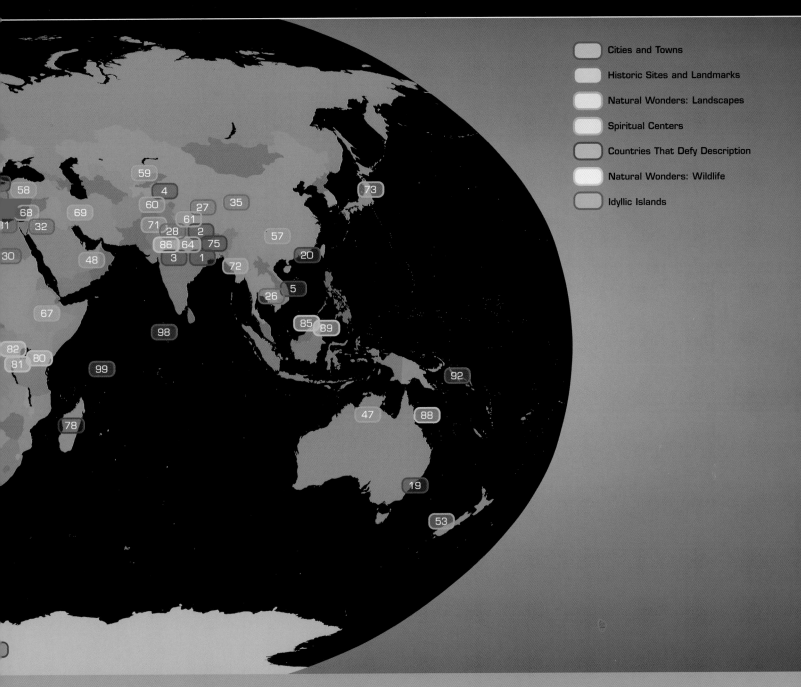

Cities and Towns

Historic Sites and Landmarks

Natural Wonders: Landscapes

Spiritual Centers

Countries That Defy Description

Natural Wonders: Wildlife

Idyllic Islands

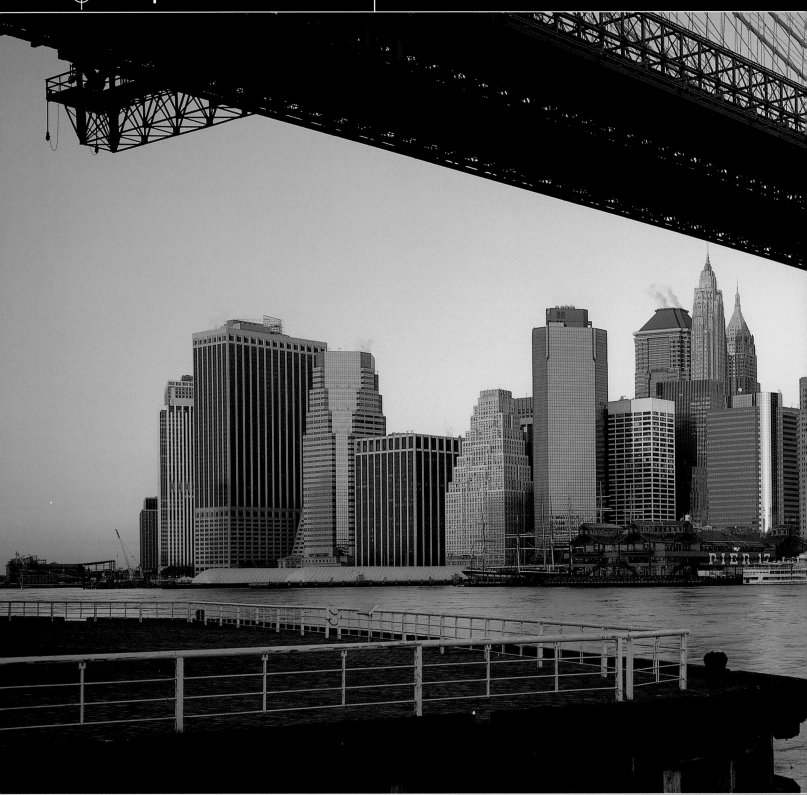

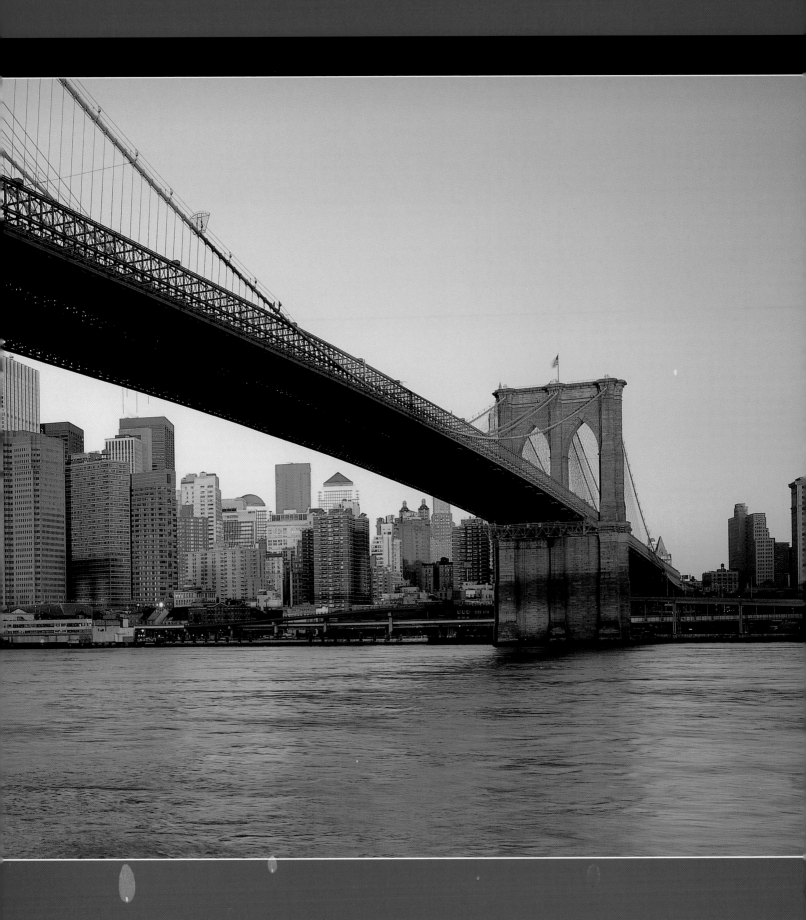

Calcutta has become a byword for poverty and filth, chaos and urban blight. Calcutta is overcrowded and chaotic, and thousands of people live on the streets, but for every visitor the city repels there is another who sees beyond the squalor. Calcutta teems with life as it teems with the monsoon rains that frequently flood its streets.

Monuments of Empire

Calcutta is a comparatively new city, founded by an English trader in 1690 who pitched his tent on a muddy bank by the Ganges when the weather was too deplorable to venture any further. This English foundation shaped Calcutta's early history, and the city's growth mirrored the expansion of the

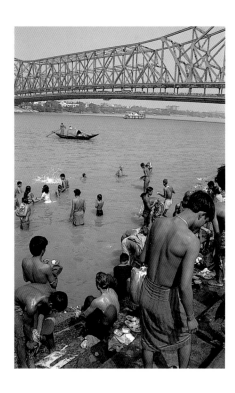

left | Bathers come daily to the ghats on the banks of the Hooghly River. The huge span of the Howrah Bridge is a prominent landmark of Calcutta.

below | A line of rickshaw wallahs rest on one of Calcutta's streets.

Essential picture list

⊕ **The ghats** beneath the massive **Howrah Bridge** spanning the Ganges are always a focal point of activity; Hindus come here to pray, bathe, and get married.

⊕ The **Victoria Memorial, Raj Bhavan** (formerly Government House), **The Writer's Building**, and the old **Town Hall** are among the better-preserved examples of colonial architecture in the city.

⊕ In **Pathuriaghat Street** and other roads of North Calcutta are the crumbling **houses of the Babus**. The Babus were wealthy Indian associates of the East India Company, whose descendants cannot afford to maintain these palatial buildings.

⊕ Calcutta's potters are concentrated in an area called **Kumartuli**. Here, in the weeks leading up to the city's famed Durga Puja celebrations (a five-day festival in honor of the mother goddess Durga, or Kali), hundreds of clay images of Durga line the streets in preparation for the festivities.

"I shall always be glad to have seen it, for…it will be unnecessary ever to see it again."

British statesman Winston Churchill (1874–1965) to his mother after visiting Calcutta

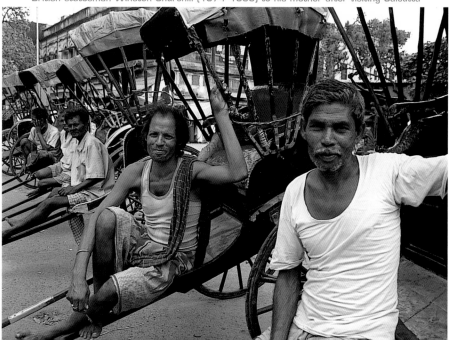

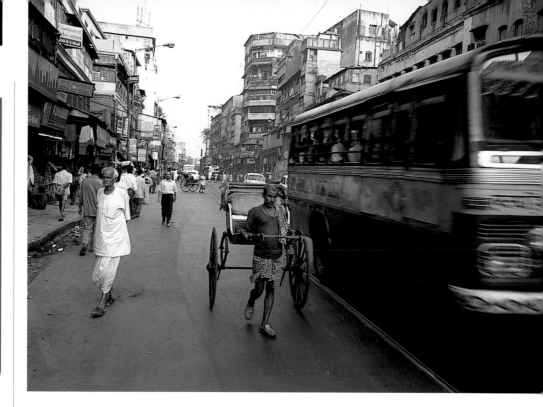

⊕ Wear **light, comfortable clothes, walking shoes or trainers**, and carry your kit in a **backpack**.

⊕ Pack a minimum of gear: **one camera** and **two or three lenses**, one of which must be a **good-quality wideangle** to get the whole atmosphere and action of the streets within the frame.

⊕ A **skylight** or **81a filter** will bring warmth to the scene and render more detail in the shadows.

British Empire. There are many reminders of the Raj in the city's public buildings and monuments. The grandest of these is the Victoria Memorial, which opened in 1921 as a museum of Anglo-Indian art and history. With its well-ordered gardens and its manicured lawns, it is now a favored meeting place for young Bengali couples, who sit in the shade beneath the trees.

Teeming street life

It is on Calcutta's streets that the photographer will find a limitless source of images, from the taxi drivers and rickshaw pullers in Chitpur Road to the acrobats in College Street. Everywhere, there are vendors, porters, street performers, barbers, potters, goats, chickens, dogs, coconut and flower sellers, and rag pickers.

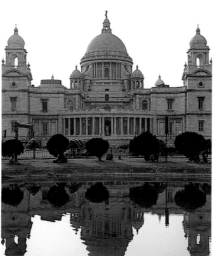

above | There is a variety of means for getting around Calcutta's busy streets, as shown here—taxis, buses, the ever-present rickshaw, or simply on foot.

left | The Queen Victoria Memorial is the grandest example of colonial architecture in Calcutta.

Historical background >>> English trader Job Charnock became the "founder" of Calcutta, after pitching his tent on the swampy banks of the River Ganges during a monsoon in August 1690. From that day until Indian independence in 1947, Calcutta was developed and administered by Britain and was the center of its imperial interests in India. The most influential of Calcutta's Governors-General was Richard Wellesley, Earl of Mornington, who assumed office in 1797. He expanded the interests of the East India Company and that of the British government throughout the Indian subcontinent. Calcutta's influence began to wane when the capital was moved to Delhi in 1912, although it remains India's most populous city.

Amid the noise, dirt, and poverty of Kathmandu, people are rarely idle. The streets are crammed with cyclists, rickshaws, children, hawkers, stalls, pilgrims, and sacred cows. This is a vibrant city that assaults your senses: smoke from dung fires, incense, and spices combine with motorbike fumes to create a permanent scented haze that hangs over the city and fills every alley.

Nepal is the world's only Hindu kingdom, and religion meets you at every corner. Small shrines to the gods Shiva, Vishnu, and Ganesh are rarely unattended, and it is not uncommon to see animal sacrifices performed in the street. In short, Kathmandu is an incredible place for photography.

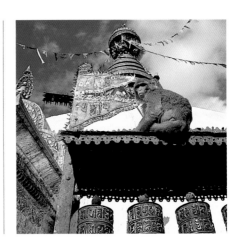

right | One of the resident monkeys looks down from his vantage point at Swayambunath Temple.

below | A rickshaw driver pauses in Durbar Square. Behind him is the Temple to Shiva and Parvati.

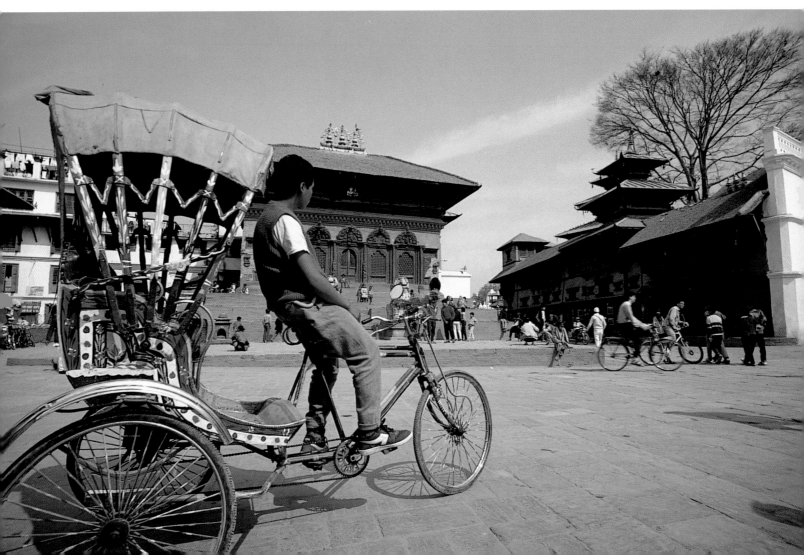

Durbar Square

Most visitors begin their experience at Durbar Square, Kathmandu's heart. It is flanked on all sides by intricately carved wooden palaces, shrines, and temples dating back to the 16th century. One of these temples is home to Nepal's living goddess, the Kumari, a prepubescent girl who is believed to be the reincarnation of a Hindu god. She occasionally appears on a balcony, so you might just get a snapshot of her.

In Durbar Square, the ground is usually covered with wares from the market sellers—anything from fruit and vegetables to pots and flowers. Worshipers climb the steps to the temples and hawkers ply tourists for trade. Kathmandu's main streets run off from Durbar Square. One of these is popularly known as Freak Street, named

Essential picture list

⊕ **Durbar Square** is the perfect place to begin your orientation around Kathmandu and witness the daily patterns of life in the city.

⊕ **The Stupa of Boudhunath** is a stunning sight and can be photographed from many angles.

⊕ A steep flight of steps it may be, but **Swayambhunath** and its resident monkeys is worth the effort. There are marvellous views over to Kathmandu.

⊕ The medieval walled city of **Bhaktapur** is crammed with centuries-old narrow streets and squares. This is a superb place for wandering around and making candids.

⊕ For your first glimpse of the mighty Himalayas, travel the 20 miles (32km) to **Nagarkot**, where a majestic mountain panorama awaits.

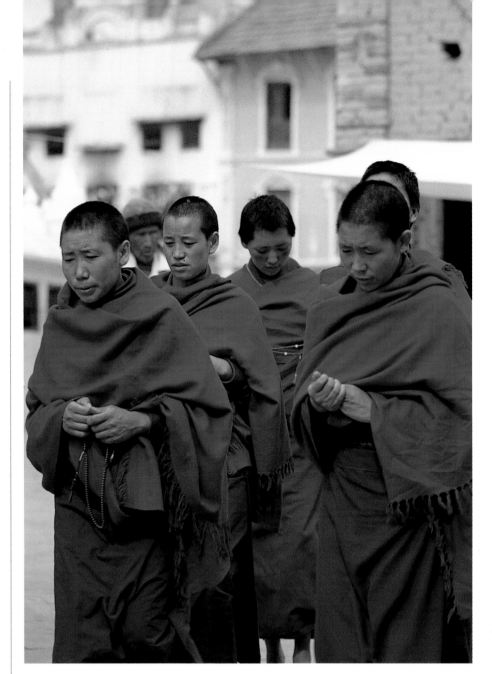

after the young Western tourists who frequented this area in the 1960s and 70s because of the ready supply of cannabis available from the cake shops.

above | Beneath Boudhunath Stupa, the most important place of Buddhist worship in Nepal, a group of nuns pray while walking around the base of the stupa.

The Stupa of Boudhunath

A short taxi ride from Durbar Square is the amazing Boudhunath, the largest and most important Buddhist stupa in Nepal. This is an amazing subject to photograph because of the four pairs of giant blue eyes—one pair for each aspect of the stupa—painted beneath the stepped roof. When composing a shot, you will find that, wherever the stupa is in the viewfinder, those eyes will look right back at you.

It is possible to get up onto the white dome of the stupa itself to admire the view. Monks often meditate up here, so respect their space. Even in the midday sun, Boudhunath looks impressive, but the best time to photograph it is in the late afternoon and into the evening, when the light glows off the dome.

Historical background >>> Nepal was unified in 1768 by King Prithvi Narayan Shah. In 1816, the Shah dynasty closed Nepal's borders and the country was isolated until the mid-20th century. Nepal was granted democracy in 1989, but the murder of the king in 2001 led to political instability, exploited by Maoist guerrillas who are active in the hills beyond the Kathmandu Valley.

below left | The undulating hills of the Kathmandu Valley give way to the snow-capped peaks of the Himalayas.

below right | Kathmandu is full of a surprising mix of craft shops. Here, the sun picks out colorful marionettes on a street stall in the old part of the city.

Pashupatinath

A short distance from Boudhunath is the Bagmati River and the holiest pilgrimage site for Nepal's Hindus—Pashupatinath. Hindu families come to the ghats (steps) here to cremate the bodies of their relatives. Insensitively, many Western tourists photograph this ritual. Show more worldly sense and put your camera away.

Pashupatinath's main temple is only open to Hindus. The image to capture here is of the saddhus (holy men), with their long tangled hair, thin, wiry bodies, and decorated faces.

Across the Bagmati River and a few miles south of Kathmandu is Patan, which is like Kathmandu in miniature. It has a Durbar Square too, surrounded by palaces, temples, and statues.

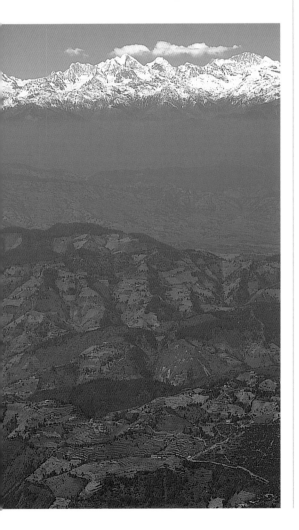

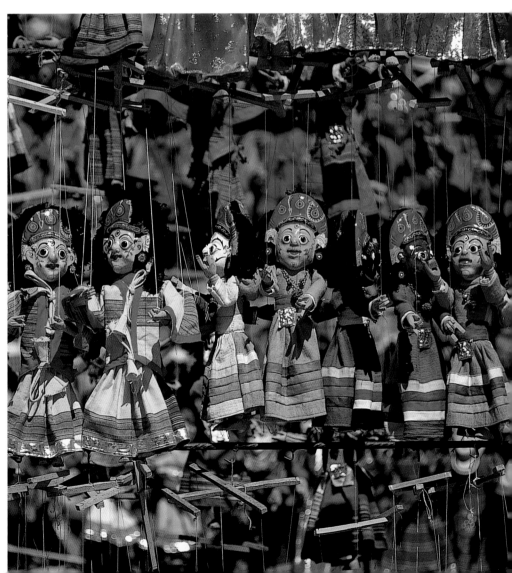

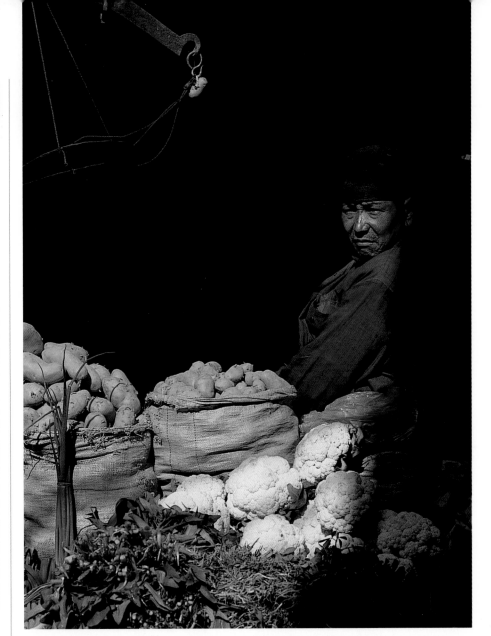

Essential kit

✛ A basic kit of **one camera body and a few zooms** covering your focal range from wideangle to telephoto carried in a backpack is the best way to get around.

✛ The city can be hot and is always dusty, so pack a **blower brush** or **lens wipes** to clean your lenses at the end of each day.

✛ Handy filters to use are a **polarizer** and **81a**, **81b**, or **81c warm-ups**.

✛ **Lens hoods** are handy to keep glare out.

✛ If you feel you can't manage a tripod then at least take **a monopod** for slower shutter speeds around dusk and dawn.

✛ Carry **bottled water** and take a **hat** and **walking boots** for each day's outing.

Traveling by bicycle

Kathmandu sits on a relatively flat plain around 5,000ft (1,525m) high, and hiring a bicycle is a good way to get around. Many visitors cycle the nine miles (14km) to Bhaktapur, a medieval walled city that is a World Heritage Site, along with Patan and much of Kathmandu. Cycling down Bhaktapur's narrow alleys is like a journey back through time. The place is magical. Fortunately, the distance from Kathmandu seems to be enough to dissuade some people from making the journey, so it should be easy to find an alley where you are the sole foreigner.

The Monkey Temple

Another must-see is Swayambhunath, better known as the Monkey Temple. The monkeys here have complete freedom to roam—and snatch. They are not shy, so don't take any food into the temple complex. They move very quickly and can be difficult to photograph. If you go at morning feeding time, you might have more success, however.

Swayambhunath is a stupa like Boudhunath, with four pairs of painted eyes looking out in four directions. It has a spectacular setting, standing on a hill with views to Kathmandu. There is a flight of more than 300 steps to the top, where the stupa stands among other temples and buildings on the site. A path leads to a monastery adorned with a myriad of prayer flags.

above | A vegetable seller peers from the shadows behind his produce in a side street of Kathmandu.

For five days in mid-November, the town of Pushkar in Rajasthan, home to 12,000 people, hosts the Pushkar camel fair, an internationally renowned festival attended by more than 200,000 people and 25,000 camels. The fair used to be a purely religious festival dedicated to the Hindu god Brahma and has always been held over the five days prior to the full moon (or *purnima*) in the Hindu month of Kartik (November). During this period, the main street becomes an open-air market with shops selling silverware, puppets, decorated slippers and clothes, religious statues, and food. Saddhus and brahmin priests make the journey, along with circus performers, musicians, craftspeople, and livestock handlers with their goats, horses, and cattle. The priests settle down on the bathing ghats at Anasagar Lake, where they give blessings in return for a small fee. Photography here is frowned upon, but elsewhere the people are friendly.

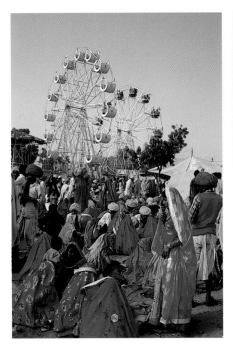

left | Colorful saris and a Ferris wheel add to the festive atmosphere of Pushkar's annual Camel Fair

below | Street traders travel from all over Rajasthan to provide services to the 200,000 visitors. This man is a street dentist, his instruments ready for use

Essential picture list

⊕ The **hill above the holy Anasagar Lake** provides spectacular views of Pushkar and the camel camp below.

⊕ The vivid mix of **saris** worn by groups of women makes a colorful close-up.

⊕ At sunset, the dust-filled sky scatters the light and creates the perfect conditions for **silhouettes of camels and their handlers**.

⊕ Walk around the camp for **portraits and candids of the camel traders and their families**. Always be courteous when asking permission to take their pictures.

⊕ **Nightfall**, with the camp fires burning and lights strung up on tent poles, is a magical time for pictures. Bring the tripod.

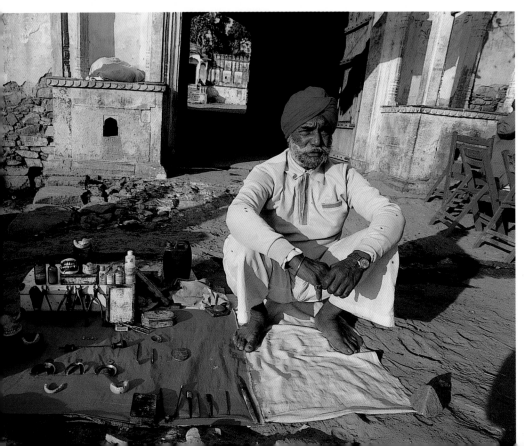

There is no shortage of subjects for the camera at Pushkar. The brilliance of women's saris and extravagant jewelry always cuts through the blanket haze of dust that covers the festival campsite and showground. The men make striking character studies, too, with their fine mustaches and substantial turbans. The real stars are the camels, however, which are groomed with the sort of care and attention that is usually given to thoroughbred horses.

below | The golden light of sunset and the dust in the atmosphere create a hazy warm light for an evocative shot of camels in the November landscape

Essential kit

◈ There is so much dust and sand that you will need a **backpack that can be completely sealed—** never walk around with it open.

◈ A **blower brush** and/or **lens cloth** will get heavy use in this environment.

◈ An ideal lightweight kit would be an **SLR** with a **good-quality wideangle zoom** and **telephoto zoom**, or a **lightweight medium-format rangefinder system**.

◈ Light is plentiful so **slow, fine-grained film** should do.

◈ Bring a **tripod** and **remote release** for long exposures for night-time scenes.

◈ The **81 series of filters** will add some warmth to the sand and dust.

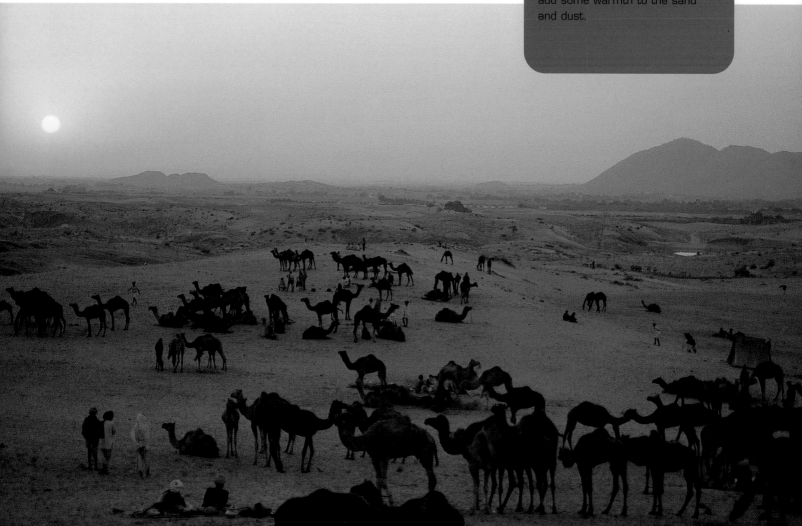

Essential kit

◈ It's a long journey to Kashgar by road, so carry only the basic kit of a **camera** and a **brace of lenses**, plenty of **spare film** or **memory cards**, and **batteries**.

◈ This is a dusty environment, so keep your gear in a **bag** or **backpack** when not in use.

◈ Take a lightweight **carbon-fiber tripod** and pack **UV** or **81-series filters** to add warmth to colors.

◈ Wear good **walking shoes** or **boots** and a **hat**.

Once one of the most important cities of the ancient silk route linking China to Europe, Kashgar continues to be a major trading post. With the completion of the Karakoram Highway in 1982, Kashgar became the major Chinese terminus of the 750 mile (1,200km)-long road across the Karakoram

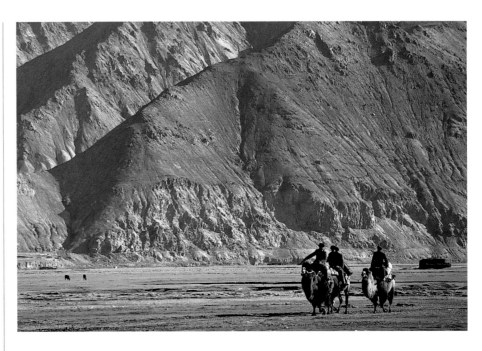

Mountains to Rawalpindi in Pakistan. The journey from Pakistan is one of the most spectacular routes on earth, reaching a high point of 16,300ft (4,940m) at the Khunjerab Pass.

Id Kah Mosque

The vast majority of Kashgar's 250,000 residents are Muslim Uighurs. The spiritual, social, and geographical center of the city is the Id Kah Mosque. Friday prayers are the busiest occasions, when Uighurs from all over town and the surrounding countryside congregate to pray and exchange news. In the streets around the mosque are stalls selling house wares, clothing, and foodstuffs. The main market day is Sunday, when fresh fruit and vegetables and livestock, including goats, sheep, yaks, and camels, are brought for sale.

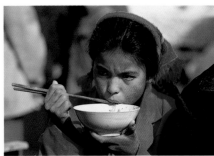

top | In a timeless scene a group of Uighurs ride their two-humped camels, a mode of transport unchanged from the days of the silk route

above| A young Uighur girl eating near a food stall at Kashgar's market

left | Livestock, trailers and people fill a Kashgar street on market day

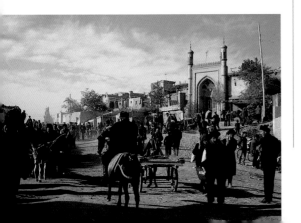

Until 1975, Vietnam was the battleground for one of the longest and fiercest post-colonial wars ever seen. Now, the first generation of children have been able to reach adulthood and become parents themselves without bombs raining down on their villages.

Perhaps ironically, many people travel to Vietnam to experience the tranquillity of its villages. While the big cities of Hanoi and Ho Chih Minh City continue to grow and industrialize, the coastal villages are very different. A favorite destination for many is Hoi An, which is just a short bus journey south of Hue, Vietnam's ancient capital.

The Central Market

Upon crossing the Cam Nam Bridge that spans the Thu Bon River, it is easy to pick out the scores of people milling around Hoi An's Central Market. This is the heart of the town, and is a vibrant location for photography. Early morning is the time to arrive. Traders rise with

Essential kit

⊕ Hoi An is easy to get around on foot, so don't weigh yourself down by packing too much kit. Take a **backpack** and travel light— an **SLR** camera and a couple of **zoom lenses**.

⊕ Other items to consider include a **polarizer** (the most obvious filter to use), a **tripod**, and a **quick-release plate**.

⊕ Attach **lens hoods** to protect your optics from flare.

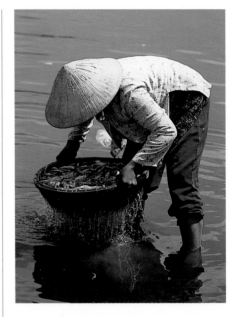

above | **A woman washes freshly caught fish in the Thu Bon River.**

below left | **A traditionally attired woman in a Hoi An street.**

the sun and set their stalls quickly, fishermen sell their catch straight from the boat, and, as more people congregate, the market seems to extend its reach to the river's edge. Women gather to wash fish and other produce in the water, and catch up on gossip. But as the sun climbs, the build-up of heat causes the market to peak and then slowly recede as people melt away to the shade of bars, verandas, and their homes. This is a time for rest and an opportunity to capture more pensive shots before Hoi An stirs back to life late in the afternoon.

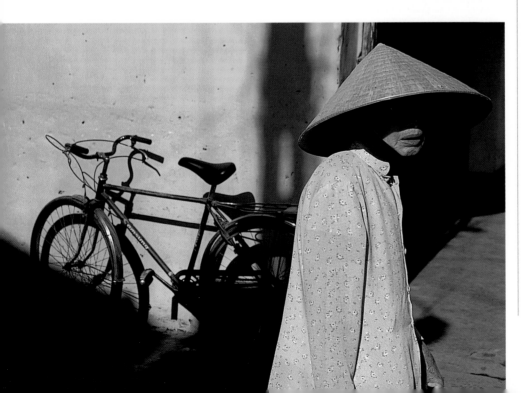

location > **Istanbul**

country > **Turkey** | when to go > **Mar, Sep** | focus on > **historic sites**

Istanbul has seen empires, religious faiths, and kingdoms come and go, leaving behind a rich legacy of amazing buildings and artefacts. Istanbul owes much to a narrow strait of water 15 miles (24km) long, linking the Black Sea with the Sea of Marmara, and separating Europe and Asia. Istanbul is the only city in the world to straddle two continents and is often regarded as the meeting point between East and West.

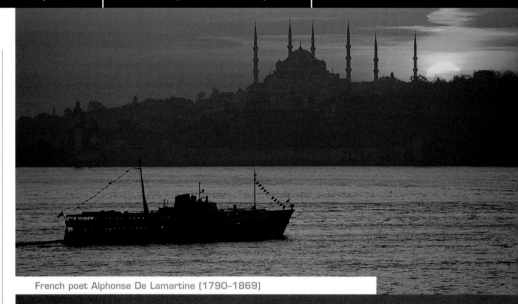

French poet Alphonse De Lamartine (1790–1869)

"If one had but a single glance to give the world, one should gaze on Istanbul."

Essential picture list

⊕ There is so much to see at the **Topkapi Palace** that you could spend all day there. The **view over the Bosphorus** to the Asian side of Istanbul is a must.

⊕ In the grassy park of what used to be the Byzantine hippodrome, you can see the domes and minarets of **Ayasofya** and the **Blue Mosque**.

⊕ Ayasofya is now a museum, so it's possible to take pictures of its **interior**. Make the best use of available lighting by using a wideangle to photograph the dome from the upper terraces.

⊕ Wander down to **the waterfront**, where fishing boats unload their daily catch to the nearby restaurants and tavernas and street vendors ply their trade.

⊕ Ferries sail along the Bosphorus north to the **Black Sea** in two hours, or south to the **Princes Islands** in the same time. Keep your telephoto zoom handy.

Many of Istanbul's historic sites can be found within walking distance of Sultanahmet Square in the center of the old city. From here you can see the giant dome and six minarets of the Mosque of Sultan Ahmet I, otherwise known as the Blue Mosque.

above | A ferry sails up the Bosphorus as the sun sets behind the Blue Mosque, Istanbul's most prominent landmark and the most important mosque in Turkey.

i

Historical background >>> Istanbul was once known as Constantinople, and before that as Byzantium. These names reflect three distinct eras in the city's history. Byzantium was a wealthy Greek city. It became Constantinople when the Roman Emperor Constantine (306–37CE) chose it as the new capital for the Roman Empire in the early 4th century. When the West Roman Empire fell in 476CE, Constantinople continued to rule the East Roman, or Byzantine, Empire for nearly a thousand years. During this period, it was the center of the Christian faith. That changed in 1453 when the city fell to the Ottoman Turks, who made it the capital of the Ottoman Empire. The Ottomans were Muslims and the Sultan rulers enjoyed great power over much of Europe and the Middle East for nearly 400 years. The Sultanate was abolished after World War I (1914–18), and Turkey became a republic in 1922. The country's capital then moved to Ankara.

This dominates the city skyline and is Istanbul's best-known landmark. Non-Muslim visitors are welcome to enter, although the mosque is closed to non-worshipers during the five daily prayers and for long periods on Fridays. Inside, hundreds of carpets cover the vast floor space and the walls are decorated with the blue and white tiles that give the mosque its popular name.

Ayasofya and Topkapi

A few minutes' walk north of the Blue Mosque is the breathtaking Ayasofya. Now a museum, Ayasofya was built by the Roman Emperor Justinian in 537CE, and was the greatest cathedral of the Byzantine age. It was then called Hagia Sophia (Greek for "Church of Divine Wisdom"). The building survived the rise of the Ottoman Empire and the arrival of Islam in 1453, when the church was turned into a mosque.

Next door to Ayasofya is the Topkapi Palace, which was home to the all-powerful Sultans for 400 years. There are hundreds of rooms in the palace, spacious courtyards within the grounds, and wonderful views of the boats on the Bosphorus. In a city of major traffic congestion and few parks or gardens, the Topkapi is an oasis of calm.

Retreats from the heat

Returning to Sultanahmet Square, there is another staggering discovery to be made, this time beneath your feet. Dozens of Byzantine cisterns filled with water lie underneath the streets and squares of Old Istanbul, to be used as emergency water supplies in times of siege. The Yerebatan Saray Sarnici is the biggest and most lavish; its name translates as "Sunken Palace Cistern" because of its capacity (more than 20 million gallons/90 million liters) and the 336 marble columns used in its construction. Walkways and spot-lighting make a walk through the cistern an atmospheric experience. It is also a pleasant retreat from the heat outside.

Another retreat is the Kapali Carsi, or Grand Bazaar, where you can buy carpets, leather goods, jewelry, and pottery. It is a busy, colorful, and exciting location, although the dull lighting, confined spaces, and crowds make it difficult to photograph.

below left | The minarets of the Blue Mosque reach for an aptly coloured sky.

below | Traditional Turkish dancers perform in the Grand Bazaar.

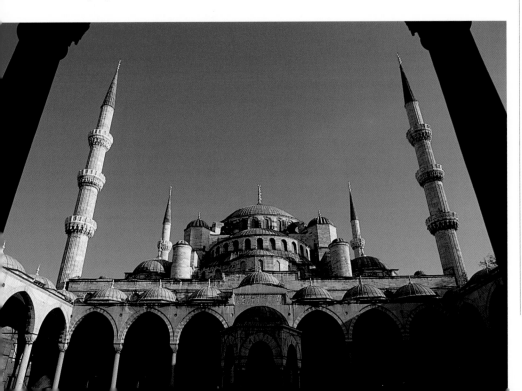

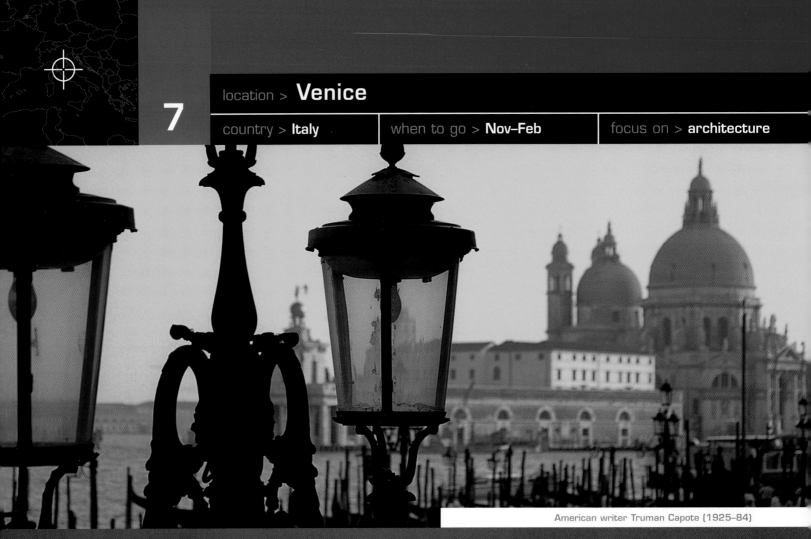

7

location > **Venice**

country > **Italy** when to go > **Nov–Feb** focus on > **architecture**

American writer Truman Capote (1925–84)

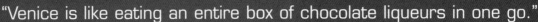

"Venice is like eating an entire box of chocolate liqueurs in one go."

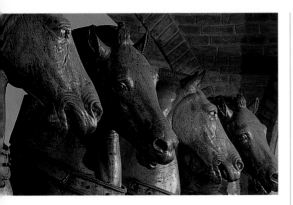

top | Venetian style is expressed from the city's lamps to the Basilica di San Marco.

above | These four golden horses adorn the exterior of the Basilica di San Marco.

Venice is many people's favorite European destination. This waterlogged city has inspired artists and writers for centuries. Photographers too have been overwhelmed by the city's unique beauty, struggling to know where to start, or when to stop. The best advice is to avoid high summer, when the place is overrun with tourists, the light is too harsh, and the canals begin to smell in the heat of the afternoon. Instead, time your stay for midwinter. Yes, it will be freezing, but the hordes of tourists will be at home and the golden hours around dawn and dusk will be at times that won't upset your sleeping arrangements. There is also the chance of waking to a blanket of mist covering the city, backlit by the rising sun.

Piazza San Marco

Its reputation may be huge, but Venice is in fact a small city; small enough to walk around. Everywhere is accessible by foot, with all paths seemingly leading to the Piazza San Marco (St Mark's Square). This sprawling space is Venice's heart, surrounded on three sides by Renaissance terraces housing cafés, and cluttered with tables and chairs. The fourth side is dominated by the 11th-century Basilica di San Marco (St Mark's Basilica). This richly decorated Byzantine church features a roof of five domes, colorful mosaics, and arches protected by gilded angels— and that's just the exterior. In the direct light of sunset, the building radiates with a golden glow.

Essential picture list

◈ It's impossible to miss the **Piazza San Marco**, and in the light of dawn or sunset during winter it is almost deserted—ideal for a moody and atmospheric shot.

◈ Take the lift to the top of the **Campanile** of the Basilica di San Marco for fabulous views over the Piazza and the Grand Canal.

◈ For a great view of the Grand Canal, go to the **Rialto** or **Accademia** bridges, look down the length of the water, and include a gondola, vaporetto, or other vessel in your shot.

◈ Look out for **moored gondolas**: they make wonderful foreground detail when tightly cropped against a defocused background of buildings.

◈ Visit some of the other islands surrounding Venice, such as the **Lido** (the city's sandy beach) and **Burano**, home of Venetian glass-blowing.

Historical background >>> Positioned at the northern end of the Adriatic Coast where Italy meets Eastern Europe, Venice has long been a strategic trading post. Its architecture and art was influenced by the rise of Byzantium, the arrival of the Moors, and the birth of Renaissance Italy. Venice was founded in the 5th century CE, when refugees from northern Italy, fleeing Attila the Hun, settled on this collection of islands and lagoons. From 697CE to 1797, an imperial family of merchants, the Doges, ruled Venice with the most powerful navy in the Adriatic. As Venice's status as a center of commerce declined, its reputation as a city of priceless artistic heritage soared.

Adjacent to the Basilica and stretching down to the Grand Canal is the Palazzo Ducale (the Doge's Palace), home to the Doges who ruled Venice for a thousand years until Napoleon forced them to retreat. One of the most memorable views in Venice is from the top of the Campanile, the Basilica's bell tower. From here you can look down on the Basilica, the Palazzo Ducale, and watch people wandering across the piazza. The rest of Venice and the Grand Canal, with its gondolas and vaporetti (water buses), stretches out into the distance—in the warm light of late afternoon, it makes a wonderful picture.

By water and by foot

Although expensive, it is hard to resist a ride on a gondola. In the sheltered seclusion of the city's smaller canals, the gondola affords a unique perspective of Venice rising straight from the water—an architectural cornucopia of faded facades from the city's Renaissance, Byzantine, and Moorish eras. But for the photographer, Venice is best explored on foot, and getting lost in the maze of alleys, canals, and bridges can be a real journey of discovery. There is a picture at almost every turn. That's the best thing about Venice—every part of the city is a subject for the camera.

below left | Venice is a wonderful city to explore on foot. Away from the crowded Piazza San Marco, quintessential scenes of everyday life can be glimpsed along the narrow bridges and canals.

Essential kit

◈ Subtle hues and ornate architectural details require **fine-grained film** or a **low ISO setting** (for digital cameras) to be rendered accurately.

◈ You will want to use a **tripod** wherever possible, particularly for shots at dawn or dusk.

◈ Take plenty of **warm clothing** for a winter visit and **comfortable walking shoes**.

◈ Take enough **zoom lenses** to cover wideangle through to telephoto focal lengths.

◈ Pack a **polarizer** and a **neutral density graduated filter**.

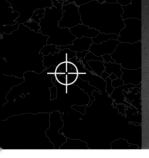
Florence has made an immense contribution to the intellectual and artistic development of the Western world. Florence was the birthplace of the Renaissance, and many of the world's greatest artists, sculptors, writers, and architects lived and worked here, including Michelangelo, Leonardo da Vinci, Machiavelli, Dante, Botticelli, Brunelleschi, and Alberti.

The Duomo

The city of 15th-century Renaissance Italy remains remarkably intact. Cars are banned from entering its compact center, enabling visitors to explore the medieval streets and squares on foot. The heart of Florence is the Duomo, a huge cathedral in green and white marble crowned by a glorious domed roof of terracotta tiles, designed by Brunelleschi and completed in 1463. Viewed from the ground, the beauty of Brunelleschi's masterpiece cannot be fully appreciated. But cross the River Arno and take a taxi to the top of one of the nearby hills overlooking Florence, and you can see the Duomo standing proud above the rest of the old city.

The Two Davids

The church of Santa Croce is another notable Florentine landmark. It is the resting place of Michelangelo, whose great creation, *David*, is the best-known and most photographed statue in the world. There are, in fact, two *Davids*: the original was removed from its site on the Piazza della Signoria to preserve it from air pollution, and now stands in the Accademia Gallery. An exact replica was installed in its original location.

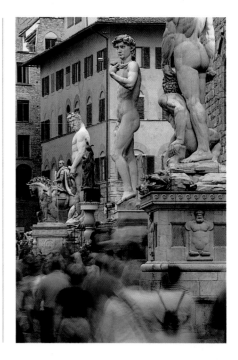

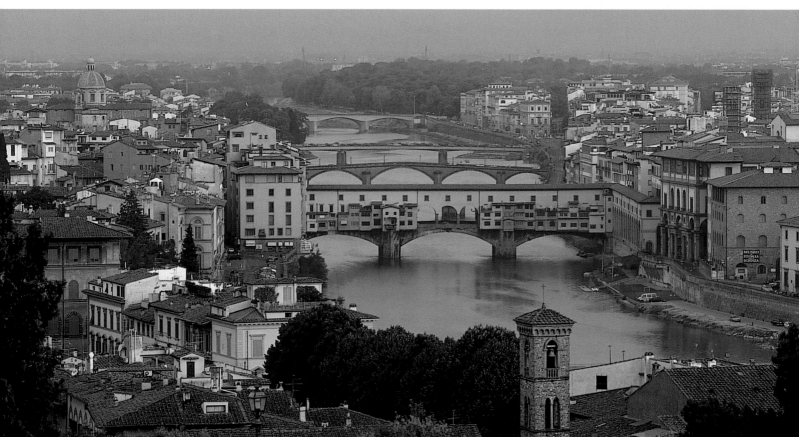

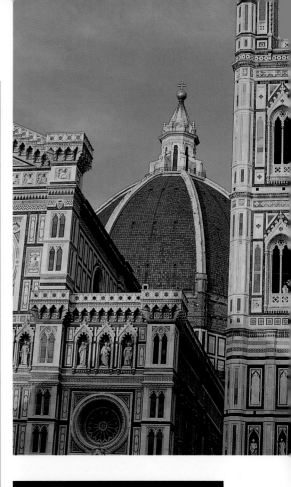

Historical background >>> In medieval times, what we now know as Italy was a collection of rival principalities, kingdoms, dukedoms, and republics. Florence became a republic in the early 12th century and eventually became the ruling city of Tuscany. In 1434, the Medici family seized power and ruled Florence with a mixture of ruthless autocracy and generous support for artists and intellectuals. In effect, the Medici funded the Renaissance. In 1966, the River Arno burst its banks and devastated the city and its treasures. Decades later, thousands of artefacts are still being restored in museums and galleries all over the city.

left | Statues on the Piazza della Signoria, including a replica of Michelangelo's David, stand supreme above the passing crowds.

opp page below | Several bridges span the River Arno; the Ponte Vecchio is closest to the camera.

Essential picture list

✛ For a fabulous view over Florence and the Duomo, take a taxi to the hills at **Fiesole**. This is a pleasant diversion in itself, complete with elegant villas, cafés, and boutiques.

✛ The **Ponte Vecchio** is a good location for candids and street cameos. After crossing the bridge, walk in either direction along the Arno and include it as foreground for views of the city.

✛ The **Piazza della Signoria** is flanked by wonderful examples of Renaissance architecture and statues, including the **Palazzo Vecchio** and a replica of Michelangelo's *David* standing in the open air.

✛ **Santa Croce** is a striking marble-fronted church, almost as famous as the Duomo.

The Ponte Vecchio

Florence is also home to the world-famous Uffizi art gallery, with its priceless collection of Renaissance art. For the photographer, however, the real treasure lies outside, at the end of a covered walkway leading from the Uffizi down to the River Arno—the 14th-century Ponte Vecchio ("Old Bridge"). Lined on either side by arcades packed with jewelry and craft shops, this bridge is cloaked in myth and intrigue; a secret passage built for the Medici family, the former rulers of Florence, still runs the entire length of the bridge. By day, the Ponte Vecchio is crowded with shoppers, but in the first light of dawn, the bridge provides a wonderful foreground for views along the Arno to the city palazzos lining its banks. To walk across the bridge just before dawn can be a ghostly quiet experience, but when the sun rises, the play of light on the water and buildings is a memorable moment for the camera.

top right | A detail of Brunelleschi's Duomo, a masterpiece in white and green marble and terracotta tiles.

Essential kit

✛ Many Florentine buildings are colored in hues of yellow, ocher, and pink that are typical of many Tuscan towns and villages. An **81a filter** is handy for bringing out the warmth of these colors.

✛ You'll find use for a **full range of lenses**, from wideangle for general vistas to short telephotos for views across the Arno to the Ponte Vecchio.

✛ Use a **tripod** wherever possible in the squares—a **telephoto zoom** is ideal for focusing on architectural details and the forms and faces of statues.

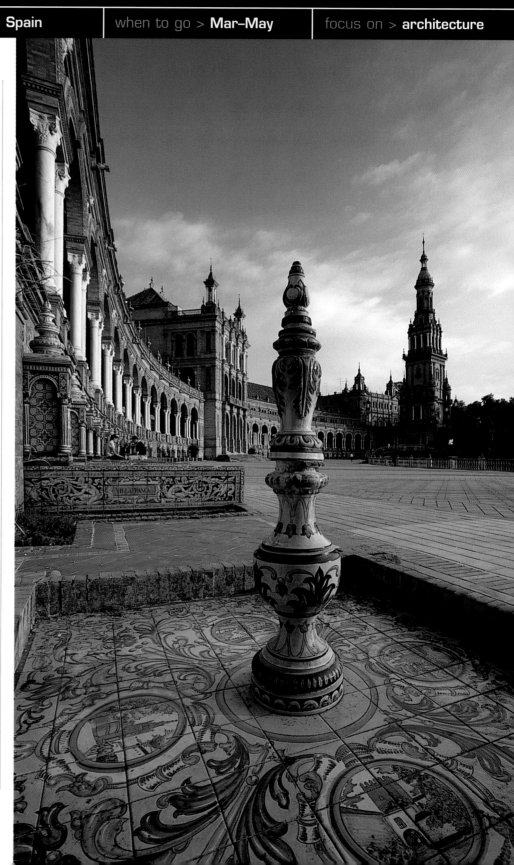

The best time to visit Seville is in the spring, when it is at its most lively and festive. Easter attracts people from all over the world to witness the city's Semana Santa (Holy Week) festival, when processions of floats bearing effigies of Jesus, the Virgin Mary, and other religious images fill the streets.

The Semana Santa dates back to the 14th century, but the city's other big celebration, the Feria de Abril (April Fair), has more recent and rustic origins. It started in the mid-19th century as an agricultural show and has since evolved into a street fair to celebrate Andalucia's rural traditions, prosperity, and culture in the last week of the month. The Sevillanos parade and dance in traditional dress, and ride their Arabian stallions.

Essential picture list

⊕ The best time to photograph **Seville Cathedral** and **La Giralda** tower is early morning. Make sure you photograph the view from the top of La Giralda.

⊕ The **Torre del Oro** is best seen at dusk on the riverbank. Otherwise, cross the river by the San Telmo Bridge for a late afternoon view including the city.

⊕ Two prime examples of Seville's modern architecture are the **Barqueta** and **Alamillo bridges**.

⊕ For its opportunity for street candids and its gentle ambience, **Santa Cruz** rarely disappoints. If you get tired of pictures, this is the place to sit and relax at lunch.

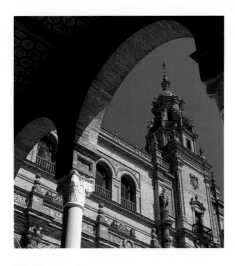

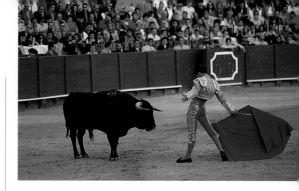

El Arenal

There is plenty else for the camera in Seville, which is compact and easy to explore by foot. The central district, known as El Arenal, is a good place to start. Situated along the banks of the Guadalquiver River, this area is dominated by a 13th-century Moorish watchtower known as the Torre del Oro (Tower of Gold), which looks most striking at dusk when the floodlights come on and the sky still holds some color from the fading day. Alternatively, you could rise early and capture the tower at daybreak. In both situations, mounting your camera on a tripod and bracketing your exposures is advisable.

Essential kit

⊕ With 300 days of sunshine a year in Seville, there is bound to be some shade in your photos. A **skylight filter** will help reduce the blue cast that occurs outdoors when shooting in shade, but even better are the **81a**, **81b** and **81c series warm-up filters**.

⊕ For dusk shots of Torre del Oro you will need a **tripod**.

⊕ A **standard zoom** should be sufficient while wandering the alleys of Santa Cruz.

⊕ A **wideangle lens** may seem the obvious choice for panoramic views from the top of La Giralda, but have a **telephoto** option too, to get some tighter compositions from this elevated position.

Santa Cruz

Many photographers like the Santa Cruz quarter, a mesh of narrow alleys and whitewashed houses surrounding Seville Cathedral and the Reales Alcazares (the Royal Palace). The most prominent landmark in Santa Cruz is the 320ft (90m)-high La Giralda, the bell tower of Seville Cathedral. It is, in fact, a 12th-century minaret—the last remnant of a Moorish mosque that stood there until Seville was recaptured by the Christians. They tore down the mosque, built Seville Cathedral in its place, and saved the minaret by turning it into a bell tower. La Giralda is open to the public and a climb of 300 steps to the top is rewarded by superb views.

left | The Plaza de Espana is a fine example of the Moorish influence on Seville's architecture.

above | Seville's long history has produced a rich legacy of architectural styles, ranging from Gothic and Rococo to Moorish and Postmodern.

top right | Bull fighting is one of many traditions preserved by the Andalucians.

Historical background >>> Like all of Andalucia's major towns and cities, Seville, Spain's third largest city, owes its character and splendor to the Moorish conquest of Spain in the early 8th century. The Moors crossed the Straits of Gibraltar from Morocco in 711CE and ruled over most of Spain for the next six centuries. By the 13th century, they had been forced south by the Christians, and made Andalucia their stronghold. The Moors left an indelible mark on the architecture and civilization of Seville, building mosques, courtyards, and water gardens, many of which remain to this day. Seville became the capital of Moorish Spain in 1236 following the fall of Cordoba to the Christians, but 12 years later it too was recaptured and the city's main mosque smashed. Seville Cathedral was built on the ruins and the minaret, known today as La Giralda, was turned into a bell tower. Christianity has held sway in Seville ever since and the city's Semana Santa festival has been celebrated virtually every Easter since then.

The charming old city of Segovia has one of the most picturesque settings in all of Spain. Situated 54 miles (82km) northwest of Madrid, this Castilian town of 50,000 people boasts historic attractions and sites from a glorious past of power, art, and industry.

The Alcazar Castle

The most famous of Segovia's sites is the Alcazar Castle. With its turrets, high battlements, and an elevated position on the northwest end of the medieval wall surrounding the old city, the Alcazar looks like a fairytale castle.

Because of its conspicuous position, the Alcazar can be photographed all year round from different parts of the city. There are specially built viewpoints and lookouts in the hills and trails outside the city, one of which, on the road to Santa Maria la Real de Nieva, is best visited in winter, when snow covers the tops of the Guadarrama Mountains to create the perfect backdrop.

No cars are allowed within the medieval walls that encircle the old city, allowing you to meander through the narrow alleys, admiring the abundance of architectural wonders, including Europe's largest concentration of Romanesque churches. In the southeast corner of the wall is the famous 2,000-year-old Roman aqueduct, which rises 100ft (30m) above the plaza below. But towering above everything is Segovia's 16th-century cathedral, which rises over the city to create a profile best captured in the golden glow of sunset.

below left | Segovia's Gothic Cathedral.

below right | Shadows from the arches of the Roman aqueduct create a graphic pattern across the street below.

Essential kit

⊕ The heart of Segovia is pedestrianized with twisting lanes, so wear **comfortable shoes** and carry a minimum of kit: one **camera body** and a **couple of zooms** will give you enough scope.

⊕ Narrow alleys mean confined spaces and large areas of shadow, so add an **81a** or **81b filter** to your lens to give warmth to darker parts of the scene.

⊕ If a tripod proves inconvenient, use a **monopod** for added stability. It can also double up as a useful walking pole.

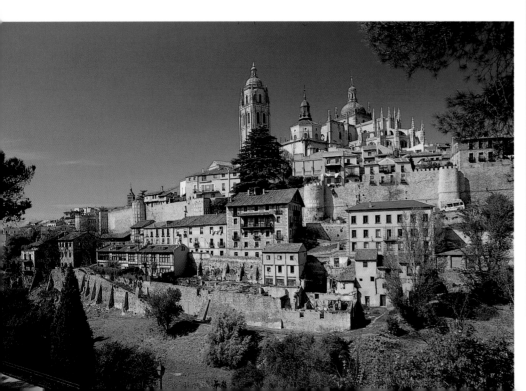

As its fortified walls, labyrinthine streets, and hilltop position so clearly indicate, Toledo has had a long and prodigious history. Architecturally, it is a history that is richly preserved and a constant source of wonder to the visitor. Within these walls lies the old city, best entered by the Puerta de Bisagra (Bisagra Gate) to attain an immediate sense of the fabric and atmosphere of the place.

The social and geographical center is the Plaza de Zocodover, surrounded by impressive architecture. From here, while your legs are still feeling strong, follow the Cuesta del Alcazar (Fortress Hill) up to the Alcazar itself. The castle, built in the 11th century by Alfonso VI, imposes itself on the rest of the old city by virtue of its position as well as the sheer magnificence of its structure. The views are worth savoring.

Essential kit

⊕ The winding, cobbled alleys and hilly situation means that Toledo can only be conquered in **sensible footwear**.

⊕ Don't carry too much gear—use a **backpack** or **waistpack** and carry only **one camera body** and a **couple of zoom lenses**.

⊕ A **carbon-fiber tripod** won't weigh you down too much.

⊕ **Warm-up filters** will help to give the Gothic stonework and city walls a lift.

⊕ Carry some **fast film** or use **ISO 400** (for digital cameras) when the streets fill with shade.

above left | The late Gothic architecture of the Church of San Juan de Los Reyes is typical of much of Toledo's architecture. This is a detail of the arches in the cloisters of the former Franciscan convent.

right | Built in the early 14th century, the Puente de San Martin (St Martin's Bridge) is another fine example of Toledo's Gothic architecture. Spanning the River Tagus, the bridge has defensive towers at each end.

The river and the cathedral

Another scenic spot is the Arco de la Sangre, which rather gruesomely translates as the "Arch of Blood." Here, take the trouble to set up your tripod and photograph the expansive view of the River Tagus. As with so many views, you are more likely to make a memorable composition by using a longer focal length lens than by reaching for the wideangle.

One of Toledo's greatest landmarks is the cathedral, regarded as one of the most architecturally important cathedrals in Europe. Situated at the end of Calle Comercio in an area full of shops and restaurants, its Gothic walls rise dramatically above the Palacio Arzobispal (the Archbishop's Palace).

For pictures of Toledans enjoying the beauty of their ancient city, take the steep walk up Calle Trinidad to Plaza del Salvador (Square of the Savior) and the pedestrianized street of Santo Tomé, which is packed with open-air cafés, art and crafts shops, restaurants, and museums.

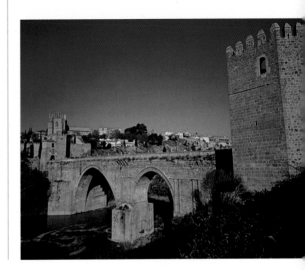

Essential picture list

⊕ The Gaudí architecture is impossible to resist, especially **La Sagrada Familia**. But also check out **Casa Battlo**, **Casa Milà**, and **Parc Güell**.

⊕ **Las Ramblas** is always a hub of activity with stalls, cafés, and street entertainers.

⊕ For views, **Montanya de Montjuïc** and the **Palau Nacional** are a must.

⊕ There are many fine buildings in the **Barri Gòtic**, including the **Catedral La Seu**. The narrow alleys make an atmospheric shot if the light is right.

⊕ The redeveloped docks are home to the **Monument a Colon** (Columbus), where you can take a lift to the top and admire the panorama. Afterward, go east along the Moll d'Espanya to see **Port Olimpic** and **La Barcelonetta**.

⊕ **Plaça de Reial** is wonderful both day and night; **Plaça del Rei** captures the medieval feel of the old quarter.

Barcelona is synonymous with the fabulous architecture of Antoni Gaudí. Scattered throughout the city are buildings that arrest your attention for their sheer uniqueness. Few people would question that Gaudí's (and Barcelona's) greatest monument is La Sagrada Familia. This unfinished cathedral dominates the Barcelona skyline and holds your attention from any direction. By day it is crawling with visitors: this is not the time to make photographs. Instead, arrive early, or go at night when it is fantastically lit, and use a telephoto lens to shoot the extraordinary detail on the facade.

Beyond Gaudí

There's more to Barcelona than Gaudí, however. Fine examples of modern architecture are a feature of the redeveloped docks. Immediately behind the docks lies Barcelona's medieval quarter, the Barri Gòtic, which is remarkably unspoilt and evocative.

Las Ramblas is Barcelona's most famous street. It is the place to stay and be seen.

bottom left | The statues and illuminated fountains of the Plaça d'Espanya make an atmospheric setting at night.

below | Las Ramblas is a prime location for street entertainers.

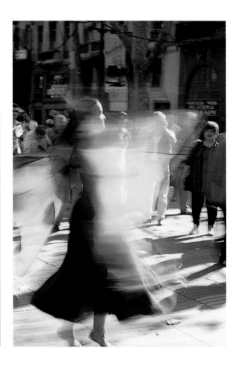

Historical background >>> No-one is certain who first settled in what is now Barcelona, but after the Romans left in the 5th century CE, the city had several invading rulers for the next five centuries. Barcelona's golden age began after the creation of the Crown of Aragon in the 12th century and the city, as capital of Catalunya, became a rival to Madrid. This rivalry culminated in the War of the Spanish Succession in 1713, in which Catalunya was defeated. Barcelona was the center of a series of Catalan separatist movements, culminating in the Spanish Civil War (1936–39) when the city was the last stronghold of the defeated Republicans. The victorious General Franco banned the teaching of Catalan, but after his death in 1975 the Catalunya government-in-exile returned from Mexico and negotiated with King Juan Carlos for the re-establishment of autonomy for Catalunya and all regions in Spain.

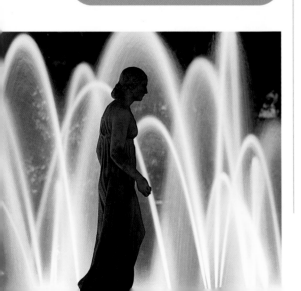

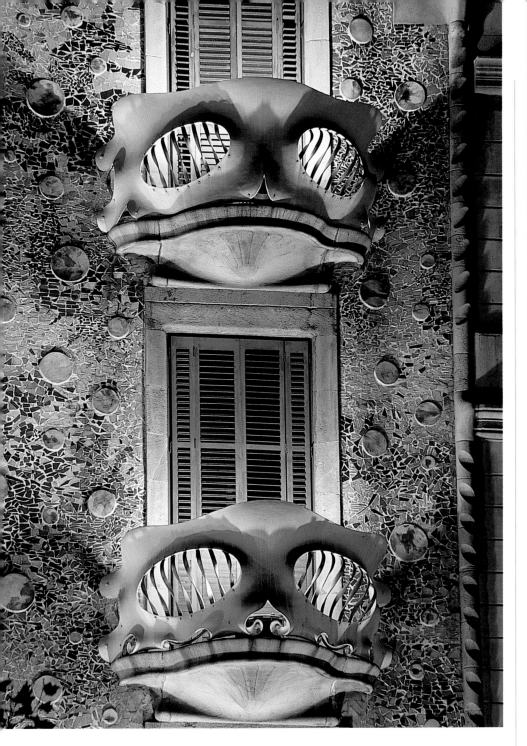

left | A night view of the balconies at the Gaudí-designed Casa Batlló.

above | Looking toward the Plaça d'Espanya from Palau Nacional.

If you're spending a Sunday in Barcelona, go to the Catedral La Seu, where La Sardana, a traditional Catalan dance, takes place in the square in front of the 14th-century cathedral.

For a different type of image, the indoor produce market at Sant Josep la Boqueria is a short walk from Las Ramblas and is great for candid images of people at work.

Open spaces

If you're in need of open space, then head for Montanya de Montjuïc, a high hill overlooking the city. With a grand view, green spaces, and a funfair, you can escape the city bustle and enjoy your photography in a more relaxed fashion. From the top of Montjuïc, you're within easy walking distance of the Palau Nacional. The views from

here are magnificent and the palace itself is best viewed when looking back from the Plaça d'Espanya below.

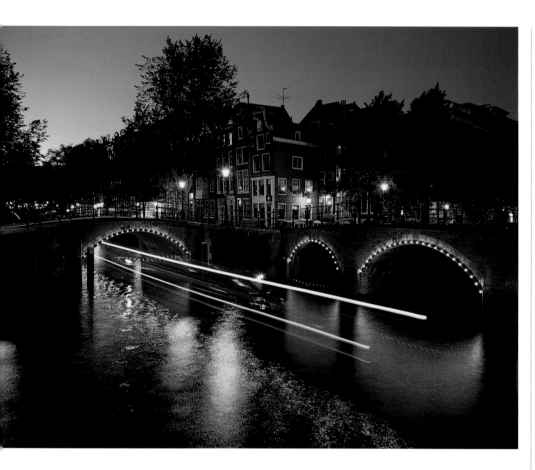

representative feature of the city's architecture. One viewpoint worth framing with your camera is the corner of Reguliersgracht and Herengracht, where 15 canal bridges can be seen.

Despite these wonderful sights, the clichéd images of windmills and tulip beds remain at the top of most visitors' lists. The nearest windmills are a fair trek out of Amsterdam. Some can be viewed on the longer canal boat cruises, although the setting can be stark and uninspiring. Flowers are far more colorful, and a good diversion is the floating flower market on the Singel, where barges overflow with sunflowers, lilies, orchids, and, yes, tulips. This is a wonderful spot for some close-up shots.

Amsterdam is the perfect size in that all its major sights can be reached on foot —or bicycle. The city is well equipped for bicycles; there are separate cycle lanes on the major streets and bikes have their own traffic lights at intersections. Best of all, Amsterdam is flat, so you don't have to be a Tour de France winner to be able to pedal around the city with relative ease.

The Venice of the North

There are more than a hundred canals in Amsterdam, earning it the sobriquet of "the Venice of the North," and the chance of viewing the city from a canal boat shouldn't be missed. Amsterdam is

above | A light trail from a passing canal boat and illuminated arches is reflected in the water as dusk falls over Amsterdam.

particularly attractive at night, when lights on the bridges and embankments are reflected in the canal waters.

Walking along the Keizersgracht, Herengracht, Singel, or Prinsengracht canals makes a very pleasant trip in the daytime, with views of elegant 16th- and 17th-century merchants' homes and warehouses with majestic facades and distinctive gable roofs. These fine buildings line the length of many streets fronting Amsterdam's canals and are a

Essential kit

⊕ A **backpack** will be the best way to carry your camera gear if you hire a bicycle.

⊕ A **camera body** and a **couple of zooms** will cover most options. If flower and garden photography is a prime interest, also pack a **macro lens** for close-ups.

⊕ A **carbon-fiber tripod** won't weigh you down while providing the support you need for night scenes.

With a city as revered and celebrated as Paris, it's hard to capture in a few sentences all its charms and character. The mention of its gardens, landmarks, and streets spark vibrant images in the mind of any visitor: Avenue des Champs-Elysées, Pont Neuf, Notre-Dame, Arc de Triomphe, Jardin de Tuileries, Pont Alexandre III, Palais du Louvre, Tour Eiffel. Every visitor has a favorite quarter of this stylish city, and it would take weeks to do these locations justice with the camera. The heart of Paris is best explored on foot, never straying far from the river Seine.

above right | This image of the Arc de Triomphe was taken from a traffic island in the middle of the Champs-Elysées.

below | A floodlit Notre-Dame viewed from the Left Bank of the Seine is an iconic image of Paris.

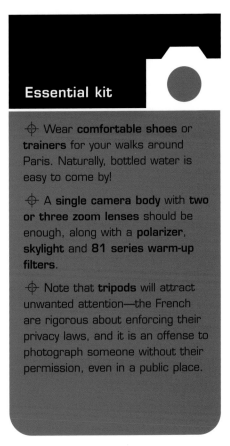

Essential kit

⊕ Wear **comfortable shoes** or **trainers** for your walks around Paris. Naturally, bottled water is easy to come by!

⊕ A **single camera body** with **two or three zoom lenses** should be enough, along with a **polarizer**, **skylight** and **81 series warm-up filters**.

⊕ Note that **tripods** will attract unwanted attention—the French are rigorous about enforcing their privacy laws, and it is an offense to photograph someone without their permission, even in a public place.

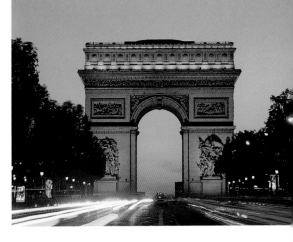

A walk to the Tuileries

Take the Metro to St Michel Notre-Dame and cross the river to Ile de la Cité and the cathedral of Notre-Dame. From here, you can complete your crossing of the Seine to the Right Bank and turn left toward the Louvre, home to the world's greatest collection of art. The forecourt is dominated by I.M. Pei's huge glass pyramid, a favorite subject with photographers. From here, you can take in one of the greatest sightlines of city planning—looking straight down the length of the Tuileries, onto the Champs Elysées, and rising up to the Arc de Triomphe in the distance.

The Tuileries is a delight, and its lines of trees, chairs, sculptures, and flowerbeds are a source of random vignettes in delicate open shade. From here, you could return underground at the Tuileries Metro and re-emerge at George V for an expensive coffee on the Champs Elysées, or cross the Seine again along Pont Royal to the Left Bank and walk back upstream, browsing at the stalls of book and print sellers.

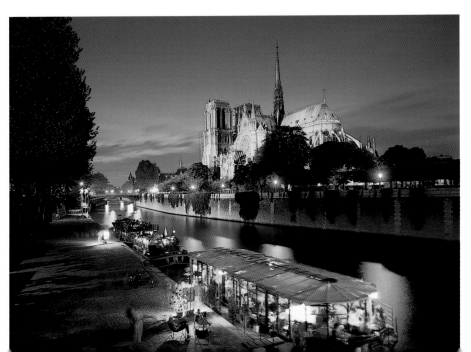

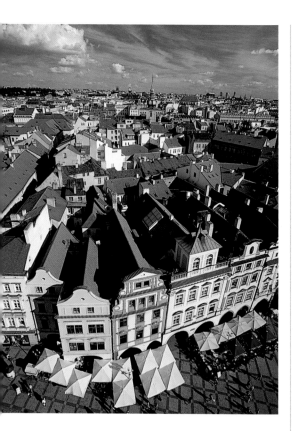

On the western bank of the river, hundreds of steps rise to the massive fortress of Hradcany, better known as Prague Castle, which is believed to be the biggest inhabited castle in the world. Here, at the seat of the Czech government, you can wander through the vast grounds and enjoy spectacular views over Prague's ancient rooftops. Within the grounds is St Vitus Cathedral, a spectacular Gothic monument begun in the 14th century but not finished until 1929.

Many streets and lanes wind their way down from the castle to the Vltava River, passing through the charming Mala Strana, or Little Quarter. With its central square dominated by the high walls and Baroque cupola of St Nicholas Church, it makes a pleasant diversion before you reach Charles Bridge for the walk across the river to Old Town.

above | **There are great views from the Castle of Old Town's streets and squares.**

right | **The Charles Bridge (center) is the most famous of Prague's river crossings.**

Prague is home to some of Europe's finest examples of Gothic, Renaissance, and Baroque buildings. There is an abundance of architectural treasures from the 14th and 15th centuries, as a walk around Staromestske namesti, the main square in Old Town, confirms. The square is lined with beautifully preserved houses, shops, and cafés.

The Old Town is on the left bank of the Vltava River, which is spanned by many bridges, the most famous being the Charles Bridge. By day, this bridge is packed with tourists, stalls, and traders. Getting a reasonable photograph is virtually impossible, although there are better prospects at dawn when the bridge is deserted.

Essential kit

⊕ Pack a **wideangle lens** for panoramic views from the top of Prague Castle or the Town Hall.

⊕ Take a **telephoto zoom** for picking out Gothic details on St Vitus Cathedral and the painted facades in Old Town square.

⊕ A **tripod** is essential if you want to photograph Charles Bridge in the light of dawn.

⊕ Cobblestone lanes and steep steps up to the castle will necessitate wearing a good pair of **walking shoes** or **boots**.

⊕ The **81 series of warm-up filters** is the most useful for adding warmth to architectural details in the flat overhead light of midday.

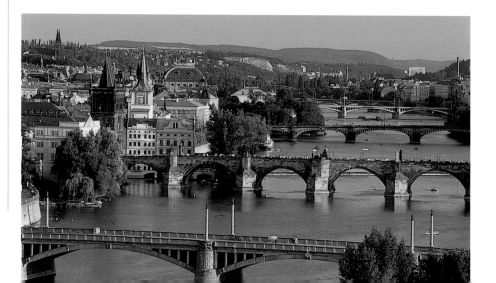

London is in fact two cities: the City of London and the City of Westminster. The City of London is just one square mile (2.5sq km) in area. This is the older part of the capital, and takes in the financial district, St Paul's Cathedral, and the Tower of London. The City of Westminster was founded in the 11th century by Edward the Confessor, who built his new palace west of the old city, on the site where the Houses of Parliament now stand. He also established Westminster Abbey, where every English monarch over the past 900 years has been crowned.

below | **The Palace of Westminster looks irresistible when viewed from the South Bank of the Thames between Lambeth and Westminster Bridges in the light of early morning.**

The Palace of Westminster

Another great landmark of the city is the Palace of Westminster, home to the Houses of Parliament with its magnificent Gothic architecture and grandiose clock tower, Big Ben. The Palace stands on a bend of the River Thames, facing east, which means that early morning, soon after sunrise, is the perfect time to photograph its extraordinary frontage. Many tour buses park on the opposite bank near Lambeth Palace, but a better view can be afforded further downstream, right by Westminster Bridge, which takes London's traffic directly past Big Ben into Parliament Square. Most people shoot over the river embankment or from the bridge, filling the foreground with the broad waters of the Thames.

The streets opposite the Palace and behind the Abbey have followed the same twists and turns from the day they were first laid. They remain remarkably secluded, considering the congestion around Parliament Square. Here you will find a random clutter of wonderful old houses and walls of character and substance, which say as much about Westminster as the overstated opulence of Big Ben.

Essential kit

⊕ **Tripods** are generally frowned upon by London's many capped authorities, but it's worth setting up, if only to see what sort of reaction you get—the British love a well-mannered, cleverly debated argument.

⊕ A **spirit level** in your tripod or as a separate attachment on the camera hotshoe will help keep the river and horizon level.

⊕ A **standard zoom** gives you the option to make a sectional crop of the Palace of Westminster; but a wideangle view of the whole facade is hard to beat.

⊕ **Skylight** and **81a warm-up filters**, as well as a **polarizer**, will give you the option to boost the colors of building and sky and cut down glare and reflections from all the Palace windows.

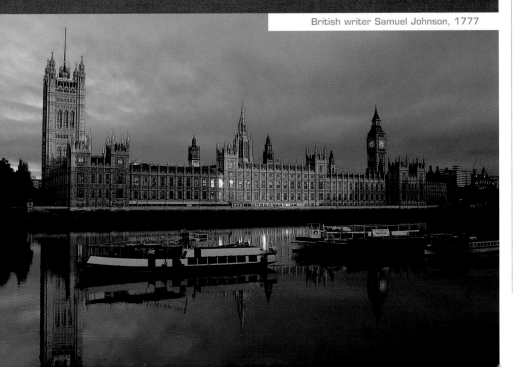

"When a man is tired of London, he is tired of life."

British writer Samuel Johnson, 1777

Cuba conjures up many images—and even more contradictions. It has one of the highest literacy rates in the world and a public health service that actually works, but power cuts are a way of life and nearly all the cars pre-date the 1960s. Like the rest of Cuba, life in Havana is a by-product of a political schism between the communist government of Fidel Castro and Cuba's superpower neighbor to the north, the United States. Castro isn't getting any younger (he was born in 1926), and there is little doubt that when he dies Cuba will change irrevocably.

top right | American cars from the 1950s are a common sight in Havana.

below | Many of Havana's buildings are in an advanced state of disrepair.

Habana Vieja

Havana Old Town (Habana Vieja) is a favorite place with photographers for the crumbling beauty of its colonial architecture and its lively streets and squares, where the scent of Cuban cigars and the sounds of salsa follow you everywhere.

Plaza Vieja and Plaza de la Catedral are the most atmospheric of Havana's historic squares and make a wonderful backdrop to cameos of daily life. On the nearby streets, children play basketball or box with oversized gloves, while habaneros (street bands) perform their repertoire for a few dollars from passing tourists—it may not be Buena Vista Social Club, but the essence is the same. Everywhere you go in Habana Vieja, there are people meeting, conversing, playing, or just passing time

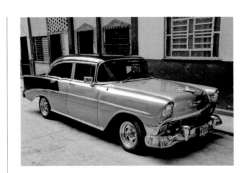

Essential kit

⊕ The cobbled squares and streets of Habana Vieja are best seen on foot, so travel light with a **single camera body** and **two or three lenses**, packed into a shoulder bag or backpack.

⊕ **Telephoto zooms** may have the greatest use for shooting candids and architectural details.

⊕ **81-series warm-up filters** are useful to bolster the faded, peeling hues of colonial buildings.

⊕ Havana is a city that photographs equally well in color or in black and white, so try both forms. A **digital camera with a black and white mode** enables you to take both types of picture in succession. See which one you prefer by viewing the images on the LCD screen.

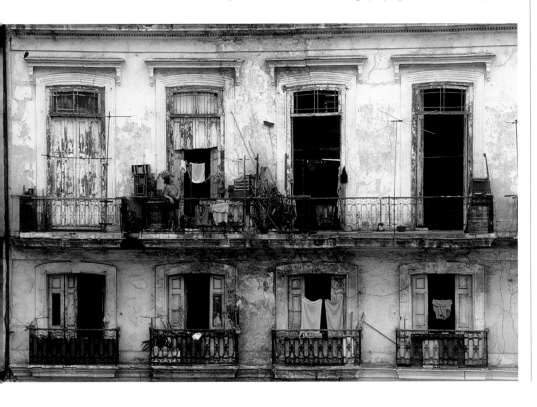

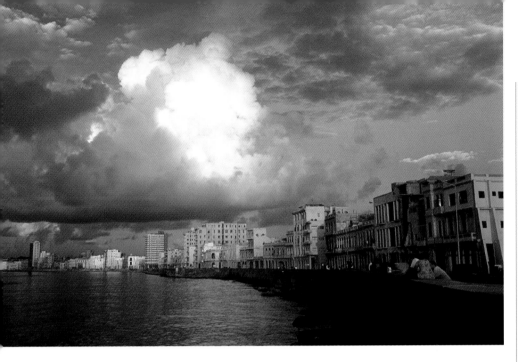

left | The Malecón, Havana's sweeping waterfront promenade, at sunset.

below left | Images of communist revolutionaries such as Che Guevara are a common sight.

Essential picture list

⊕ There's no better place to get a feel for the atmosphere of Havana than the **Plaza de la Catedral**. The street life is pure theater.

⊕ One end of the plaza is dominated by the **Catedral de la Habana**, a grand old Baroque cathedral that is floodlit at night.

⊕ Brightly colored **1950s American cars** are an iconic symbol of Havana. The streets around the Capitolio Nacional have some of the highest concentrations.

⊕ The end of each day in Havana is best spent on the **Malecón**, the waterfront promenade where many locals gather to watch the sunset.

on the streets—there is no commuter crush here. This is especially true on the Malecón, Havana's sweeping waterfront promenade. The Malecón is best visited just before sunset, when hundreds of people converge to gaze out over the sea and look in awe at the flame-red sky. This is also the ideal time for photographing the waterfront buildings, as the setting sun brings a golden hue to the weathered and damp buildings facing the waterfront.

The time-warp cars

If the easy pace of the old city doesn't make you think you've been caught in a 1950s time warp, then the sight of old Chevrolets, Buicks, and Cadillacs, parked in front of the Capitolio Nacional on the Calle Obispo, will certainly have

you checking the date. Like so much of Havana, the cars have seen better days, but when you see a battered red or yellow Chevy parked in front of a decaying, paint-peeling colonial terrace, there is no more archetypal image of Havana to be found.

i

Historical background >>> Perhaps ironically, the man who the United States claims as its principal discoverer, Christopher Columbus, also landed in Cuba during his famous voyage of 1492. Spanish rule of the island lasted more than 400 years, and Havana became the capital city in 1607. It remains Cuba's most important city and has a population of approximately two million.

In the 60 years following the 1895–98 War of Independence, Havana was the center of a prosperous and sometimes hedonistic way of life, immortalized by the life and writings of Ernest Hemingway. In 1958, Fidel Castro's band of revolutionaries overthrew the government of President Fulgencio Batista. Castro has remained a thorn in the side of America ever since, surviving several assassination attempts and the CIA's bungled invasion at the Bay of Pigs in 1961. Castro's Cuba was one of Soviet Russia's staunchest allies, but since the collapse of the Soviet Union in the early 1990s, the Cuban economy has deteriorated and living standards are generally poor.

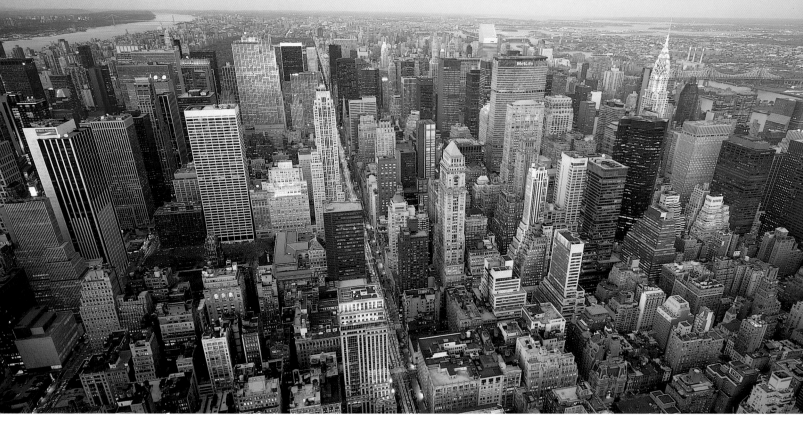

Manhattan is probably the most influential city in the world. Images of its dense cluster of skyscrapers, photographed from the water, the Staten Island ferry, or the Brooklyn Bridge, have become representational views for the whole of New York. Manhattan's skyline was altered forever following the terrorist attacks of 11 September 2001. 9/11 has changed New York, but not enough to alter the essential character of the place.

above | **Manhattan from the observation deck of the Empire State Building.**

right | **The weblike suspension cables of the Brooklyn Bridge fill the frame when viewed from the pedestrian boardwalk.**

Manhattan icons

On Manhattan's streets, life never slows down, and the crowded paths and traffic noise is both intimidating and intoxicating. It is on the street that some of the most iconic images of New York can be made: lines of yellow taxis; Central Park roller bladers; Fifth Avenue stores; Times Square at night; the brownstone tenements with their iron fire-escapes.

One of the best views of Manhattan is from the Brooklyn Bridge on the other side of the East River. The bridge itself is photogenic, with its suspension cables radiating web-like from two stone-built towers, making a dynamic foreground to the panorama of skyscrapers behind. Even better, though, is the view of Manhattan across

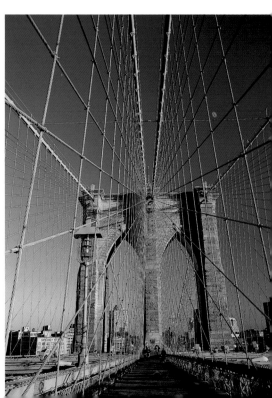

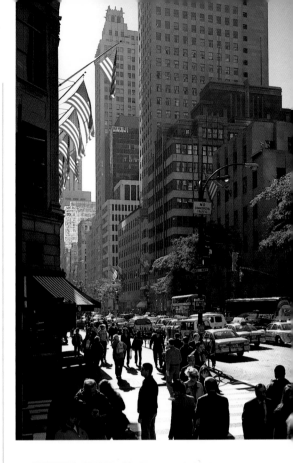

Historical background >>> For nearly 400 years, Manhattan has been the heart of America's largest city. An important hunting and fishing area for Native Americans, it soon caught the eye of European settlers, attracted to its ice-free harbor with access to the interior through the Hudson River. As an island, it was also defensible from invasion by land or sea. The Dutch West India Company settled here in 1624, laying the foundations for New York's future role as a financial center. Manhattan's famous street grid was laid out from 1811, but the older, narrower streets of Lower Manhattan were spared. When the receiving station at Ellis Island opened in the late 19th century, Manhattan became the first port of call for immigrants.

Essential picture list

⊕ Where Broadway meets Seventh Avenue is **Times Square**, the heart of New York's theater land. After dark is the time to visit, when neon advertising lights up the streets.

⊕ The **Empire State** is New York's tallest building and the platform offers an unforgettable view of the city. Visit the **observation deck** on the 86th floor in the late afternoon to photograph the sunset and city lights.

⊕ Many photographers rate the **Chrysler Building** as the most photogenic Manhattan skyscraper. Zoom in on the curved, tiered top stories with their chrome plating and distinctive sawtooth-shaped windows.

⊕ **Central Park** is a green oasis in the middle of Manhattan's concrete jungle. From the southeast corner, there is a lovely view across one of the ponds and trees to the buildings of Fifth Avenue. This scene is at its best in fall.

⊕ Take the ferry to **Liberty Island** and the **Statue of Liberty**. The views of Manhattan from the ferry are well worth a few frames.

right | Shafts of sunlight squeezing between skyscapers provide dramatic backlighting in this scene.

the East River from beneath the bridge. It is best to get here at dawn when the first light of sunrise is shining off Manhattan's glass towers. Sunset is equally spectacular.

Since 9/11, the Empire State Building has regained the title of New York's tallest building, and the views from the observation floor are breathtaking. However, many photographers regard the Chrysler Building as their favorite. With its chrome-plated roof, it takes on a golden hue in sunlight and looks impressive from any angle. On a clear day in fall, the view from 42nd Street around mid-morning is worth a few frames.

Although not strictly part of Manhattan, no visit is complete without taking the ferry from Manhattan to Liberty Island and the Statue of Liberty. The city views from the ferry are worth the ride alone. Post-9/11 security measures for the Statue of Liberty, have been partially lifted, but it is still not yet possible to climb inside the statue to enjoy the views from the top.

Essential kit

⊕ With so much concrete and brick, the **81 series of filters** will add some warmth to the gray and beige buildings.

⊕ For night work such as at Times Square or looking back at Manhattan from beneath the Brooklyn Bridge, a **tripod** is a must.

⊕ **Wideangle lenses** are useful for panoramic views and also for photographing skyscrapers while looking up from street level.

⊕ A **polarizing filter** will cut down distracting reflections and highlights from glass.

With its huge steel arch bridge and the unmistakable opera house, Sydney Harbour is one of the most recognizable cities in the world. It is also accessible, with excellent rail and bus links centered around Circular Quay—the small cove between the Harbour Bridge and Opera House—and the terminus for ferries.

below right | From a vantage point known as Mrs Macquarie's Chair, you can get this classic view of the Sydney Opera House in profile against the sleek iron span of the Harbour Bridge. In this case, the sun has set in the west, right behind the bridge.

Essential kit

◆ A **wide range of lens focal lengths** is needed to capture the breadth and details of Sydney Harbour. In 35mm format, a **28mm wideangle lens** is advisable, and a **wideangle zoom of 17–35mm** would get plenty of use. **Telephoto zooms up to 300mm** are also handy for cropping closely on the bridge or isolating subject details.

◆ Sydney enjoys wonderful light most months of the year, so **fine-grain color films** are ideal.

◆ A **polarizing filter** can prove to be invaluable.

A walk around the quay

Circular Quay is the obvious place to start, and you could spend a whole day idling around this historic port. It is from Circular Quay that most people, arriving by train or bus, have their first view of the Harbour Bridge and Opera House. Both are a short walk away— the Bridge marks the western end of the Quay, and the Opera House is the eastern end. Deciding which to visit first is not easy, as both views and settings are equally spectacular. The Bridge is the bigger of the two structures and rises above the oldest part of the city, known as The Rocks. From here you can look directly east across the water onto the Opera House, its white ceramic "sails" in profile against the sky.

For a closer look, you need to retrace your steps back to Circular Quay and follow the water's edge along the other side of the Quay to the Opera House steps. There is a public walkway around the building, enabling you to photograph the Opera House at close quarters from any direction. When you are this close, you can use telephoto lenses to make graphic compositions,

Essential picture list

◆ **Circular Quay** is Sydney's historic and commercial heart, with wonderful views of the Harbour Bridge and Opera House.

◆ Situated adjacent to Circular Quay, **Darling Harbour** is a redeveloped waterfront that provides superb views of the city skyline.

◆ Look due west from **Mrs Macquarie's Chair** to take in the famous view of the Opera House against the Harbour Bridge.

◆ If you haven't photographed a view of **Sydney from the deck of a ferry** then you haven't really photographed Sydney at all.

◆ The **Royal Botanic Gardens** offer a green oasis of calm among tall palms and eucalyptus trees where hundreds of flying foxes roost by day.

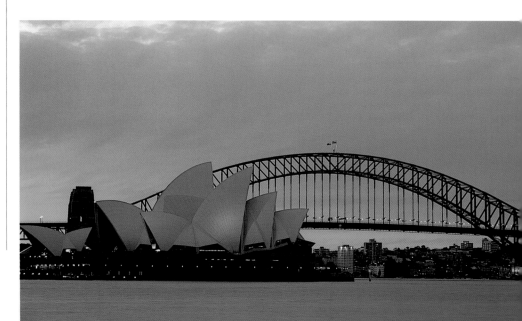

while the curves of the building can be accentuated using wideangle lenses.

The Opera House rises up from the water on a spit of land called Bennelong Point. The next cove along from here, Farm Cove, is the northern perimeter of Sydney's Royal Botanic Gardens.

At the next headland, marking the eastern end of Farm Cove, is Mrs Macquarie's Chair, a seat hewn out of the sandstone outcrop for the wife of Lachlan Macquarie, an early 19th-century governor of the colony. She would sit here to admire the view, and thousands have followed her example. From here you can take in the classic scene, looking west toward the Opera House with the rising span of the Harbour Bridge as the backdrop. The best time to be here is early morning when the Opera House is bathed in the warm glow of sunrise.

above | The National Maritime Museum on Darling Harbour provides the contrasting spectacle of a modern ferry passing the moored replica of one of the first ships to sail into Sydney Harbour more than 200 years before

Historical background >>> Sydney Harbour is the popular but incorrect name for Port Jackson, the largest natural harbor in the world. It was discovered by Captain James Cook in 1770 and settled 18 years later when the First Fleet of 11 ships, carrying around 900 convicts, left England to establish a penal colony on the Australian continent. The nine-month voyage ended on 26 January 1788, when the fleet's leader, Captain Arthur Phillip, landed at Sydney Cove (now known as Circular Quay). Today, the pictorial heart of Sydney remains where those first settlers arrived. Circular Quay (Sydney Cove) is flanked by the city's two greatest architectural feats: the Harbour Bridge and the Opera House. These have become iconic symbols of Sydney.

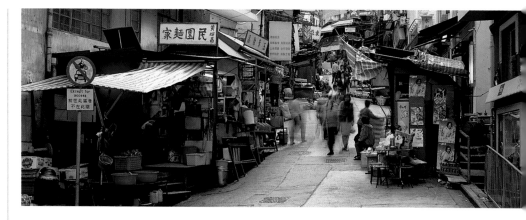

Until 1997, Hong Kong was the world's most famous colony. In that year, the last outpost of the British Empire was handed back to China, ending more than 150 years of colonial rule. Chinese rule has seen little change. Even under a nominally communist regime, Hong Kong remains a potent symbol of capitalism and hedonism.

Around seven million people are crammed into the forest of high-rise apartments that stretches from the New Territories and Kowloon on the mainland to the opulent homes of the rich on Victoria Peak. Most of Hong Kong's ten million annual visitors spend their time in Kowloon or Hong Kong Island, plying the waters between the

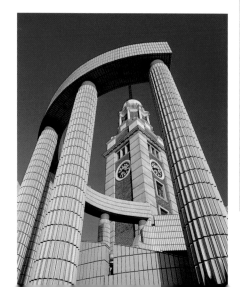

two on the extremely cheap and efficient Star Ferry. It's a brief but spectacular journey and a great way to get orientated. From the ferry you can see an impressive line-up of skyscrapers and buildings adorning the waterfront on both sides of Victoria Harbor. The most famous view, however, is from the top of Victoria Peak on Hong Kong Island. If you only make the trip once,

top | The markets and stalls in the Sheung Wan area of Hong Kong Island is a typical street to be found away from the central business district.

above left | Two of the statues found at the Monastery of the Ten Thousand Buddhas, Sha Tin, in the New Territories.

below left | Looking up at the Victoria Clock Tower in the Cultural Plaza, Kowloon.

opp page top right | The neon-lit Nathan Road, Kowloon's busiest shopping street.

opp page right | The view across Victoria Harbor to the skyscrapers of Hong Kong Island from the Tsim Sha Tin waterfront on Kowloon makes a spectacular panorama.

Essential picture list

⊕ Take your tripod for the trip to the top of **Victoria Peak**, where the night-time views of the north side of Hong Kong Island, Victoria Harbor, and across to Kowloon are stunning.

⊕ The view of Hong Kong Island from the **Tsim Sha Tui waterfront** is another classic, best seen at sunset while there's still color in the sky.

⊕ **Reclamation Street market**, Kowloon, is packed with shops selling unusual produce.

⊕ On the southern tip of Hong Kong Island is **Stanley**, a quiet corner with an attractive harbor and market.

⊕ Take the ferry to Lantau Island to visit the **Po Lin Monastery** and **Tai O**, one of the last fishing villages in Hong Kong to feature houses built on stilts.

⊕ The **Monastery of the Ten Thousand Buddhas** in Sha Tin is best seen in the morning or late afternoon.

Historical background >>> Hong Kong's affluence and strategic importance emerged from a series of wars between China and Britain over the opium trade. It was China's attempt to stop Britain from forcing the sale of opium to the Chinese that led to the first Opium War in 1841. China lost, and Hong Kong Island became a British colony. A second war soon followed, with the same result, and in 1859 Kowloon was added to the colony. In 1898, while seeking to expand the colony, Britain leased the New Territories from China for 99 years. With the expiry of this lease due in 1997, the British and Chinese governments met to negotiate the return of the whole of Hong Kong to China. An agreement was signed in 1984 and, on 30 June 1997, Hong Kong was formally handed back to China.

Essential kit

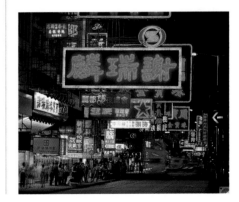

⊕ You will be on foot most of the time, so it makes sense to travel light, and restrict yourself to **one camera** and a **brace of lenses**—say, a couple of zooms that can take you from wideangle to telephoto.

⊕ A **tripod** is a must for the night-time and sunset views of Hong Kong from Victoria Peak or shooting the street lights of Kowloon.

⊕ If you haven't a remote/cable release, then use your camera's **self-timer** for long exposures.

⊕ Hong Kong is excellent for topping up on accessories like **film**, **memory cards**, and **batteries**.

do it at night, when hundreds of buildings are illuminated, providing a spectacular light show. For night shots from the Peak, it is essential to use a tripod and a slow film (or equivalent low ISO setting for digital cameras).

Also on Kowloon, it is worth heading to the Tsim Sha Tsui waterfront at sunset. From here you can look back across the harbor to the high-rise waterfront of Hong Kong Island against the impressive backdrop of Victoria Peak and a pink sky.

There are markets all over Hong Kong; some of the best, for both photography and shopping, are at Stanley and Sheung Wan, on Hong Kong Island, and Reclamation Street in Tsim Sha Tsui. Markets and street traders provide a view of Hong Kong life that is more typical of Asia, and there are great opportunities for candids.

Buddhist sites

There is another, more tranquil, side to Hong Kong. Dozens of Buddhist temples are situated in the outlying islands. Lantau Island can be reached via an hour-long ferry trip. Another hour on a bus takes you to Po Lin Monastery, home to a statue of Buddha 100ft (30m) high. Here, the architecture, orchid gardens, and burning incense prove irresistible through a viewfinder.

A trip into the New Territories to the Monastery of the Ten Thousand Buddhas is worth making in the morning or late afternoon to see the gold Buddha statues at their best.

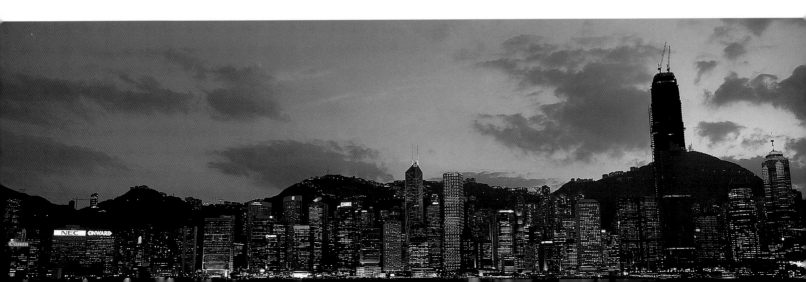

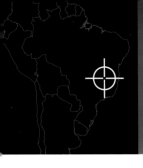
Rio de Janeiro is a stunning harbor-side city, and the view from Corcovado Mountain, looking over Rio's metropolis to the thin white ribbon of sand that is Copacabana Beach and onto the peak of Sugar Loaf Mountain, has become an iconic image for the whole of Brazil. From here you can see how the city hugs the shoreline, while in the distance stretch forest-covered islands and rugged mountains. This view is worth capturing at different times of day: early morning for the low-lying cloud and mist penetrated by island peaks, and dusk when the sky fills with color and a million lights illuminate the city.

Symbols of Rio

At the summit of Corcovado stands a true icon of Rio—the giant statue of Christ the Redeemer with its outstretched arms and passive expression. Well worth the money is the short helicopter ride that flies up from Sugar Loaf and makes a circuit of the 100ft (30m)-high statue. You will get only one chance to see the face, so shoot with your lens at full aperture to get the maximum shutter speed.

In addition, no trip to Rio is complete without seeing one or both of its famous beaches—Copacabana and Ipanema—filled with beautiful people.

Essential kit

⊕ For the famous view from Corcovado Mountain, take both a **standard zoom** and a **telephoto zoom**. The former will give you the wideangle vista, while a telephoto zoom will enable you to make more selective compositions.

⊕ To reduce the influence of a flat, bright sky, take a range of **neutral density graduate filters**.

⊕ On cloudy days, use a **polarizer**.

⊕ For night views, a **tripod** is essential.

⊕ If you forget your remote release, use the camera's **self-timer** and try several long exposure settings.

⊕ When shooting from a helicopter, **image stabilizer (IS)** or **vibration reduction (VR)** lenses have an advantage over other lenses.

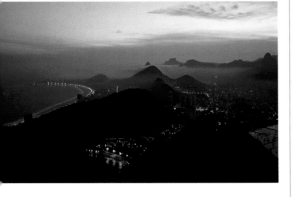

chapter one: cities and towns

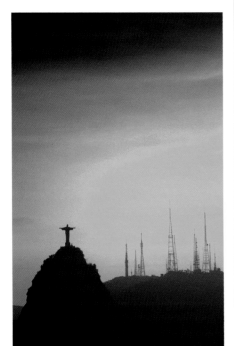

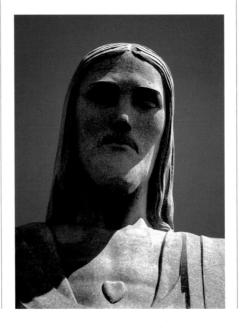

top left | The city lights, hills, and coast of Rio seen from Corcovado Mountain.

far left | The statue of Christ the Redeemer silhouetted against the sky.

left | The face of the statue of Christ, photographed from a helicopter.

There are only 1,700 people in Ammassalik, but that is enough for the town to enjoy the status of being the largest in East Greenland. The town is a tiny settlement on the edge of an Arctic wilderness. To the south and east are the freezing waters of the North Atlantic; to the west and north is the impenetrable Greenland icecap.

below | A team of huskies pull a sledge across Ammassalik's frozen bay.

above right | Children dressed for the winter sit in their sledges, which their mothers push across the ice.

far right | Ammassalik in April is a study of clear skies, snow-covered streets, and impressive mountains.

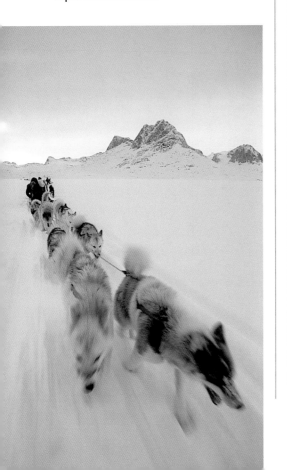

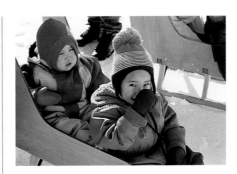

Essential kit

⊕ A winter trip to Ammassalik necessitates **warm, thermal layers of clothing**, including **gloves** and a **hat or balaclava.**

⊕ Wear **waterproof boots** and keep your camera gear in a **bag or backpack** when you are not taking pictures.

⊕ Carry an **18% gray card** to make meter readings, as the snow and ice will trick your camera's meter into underexposing.

⊕ Pack lenses that cover options from **wideangle to telephoto** and bring the **tripod.**

⊕ A **polarizer** and **81 series warm-up filters** are the most useful.

⊕ Take **spare batteries** with you, as the extreme cold will drain them quickly.

Wilderness town

Ammassalik is a harbor town on a coastal island of the same name, but for eight or nine months a year it is joined to the mainland when the bay freezes up and snow covers the mountainous coastline. In these conditions, with the sea ice packed solid around a few fishing boats, East Greenlanders resort to the skills of their ancestors by going on regular seal-hunting trips along the coast, their sleek wooden sledges pulled by teams of huskies. The traditional dog sledge remains popular because, unlike skidoos, they do not run out of petrol or freeze to a standstill.

In the winter, the mothers of Ammassalik use a different type of sledge, a child-sized model with front and back seats, to push their small children while out shopping in the town's snow-filled "streets." A close-knit society with colorful houses and a setting of pristine peaks and clean, invigorating air, Ammassalik offers the traveler a wonderful sense of community on the edge of a ravishingly beautiful and pristine wilderness.

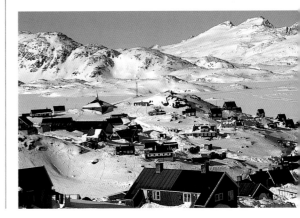

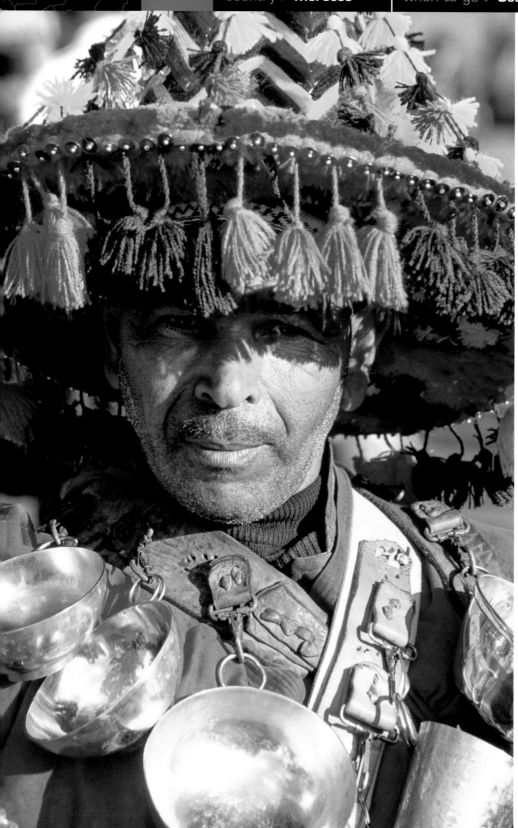

Marrakesh is nearly a thousand years old. It is surrounded by a 12-mile (19km) wall, which looks its best when photographed in the last hour of daylight. Within these walls are some of the best examples of Moorish architecture to be found in Morocco. The most striking is the Koutoubia Mosque, barred to non-Muslims, but with a tall and elegant minaret that serves as a useful landmark for checking your bearings in the city.

Don't miss the Saadian Tombs for their colorful mosaics and intricate details. Here, amid a peaceful garden of cypress pines and roses, lie the 16th-century graves of the Saadi Sultans. Another oasis of calm from this era is the Bahia Palace, no longer inhabited, but a wonderful architectural study with its marbled courtyards and spacious rooms hinting at an opulent past.

Historical background >>>

Marrakesh was founded in 1062 at the foot of the Atlas Mountains. The city's founders were the Almoravid dynasty, whose empire stretched from Senegal on the west coast of Africa north to Toledo in southern Spain. Most of the old city's mosques and palaces were built and decorated by the Moors from the 12th century onward. The city has been a prize for many warring dynasties over the centuries in their quest to control the land west from the Atlas Mountains to the sea. From 1912 to 1956, Marrakesh was a French protectorate along with the rest of Morocco. Today, it is an independent kingdom and is one of the most stable nations in North Africa.

far left | A water seller in the Djema el Fna wears traditional dress with brass goblets around his chest.

left | Ornate mosaics and carvings inside the Sa'adian Tombs.

Djema el Fna

In Marrakesh's main square, the Djema el Fna, traders and entertainers, travelers and residents congregate daily to socialize, talk business, haggle, and argue. The square, ostensibly a marketplace, becomes a stage for entertainers, including acrobats, snake charmers, story-tellers, musicians, dancers, fire-eaters, jugglers, and fortune-tellers. With all this activity, together with the general commotion from the food stalls, the Djema el Fna is the liveliest part of Marrakesh, and a huge store of cameos and candids.

⊕ Protect yourself from the sun by wearing a **hat** and keep your camera in your **backpack** when not in use.

⊕ Take the **full complement of lenses**, from wideangle for the buskers and performers of the Djema el Fna, to short telephoto when capturing candids in the Medina.

⊕ A **telephoto zoom** will make the Atlas Mountains more prominent in the frame.

⊕ Useful filters include a **neutral density graduate**, **81 series warm-ups,** and a **polarizer**.

⊕ For the night view of the Djema el Fna, use a **tripod** and pack some **fast film** for the low light of the Medina.

Essential picture list

⊕ Your first stop should be the **Djema el Fna**, the central square of Marrakesh. There is always something happening here, so keep your camera ready.

⊕ For fine examples of 16th-century Moroccan architecture, visit the **Saadian Tombs** and **Bahia Palace**.

⊕ With so many traders and shoppers crammed into narrow streets, the **Medina** is a perfect location for candid images.

⊕ Hire a car and make a day trip into the **Atlas Mountains** for images of Berber village life and landscapes. Detour to **Telouet** for its battered old kasbah.

⊕ Wait till the late afternoon to photograph **Marrakesh's city walls**.

below | The peaceful gardens of Menara with their tranquil water features and classic Moorish architecture provide a relaxing diversion from the busy activity at Djema el Fna.

above | The cable car up to Table Mountain is a spectacular ride.

below | An aerial view showing part of the city clinging between sea and the chain of rocky peaks known as the Twelve Apostles.

Cape Town is a city with a disposition as sunny and outgoing as its climate, and a quick glance up to the magnificent form of Table Mountain serves to remind the visitor that there is a vast country to be explored beyond. With the spectacular backdrop of Table Mountain and the Twelve Apostles, beautiful ocean beaches, and a temperate climate, Cape Town has one of the most memorable settings of any city in the world. Clinging to the lower reaches of the mountains and skirting the sea with its hems of white sand, Cape Town is fondly known as "the fairest Cape."

Table Mountain

One of many memorable views to be savored is from Clifton Beach looking up to the line of rocky pinnacles known as the Twelve Apostles. These jagged sentinels extend southwest from Table Mountain and are often enveloped by a blanket of swirling cloud known locally as the "Tablecloth." On a clear day (and there are many), Table Mountain and the Twelve Apostles can be seen from

the sea up to 30 miles (50km) away. In many ways, this is the best view of all, so any opportunity to take a scenic cruise should not be missed. And you can't miss the view from the top of Table Mountain—the journey up on the cable car is an event in itself.

Essential kit

⊕ A **whole gamut of lenses**, from wideangle to long telephoto, will be necessary, especially if you're planning to tour the wine lands of Stellenbosch or any game reserves.

⊕ To save on weight, pack a **1.4x** or **2x teleconverter** instead of an expensive extra-long telephoto.

⊕ If shooting Table Mountain and the city from the sea, **image stabilizing (IS)** or **vibration reduction (VR) lenses** will help counteract movement caused by ocean swell.

⊕ A **polarizing filter** will be useful, particularly in the summer.

⊕ Pack **lens hoods** for reducing the risk of flare.

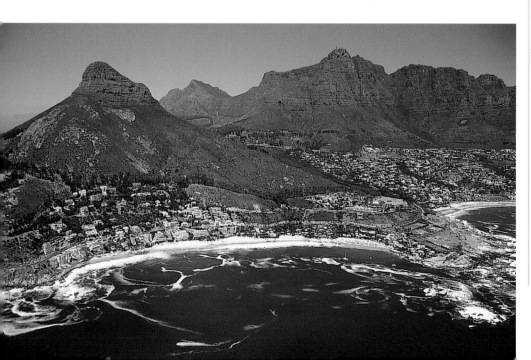

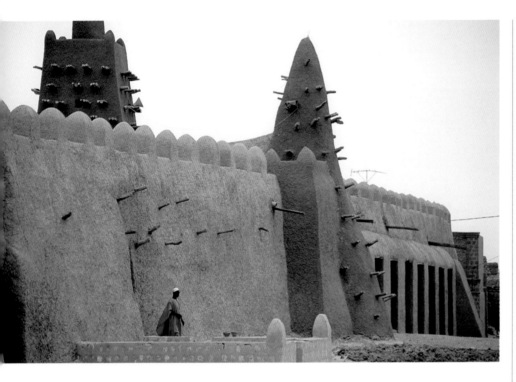

Essential kit

⊕ Timbuktu is a hot and sandy place, so keep your camera gear clear of dust by cleaning it every day with **lens wipes**, **cloth**, and **blower brush**. Keep your camera in a bag at all times unless you're taking a picture.

⊕ Carry **spare batteries** and **film**; don't expect to be able to top up on these essentials here.

⊕ A **polarizer** and **81 series warm-up filters** are worth carrying.

⊕ Use your **tripod** as often as possible.

⊕ Find out if there are any **restrictions on photography** around any of the mosques before getting your camera out.

⊕ To beat the heat, wear a **hat** and carry plenty of **bottled water**.

The reputation that precedes Timbuktu is far from glamorous; it is a metaphor for places remote, mysterious, and forbidden. But that is a misplaced perception borne out of the West's lack of influence in the city's history. For West Africans, Timbuktu was a city of economic and cultural power, and for 300 years, from the 13th to the 16th centuries, it enjoyed a golden age equal in historical importance to Jerusalem, Rome, and Mecca, thanks to the prosperity enjoyed through the trans-Saharan gold and salt trade routes.

European explorers had no experience of such riches. When Réné Caillié became the first man from the West to reach Timbuktu in 1828, he found a city in decay. But one area where the city still thrived was as a spiritual and academic center of the Islamic world, and some of the great mosques, libraries, universities, and schools built during Timbuktu's golden age are still standing today.

In the narrow alleys and sandy streets that run between Timbuktu's mud-brick houses, it is hard to imagine a past of any glory. But around the next corner you find a mosque or grand Moorish house that has stood for more than 400 years—faded, but lasting.

above | Timbuktu's mud-brick mosques are evocative reminders of the past.

right | The colorful head dress of the Tuareg protects the wearer from fierce winds and sandstorms.

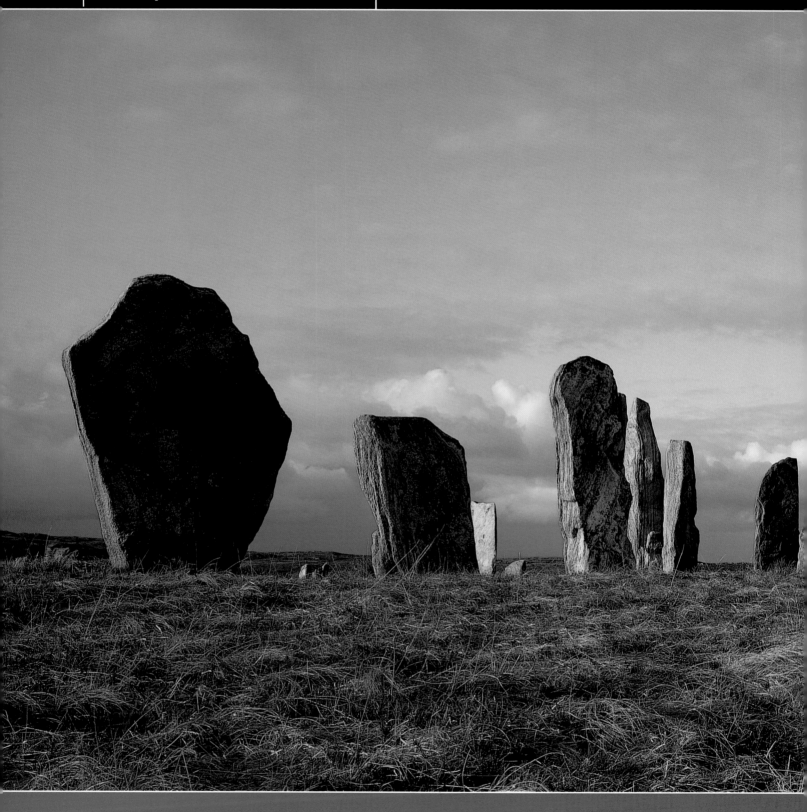

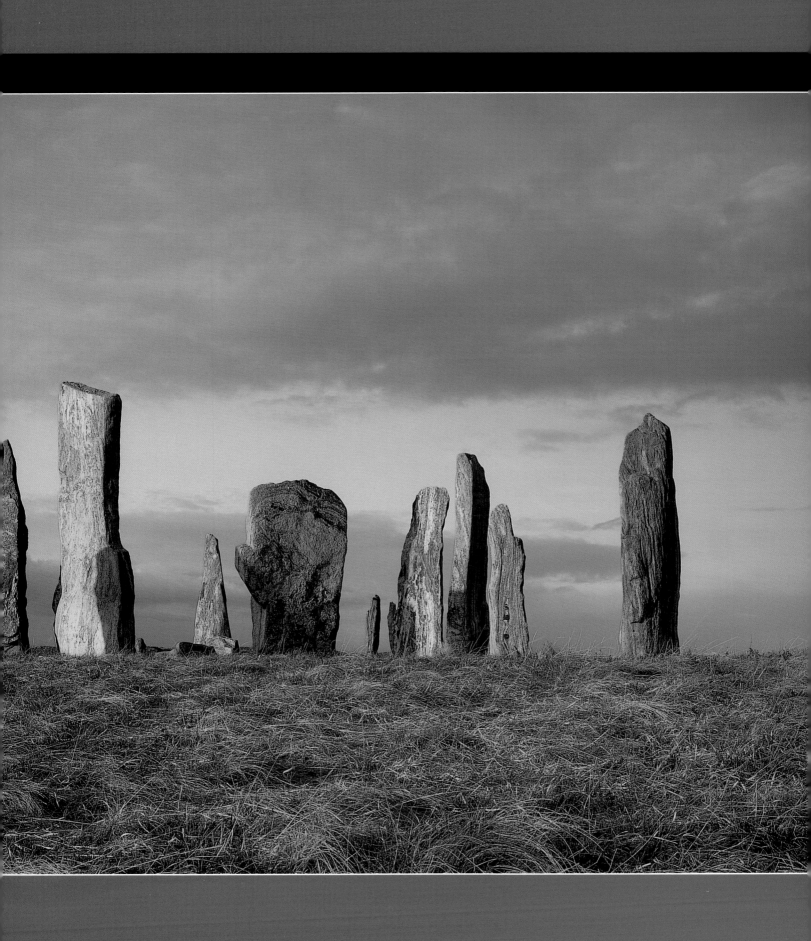

location > **Angkor Wat**

country > **Cambodia** | when to go > **Oct–Apr** | focus on > **temples**

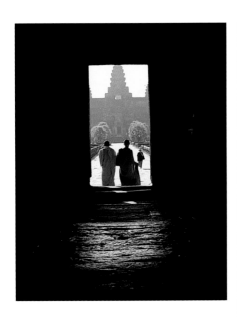

Essential picture list

⊕ **Angkor Wat's reflection** makes an evocative image early or late in the day.

⊕ It may be a cliché, but the **orange-robed Buddhist monks** provide a wonderful point of color against the weathered gray temple stone.

⊕ **Ta Prohm** is a largely ruined temple where banyan trees seem to grow out of the stonework.

⊕ Focus closely on the **apsaras** (stone-carved nymphs) and bas reliefs when the light is oblique to the surface. This will reveal more of the details.

⊕ Nearby is the **Bayon**, a small temple that is clad in huge stone faces of Buddha.

The temple of Angkor Wat is the grandest and most famous of hundreds of temples built over a 400-year period between the 9th and 13th centuries at Angkor, the former royal city of the Khmer civilization. Although "Wat" is the name for a Buddhist temple or monastery, the temple of Angkor was built in honor of the Hindu god Shiva.

The first rulers of Angkor were Hindu kings, and most of their temples are dedicated to Shiva and Vishnu. Representations of these and other Hindu gods, and latterly Buddha, can be found throughout the vast complex of temples, revealing how one faith came

left | Monks framed by a doorway stroll through the entry tower of Angkor Wat.

below | Angkor Wat's distinctive central towers make an unforgettable sight from the main approach.

to supersede—but not destroy—the other. Today, Angkor Wat is regarded as Cambodia's greatest Buddhist monastery, and the sight of orange-robed monks walking down one of the many flights of steps in the complex has become a hallmark image.

Another image associated with the area is that of the massive roots of banyan trees smothering and splitting temple stones as the jungle reclaims the building. Such scenes can be found at the nearby temple of Ta Prohm.

Evocative light
The first and last light of day is the best time to see Angkor Wat. The temple is surrounded by pools scattered with water lilies, and the building's reflection at dawn or dusk makes an evocative image, either in silhouette or lit directly by the sun. Even more fleeting is the light that reaches the inner walls of the

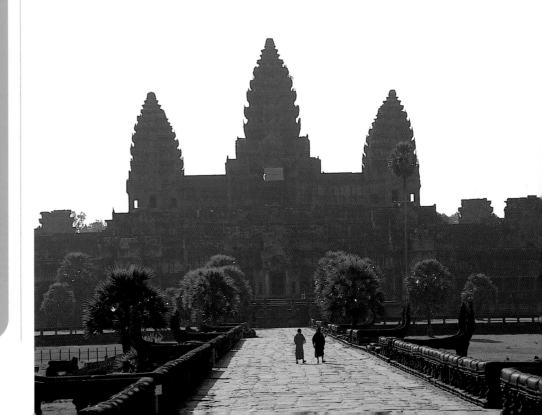

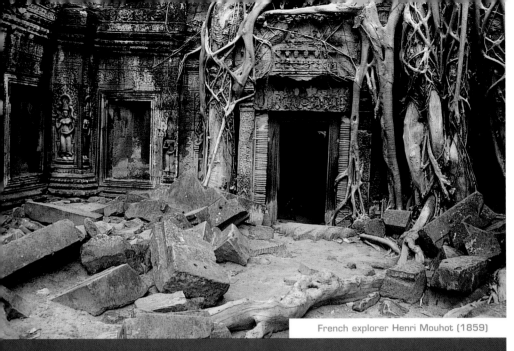

French explorer Henri Mouhot (1859)

> "One of these temples might take an honorable place beside our most beautiful buildings. It is grander than anything left to us by Greece or Rome."

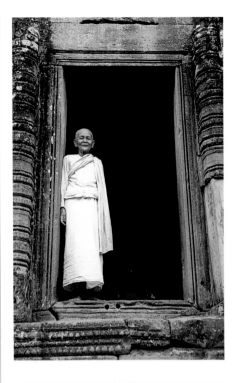

Sanctuary—the highest of the temple's three levels. For a few minutes after sunrise, light penetrates the windows to illuminate figures of Buddhist nymphs ("apsaras") carved into the walls.

above | The jungle is slowly reclaiming Ta Prohm temple.

top right | A Buddhist nun stands in a doorway of The Bayon, a small temple clad in carved stone faces of Buddha.

Outside the temple

Since visitors began to return in significant numbers in the early 1990s, Angkor Wat has become more a living community and less a curious ruin of a lost age. As a result, religious ceremony and commercial activity are played out simultaneously within its precincts and present a rich source of subjects for the camera.

Historical background >>> Ever since Thai invaders forced the Khmers to move their royal residence from Angkor to Phnom Penh in 1431, Buddhist monks have continued to reside at Angkor Wat. Despite many centuries of erosion, jungle reclamation, and plundering, an extraordinary amount survives. The temple was "rediscovered" in 1859 by Henri Mouhot, but from the mid-1970s to the late 1980s, Angkor was closed by the Khmer Rouge who, despite their extreme form of communism, which condemned all religious faith, made the complex one of their last strongholds before they were finally displaced. Since then, visitors and pilgrims have returned in significant numbers, and Angkor Wat is once again a major center of Buddhism in Cambodia.

Essential kit

⊕ The climate is humid and hot, so take plenty of **water,** a **hat,** and wear **sensible shoes or boots**.

⊕ Keep **silica gel** in your bag or backpack to absorb excessive moisture.

⊕ A **polarizing filter** is useful for reducing reflected glare from the pools surrounding the temples.

⊕ Carry a **tripod**—it will prove handy for long exposures inside the temple and also under the heavy shade of the banyan trees.

⊕ Pack some **ISO 400 film.** Digital camera users should try to avoid using faster ISO speeds because of excessive noise.

It is a sign of the times that in Lhasa, the capital of Tibet, there are more Chinese people than Tibetans. Since the Chinese invasion of 1951, Lhasa has grown into a large, modern, concrete-clad city where soldiers of the Red Army and Chinese shopkeepers seem more prevalent than Buddhist pilgrims. Fortunately, the magnificent white exterior of the Potala Palace, cascading down the side of Red Mountain, still dominates the profile of this city.

Essential kit

⊕ At an altitude of 14,100ft (4,300m), there is a lot less oxygen in the atmosphere at Lhasa than what you will be used to at sea level. Drink plenty of **bottled water** to avoid dehydration.

⊕ Travel light, using **one camera body** and **two or three lenses**, preferably lightweight zooms.

⊕ A **UV filter** will help reduce the extra ultraviolet light experienced at this height.

⊕ Other filters worth taking are **81 series warm-ups** and a **polarizer**.

⊕ Though more expensive, **carbon-fiber tripods** are lightweight and robust.

⊕ A **backpack** will be easier to carry than a shoulder bag.

Expressions of Buddhism

Now a museum, the Potala used to be the seat of government in Tibet and the winter palace of the now-exiled Dalai Lama. Despite a prolonged period of repression and occupation, Buddhism maintains a strong hold on the city. Nowhere is this more visible than on the pilgrimage circuits around the base of the Potala and the Jokhang Temple, the center of Tibetan Buddhism. On these circuits, pilgrims pray and walk (always clockwise), spinning prayer wheels, chanting, and prostrating themselves at regular intervals.

The Barkhor is the most popular of these circuits, with a continuous procession of the faithful practicing one of Buddhism's oldest and most entrancing rituals. In their colorful robes and costumes, pilgrims and monks are natural subjects for the camera, and it is common to see Western travelers

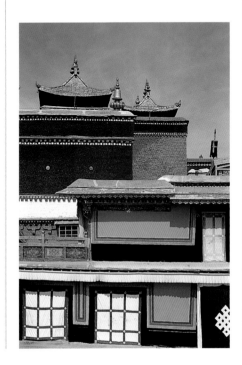

taking shots from a distance. Generally, this is tolerated by the Tibetans, but do not intrude on any expression of faith just for the sake of a picture.

Compared to the rest of Lhasa, the Barkhor retains its old Tibetan character. Jokhang temple was built in the 7th century. In front of the temple is a square and market selling prayer wheels and flags, yak-butter lamps, and juniper, which pilgrims burn continuously in nearby brasiers—the scent permeates the city.

Essential picture list

⊕ Not only does the **Barkhor** offer a wealth of picture possibilities, it also gives the best introduction to the lives and faith of the Tibetans. Just watch and learn.

⊕ The best views of the **Potala Palace** are from the roads heading south and west out of the city. Early morning and late afternoon are the best times to go.

⊕ The wrinkled faces of elderly **Tibetan pilgrims and monks** in their colorful costumes and jewelry make striking portrait and candid studies.

⊕ In front of the **Jokhang Temple** is a square and market where pilgrims buy prayer flags, juniper, and candles.

⊕ Look for **colorful details and decoration** on temple exteriors, roofs, and entrances, lines of prayer wheels, and market stalls selling jewelry and prayer flags.

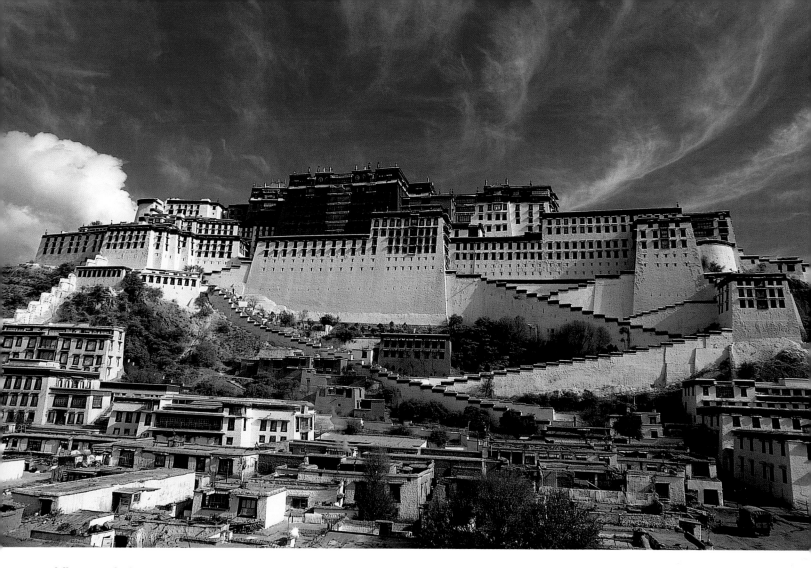

Views of the palace

Wherever you are in Lhasa, the huge white edifice of the Potala Palace rises above all else. Now surrounded by modern apartments, offices, and hotels, the palace is a symbol of Tibet's past—a rather grand, overblown museum. Inside are hundreds of rooms linked by miles of passageways. The most stunning sights are the gilded and bejeweled tombs of the Dalai Lamas. For the best views of Lhasa and the Potala, there is a good viewpoint from the road heading south out of the city. From here you can make best use of the low-angled sun at early morning or late afternoon, trying a range of focal lengths to show the Potala in the context of its surroundings.

i

Historical background >>> The Potala Palace dates from the 17th century. It served as the seat of government for Tibet as well as being the winter residence for Tibet's Dalai Lamas. This changed when China invaded Tibet in 1951 and enforced its authority by destroying Buddhist temples and monasteries all over the country. The current Dalai Lama fled from Tibet in 1959 and now resides in India, as Tibet's spiritual leader in exile. The Chinese maintain a highly visible military presence in Lhasa, although they have relaxed their stance on religious expression, and have even helped to restore some of the monasteries damaged during the Cultural Revolution (1966–76). Ethnic Han Chinese now make up more than half of Lhasa's population, a result of financial inducements to encourage more Chinese people to resettle in Tibet.

above | Lhasa may have changed since China's 1951 invasion, but the Potala Palace still dominates the skyline.

left | These are the colorfully decorated exteriors of the Dalai Lama's apartments.

Some may find the romance cloying, but the fact remains that the world's most recognizable building was inspired by a man's love for his wife. They were not just any man and wife, it has to be said, but the death of Mumtaz Mahal unleashed a grief so intense that her husband, the Emperor Shah Jehan, spent the next 18 years constructing a mausoleum of beauty and symmetrical perfection for her final resting place. The result was the Taj Mahal, an exquisite creation in white marble, intricately carved and inlaid with thousands of semi-precious stones. Completed in 1648, the Taj Mahal is an even more iconic image of India than the country's famous tiger. It also has the advantage of staying still for the camera.

Looking beyond the cliché

Despite all the pictures of the Taj Mahal in books, tourist brochures, posters, and magazines, nothing compares to actually witnessing the white-marbled elegance of this building for the first time. The impressive main gateway frames the central dome perfectly, and when you step through you are immediately met by the view that is immortalized in so many postcards. Even on an overcast day, there is enough light to reflect the image of the building in the central canal of the water garden that leads up to the mausoleum. Virtually every visitor, as if by reflex, positions themselves in front of this canal to align the dome and four minarets symmetrically in the frame, making sure that the reflections in the

Essential picture list

⊕ You've seen it before, but can you really stop yourself from photographing **the Taj Mahal and its reflection** from the central canal of the water garden? Try to use a tripod and don't let others pressure you into making the shot before you're ready.

⊕ Try focusing on **close-up details** of the marble inlay as well as **architectural features** such as the entrance bay and minarets.

⊕ Capture the **view from the opposite banks of the Yamuna River** at sunrise or sunset. The Taj Mahal makes a distinctive silhouette against an orange sky at these times.

⊕ Photograph the people visiting the Taj Mahal, particularly women wearing **colorful saris**, which stand out vibrantly against the white marble exterior.

⊕ From the nearby **Agra Red Fort**, try to photograph part of the Fort and the Taj Mahal in a way that reveals the complementary styles of their architecture.

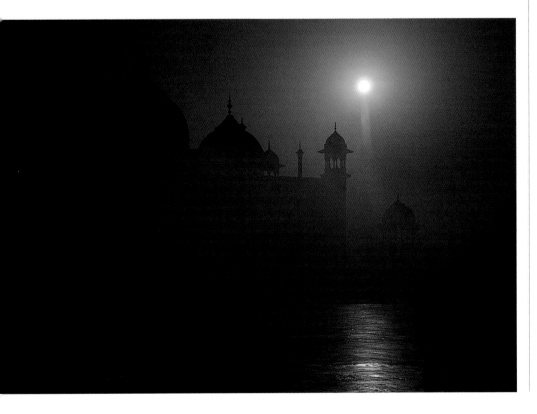

left | A visit to the Taj is best made soon after sunrise or in the hour before sunset. Here, the sun reflected off the marble court and the silhouetted domes and figures create an evocative scene that you wont find on a postcard.

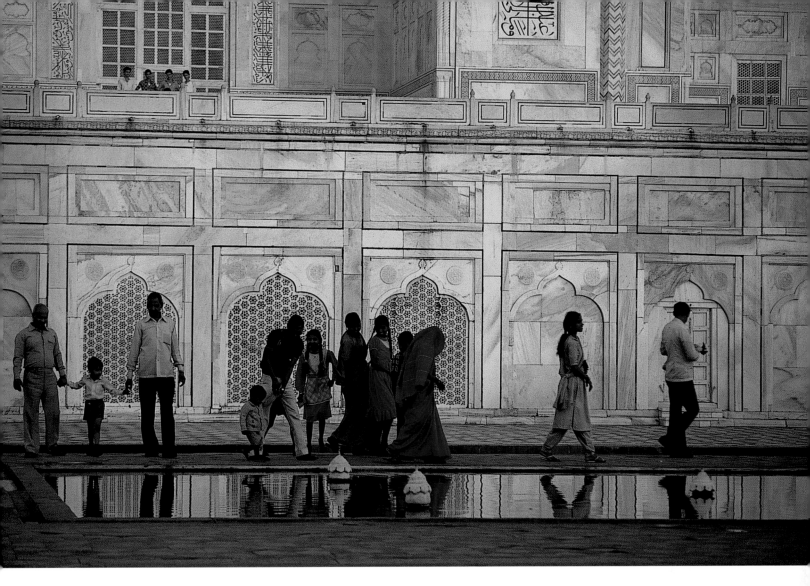

above | It isn't only tourists from abroad who flock to the Taj Mahal; the mausoleum is a major attraction for Indians, too. This family group complements the stunning surroundings far more effectively than a group of Westerners would have done. The latticed marble archways frame them both individually and as groups.

i

Historical background >>> Mumtaz Mahal was the second wife of Shah Jehan, the fifth Mughal emperor of India. When they married in 1612, he was then Prince Khurrum and it was another 15 years before they ascended the throne as emperor and empress. Mumtaz was her husband's inseparable companion, even on military campaigns, and she bore him 14 children. In 1630, Mumtaz died while delivering her 15th child. On Shah Jehan's orders, more than 20,000 laborers and craftsmen began work on the mausoleum that the emperor designed for his late wife. The work was finally completed in 1648. The building wasn't called Taj Mahal at the time; that name has evolved as an abbreviation of the late empress's name.

water features are mirror-perfect. It's not easy handheld, particularly if your camera viewfinder (like the vast majority of models) doesn't show the full or exact field of view of your lenses.

It is far more challenging to make alternative views, changing lenses and perspective as you move toward the main building. It's only on closer inspection that you notice the wonderful inlay details carved into the marble. These are well worth framing for a photograph, as the designs are classic examples of Islamic art.

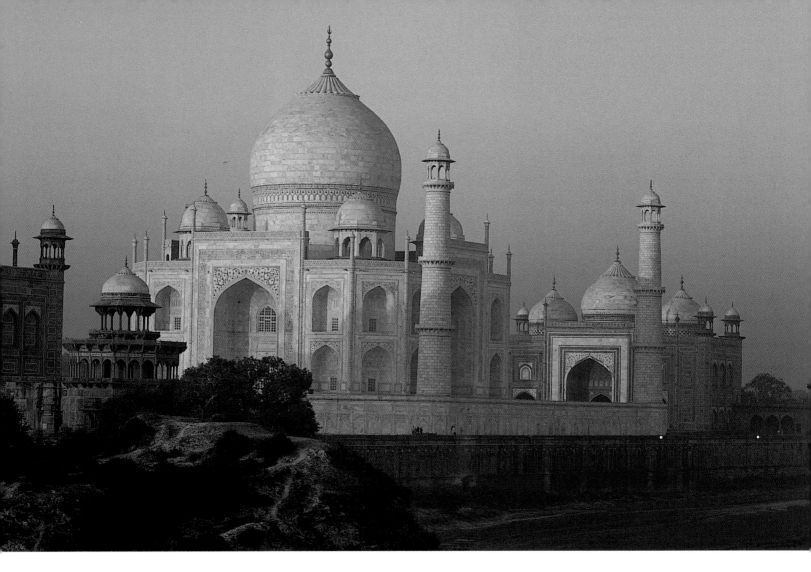

The marble isn't as reflective as you might think, and it presents few metering difficulties. Indeed, a bright sky is more likely to cause underexposure. Because the Taj Mahal is enclosed within a walled garden and built on a raised terrace, few people bother to venture out and view the mausoleum from a distance. There are superb views to be enjoyed from Agra's nearby Red Fort, and from the banks of the Yamuna River. These views also reveal the significant amount of red sandstone on the rear of the Taj Mahal, the terrace and perimeter walls. This is the same type of stone as used on the Red Fort. Some people prefer to compose their images in a way that omits the sandstone, but such an approach limits your scope to make different and truly original images.

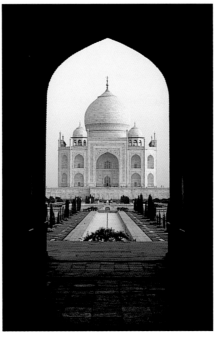

above | From the banks of the Yamuna River, the scale of the marble terrace supporting the buildings and the perimeter of red sandstone can be fully appreciated. In the soft light of dawn, the Taj takes on a dream-like quality.

left | The mausoleum framed by the main entrance gate. A few steps forward and the four minarets come into view for the classic image of the Taj that has become an emblem of India. Early morning is the best time to arrive for the soft light and to avoid having too many visitors from walking into your shot.

The shape and design of the Taj Mahal is so well known that you can feature practically any part of the building in your composition and people will recognize the setting. Added to this, the vast areas of marble make a wonderful, evenly lit backdrop for candid studies of visitors exploring the building. Look out for the colorful saris of Indian women as they wander across the marbled forecourt, or stand momentarily in front of the defocused outline of a minaret or the dome rising above them.

Symmetry is everywhere in the architecture of this complex, and the profusion of curves and sweeping lines gives a wonderful opportunity for exaggerating these features through wideangle lens photography. The results may not be pure or particularly sympathetic to the architectural aesthetics, but they will provide a striking interpretation of this much-photographed building.

It is worth noting that the Taj Mahal houses a mosque as well as a tomb and is a place for worship. As such, its precinct commands quiet and respect.

below | The brilliant white marbled domes and minarets can be seen in the context of their surroundings in this view taken from the main approach road as it crosses the Yamuna River. Fortunately, there is no other major structure in the immediate vicinity to spoil the presence of the Taj.

bottom | Women in colorful saris walk across the marble courtyard.

Essential kit

⊕ **Ultra-wideangle lenses** produce some startling effects with a building like this, while a **telephoto** is essential for views from a distance, or close-ups of the marble inlay.

⊕ A **tripod** or **monopod** is useful for steadying the camera and for accurate framing of compositions.

⊕ Pack a **neutral density graduated filter** for balancing high-contrast conditions and a **polarizer** for a denser sky and better-defined clouds.

⊕ **Avoid using colored graduated filters**, as these will change turn the subtle hues of the marble into a dull and tinted cliché.

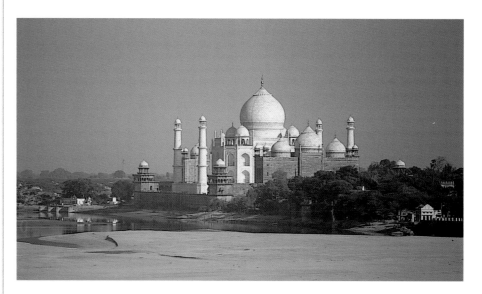

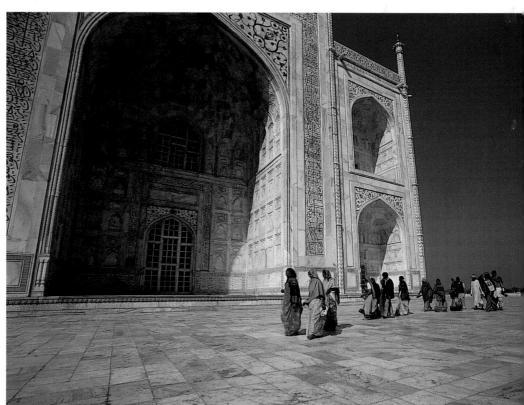

You have only to walk down the Street of Curetes—the main thoroughfare in Ephesus—to realize what an important city this was to the Roman Empire. The long rows of marble columns lining the streets, the numerous temples, the open theater for 25,000 people, beautifully preserved statues, and the magnificent double-story facade of the Library of Celsus all provide ample evidence of the city's past glory.

Ephesus was founded 3,000 years ago by the Ancient Greeks, and was home to one of the Seven Wonders of the World—the Temple of Diana. The city's greatest days were under the control of the Romans and it continued to grow in importance until the port began to silt up.

Ancient splendors

Ephesus is the largest and best-preserved Roman ruin in the eastern Mediterranean. The most spectacular ruin is the Library of Celsus, with its facade of intricately carved marble

columns and windows standing two stories high. While most people take an overview of the whole facade, the decorative carvings are also worth focusing on, and the evenly spaced pillars can be framed from a low viewpoint to create striking diagonals.

The view looking down the Street of Curetes from the Monument of Memmius toward the Library of Celsus is very evocative. Wait till the late afternoon when the pillars are casting shadows in rows across the street.

Not far from the Library of Celsus is the Great Theater, a magnificent auditorium still used for concerts. Walking up to the top affords a superb view of the stage with the Street of Curetes receding into the background.

below | **Visitors explore the huge Roman theater, which is still used for concerts and festivals.**

below | **Looking up the impressive marble facade of the Library of Celsus. Its beautifully carved marble columns and statues attract many admiring gazes.**

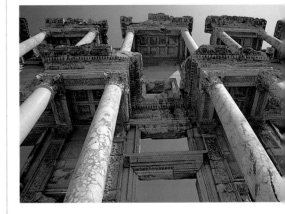

Essential kit

⊕ Ephesus is a vast site, and walking is the only means of getting around, so wear a sensible pair of **walking shoes** or **boots**.

⊕ Travel light: stick to **one camera body** and a couple **of zoom lenses** covering the full range from wideangle to telephoto.

⊕ Spring is the best time to visit for the light and air temperature, but summer visitors should bring a **neutral density graduated filter** to temper the burnt-out skies in the midday sun.

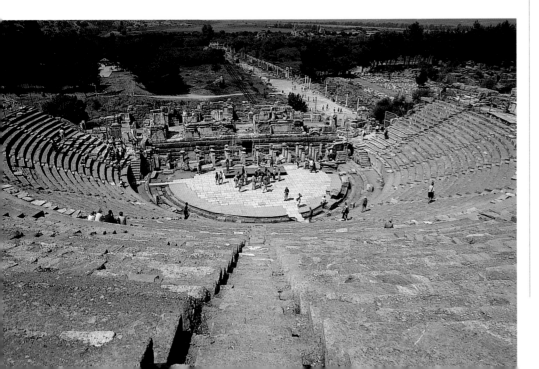

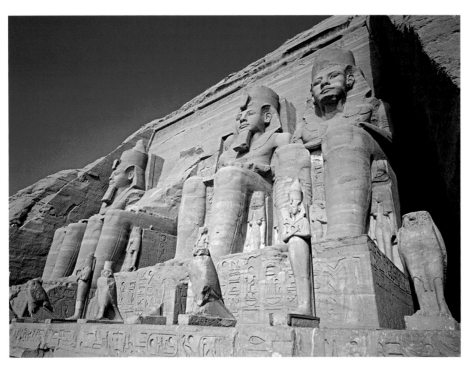

Essential kit

◈ You can be virtually guaranteed of clear blue skies every day at Abu Simbel and the desert air is wonderfully clear, so stick to **slow film** (**ISO 50 or 100** for digital cameras).

◈ Wear a **hat, comfortable shoes** or **boots** and carry plenty of **bottled water**.

◈ Shoot in the first hour or two of morning when the sun is shining directly onto the temple entrance. A low angle with a **wideangle lens** creates a particularly striking effect.

There may never have been a greater feat of archeological preservation than the reconstruction of the two temples of Abu Simbel in the 1960s. The rising waters of Lake Nasser, created by the construction of the Aswan Dam, had threatened to flood the 3,000-year-old temples built in honor of Rameses II and his favorite wife, Nefertari.

During the salvage, the temples were systematically dismantled and raised nearly 200ft (60m) up a sandstone cliff above their original site. Archeologists then painstakingly reconstructed the temples, making certain that the facing directions of their enormous facades and their relationship to each other were not altered in any way. Preserving the alignment of the Temple to Rameses II was crucial, as twice a year the sun's rays reach into the innermost sanctuary to shine directly on the seated statues of the pharaoh, along with the gods Ptah, Amun-Re and Re-Horakhty.

Rameses II was Pharaoh from 1279–1213BCE. His greatness is symbolized by the four colossal seated statues of him, each 67ft (20m) high, sitting in pairs flanking the temple entrance. Facing east, the temple looks magnificent at sunrise when the sandstone seems to glow before you.

The smaller Temple of Hathor was built in honor of Hathor, goddess of love and music, and of Rameses' queen, Nefertari. On each side of the temple's entrance, two statues of Rameses flank one of Nefertari, each more than 33ft (10m) high.

above left | **Statues of Rameses II flank the entrance to the pharaoh's temple.**

below | **These figures are 67ft (20m) high.**

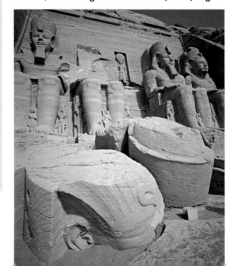

The Great Pyramid of Giza is probably the best-known archeological site in the world. It is 4,500 years old; it is the only one of the Seven Ancient Wonders of the world still standing; and, at 481ft (146m) high, it was the world's tallest manmade structure until the 19th century. But the simplest fact of all is the most remarkable—it is the tomb for one man, the Pharaoh Khufu.

The Three Pyramids

Of course, there are three main pyramids at Giza on the west bank of the Nile, each built as a tomb for the pharaohs of the Fourth Dynasty, but the Great Pyramid is the only Ancient Wonder; it was the first to be built and is the largest of the three. The second, centrally positioned and almost as large, was built for Khufu's son Khephren, and the third pyramid, considerably smaller, for Khephren's son Menkaure. Together they are a matchless sight, impressive and awe-inspiring to all who visit. In 1798, addressing his troops before the Battle of Giza, Napoleon Bonaparte exclaimed: "From atop these pyramids, forty centuries look down upon you."

Today, Giza is on the periphery of modern Cairo's urban sprawl, a half-hour cab ride from the city center. This may be the most direct way of

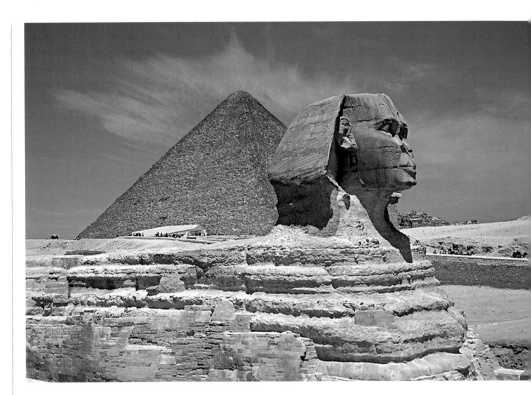

approaching the site, but it isn't the most scenic. For a view that places the pyramids in the context of the desert and gives a hint of how they must have looked in ancient times, it is possible to arrive by camel (with a guide) from the west, across the desert sands from the village of Nazlat Al Samman. If you do this in the late afternoon, you will also

above | **The unmistakable form of the Sphinx—an effigy of a human face on the body of a lion—has suffered badly from erosion and plundering, but remains an extraordinary sight. The Great Pyramid looms in the background.**

left | **Part of the long causeway linking the Pyramid of Khephren to the temple of the same name.**

Essential picture list

⊕ For the best view of all three **Great Pyramids**, approach from the west in the afternoon and fill the foreground with the desert.

⊕ The **Sphinx** faces east, so is best photographed in the morning.

⊕ Use the **temples, cemeteries,** and **other ruins** dotted around the Great Pyramid of Khufu as foreground interest.

⊕ Photograph the smaller **Queens' Pyramids** or other ruins and use the bases or inclines of the main pyramids as background or lead-in lines.

have the benefit of seeing the three pyramids directly lit by a warm afternoon light that brings out the reddish-brown color of the sands.

The winter months from November through to March are the best time to go, but even at this time of year, midday temperatures are hotter than most European summers, so time your visit for morning or late afternoon.

Historical background >>> Giza had been a burial site long before the construction of the Great Pyramid. It was a favored place of burial because of its elevated flat position overlooking the Nile and the ancient city of Memphis. The Pyramids have suffered centuries of plunder and vandalism—much of old Cairo was built from the large limestone blocks used for their construction. No one knows for certain how the blocks, each weighing more than two tons, were put in place, but archeologists believe that it took 20 years to construct the Great Pyramid. Although smaller, the Pyramid of Khephren is built on higher ground and looks taller than the Great Pyramid from a distance. As a result, it is often wrongly referred to as the Great Pyramid.

Other sights in Gaza

There is more to Giza than the pyramids. The Sphinx is a major attraction, lying adjacent to the temple of Khephren near the end of a long causeway linking the temple to the Pyramid of Khephren. It faces east, so is best visited in the morning. Between the Sphinx and the Great Pyramid is the Eastern Cemetery and a group of three small pyramids known as the Queens' Pyramids. There is another cemetery on the western side of the Great Pyramid, which serves to remind the visitor that Giza was a vast city of the dead, only a fraction of which has been uncovered.

Essential kit

⊕ The Pyramids are huge, so you will need a **wideangle lens** to get everything within the frame if you aren't planning on taking a camel ride further out.

⊕ The sun is always bright, so use a **UV filter**, or a **polarizer** if there's any hint of cloud.

⊕ **Lens hoods** should be attached, and you should keep your camera gear closed tight in a **bag** or **backpack** when not in use to stop sand from coming in.

⊕ Wear a **hat**, **boots**, and **sunscreen** and bring plenty of **bottled water**.

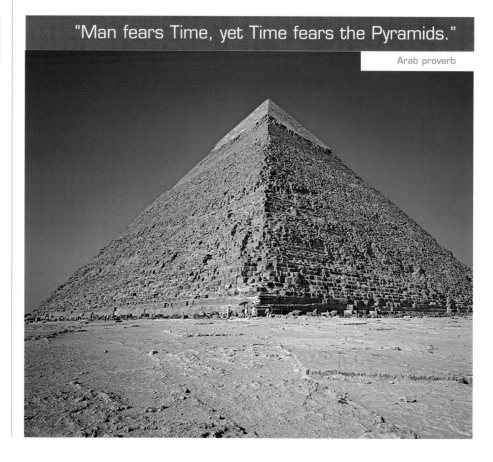

"Man fears Time, yet Time fears the Pyramids."

Arab proverb

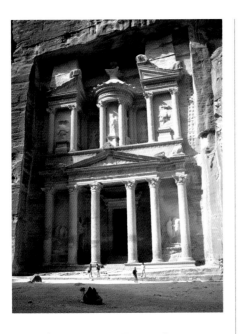

above | **The Khazneh (Treasury).**

below right | **It is a steep walk to the magnificent El Deir (the Monastery).**

The main route into the ancient city of Petra is laden with suspense. The passage, known as the Siq, is a narrow, winding fissure that creeps through sandstone walls for half a mile, narrowing to little more than 16ft (5m) in width. Just when you wonder if there is a way out at the other end, the Siq turns for a final time and there, through a cleft in the rock, is the Khazneh (the Treasury), your first view of Petra.

At this point, people reach for their cameras, identifying the grand entrance as a perfect viewpoint for representing Petra's history, location, architecture, and color in a single frame. See it early in the morning when the sun is shining on the Khazneh's red sandstone facade—by mid- to late morning, it will be in shade for the rest of the day.

The Khazneh is Petra's best-known monument. All around are grand temples, tombs, houses, halls, and arched gates, carved out of sandstone. By contrast, the interiors are plain— small, dark chambers without the carvings that decorate Petra's facades.

Beyond the open space in front of the Khazneh, another path winds through the rock walls pocked with tombs, leading to a 3,000-seat open theater built by the Romans.

Another outstanding building is El Deir, also known as the Monastery, because it was used as such during the Byzantine period. Its facade is carved into an outcrop of rock that takes 800 steep steps to climb. There are several paths to the top of the surrounding rock faces, which give superb views of El Deir and the rest of Petra beyond.

Essential kit

⊕ Keep your camera gear well protected from the sand in a **bag** or **backpack** when not making pictures.

⊕ A **blower brush** is handy to clear away sand and dust from your cameras and lenses.

⊕ **Wideangle zooms** will help you include the carved facades in the frame while also showing the amazing setting.

⊕ **Good walking boots** are advisable for all the steps you will have to climb.

"Match me such a marvel, save in Eastern clime, a rose-red city half as old as time"

Dean William Burgeon, Victorian traveler, upon visiting Petra (1845)

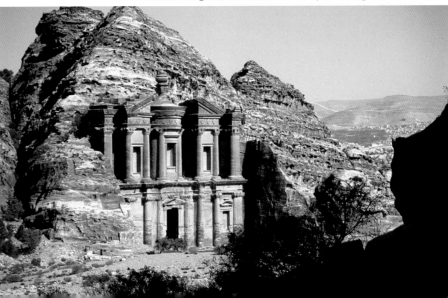

chapter two: historic sites and landmarks

The 36 mile (60km)-long Canyon de Chelly in northeast Arizona is awe-inspiring, with its staggering rock stacks and the gravity-defying pueblos built into its sheer cliff faces. First settled by the Anasazi Indians, the ruined dwellings of Canyon de Chelly date back to the fourth century CE and range from simple pit houses to multi-storied structures like the White House ruin. The Anasazi lived here for a thousand years; the current occupants, the Navajo, settled at the site in the late 16th century.

Many photography students' knowledge of Canyon de Chelly is through an Ansel Adams print of the White House ruin, the most famous of the Canyon's 800 known archeological sites. While some might say that the White House ruin owes its fame to that

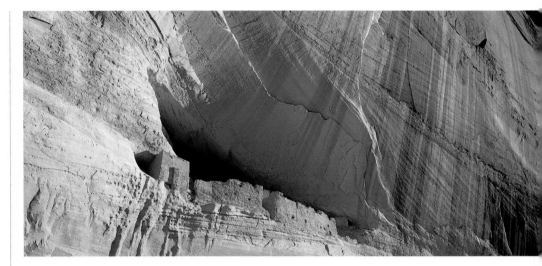

image, a more likely explanation is its accessibility; it is at the end of the only inner-Canyon hike that doesn't require a permit. Without a permit, visitors are restricted to peering down from a series of lookouts, or overlooks, along the two scenic routes that run along the top of the north and south rims of the Canyon.

The Spider Woman

For the most extraordinary sight in the Canyon, drive to the end of South Rim for the view of Spider Rock from the overlook of the same name. This rust-red twin-rock stack rises like a skyscraper 800ft (240m) to a flat summit home to Spider Woman, who, according to Navajo legend, takes a dim view of climbers and trespassers.

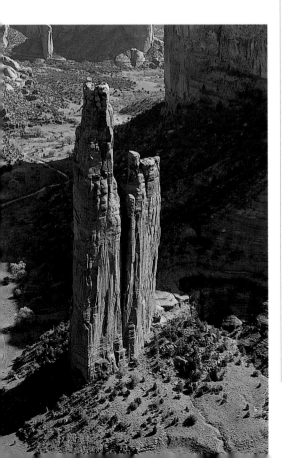

above | The legendary White House ruin.

left | The 800ft (244m)-tall Spider Rock.

Essential kit

⊕ A **telephoto zoom** will be your main lens for photographing the pueblos and other dwellings from the North or South Rims.

⊕ **Tripods** are permitted, so large-format camera users can try to emulate Ansel Adams' famous composition of the White House ruin—don't forget your **finest-grained black and white film** and an **orange or red filter**.

⊕ If you obtain a permit to explore the Canyon floor with a Navajo guide, then either rent or bring your own **four-wheel-drive vehicle** and don't forget good **walking shoes** or **boots**, plenty of **bottled water**, and a **backpack**.

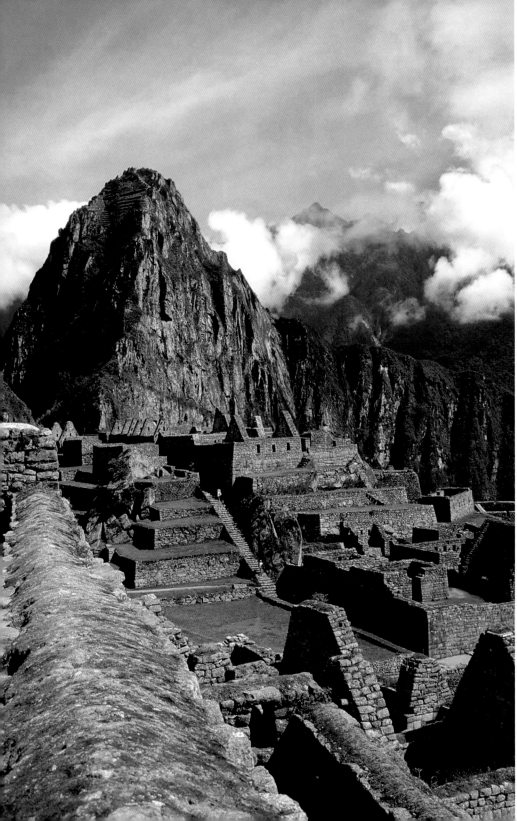

When American explorer Hiram Bingham rediscovered the ruins of Inca city Machu Picchu in 1911, his first action was to take out his camera and begin making photographs. People have been doing much the same ever since: with around 500,000 visitors every year, Machu Picchu is one of the most photographed ancient sites in the world.

Machu Picchu's significance in the Inca civilization is obscure, but with temples, a royal palace, homes for around 1,100 people, and terraces for agriculture, it was clearly a city of some importance. Given its situation, perched on a mountain saddle between two peaks and with steep slopes dropping away on either side, it is not surprising that this Inca outpost remained beyond the reach of the Spanish Conquistadors.

Machu Picchu by dawn

To fully appreciate the setting of this 700-year-old city, you should make the ascent to Wayna Picchu, the peak behind Machu Picchu, which overlooks the whole site down to the Urubamba River below. If there is mist or low cloud

above | The Incas cut their stones with extraordinary precision.

left | Looking toward Machu Picchu peak from the ruins of the "lost" Inca city.

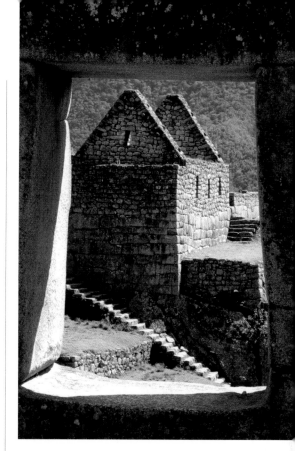

Historical background >>> When Hiram Bingham clambered up from the Urubamba Valley on 24 July 1911, and stumbled across the ruins of the previously unrecorded city of Machu Picchu, he stayed only a few hours and took 31 photographs, each one carefully listed in his notebook. While not the greatest of images, they were strong enough to impress George Eastman, founder of Kodak, and Gilbert Grosvenor, head of the National Geographic Society, into sponsoring a return expedition to Machu Picchu the following summer. Bingham's photographs and writings from the second expedition filled an entire issue of *National Geographic*. The April 1913 edition of the magazine was the first to be exclusively devoted to one subject. Thus began the first pilgrimages to Peru's greatest tourist attraction. Machu Picchu became more accessible to tourists in the mid-1930s, when a new road and railway were built in the valley below, and a hotel erected on the site of Bingham's old expedition camp.

Essential picture list

✦ It's a steep climb, but the view of the city from **Wayna Picchu** is one of the most famous views from anywhere in the world.

✦ Architectural highlights include the **Temple of the Sun** and the maze of stone walls and terraced dwellings that were home to 1,100 Incas.

✦ Make close-up details of the **intricate stonework** and use the numerous **open doorways** to frame more recognizable parts of the city.

✦ Photograph the **first light of sunrise** from Machu Picchu peak as it casts a lovely warm light over the whole of the lost city.

✦ The **Intihuatana** may not look exciting on its own, but its religious and historical significance will make you think about how to capture it as a powerful symbol of life and eternity.

in the adjacent valleys, the impression of isolation, of a lost city in the clouds becomes even more pronounced.

The dawn view of Machu Picchu, viewed from the peak at the other end of the city, is worth shooting as the first rays of sunrise give a soft, golden cast on the walls and terraces of the city.

It's also worth exploring the many fine buildings, each constructed with stone blocks aligned so neatly that in many places it is impossible to slip a piece of paper between the joins. There is a palace, a central plaza, and the Temple of the Sun, built for the worship of the Inca sun god Inti.

The hitching post of the sun

The most important religious site at Machu Picchu is a large vertical block of stone called the Intihuatana, which translates as the "hitching post of the sun." It was erected by the Incas to mark the sun's position at the winter solstice, thereby preventing its complete disappearance. In 2001, the lighting gantry of a film crew shooting a beer commercial chipped a corner of the stone. An ill omen from the Inca gods has been predicted for all involved...

Essential kit

✦ For one of the most famous views in the world, use a **tripod** and **remote release** to ensure the sharpest possible image.

✦ At nearly 8,200 ft (2,500m), a **UV filter** is advisable to filter out excessive ultraviolet light.

✦ Other useful filters to take include a **polarizer** and a **neutral density gradient filter**, as skies tend to be mostly cloudy or hazy.

✦ **Wideangle** and **standard zoom lenses** are the most useful here

✦ Film users should be content with **ISO 50** or **ISO 100 speeds**.

above right | **One of the ruined houses framed by the window of another.**

The Great Wall of China is one of the greatest feats of construction ever undertaken. It originally began as a series of separate walls and barriers built by different states to keep out invading Mongols. Following China's unification under Emperor Qin Shihuandi (221–206BCE), work began to link these separate defenses into an unbroken wall. Work lasted for centuries and used the forced labor of up to a million people. The wall that we see today is largely the work of the Ming Dynasty (1368–1644).

The snaking wall

What surprises many visitors to the Wall is how it snakes up and down mountain ridges, even at very steep angles. In these places, the top of the Wall is not a smooth incline, but a flight of enormous steps that are exhausting to climb. However, when you reach the top of one of these sections, the view makes it worthwhile.

Most tours to the Great Wall leave from Beijing, and day trips are common. The sections of the wall within reach of Beijing are well restored, but the crowds make photography far from pleasurable. With the aid of a long telephoto lens, you can focus on a stretch of the Wall in the distance beyond the reach of most daytrippers. Remember to include enough of the surrounding hills to convey the rugged terrain of this part of China.

If you prefer to see the Wall in a more natural state, then travel to Simatai, 63 miles (101km) northeast of Beijing. This part of the Wall is still far enough away from Beijing to have remained free of excessive tourist development...for now.

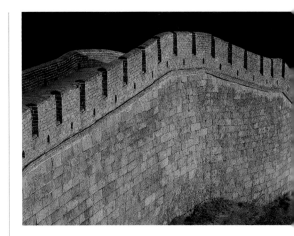

Essential kit

⊕ Treat your visit to the Great Wall as you would a trek and wear your **hiking boots**.

⊕ Take a **backpack**, as this will be more comfortable to carry than a shoulder bag.

⊕ Don't forget to take a **telephoto lens**. Alternatively, to reduce weight, take a **1.4x or 2x teleconverter**.

⊕ A **monopod** is useful both as a support for your camera and as a walking pole on some of the steeper stretches of the Wall.

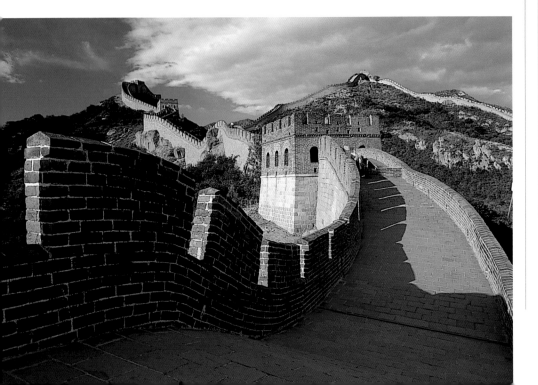

above | **A sectional detail of the Wall.**

left | **Inside the Great Wall, near Badaling.**

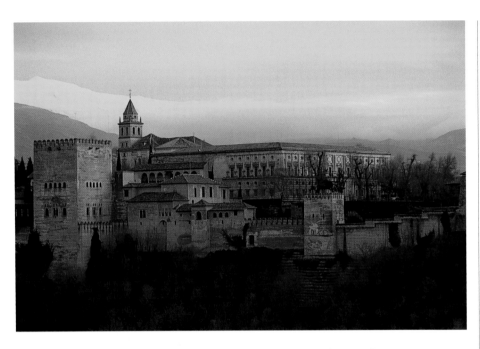

Essential kit

⊕ You can't hope to make a sharp, perfectly exposed shot of the Alhambra at night under floodlights without a **tripod**.

⊕ Take plenty of slow-speed **ISO 50 and 100 film**. If using a digital camera, stick to these ISO settings too, although you may want to try ISO 400 for some interiors.

⊕ A **panorama camera** is the ideal format for the Alhambra from Sacromonte.

⊕ Try a **skylight** or **81 series warm-up filter** to enhance the background peaks of the Sierra Nevada.

With the Sierra Nevada as a backdrop, the hilltop fortress of the Alhambra Palace has one of the finest settings in Andalucia. Built in the 13th century, it dominates the city of Granada, the last stronghold of the Moors who once reigned over most of Spain.

The Alhambra's primary purpose was as a palace, and for 200 years the Moors ruled Granada from within its walls and ramparts. At night, with the walls floodlit, the Alhambra looks even more imposing than it does by day, its solid fortifications belying the beauty and delicacy of decoration that lies within.

The main fortress within the Alhambra is the Alcazaba, but the most photogenic part of the complex is the Casa Real (Royal Palace), with its intricate patterned arches and windows, delicate tiles, and artful inscriptions from the Koran. Many of the rooms look out onto courtyards of shaded gardens and fountains.

Views of the palace

The most famous view of the palace is from the Sacromonte hill. From here, the Alhambra makes a perfect subject for the panoramic format. In the late afternoon the ramparts glow as they're bathed in warm light. When the floodlights switch on, the palace reflects a different hue with an inky blue night sky adding richness to the scene.

Another viewpoint to be savored is from the Mirador San Cristobal, looking straight across to the Alcazaba, with the Sierra Nevada behind. There will still be snow on the peaks in spring and the light is consistently bright.

above | **The Alhambra at dusk.**

right | **Battlements and ramparts.**

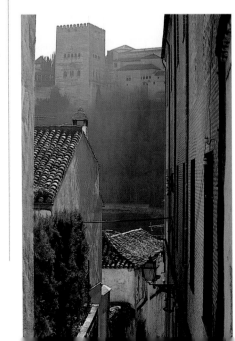

Callanish is a tiny village on the Outer Hebridean island of Lewis, off the northwest coast of Scotland, famous for its gray granite stone circles. The largest circle is popularly known as the Standing Stones of Callanish, but is also referred to as Callanish I due to the presence of three other circles spread along a northwest–southeast axis from the main circle.

The stones were erected at least 4,000 years ago (some say 5,000). The stones' position, on a ridge overlooking Loch Roag and the hills of Harris, gives them an imposing presence against the skyline. At any time of year the stones are directly lit (cloud permitting) by the rising and setting sun, making them perfect subjects for photography.

below | The circle of stones of Callanish I are an impressive feature in the local landscape set against a windswept sky.

Callanish I offers the greatest picture potential. It consists of 13 tall and slender Lewisian gneiss stones arranged in an elliptical circle 43 by 37ft (13.1 by 11.3m), in the center of which stands the tallest stone, which is nearly 16ft (4.9m) high.

Callanish I resonates a sense of the supernatural, a feeling enhanced by the legends attached to its origins. Local tradition says that the stones are a group of giants who refused to be converted to Christianity by St Kieran. However, the circles pre-date Christianity, and it is more likely that they served as an astronomical calendar for the farmers of Loch Roag before the great climate change of around 1500BCE.

Essential kit

⊕ As the stones stand on a ridge with a background of sky, controlling the influence of the sky on your exposure is critical. A **polarizer** will be useful if the sun is to the left or right of the frame.

⊕ **Neutral density graduate filters** will balance out any marked exposure variance between sky and stone, and an **81b warm-up filter** will reduce any blue cast in the shadow areas.

⊕ There's no excuse for not using a **tripod**.

⊕ A **standard zoom lens** will cover most framing options. Use a short telephoto if you want to isolate a section of the stones.

⊕ This is a superb subject for atmospheric **black and white**.

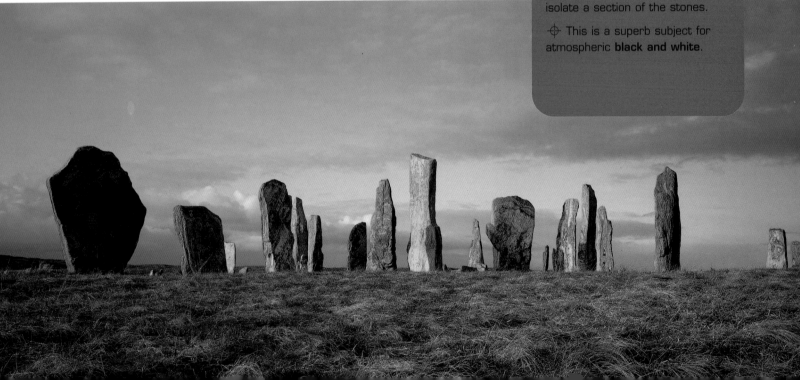

The island of South Georgia is legendary. Geographically, it is the last habitable place in the South Atlantic before the Antarctic ice shelf; for the great explorer Sir Ernest Shackleton, it was the last chance of survival in the greatest rescue story of the 20th century. Little has changed since Shackleton reached Stromness on 20 May 1916, but the island is now deserted, save for a small base of scientists from the British Antarctic Survey at Grytviken, a former whaling station.

The abundance of wildlife and the spectacular scenery have now made South Georgia a popular stopover for tour ships cruising to Antarctica, and the one place where everyone stops to take a picture is at Shackleton's grave at Grytviken.

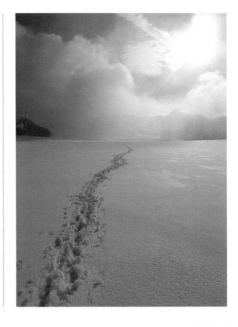

right | **Looking back toward Trident Ridge from Crean Glacier.**

below | **Approaching South Georgia.**

Essential kit

⊕ South Georgia is bitterly cold and windy, so make sure that you are properly attired with **thermal clothing**, including gloves and hat. Wear **three or four-weather boots** and if you intend walking on any ice, use **crampons**.

⊕ A **standard zoom lens** covering wideangle to short telephoto will cover most options and reduce the need for changing lenses. Mammals such as penguins and seals are approachable with a **modest telephoto zoom**, but seabirds require something longer.

⊕ Use a **tripod**; it will keep the camera steady when your hands are shaking.

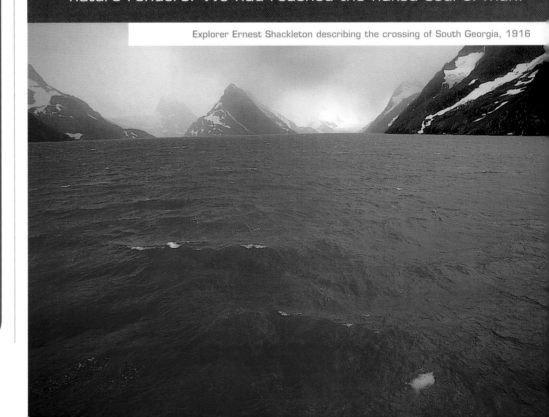

"We had seen God in His splendors, heard the text that nature renders. We had reached the naked soul of man."

Explorer Ernest Shackleton describing the crossing of South Georgia, 1916

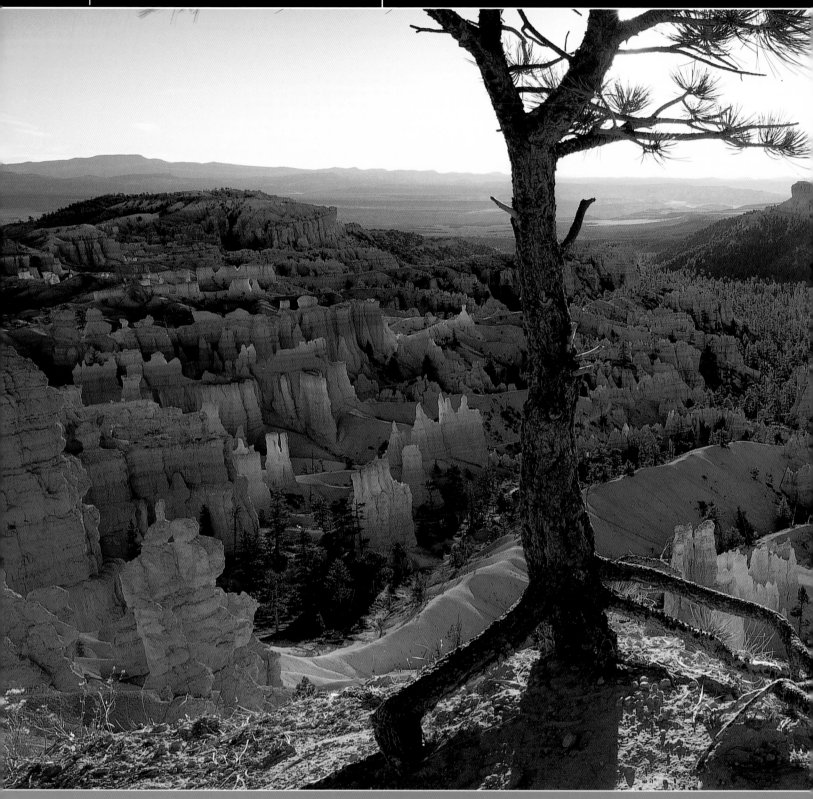

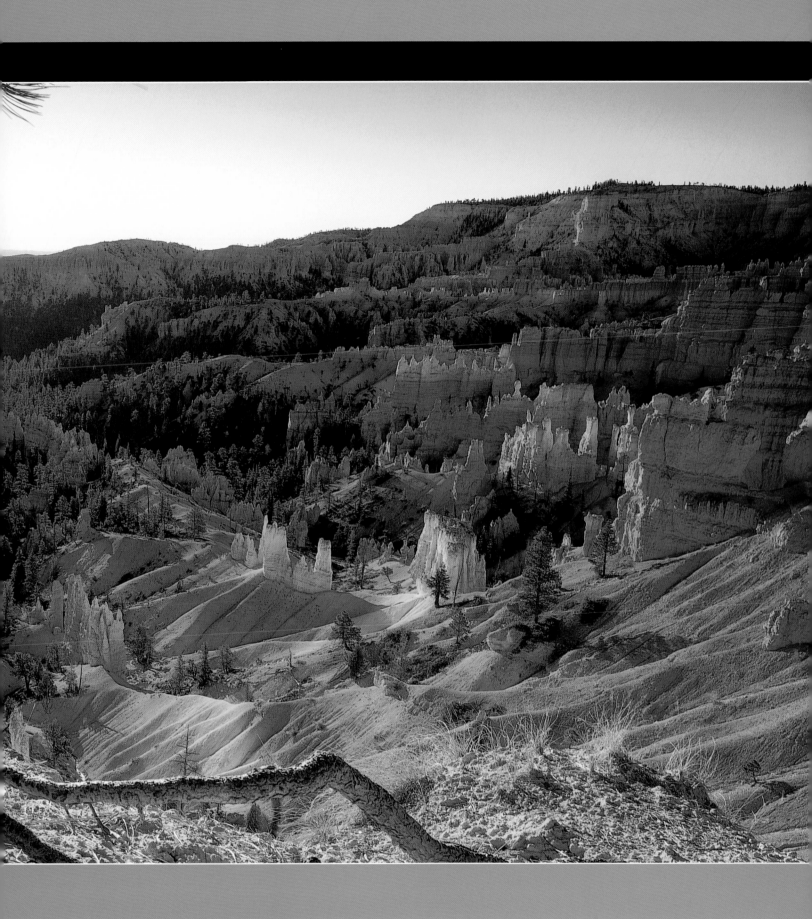

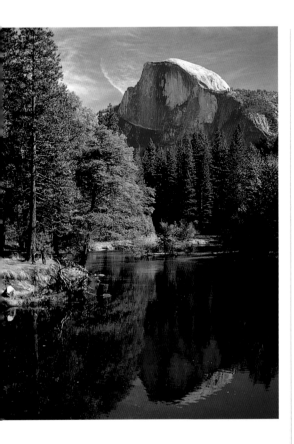

chapter three: natural wonders: landscapes

above | Yosemite's most famous monolith, the magnificent Half Dome, and its reflection on a perfectly still day.

right | Wonderful views of Vernal Falls can be enjoyed along the Mist Trail.

The Yosemite Valley can be regarded as the birthplace of the American conservation movement and of modern landscape photography. Some of the world's favorite landscape images, by the legendary photographer Ansel Adams, were captured here. Photographs such as *Moon and Half Dome* and *Clearing Winter Storm* have provided the inspiration for thousands of people to experience the beauty and diversity of this landscape.

Ice Age grandeur

Yosemite lies in the heart of the Sierra Nevada mountain range, 150 miles (240km) east of San Francisco. It is home to waterfalls, spectacular slabs of exposed granite, and great forests of oak, sequoias, cedar, and pine.

Yosemite is a creation of the last Ice Age; glaciers shaped the valley as they forced out vast quantities of ice and rock and even split mountains. Half Dome, Yosemite's most recognizable monolith, was formed when glacial action caused one side of it to collapse. Other granite giants include El Capitan, Cathedral Spires, and Liberty Cap.

Just as spectacular are the waterfalls that tumble over these sheer rock faces: the Upper and Lower Yosemite Falls form the highest falls in North America, with a combined drop

Essential picture list

⊕ On Highway 41 heading south out of the valley, pull over to the lay-by marked **Tunnel View**. This is the viewpoint for a panoramic vista of Yosemite Valley.

⊕ For fabulous views of **Vernal and Nevada Falls**, take the Mist Trail and continue along the John Muir Trail to the top of **Half Dome**.

⊕ On the valley floor, **Cooks Meadow** is a lovely setting, particularly in spring, with views to Yosemite Falls and Half Dome.

⊕ At **Glacier Point**, you can gaze down 3,000ft (915m) to the valley floor or look across to the high country beyond Half Dome.

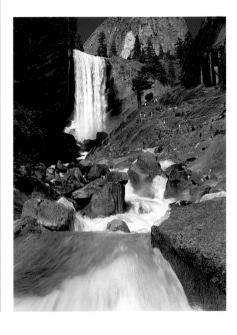

Historical background >>> Yosemite was the word for "grizzly bear" in the language of the Native American tribes who used to live in the area. The grizzly bears are long gone, although black bears are still plentiful. One of America's first three national parks, Yosemite's importance was first realized by John Muir, who visited the valley in 1868 soon after arriving in San Francisco from his native Scotland. Muir's subsequent visits and explorations of the Sierra Nevada inspired him and others to establish the Sierra Club, one of America's foremost conservation groups.

of 2,420ft (738m). For the best view, hike up the Yosemite Falls Trail. For more photogenic waterfalls, hike up the Mist Trail, which passes close to Vernal and Nevada Falls.

The most popular spot in Yosemite Valley is Tunnel View, a lay-by on Highway 41. From this viewpoint, all of Yosemite's famous landmarks can be contained in a single frame: El Capitan, Cathedral Rocks, Half Dome, and the Bridalveil Falls.

Exposure problems

Making accurate exposures is not easy. By the time the sun reaches the valley floor, the soft light of dawn is long past. Similarly, the valley is plunged into shade while the granite peaks above are lit at sunset. This presents problems with high contrast on clear days, rectified by using a combination of filters, or taking the high trails at dawn and focusing on the landmarks at the valley top.

Essential kit

⊕ Take your full complement of filters: **81a**, **81b**, and **81c warm-ups** to counteract the cool cast and loss of detail in shadow areas, and a **polarizer**. Also, one or more **neutral density graduates** will help control contrast levels.

⊕ Wear proper **walking boots** and a **hat**, and carry all your kit, including **bottled water**, in a **backpack**.

⊕ There's no excuse for not using a **tripod**—do you think Ansel Adams managed such sharp images of Yosemite without one?

⊕ You will need lenses to cover all options from **wideangle** to **telephoto**.

below | El Capitan is one of several huge granite monoliths rising vertically from the valley floor and dwarfing the 200ft (60m)-high sequoia pines.

"Into this one mountain mansion Nature had gathered her choicest treasures."

John Muir, *The Yosemite* (1912)

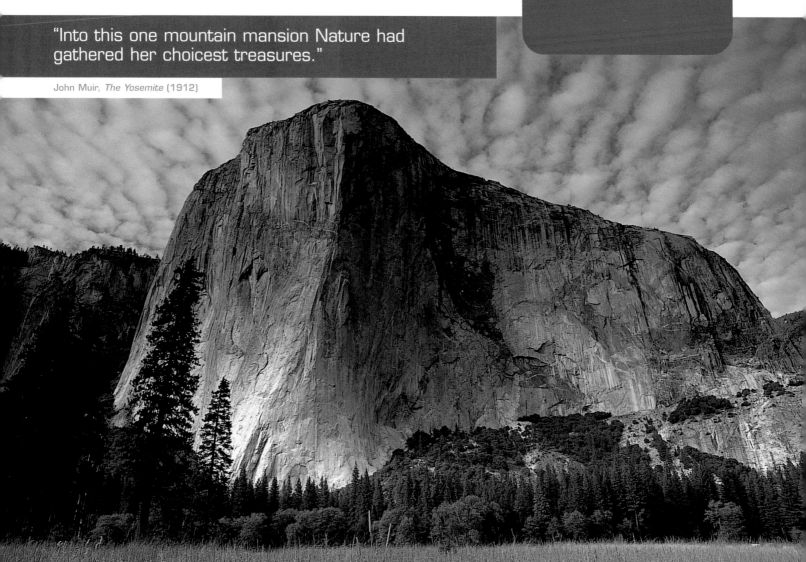

Monument Valley is one of the most recognizable landscapes on earth. The craggy red sandstone buttes that rise steeply from its arid sandy floor have been the backdrop to countless Hollywood and TV westerns.

Monument Valley is contained within the Navajo Nation Tribal Park on the Colorado Plateau in the hinterland of the Arizona/Utah border. The area has been populated by tribes of hunter-gatherers for thousands of years, and

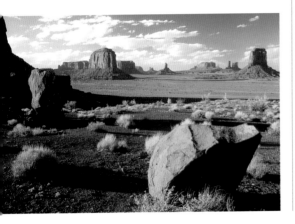

the buttes and spires ascribed with mystical powers. Totem Pole Rock is said to be a god held up by lightning, and El Capitan a sky supporter. Today, the Navajo are the residents and keepers of the valley.

Strictly speaking, however, Monument Valley is not a valley at all. Instead, the buttes and spires are the weathered remnants of sandstone and shale layers that once covered this part of the Colorado Plateau. These layers date back millions of years, and were eroded over millennia into the shapes we see today. The reddish hues of the landscape are caused by iron oxide.

At just over 5,500ft (1,676m), Monument Valley can be cool in winter, but the clarity of the atmosphere, and the long shadows of early morning and late afternoon, makes photography a pure pleasure at this time of year.

Essential kit

⊕ There's no need to rush here, so take your time, find your place, and use a **tripod**.

⊕ Monument Valley is one of the few landscapes where you can make a striking and balanced composition at **virtually any focal length** from wideangle to telephoto without changing position.

⊕ The light is clear and bright, so use a **slow film (ISO 50 or 100** for digital cameras).

⊕ A **lens hood** will help to reduce flare.

⊕ The most useful filters are a **polarizer** and a **neutral density graduated filter**.

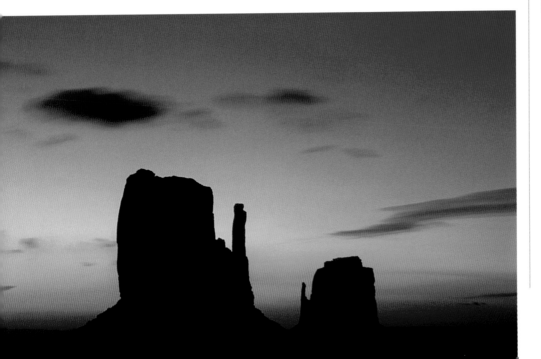

above left | With its red sandstone buttes, stacks, and hoodoos, shaped by millions of years of erosion, Monument Valley is a landscape synonymous with the American West. It looks particularly dramatic around sunrise and sunset.

left | Silhouettes of Monument Valley just after sunset make a graphic image that is immediately recognizable. With an altitude of just over 5,500ft (1,676m) and dry desert air, the skies over Monument Valley are clear for most of the year.

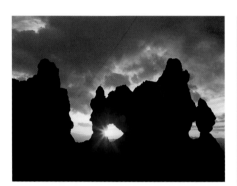

When the first rays of sunlight strike the rows of eroded rock pillars, fins, and walls of Bryce Canyon at dawn, the rock seems to be glowing from within. It is a stunning light show that looks wonderful in any photograph.

Fantastic forms

Bryce Canyon stretches for nearly 18 miles (29km), carved into the soft banded sandstone of the Paunsaugunt Plateau in Utah, its rocky spires formed by millions of years of erosion. Although the richest colors occur at dawn and sunset—depending on which part of the canyon you are approaching—the impressive shapes and their sheer scale are too tempting to ignore, even in the midday sun.

These fantastic forms are a stark contrast to the surrounding plateau, which, at nearly 8,000ft (2,500m), is a similar height to the Colorado Plateau surrounding the Grand Canyon. Temperatures drop below freezing for more than six months of the year and this and the subsequent thawing over the ages have helped to shape Bryce into what it is today.

One of the best times to visit is in the late fall, when the first snowfall of the winter dusts the spires and fins of the canyon like icing sugar on a cake. Then at dawn or sunset, the glowing orange and red rock gives a pinkish cast to some of the snow.

above left | sunrise framed through a hole in a sandstone hoodoo near Sunset Point.

below | The Canyon's rich display of colors can be enjoyed from numerous overlooks.

above right | A detail of the rock pillars and fins of Bryce Canyon at dawn.

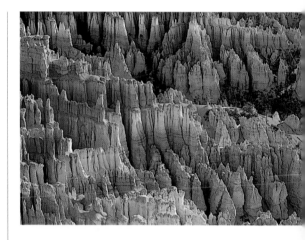

Essential kit

◈ Filtration is important, especially when controlling the exposure variance between highlight and shadow areas at dawn and sunset. **Neutral density graduated filters** will help.

◈ Use a **tripod** and **fine-grained film** (or a low speed setting of **ISO 50 or ISO 100** for digital capture).

◈ **Panoramic camera formats** such as 6x12cm and 6x17cm work well at Bryce, mostly with **wideangle** or **standard lenses**.

◈ **Walking boots** should be worn to get around safely, and you should carry your gear in a **backpack**.

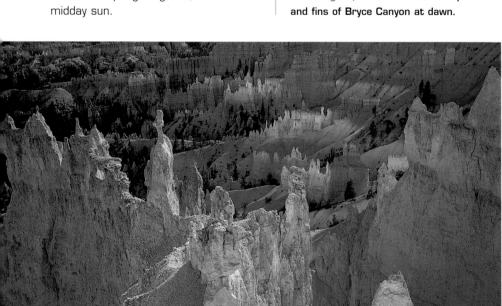

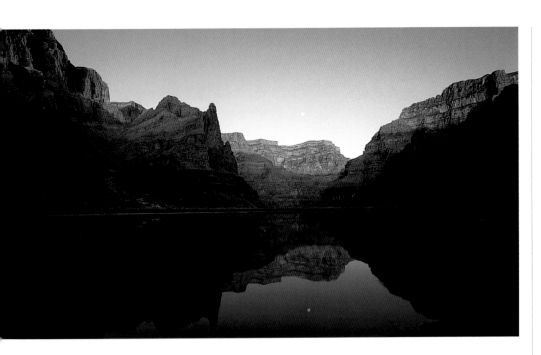

Essential kit

⊕ A **wideangle zoom** is the most obvious lens to take, but a **telephoto zoom** is useful for composing the impressive cliffs and canyon walls from a distance.

⊕ A **tripod** or **monopod** is essential.

⊕ Also pack a **neutral density graduated filter** for any hazy bright skies.

⊕ A **polarizer** will also prove useful for cloudy days.

⊕ Take **plenty of film** or **memory cards** and a **spare set of batteries**, as prices are high at the Canyon View Center, and the nearest camera store is at Flagstaff.

Essential picture list

⊕ There are great panoramic views from the **Yavapai Observation Center** at Yavapai Point on the South Rim at any time of day—weather permitting.

⊕ Take the scenic drive along the North Rim to **Cape Royal** and **Imperial Point** for morning views of the canyon.

⊕ Sunset is the best time to visit **Bright Angel Point** on the North Rim.

⊕ Book a camping permit to the **Inner Canyon**. An overnight stay in a tent or at Phantom Ranch will ensure you have enough time to hike down to the **Colorado River** to photograph the amazing scenery that can't be seen from the rims.

The Grand Canyon is the best-known example of arid land erosion in the world. It was created by the Colorado River's gradual incision into the plateau over a distance of 277 miles (445km), averaging a depth of 4,000ft (1,220m) along its entire length. At its lowest point, the canyon is 6,000ft (1,830m) deep and up to 15 miles (24km) wide.

Capturing immensity

The photographer faces the problem of how to capture the immensity of this natural wonder. You need to understand the layout of the canyon and the different perspectives from the North and South Rims. The South Rim is the most visited part of the Grand Canyon. It is here, at the Canyon View Center, that most visitors to the National Park arrive, taking advantage of the many overlooks accessible by car along Desert View Drive, which follows the rim of the canyon for 26 miles (42km).

There are plenty of views to be enjoyed along the Rim, and the best light for photography is early or late in the day. Yavapai Observation Station at Yavapai Point offers wonderful panoramic views. The North Rim is open only from mid-May to mid-October. It is far less congested, and many photographers prefer the views from Cape Royal and Point Imperial. At 8,803ft (2,680m), Point Imperial is the highest point on the North Rim and overlooks the Painted Desert and the eastern end of the canyon. It is best visited in the

morning, when the light reveals the contrasting layers of red and black pre-Cambrian rocks.

The problem with photographing the canyon from the North or South Rims is that you get few glimpses of the Colorado River at the bottom. Also, it is hard not to include the sky in your pictures, so often a flat, colorless sky diminishes the scale and depth of the canyon below. There are two courses of action: set up your tripod, compose your picture, and wait for an interesting sky to form; or put on your rucksack and hike down into the Inner Canyon.

Historical background >>> The Grand Canyon and surrounding Colorado Plateau has been inhabited for approximately 10,000 years by a succession of hunter-gatherers, Native Americans, and European settlers, but it wasn't until the 20th century that the natural and cultural importance of the canyon was acknowledged. After President Theodore Roosevelt's visit in 1903, the canyon was granted National Monument status in 1908 and upgraded to a National Park in 1919. The size of the park was doubled in 1975 and four years later it was declared a World Heritage Site. The last Native Americans to reach the canyon were the Navajo in the 1400s, and they have remained ever since. Today, they are the largest Native American tribe in the United States, and their huge reservation abuts the eastern section of the National Park.

opposite page | The Colorado River flowing through the Grand Canyon near Lake Mead.

below | One of the Grand Canyon's most popular views, Cape Royal, seen from the North Rim, under a moody sky.

"Ours has been the first, and will doubtless be the last, party of whites to visit this profitless locality."

Lieutenant Joseph Ives, leader of a US Army Survey Party to the Grand Canyon region in 1857

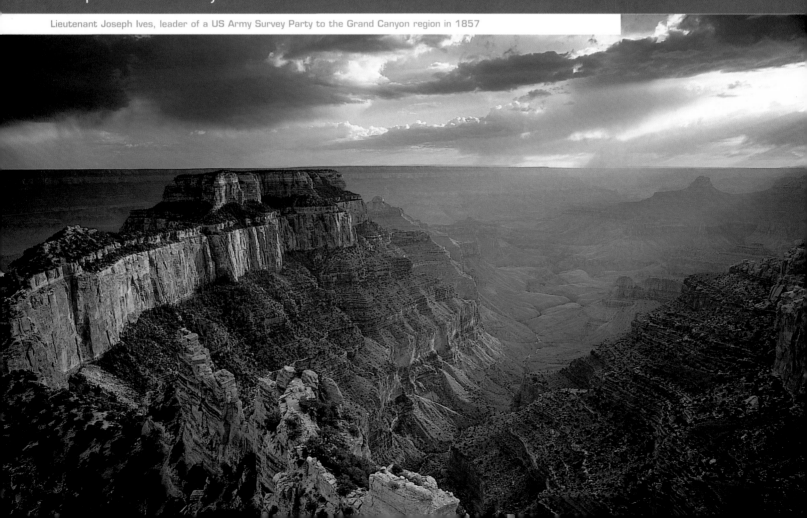

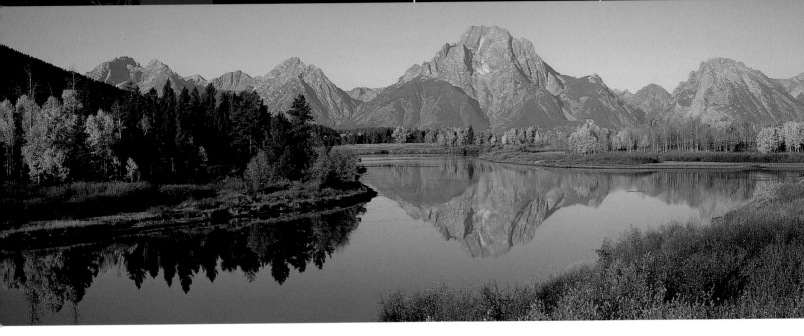

Yellowstone spreads out from a centrally located lake that sits in the middle of a giant caldera, the legacy of a massive eruption more than 600,000 years ago that cloaked ash over most of the North American continent. Today, Yellowstone is home to more than half of the world's geysers and has 10,000 thermal features within its boundaries. It is one of the most geologically active regions in the world, with hundreds of geysers, hot springs, mud pots, and fumeroles. Old Faithful is the best-known geyser and it preserves its popularity by keeping people waiting only 90 minutes between eruptions. A longer wait is required for Castle Geyser—about 12 hours—but its plume of steam is rather more spectacular and the eruption lasts up to an hour.

Shooting geysers

One of the most striking ways to photograph Old Faithful, Castle, or any of the larger geysers, is to time your arrival for a morning eruption and shoot into the sun. The cloud of steam blocks out most of the sun's glare, and the resulting backlighting gives a clear outline to the plume. The cold air of early morning also means that steam will be rising from the geysers before any eruptions take place.

It's not often that the middle of the day is recommended for photography, but that's certainly the case for Morning Glory Pool. Located in the Upper Geyser Basin, this deep-colored thermal vent is

above | **Oxbow Bend on the Snake River is a favorite beauty spot throughout the year, with the forbidding Mt Moran dominating the view. Fall is the most spectacular season, when aspens and cottonwoods bring a burst of color to the Grand Tetons.**

right | **In winter, animals such as this young elk become more visible as they forage for food.**

⊕ A **full complement of lens focal lengths**, from wideangle to telephoto zoom, will be necessary to accommodate the huge range of subject matter from frothing geysers to elk and bison drinking from a river.

⊕ A **tripod** will help keep your camera and lens still, but also place a **beanbag** on your car windowsill to rest your lens when shooting from the car.

⊕ A **polarizing filter** is handy for cutting through the glare of Morning Glory Pool and for emphasizing the clouds of steam from the geyser, thermal vents, and hot pools.

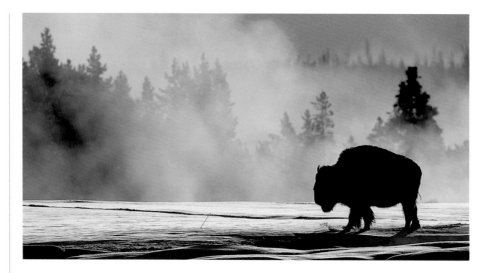

at its most vivid between noon and 2pm. With the sun at its highest, this also means that no shadows are creeping across the surface of the pool. It can be photographed from the public boardwalk, and a polarizing filter will cut out the surface glare so that you can see beneath the water's surface.

above | A bison walks across a snowfield in Yellowstone, oblivious to the background of rising steam from vents, fumeroles, and hot springs.

below | A break in the clouds after a snowstorm lights up a forest of willowscrub with the Tetons in the distance, viewed from the Beavertail Ponds Overlook.

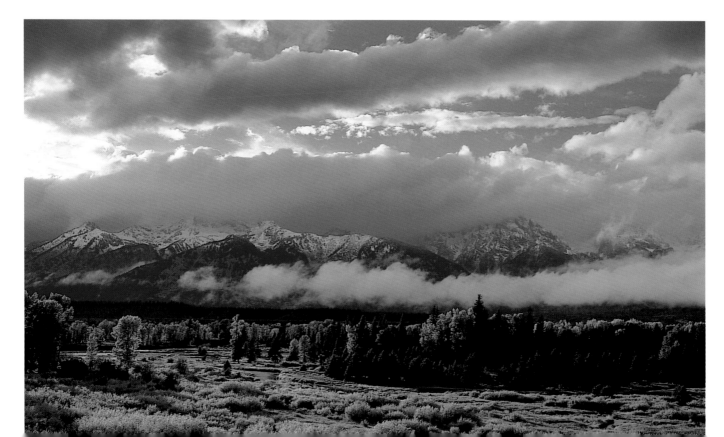

below | Mammoth Hot Springs is a cross-section of an active travertine terrace, and provides a striking example of the layers of mineral deposits from thousands of years of geothermal activity.

Wildlife watching

Near Yellowstone's north entrance on the Montana–Wyoming border is Mammoth Hot Springs. This end of Yellowstone is best for photographing wildlife, particularly the herds of bison and elk that graze on the meadows on either side of the Madisson and Firehole Rivers. Bison are the largest mammals to roam the North American plains, and Yellowstone is the only place in the lower 48 states of the USA where a population of wild bison has survived since prehistoric times—albeit only just. In 1902, there were just 50 bison left in Yellowstone. Today, their numbers have recovered to around 3,500.

Other mammals to be seen in Yellowstone are grizzly bears, coyotes, mountain lions, and bobcat. The last two are extremely rare, so any sighting, let alone a photograph, should be treated as a bonus. In 1995, wolves were successfully reintroduced into the park and today they are believed to number more than 100. Winter is a good time to see most of the wildlife,

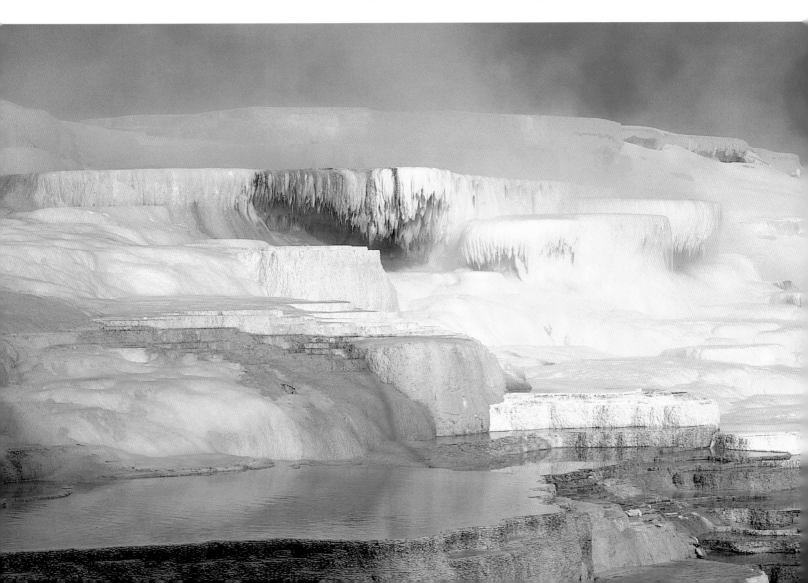

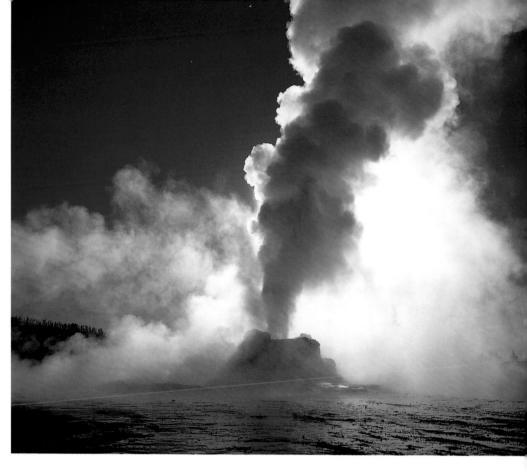

right | Castle Geyser blows every 12 hours and the eruptions last for up to an hour. Time your visit for the morning, soon after sunrise, and shoot into the sun so that the plume of steam is backlit as in this picture, taken around 9am in the fall. Because the eruption lasts so long, you have time to shoot at different exposure settings, thereby improving your chances of making a successful image.

Essential picture list

⊕ **Upper Geyser Basin** is the site for Old Faithful and Castle Geyser, plus the Morning Glory Pool. This is the most visited part of Yellowstone, so you won't be alone. Watch out for bison roaming across the plain.

⊕ **Elk and bison** frequently cross **Madisson River** during the day, giving you the best chance to get frame-filling images of these large mammals.

⊕ **Mammoth Hot Springs** is an attractive terraced hot spring built by thousands of years of mineral deposits and still very active.

⊕ In the north end of Yellowstone, **Lamar Valley** is one of the best places to see bison, elk, wolves, and even grizzly bears.

⊕ **Oxbow Bend** offers a stunning Teton landscape at its golden best soon after sunrise, with Mt Moran looming in the background and river mist adding to the atmosphere.

⊕ **Moulton Barn** is possibly even more popular at sunrise than Oxbow Bend, but looks impressive at any time of year. When photographed in snow, this old timber barn gives you an idea of the isolation the early settlers must have felt during their first winters.

as there is less cover and the animals have to travel more widely and conspicuously in their quest for food.

Most wildlife photographers use a 400mm or 500mm telephoto lens as standard and select a fast shutter speed, even with a tripod, to keep the image as sharp as possible. If your telephoto is something more modest, try adding a 1.4x or 2x teleconverter for that magnification and use a support to keep your lens still. It is possible in Yellowstone to shoot from your car window, so use a beanbag on the windowsill to rest your lens and switch the car off to stop any engine vibration.

Grand Teton

Fall is the best time for visiting neighboring Grand Teton National Park. Here, The Teton Range provides a magnificent mountain backdrop to the open landscape of cottonwoods, aspen, and willowscrub that draw so many photographers here from late September onward. Oxbow Bend, on the Snake River, is a favorite location for

sunrise images where the jagged face of Mt Moran contrasts starkly with the golden colors of fall and a thin veil of mist rises from the river. Not surprisingly, many photographers mark their spot before dawn, but don't despair, because many of them leave soon after the sun has cleared the horizon, missing out on the sun lighting up the willowscrub in the foreground. The view is rarely disappointing, and it's definitely one for the wideangle lens.

Another great American landscape is of the Tetons from Antelope Flats, with the famous Moulton Barn in the foreground. This view looks even more dramatic in early winter after the first snow has transformed the landscape.

location > **Denali**

country > **Alaska** | when to go > **May–Aug** | focus on > **plant life**

At 20,320ft (6,193m), Denali is North America's highest mountain, situated on the 600 mile (965km)-long Alaska Range and located within the 6 million acre (2.4 million hectare) national park bearing its name.

Denali is a sub-arctic wilderness of global reputation, favored by climbers, naturalists, and photographers. There is an abundance of animal life: 39 species of mammals including grizzly bears, moose, and wolves; 167 species of birds; and ten species of fish.

The national park's greatest treasures are the plants that give vivid color to the landscape. There are more than 650 species of flowering plants within the park, as well as lichens, mosses, and fungi in the valleys and foothills. The plants have adapted over millions of years to survive the frozen winters and short growing season of the sub-arctic.

To photograph the wildlife or get close enough to Denali for the morning light, it is essential to camp overnight at Wonder Lake, Teklanika, or Savage camping grounds. Alternatively, some of the lodges in the Kantishna area of the park have views of Denali.

below left | Denali National Park is home to a huge variety of sub-arctic plants.

Essential kit

⊕ If you're going to Denali primarily for the landscape and plant life, then **wideangle** and **macro lenses** are essential. If wildlife is your goal, then a **long telephoto** is a must.

⊕ Whatever your subject, a **tripod** will be needed, although a **beanbag** or two will be more practical if you are photographing bears, moose, or other large mammals from your vehicle.

⊕ The mosquitoes can be annoying during June and July, so don't forget the **insect repellent**.

⊕ **ND graduate** and **UV filters** should be in your backpack, as well as **spare batteries**, **film**, and **memory cards**.

⊕ Denali's terrain demands hard-wearing and comfortable **boots**.

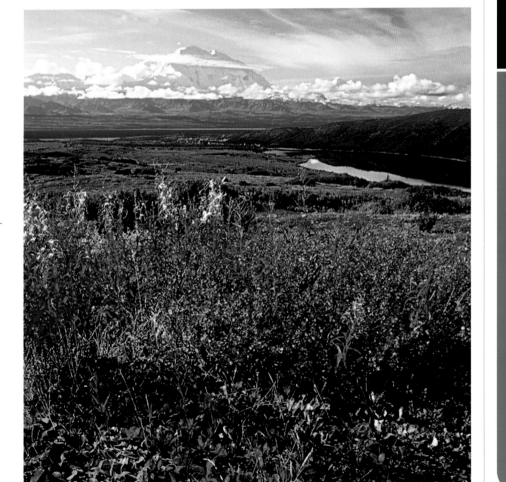

Death Valley has a fearsome reputation, and one that is wholly deserved. This sunken basin of sand dunes and salt pans is one of the hottest, driest places on earth and the lowest point in the Western Hemisphere—282ft (86m) below sea level at the appropriately named Badwater. This and other descriptive names give Death Valley much of its fascination: there is the Devil's Haystacks, Furnace Creek, and the incredible Dante's View.

To appreciate the unique position of Death Valley, the drive up to Dante's View is a must. From a height of nearly 5,500ft (1,600m), you can look right across the 15 mile (24km)-wide valley and look down onto the baking hot salt pans of Badwater below.

An air-conditioned vehicle, preferably a 4x4, is the best way to get around, and most visitors make Badwater their first stop. It is a desolate place; a harsh, flat terrain of bright white salt pans that shimmer in the sun. Summer temperatures here reach 100°F (38°C) before 6am. Winter is the sensible time of year to go, but even then taking accurate exposures can be problematic. The salt reflects sun much like snow

and tricks camera meters into underexposing, so it's advisable to increase your metered exposure by 1.5 to 2 stops and bracket around your new "correct" exposure by half a stop.

Zabriskie Point is another landmark popular with photographers. It is a five-minute drive from Badwater and best photographed at sunrise, when the dawn light strikes the pale yellow snub of rock. This is a markedly different landscape, with smooth, rolling ranges of bare yellow and orange rock that make an attractive foreground for pictures of the Point. For classic images of sand dunes, go to the Devil's Haystacks. They make a perfect foreground for a wideangle view of desert sands.

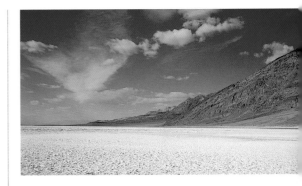

above | At 282ft (86m) below sea level, the salt pans of Badwater are the lowest point in the Western Hemisphere.

below | The sand dunes of Death Valley are a classic desert landscape.

Essential kit

⊕ This is an arid, parched landscape, so take plenty of **water**, **sunscreen**, and a **hat**.

⊕ When out of your vehicle, travel light with a **single camera body** and a **minimum of lenses** in a backpack.

⊕ **Zooms** are ideal, particularly for a location like Zabriskie Point where the colors and patterns in the rocks can be composed in an infinite number of ways.

⊕ Take a **tripod**, but be careful that rubber feet don't melt and remember that any metal will get hot fairly quickly.

⊕ Take **lens hoods** and **skylight** or **warm-up filters** to control glare and reduce any blue cast in shaded areas. A **polarizer** will help emphasize clouds.

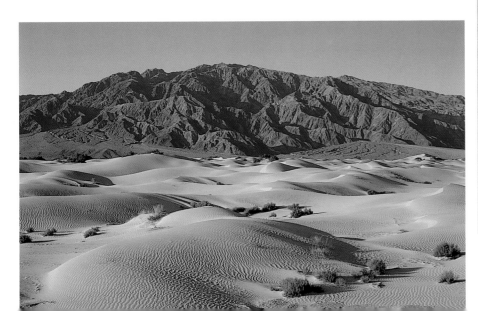

There are many locations described by a phrase that has become something of a cliché in adventure travel writing—"one of the most inhospitable places on earth"—but in the case of Dead Vlei, such a description is not inappropriate. Dead Vlei is a desperately hot, white salt pan located within Namibia's Sossusvlei National Park. Scattered across its flat and empty surface rise the eerie twisted trunks of dead camelthorn trees.

The real spectacle lies on the margins, where the white of the salt pan meets the massive range of orange sand dunes, hundreds of feet high. Here, the locals will tell you, it hasn't rained in living memory and it's hard to dispute such a claim while looking at the desiccated limbs of the trees.

Smothering sand dunes

Dead Vlei and the surrounding dunes are part of the vast Namib Desert, from which Namibia derives its names. It is said to be the oldest desert in the world, and the sand dunes are among the highest to be found in Africa. With no rock beneath to support them, they are constantly reshaped by the wind, shifting and changing direction, encroaching on the pan, and slowly smothering a camelthorn should it get too close.

To witness the emergence of Dead Vlei and the surrounding dunes from the shadows, it is worth arriving before sunrise. When the sun rises and its rays illuminate the tips of the first dunes, the light advances down these mountainous slopes of sand and across the salt pan, sending the shadows into a rapid retreat. This strong light makes the sand appear to be glowing orange and bright red, and the shadows cast by the camelthorns are so clearly defined that they seem to be scorched into the sand.

With a strong blue sky, radiant orange dunes, and bleached white salt pan, this harsh landscape appears as three distinct bands of color in the viewfinder. The claw-like branches of the trees provide the only vertical features to break up these bands.

Essential picture list

⊕ Focus on the **east-facing sand dunes** of Dead Vlei in the morning soon after dawn and use the dead camelthorn trees as foreground interest.

⊕ Climb a sand dune and enjoy the **view of the desert** sweeping to the horizon.

⊕ Climb **Big Daddy**, **Dune 45**, or one of the other high dunes in the national park to photograph the view: orange sand dunes stretch for miles in all directions.

⊕ A diversion to **Kolman's Kop** is worth making to witness the surreal sight of a deserted town being reclaimed by the desert.

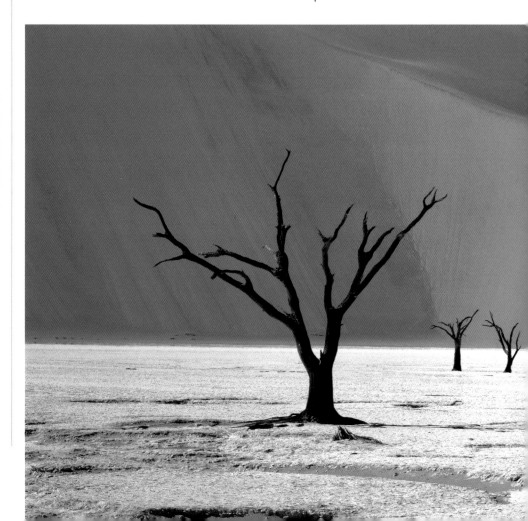

Historical background >>> How old are the dunes of the Namib Desert? Reputedly the oldest on earth, they date back many millions of years in a landscape where the geography is still taking shape. Over time, the dunes have altered the course of the Tsauchab River (now mostly dry) by cutting sections off, forming isolated lakes that dry up and form salt pans. Dead Vlei is one of many white salt pans that have been formed in this way.

The Skeleton Coast

Summers are unbearably hot here, and most travelers visit between April and October, when climbing a dune popularly known as "Big Daddy" is high on most people's lists. The views from the top more than make up for the hard slog in the sand. Elsewhere, the dunes of the Namib Desert roll straight into the South Atlantic Ocean on a strip of shoreline known as the Skeleton Coast, where the parched remains of a former whaling fleet (and whale bones) are buried in the sand. Similarly, the desert is slowly covering the ruins of Kolman's Kop, a former diamond mining town.

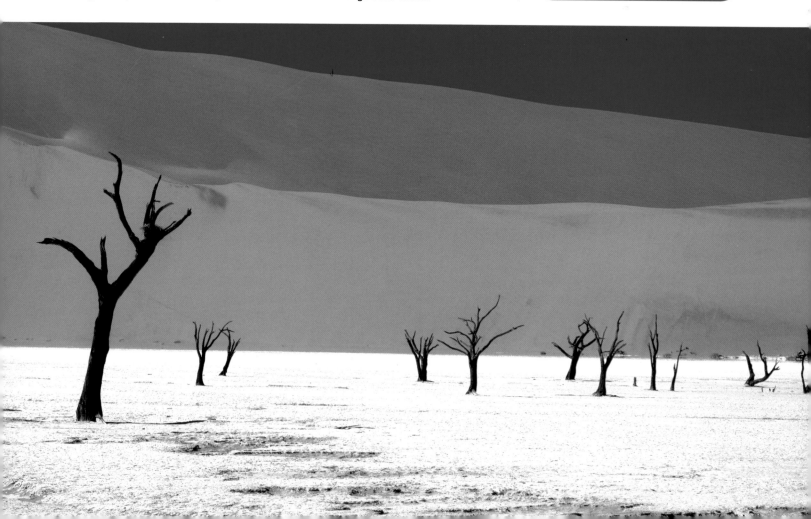

below | The salt pan punctured by dead camelthorn trees against a backdrop of brilliant orange sand dunes.

"This rock is certainly the most wonderful natural feature I have ever seen."

William Gosse, the first white man to climb Uluru (1873)

Essential kit

⊕ Take a lightweight camera bag with enough lenses to cover the range from **wideangle to telephoto**.

⊕ The desert air is very clear, so your colors will sing, and a **polarizer** may be the only filter that you need.

⊕ The ground is sand and dust as far as the eye can see, so keep your equipment clean by using **lens wipes** or a **blower brush**.

⊕ This is remote, dry, dusty, and rugged terrain, so nothing less than **walking shoes** or **boots** will do for your feet.

Uluru (formerly known as Ayers Rock) is one of the most sacred of Australia's Aboriginal sites. Along with nearby Kata Tjuta (also known as The Olgas), it draws thousands of visitors each year—a fact that does not rest easy with the Anangu, the local tribe of Aborigines who are the rock's traditional owners.

above | Rising above a flat landscape of red dust and spinifiex grass, Uluru dominates the skyline for miles around.

A sacred place

Many white Australians regard the journey to the "Red Center" and the walk to the summit of Uluru as a rite of passage, but the Anangu object to the practice and are trying to have it stopped. Nonetheless, around 100,000 visitors make the walk each year. It's not an easy undertaking, and during the summer Uluru is closed to climbers from 8am because temperatures are too high. With a summit of 1,145ft (348m), the rock is very exposed to buffeting winds, and although there is less than 8in (20cm) of rain a year, when it does fall, it pours.

Uluru is the world's largest monolith, a single piece of sandstone rock six miles (10km) in circumference. Geologists believe that most of this rock lies beneath the dusty desert surface, up to 8,000ft (2,500m) below. By day, Uluru is a reddish brown, but for the most stunning view, visitors should drive to the Sunset Viewing Spot to the northwest of the rock, where you can park your car and wait for the light show. In just a few minutes, Uluru changes color from yellow, to burnt orange, to a fiery red, and even purple.

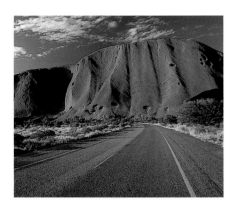

above | Uluru looms ever larger at the end of the road.

below right | Most of Kata Tjuta is out of bounds to commercial photography.

Kata Tjuta

Within the same national park, lying 20 miles (30km) west of Uluru, is Kata Tjuta, a group of 36 giant domed rocks. The highest, Mt Olga, stands 1,790ft (546m) high—more than 600ft (180m) higher than Uluru. Many people prefer Kata Tjuta because of the greater variety of shapes and the track leading to the Valley of the Winds, a mysterious ravine that magnifies the sound of the slightest breeze.

Many people want to photograph the Valley of the Winds. However, since 2000, regulations passed by the Australian parliament have made it an offense to undertake commercial filming or photography of designated areas within the Uluru–Kata Tjuta National Park without a permit. The affected areas cover nearly half of Uluru and around three-quarters of Kata Tjuta, including the Valley of the Winds. While holiday snapshots are tolerated and don't require a permit, any subsequent reproduction in a publication, on a postcard, or even as a result of success in a competition, can be deemed in breach of the law. The legislation carries a fine of $A5,500 and can be applied retrospectively. In 2003, a photograph of the Valley of the Winds by film director Wim Wenders was withdrawn from exhibition at a leading Sydney art gallery, even though it had been taken in 1988.

i

Historical background >>> Although known to the Aborigines for thousands of years, the first European settler to see Uluru was the explorer and surveyor Ernest Giles in 1872. The following year, William Gosse walked to the summit of Uluru and claimed it for the Governor of South Australia, Henry Ayers. Ayers Rock became Uluru in 1985 when ownership was handed back to the Anangu Aborigines, who promptly leased it back to the Australian government. Today, the government and the Anangu jointly administer Uluru and Kata Tjuta.

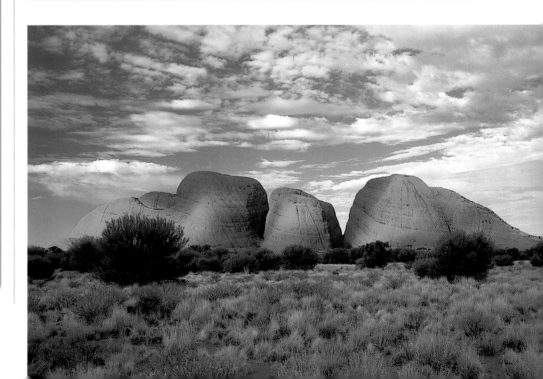

48 location > **Empty Quarter**

country > **Arabian Peninsula** | when to go > **Nov–Feb** | focus on > **sand dunes**

The Empty Quarter is a baking expanse of sand stretching nearly 620 miles (1,000km) across the eastern region of Saudi Arabia into neighboring Oman and the United Arab Emirates to the north. There is more sand in the Empty Quarter (or Ar Rub'al Khali, to give it its Arabic name), both in volume and surface area, than anywhere else on earth. Venturing into the Empty Quarter is not to be taken lightly—sand temperatures can reach 80°C—and apart from the extreme heat, blinding sandstorms can last many days, leaving the traveler stranded. Yet it is these winds that give the dunes their shape and character, creating hills of sand up to 700ft (300m) high. It is an intimidating sight to see a vast expanse of sand, topped by clean blue sky with nothing else to break the horizon. In a landscape reduced to such a minimalist state of sand, sky, and silence, the wind is the modeler, creating dunes that seem to change in shape and form with each passing day.

In such a setting, there's no need for haste. A photographer can set up a tripod without distraction and compose with care and purpose. The light of early morning and the hour before sunset provide long shadows that clearly define the subtle textures of these surfaces. At these times, the sky bears a warm light complementing the color of the dunes.

The light of each day bears a consistency and clarity that only a dry and unpolluted atmosphere can provide—ideal for making accurate exposures with little call for filters.

> "As one looks out from the summit of a dune the feeling of grandeur and remoteness is overwhelming."
>
> From *Wilderness Oman* by Malcolm MacGregor (2002)

Essential kit

⊕ Protecting your camera gear from the sun and sand should be your first priority, so when you are not using your camera keep it in a **well-sealed bag** or **rucksack**, preferably one made of insulating materials.

⊕ **Lens hoods** will protect your lenses from flare.

⊕ A **UV** or **skylight filter** will at least protect the front lens element from being scratched by airborne sand.

⊕ Instead of a polarizer, a **neutral density graduated filter** is more useful in these conditions as it will help temper an overly bright sky.

⊕ Because pictures here are more about placing lines and shapes for a pleasing composition, working with your camera on a **tripod** will ensure greater success.

left | In the Empty Quarter, the landscape never stays the same. With no rocky base to hold them, these giant sand dunes are constantly shifting in the wind. Although the minimalist beauty of the landscape makes for wonderful photography, travel here is a dangerous undertaking.

location > **Lake Moraine**

country > **Canada** when to go > **Jun–Sep** focus on > **reflections**

The road to Lake Moraine is open only from June to early October, but it is a road worth taking. With crystal-clear blue-green water and a backdrop of ten jagged, snow-capped mountain peaks, the view of Lake Moraine is more than a match for the better-known Lake Louise, ten minutes down the road.

In this era of digital imaging, some people find it hard to accept that the color of Lake Moraine is real. But with this fabulous viewpoint, there is no need to exaggerate the beauty of the scene.

Park in the carpark by the shores and take the short walk up the Rockpile trail. Here, the views of the lake and the Valley of the Ten Peaks are among the best to be seen in the Canadian Rockies. The lake mirrors the Ten Peaks perfectly.

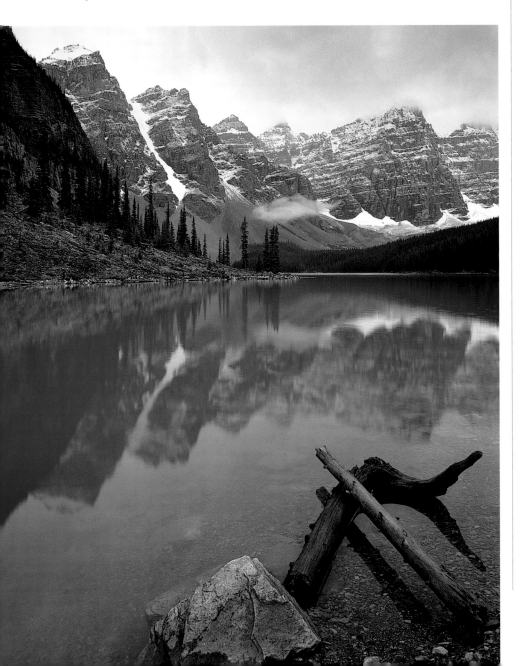

Essential kit

⊕ A **tripod** should be top of your list. The air is so clear and the color so pristine, you must keep your camera absolutely still in order to render maximum detail.

⊕ Use a **polarizing filter** to saturate the blue of the sky, and an **ND graduate**, say 0.3, to control any excessive brightness in the sky or off the water.

⊕ A **wideangle lens** is the most likely focal length, but use a **zoom lens** to try a number of different compositions at various focal lengths.

⊕ Wear good **walking boots** and carry your kit in a **backpack**.

left | At the end of the Rockpile trail is the ideal location for photographing Lake Moraine. The lake's calm, turquoise-blue water makes a superb reflection of the mountainous Ten Peaks backdrop.

Within the 450,000 acres (182,115 hectares) of the Torres del Paine national park are the granite peaks and rock towers that have become a favorite walking and photography destination. But the climate is volatile and the land frequently pounded by fierce winds, even in summer.

Rising more than 9,840ft (3,000m) above sea level from the plains of the Patagonian steppes, the mountains of Torres del Paine are part of the Paine Massif east of the Andean spine. They are believed to have derived their name from an ancient Indian word meaning "blue." Certainly, the lakes of this area are an intense shade of blue, but the snow-capped peaks of the Cueronos del Paine mountains tend to take on more of a magenta cast in the morning sun.

A trail in the wilderness

The park has one of the world's great wilderness walks within its boundaries—the Torres del Paine Circuit—and hitting this trail is the best way to see the natural spectacles of this region. The full-circuit walk takes about eight to ten days, so you will need a tent and enough food to sustain you. If you have less time or no tent, then a day walk on the Lago Grey hike to Glacier Grey makes a memorable appetizer. From Puerto Natales (the nearest town to the park), take a bus to the park's administration center at Lago Pehoi, which marks the starting point of the hike. From here it is possible to reach Glacier Grey in half a day. The trail leads onto the glacier snout with its cold, cracked surface and freezing blue glacier caves. This is also the first leg of the full-circuit walk, which ventures into a wide variety of terrain, through forests, across streams and bogs, and up gullies strewn with rocks.

Hundreds of people walk the Torres del Paine circuit every year and it is well signposted. Lago Paine, a small glacial lake in a mountain valley, and Lago Dickson are the next landmarks on the trail. Further on, the highest point of the circuit is a mountain pass overlooking the Ventisquero Grey glacier. The trail follows the edge of this glacier for two days and takes in a campsite near a dramatic waterfall. From here it is another few days' walk to Lago Pehoi and the administration center.

below left | The Cueronos del Paine mountains are a majestic sight in the morning light

Essential picture list

⊕ For one of the great mountain views, you can't do better than the **Cuernos del Paine mountains**—a classic example of the landscape of this region.

⊕ **Glacier Grey** is the most accessible of the Torres del Paine glaciers. It can easily be photographed in context of its surroundings.

⊕ Another accessible natural landmark is **Lago Pehoi**, with its wonderful turquoise-blue surface.

⊕ The massive **Ventisquero Grey glacier** is best seen from the mountain pass that marks the highest point of the Torres del Paine Circuit

⊕ Wildlife subjects worth watching out for are **rheas**, **Andean condors**, and **guanacos**.

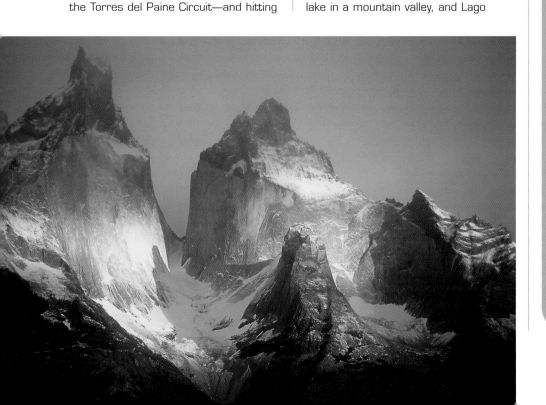

Essential kit

⊕ The best time to visit may be late spring and summer (November to March), but you should still prepare for windy, wintry weather. Pack **fleeces**, a **windproof jacket**, **thermal gloves and hat**, and wear proper **walking boots**.

⊕ Pack your **tripod** and **plenty of film** and/or **memory cards** and **spare batteries**.

⊕ A **wideangle lens** is a must and a **standard zoom** will be enough for most subjects.

⊕ For wildlife, a **long telephoto lens** and **1.4x teleconverter** will be vital.

The best view

A diversion worth taking is the day walk to the base of the Cuernos del Paine mountains. For many photographers, this is finest landscape view in all of Torres del Paine—weather permitting. If the light isn't with you, come back the following day and wait. With the inclement weather and changing cloud cover, the plus side is that shafts of sunlight break through to create a fleeting but dramatic spectacle.

For wildlife watchers, two species to look for are the rhea, a large flightless ostrich-like bird, and the guanaco, which is related to the llama.

above | One of the greatest walks in South America, the Torres del Paine draws hundreds of walkers every years with its spectacular mountain scenery, massive glaciers, icy lakes and challenging weather.

Historical background >>> In 1520, Ferdinand Magellan led a historic voyage around the tip of Cape Horn to become the first European to sail into the Pacific Ocean from the Atlantic. Until the opening of the Panama Canal in 1914, Magellan's route, through the straits that bear his name, was the only passage between the world's two biggest oceans. Magellan was also the first European to lay eyes on Chile and the southernmost extremities of Torres del Paine. He also gave Tierra del Fuego its name after spotting several fumaroles along its coast. The area remained relatively untouched by Europeans and was left to native tribes of nomads until the 19th century, when Chile established settlements at Punta Arenas and Fort Bulnes. Sheep ranches were established in the surrounding areas and the natives soon wiped out.

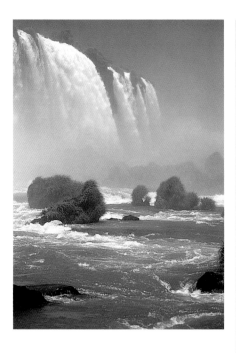

above | **There is always a constant veil of mist over Iguacu.**

below | **Some of Iguacu's 275 waterfalls.**

Iguacu Falls is made up of 275 waterfalls separated by a series of islands, marking the point where the Iguacu River plummets 984ft (300m) over the edge of the Parana Plateau. Three times wider than Niagara, Iguacu is the largest waterfall in the world, spewing nearly half a million cubic feet of water per second. With so much mist and subtropical heat, the humidity is extreme, making conditions for photography far from easy. The only sure way of keeping your gear dry is to use a waterproof housing or an underwater camera.

Assuming you don't mind getting wet in the process, photographing such an awesome spectacle poses some difficult technical challenges. For instance, the number of rainbows forming around the falls shows just how much light is being reflected and refracted, so use a polarizing filter to try to control this. The fast-moving water may make it hard for your camera's autofocus mechanism to lock, so switch to manual focus instead. In bright sun, the catchlights on the water will trick the meter into underexposing, so take a reading off a midtone, such as the ground at your feet or a patch of blue sky, and then lock your exposure setting on this.

Essential kit

⊕ It may seem somewhat futile, but plenty of **cloths to wipe your camera** dry are advisable, especially if you haven't got a waterproof housing.

⊕ A **lens hood** will help keep some (but not all) of the spray off the lens.

⊕ A **polarizing filter** will cut out the glare and catchlights on the water that form on a day in full sun.

⊕ Keep lens changes to a minimum, so use **two zooms** to take you from wideangle to telephoto, or a **single 28–300mm superzoom**.

⊕ The heat will drain your power quicker, so take **spare batteries**.

⊕ Take **bottled water** to prevent dehydration, and wear a **hat**.

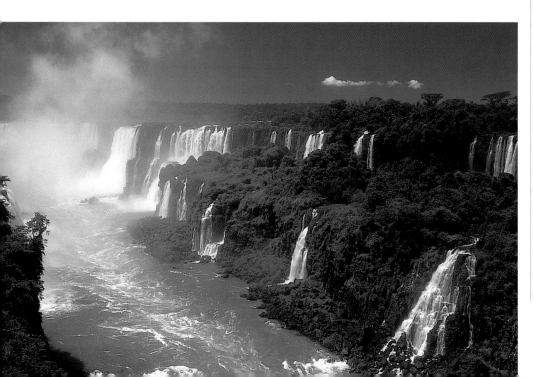

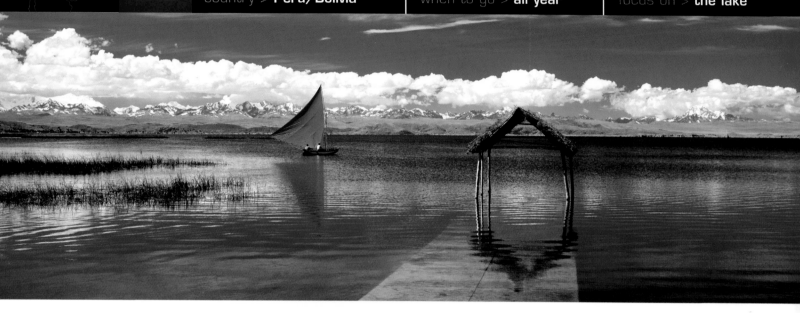

It sounds like a scene from a fairytale: a lake more than 100 miles (160km) long perched in the clouds nearly 12,000ft (3,660m) high, rimmed by snow-capped mountains and containing floating islands made of reeds. Too far-fetched? Not if it's Lake Titicaca.

This extraordinary body of intensely blue freshwater, 110 miles (175km) long and 31 miles (49km) wide, is the highest navigable lake in the world, and shares the border between Peru and Bolivia in the Andes mountain range.

Visions in blue

Lake Titicaca is like nowhere else on earth. Here, the landscape is a vision in blue, from the ultraviolet sky, to the mountains, down to the deep blue of the lake, where sailing boats are dwarfed by the grandeur of the scenery. As if the lake itself weren't isolated enough, hundreds of families of fishermen, farmers, and weavers have retreated still further to a group of islands where they continues centuries-old traditions, relatively untouched by modern tourism.

Essential kit

⊕ Give yourself the **time to acclimatize**—at this altitude, there is 50 percent less oxygen than at sea level.

⊕ The altitude means that there is a greater level of ultraviolet light in the atmosphere, so compensate by using a **81a warm-up** or **UV filter** on your lenses.

⊕ A **polarizer** will filter out any surface glare on the water.

⊕ Travel light and carry everything in a **backpack**.

⊕ Take plenty of **bottled water** as dehydration is a greater risk at high altitude.

If you have not acclimatized, the altitude will leave you short of breath, but the clarity of the air produces an extra sharpness to photographs. Lake Titicaca's islands provide a variety of perspectives, according to their proximity to the lake's edge. The floating islands of Uros, made by bundles of weeds tied together, are the most curious, but the views of the snow-covered Bolivian Cordillera from Isla del Sol (Island of the Sun) and Isla de la Luna (Island of the Moon), offer the greatest photographic potential.

For images of a unique community practicing a way of life found nowhere else in Peru, take the three-hour sailing trip to the islands of Taquile and Amantani from Puno. You will feel that you have stepped back in time.

above | Lake Titicaca is a vision of blue water set against the snow-covered mountains of the Bolivian Cordillera.

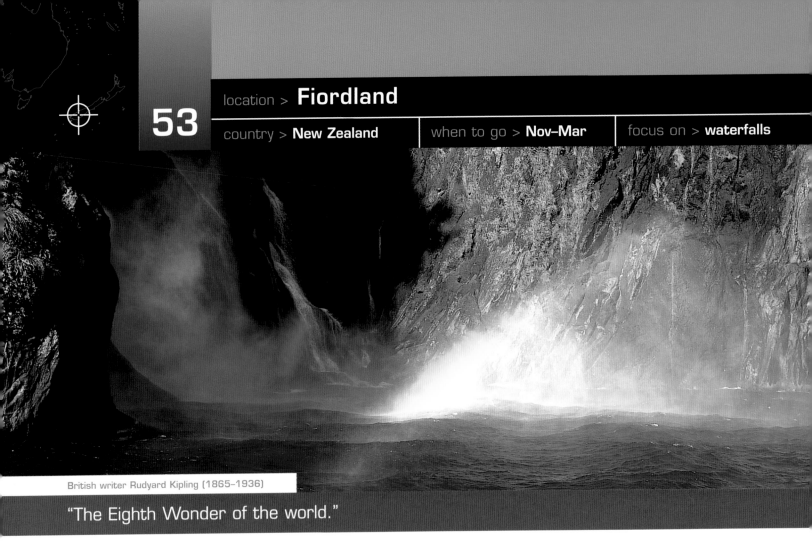

British writer Rudyard Kipling (1865–1936)

"The Eighth Wonder of the world."

Fiordland is New Zealand's biggest national park and largest area of wilderness. Situated on the southwest coast of the South Island, Fiordland covers an area of three million acres, stretching 143 miles (230km) from northeast to southwest and 50 miles (80km) across at its widest point. Only three roads run through the park, but there are many more walking trails that take in most of Fiordland's remote and rugged sights. There are several reasons why Fiordland has remained wild—it is an extremely mountainous landscape with jagged granite peaks, and the climate is one of the wettest in the Southern Hemisphere. At Milford Sound, the annual average rainfall is nearly 260in (660cm).

above | **Fiordland is a world of torrential waterfalls and unexpected color.**

Essential kit

⊕ It rains a lot in Fiordland, so take **waterproof clothing**, **boots**, and **sealable bags**.

⊕ Pack some **faster films**, say **ISO 400** or even **ISO 800**. Digital camera owners can adjust their ISO ratings for every frame without affecting overall exposure.

⊕ Carry all your gear in a **backpack** and don't forget your **tripod**.

Rainfall and waterfalls

All that rain doesn't prevent boatloads of tourists from sailing into Milford Sound on a daily basis. These cruises are the best way to see Milford Sound, sailing its 9-mile (15km) length and bringing you in close proximity to the giant waterfalls of Bowen and Stirling, as well as the pyramid-like Mitre Peak, rising out of the sea.

As well as the impressive landscape of fjords, mountains, waterfalls, and deep lakes, wildlife photographers can find several species of interest. The rarest of these is the takahe, a bird found only in New Zealand and that was thought to be extinct until it was rediscovered in 1948.

The jagged peaks of the Cuillins are perhaps the most challenging mountains in Scotland. For many visitors, a trip to the island will be their first introduction to Gaelic, a language wonderfully descriptive of the geographical features to be encountered along the way. There's Bruach na Frithe (Slope of the Forest), Bealach nan Lice (Slabby Pass), Sgurr nan Gillean (Peak of the Young Men), and the chillingly named summit: Am Basteir (The Executioner).

Although the highest peak in the Cuillins is only 3,258ft (993m), any hike to the top should not be taken lightly as the weather changes rapidly. However, it is this very unpredictability—the slate-gray storm clouds, the intense rays of sun bursting through, the soft light reflecting off the sea at dusk—that makes the Cuillins such a popular subject with landscape photographers; this, and the proximity of rugged mountain peaks to the open sea.

above | From the sea, the Cuillins appear to rise directly from the water and their summits are often obscured by thick cloud.

below | This image shows in one frame the island's primary natural attractions of mountains and crystal-clear rivers.

Essential kit

⊕ Good quality **walking boots** are an absolute must.

⊕ Travel light, especially if you're intending to climb to the top of one of the Cuillins, and carry everything in a **backpack**.

⊕ If walking, use a **monopod** that doubles up as a walking pole; otherwise, use a **tripod**, especially for dawn or dusk images.

⊕ Pack **neutral density graduates** and **81 series warm-up filters**.

⊕ Don't forget the **midge spray** if you're out in the summer months—you'll need it.

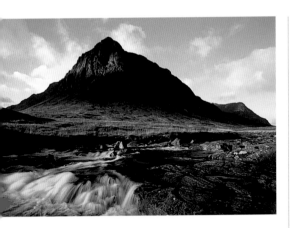

above | Buchaillie Etive Mor.

Essential kit

⊕ This is definitely a location for **wideangle lenses**. Remember to get low down and look for foreground interest.

⊕ **Tripods** and **polarizing filters** are advisable.

⊕ In late autumn or winter, with snow on the peaks and a flat gray sky producing a cold light, an **81a** or **81b filter** will help add warmth to the scene.

⊕ Wear a **waterproof jacket** and **watertight boots**, especially on waterlogged Rannoch Moor.

⊕ In summer, **insect repellent** is essential if you want to avoid being driven mad by swarms of midges.

For Britain's landscape photographers, the A82 is one of the most revered roads in Scotland, passing through Rannoch Moor on the way to those other marvels of the Highlands—the Torridon Hills and the Isle of Skye. The weather can be foul, even in summer, but because of this changeable climate there is such an extraordinary range of light that no two visits are alike.

Moody landscapes

The view of Rannoch Moor usually provokes the first decision to pull over. With the hills of Argyll rolling out to the west and a foreground of flooded peat moor packed with heather and gorse, the most photographed wild rowan trees in Scotland provide a key compositional element in this landscape. Rannoch Moor is synonymous with bleak weather, so the last thing you want here is a clear blue sky. A low sun breaking through gray clouds creates the moody lighting that has become closely associated with this scene.

Just to the north is the pyramid-shaped peak of Buchaille Etive Mor. It's hard to resist this most perfect of mountains—in height it can't compare with the grand peaks of the Alps and Himalayas, but in presence, position, and form, Buchaille Etive Mor has few equals. With the River Etive providing the foreground interest, the low wideangle view of the peak has inspired many photographers. In any season, but particularly fall and winter, it is one of the best-loved images of Scotland.

Another favorite view is of Blackrock cottage, located at the entrance to the glen. This 17th-century Highland bothy makes a focal point for a photograph while also reminding visitors of the scale of Glen Coe's physical grandeur.

Essential picture list

⊕ Before you reach the turnoff for Glen Coe, pull over and take in the view of **Rannoch Moor** looking toward **Black Mount**.

⊕ **Buchaille Etive Mor** stands between Rannoch Moor and the entrance to Glen Coe, and is one of the most perfectly proportioned Scottish peaks.

⊕ The whitewashed **Blackrock Cottage** provides a wonderful foreground to the surrounding mountains of Glen Coe.

⊕ If you fancy stretching your legs, a partial traverse of the **Aonach Eagach ridge** on the north side of Glen Coe will reward you with some of the best views in the western Highlands. Be warned: this is a steep climb and not for the faint-hearted.

⊕ **The Three Sisters** makes a very attractive landscape image, but give yourself time to walk up to the Lost Valley, a lovely spot with a haunting story.

From the A82, the turnoff to Glen Coe village passes right through the middle of this perfect U-shaped glen, the legacy of glacial action from the last Ice Age. The north side of the glen rises to the mighty Aonach Eagach ridge, a favorite traverse for seasoned hill walkers, while the southern ridge is dominated by three steep rocky buttresses known as the Three Sisters. Between two of

these peaks, hidden behind thick woods, is a mountain saddle popularly known as the Lost Valley. It was here that the survivors of the Glen Coe massacre fled from government troops in 1692. Today, you can see the furrows where the fugitive Macdonalds tilled the land while hiding from their assailants.

Loch Leven marks both the western end of Glen Coe and the end of the road from the A82. Victims of the 1692 massacre are buried on an island in the middle of the loch and the gravestones can still be seen today. From this westerly viewpoint, the sunset can promise much, providing the sky is mostly clear and the water calm enough to produce an eye-catching reflection.

Historical background >>> Glen Coe was the site of the notorious massacre of members of the Macdonald Clan in February 1692, which remains one of the most controversial incidents in Scotland's highland history. The massacre was masterminded by the troops of King William III (known by the Scots as the Hanoverians), and assisted by the Campbells, who had a history of feuding with the Macdonalds.

right | Typical of the Highland homes of the 17th century, Blackrock Cottage has become a landmark of Glen Coe and the subject of many postcards.

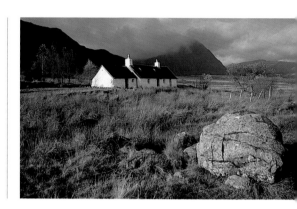

below | A fleeting wash of winter light reveals a snow covered Black Mount forming a formidable but bleak backdrop to a lonely rowan tree on Rannoch Moor.

"Cruel was the snow that fell on Glen Coe and covered the house of Macdonald."

Traditional Scottish lament

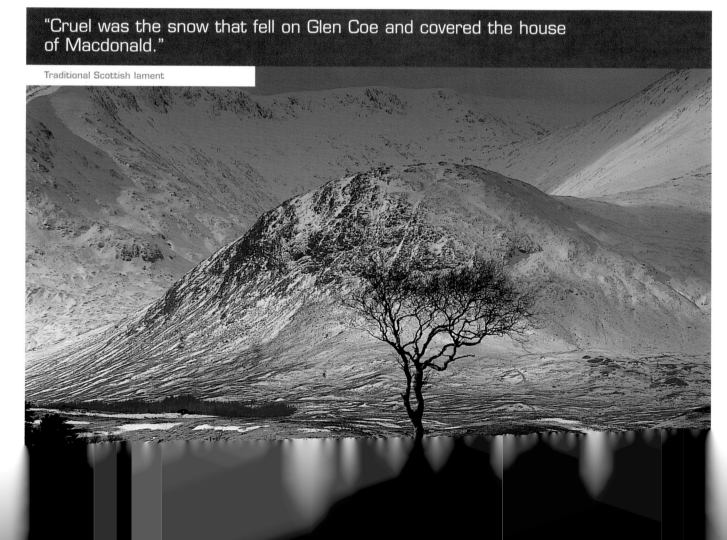

Sutherland is perhaps Scotland's best kept secret. It is sparsely populated, and large tracts of this landscape of heather-clad hills, lochs, and moors is untainted wilderness.

Wilder still are the hundreds of miles of coastline fronting the tempestuous seas of the North Atlantic. From Bettyhill and Melvich in the northeast, the coast threads its way west to Cape Wrath with its lonely lighthouse, before heading south to the busy fishing port of Kinlochbervie, and onto Ullapool, the main departure point for the Isle of Lewis. The road that follows this coast is one of the most

Essential picture list

⊕ For sandy beaches and coves, **Sandwood Bay** and **Torrisdale Sands** are two of the most beautiful locations for landscapes in Sutherland.

⊕ An isolated lighthouse, volatile weather conditions, and high seacliffs make the coast around **Cape Wrath** a dramatic setting for photography.

⊕ When the boats are in, the port of **Kinlochbervie** makes an interesting setting.

⊕ The peak of **Suilven** looks forbidding when viewed from the coastal town of Lochinver. Shoot the views of **Quinag** and **Stac Polliadh** from the ridge.

⊕ For a totally different picture, **Dunrobin Castle** on a fine day looks more like a French chateau than a Highland castle.

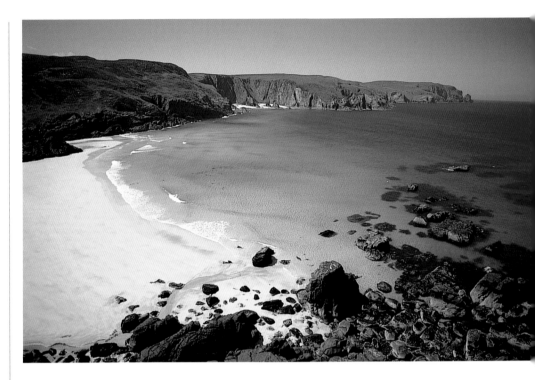

spectacular in Europe, and the journey is best enjoyed at a slow pace with many stops and detours. For example, the village of Bettyhill stands at the mouth of the River Naver, overlooking the sands of Torrisdale Bay, a viewpoint far too attractive to bypass. A few miles south is a detour following the river upstream to Loch Naver and the town of Altnaharra. From here, you can head north to rejoin the main road at Tongue, passing between Ben Loyal and the neighboring Loch Loyal on the way. Only appalling weather should prevent you from stopping along this route to make some landscape studies of classic Highland scenery.

After crossing the Kyle of Tongue, the next major natural attraction is Loch Eriboll, Britain's deepest sealoch and a haven for wildlife such as seals and otters. From here, the coast road

above | Looking toward the Cape Wrath from the beach and coast at Kearvaig.

below | The sea cliffs near Cape Wrath are the highest in mainland Britain.

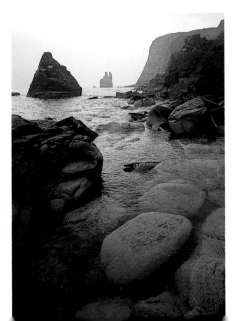

chapter three: natural wonders: landscapes

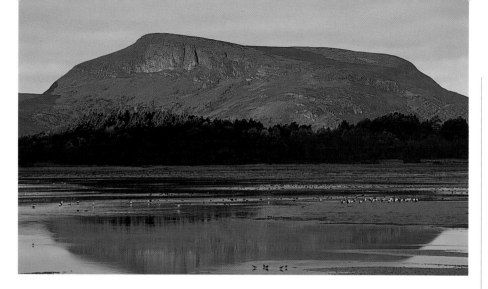

leads to Durness and Keoldale, the turnoff for a road that finishes at Cape Wrath, the most northwesterly point on the British mainland and the site of a magnificent lighthouse. Nearby are the seacliffs of Clo Mor. The weather is rarely calm, but such is the grandeur and raw beauty of this location that dramatic lighting is never far away.

Between Cape Wrath and Kinlochbervie is the delightful Sandwood Bay, a sandy northwest-facing beach, miles from any signs of civilization.

South from Kinlochbervie to Scourie, Kylesku, and Loch Assynt, the landscape is dotted with dozens of hill lochs and becomes progressively more mountainous with some lovely peaks, including Quinag, Canisp, Ben More, and Suilven.

A chateau in the Highlands

The east coast of Sutherland isn't as wild; the main road from Inverness to Caithness makes this part of Sutherland more accessible. A major landmark along this route is the chateau-style Dunrobin Castle, just north of Golspie. The gentility of the castle architecture is a total contrast to the croft houses scattered over the rest of Sutherland.

Essential kit

◈ With so much prime walking and climbing country, you will need good-quality **walking boots**.

◈ When leaving your car, carry everything in a **backpack** and take a **tripod**.

◈ Sutherland's northwest coast is spectacular, so use a **spirit level** that fits the camera hotshoe to keep the horizon level in the frame.

◈ Pack **neutral density graduates** and **81 series warm-up filters**.

◈ In the summer, mosquitoes and midges are ever-present, so take **insect repellant**.

above left | The rust-colored hill of Craig Liath mirrored in the tranquil waters of Loch Fleet.

below | The lovely beach at Sandwood Bay is a wonderful spot to enjoy the sunset over the North Atlantic.

Historical background >>> Sutherland used to support a greater population than it now does. Following the defeat of the Jacobite clans at the Battle of Culloden in 1746, the traditional clan system in Scotland was broken up, destroying the supporting social structures of small holdings and cattle droving. English and Lowland landlords, in partnership with ex-clan chiefs, forcibly moved the population so the land could be given over to more profitable sheep farming. Those evicted were either moved to small farms in coastal areas (crofts), or they were put on emigration ships to Canada, New Zealand, Australia, or the United States. Sutherland suffered more than most counties from these so-called Clearances—the daughter of the last Earl of Sutherland married an English nobleman, the Marquis of Stafford, who obtained the largest estate in Scotland. In the first 20 years of the 19th century, Stafford removed thousands of people from their ancestral homes, burning the houses and contents to the ground.

If the Great Wall is China's most recognizable landmark, then the limestone peaks of the Li River Valley in Guangxi Province form the country's most famous landscape. Stretching from the town of Guilin to Yangshuo and Xingping, these extraordinary formations rise sharply from the river and surrounding rice paddies as far as the eye can see. They are not hills or mountains, but rounded peaks of limestone eroded into shapes resembling giant termite mounds known as "karst," thickly covered in bamboo and other subtropical plants.

below | Green rice paddies stretch into a background of lumpy karst peaks covered in thick forests of bamboo.

Lush colors

Most visitors begin their sightseeing at Guilin, taking one of the official tourist boats along the Li to view the towers of karst nearest to this rapidly expanding tourist town. Taking this trip in the middle of the day, many travelers are left disappointed as the hazy sunlight overhead bleaches out much of the lush color of this landscape and heavy shadows block out the details. Instead, time your visit for early morning or late in the afternoon and venture further downstream, taking the bus to Yangshuo for the finest karst scenery.

It's worth staying here a couple of nights to give yourself the chance of photographing the landscape at sunrise and sunset and a full day to scale a couple of peaks to get the very best views. This being China, bicycle hire is easy and cheap, giving you the freedom to tour the area at your pleasure. Two peaks worth climbing in the Yangshuo area are Pantao Shan and Yueliang Shan (also known as "Moon Hill"). The views are stunning, particularly in the moments immediately after sunrise when thick clouds of mist fill the valley between the karst peaks.

Of course, to enjoy such a position necessitates a steep climb to the top, preceded by a cycle ride, both in the cold dark hour before sunrise, but it is an effort worth the undertaking. Alternatively, you could climb either peak late in the afternoon to take in the wonderful colors of sunset, but if you stay too long, you risk a tricky descent in darkness.

Essential picture list

⊕ From Guilin, board a boat to view the **karst peaks from the Li River**. Try to avoid making this trip in the middle of the day as the light won't be at its best.

⊕ Take the path to the top of one of the peaks to get an idea of their size and magnitude. **Yangshuo** makes a good base for more extensive photography.

⊕ The views from **Yueliang Shan** and **Pantao Shan** are spectacular, particularly at sunrise and toward sunset.

⊕ **Xingping** is home to cormorant fishermen. Look out for water buffalo and other images of rural China.

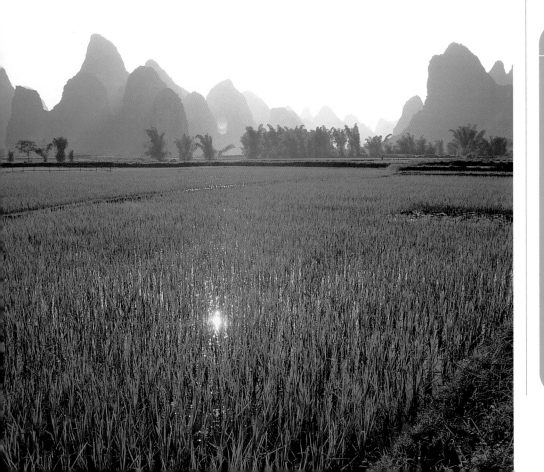

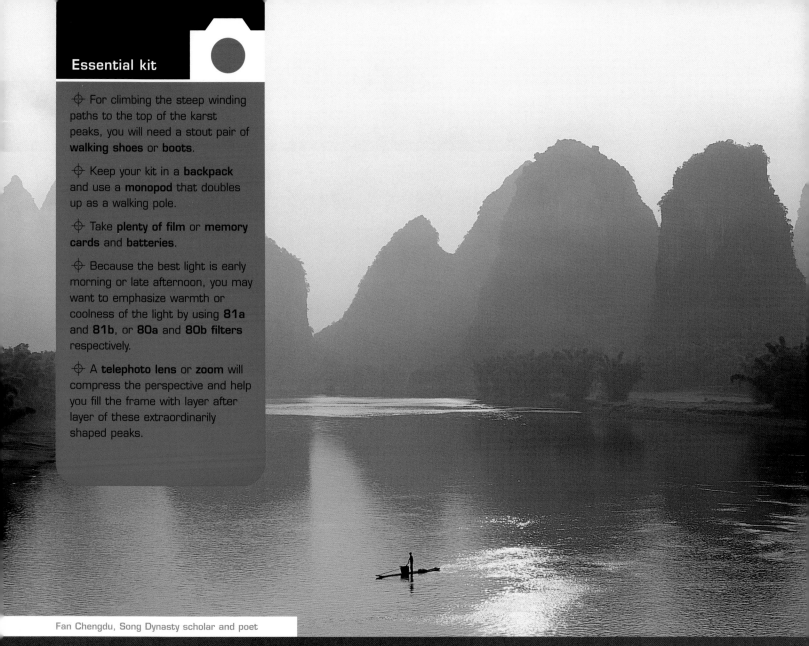

Fan Chengdu, Song Dynasty scholar and poet

"I often sent pictures of the hills of Guilin which I painted to friends back home, but few believed what they saw."

The cormorant fishermen

From Yangshuo to Xingping is just an hour by bus, and as well as more spectacular peaks lining the river, you will find a way of life that has so far defied China's rapid march into industrialization. Along this twisting stretch of river, fishermen still use cormorants to make their daily catch. As they have done for centuries, fishermen tie the throats of these slender, long-necked birds in order to prevent them from swallowing the fish that they pluck from the river. The fisherman retrieves the catch and then releases the bird to hunt again.

above | In the low light of late afternoon, a fisherman in his slender boat moves across the broad expanse of the Li River. The rounded shapes of the limestone karst peaks that line the river banks are the result of thousands of years of erosion. From a distance they seem impossible to scale, but steep flights of steps carved into the soft ground make it possible for the fit to reach the summit, with the promise of wonderful views from the top.

"The land of the fairy chimneys" may sound like the title of a children's story, but it is in fact the evocative description given to the hundreds of cone-shaped rock formations of Cappadocia, in the Anatolia region of southern Turkey. This remarkable landscape was formed after a series of eruptions from Mt Erciyes and Mt Hasan covered a huge area in ash, which later hardened to form the volcanic rock known as tufa.

Erosion over thousands of years carved out the surrounding valleys and gorges, but the "fairy chimneys" were formed when a cap of more resilient rock protected the cone of softer stone beneath while the surrounding tufa was gradually worn away.

The landscape of Cappadocia is extraordinary enough to attract attention, but what gives this area additional interest is its role in early Christian history. St Paul passed here on his way to Ankara. The Christians

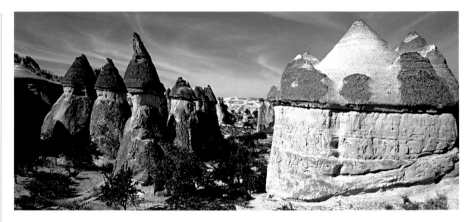

who followed him carved out their homes and chapels from the rock of Cappadocia and decorated the interiors with beautiful religious frescoes. When Arab raiding parties began incursions into the area in the 7th century, the Christians retreated further into their subterranean world, creating underground cities with many levels. One of the largest of these was Derinkuyu, with 18 stories dug into the plateau. Eight floors of tunnels are open to visitors today.

above | **Some of the "fairy chimneys."**

Essential kit

⊕ This surreal, rocky landscape of fairy chimneys is best framed using a **wideangle lens** or the **wide end of a standard zoom**.

⊕ Use a **tripod** whenever possible, even in bright sunshine, as this will enable you to stop down, add filters, and still get a sharp result from a slow shutter speed.

⊕ Most useful filters are likely to be **ND graduates** and a **polarizer**.

⊕ Wear **boots**, a **hat**, and a **backpack**.

⊕ **DO NOT use flash** for photographing the fresco interiors.

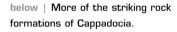

below | **More of the striking rock formations of Cappadocia.**

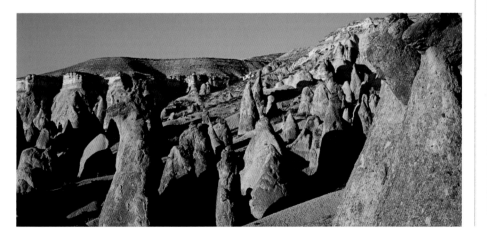

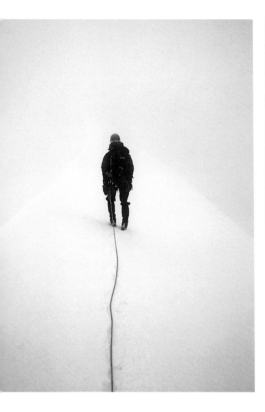

The Pamir Mountains of Tajikistan and southern Kyrgyzstan are the least visited range of high-altitude peaks on earth. They lie at the junction of three other great mountain ranges, the Hindu Kush, Tien Shan, and the Karakoram, in one of the world's most inaccessible regions.

For most of the 20th century, the Pamirs remained within the boundaries of the former Soviet Union, closed to the outside world. During the Soviet regime, the highest summits—Peak Communism, Lenin Peak, and Victory Peak (each higher than 22,965ft/7,000m)—attracted the greatest attention, primarily for propaganda reasons. The rest of the mountain range was largely ignored and unmapped. Only since the early 1990s,

Essential kit

⊕ The Eastern Pamirs is a vast mountain wilderness with no infrastructure to support tourism, so you will need to take everything to sustain yourself: **tent, sleeping bag, stove, food**, and **water bottles**, for the length of your trek.

⊕ Other essentials include windproof clothing, four-season boots, thermal hat and gloves, and **sunscreen**.

⊕ Essential camera gear includes **wideangle** and **telephoto zoom lenses**.

⊕ Filters worth packing are **UV, 81 series warm-ups**, and a **polarizer**.

⊕ There are no shops to speak of so pack plenty of **spare batteries, film** and/or **memory cards**.

above left | A climber makes his last steps on the first ascent of Mt Anatoli Boukreev

right | The Zaalayskiy Range reflected in a shallow lake of meltwater.

with the collapse of communism, has the rest of this extensive range of peaks been open to exploration. At least 50 peaks are estimated to be more than 19,685ft (6,000m) high, and many have not been climbed.

The Eastern Pamirs in southern Kyrgyzstan are regarded as the "true" Pamirs. They comprise the Murghab district and the upper reaches of the Pamir River. In this region, no point is lower than 9,840ft (3,000m). The pictures published here were taken on a Motorola-sponsored expedition in 1999, which succeeded in climbing several virgin peaks.

Trekking here, as in the rest of the Pamirs, is an onerous undertaking. Beyond the camps of nomadic shepherds, there are no paths, teahouses, or lodges, as in the Himalayas, so all travelers need to be well equipped and self-sufficient. The climate is harsh; winters are extremely cold and summers dry and hot. In the high mountains, it can snow all year round. If you do harbor ideas of visiting the Pamirs, it is strongly recommended that you trek only on an organized tour or with a local guide.

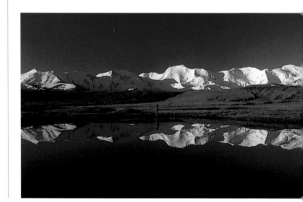

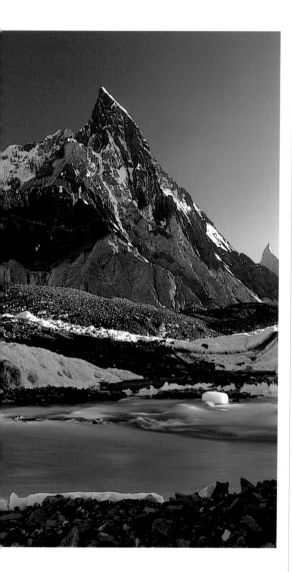

In a world of awesome mountain ranges and peaks, it is impossible to imagine anywhere with more breathtaking views than those from Concordia, in the heart of the Karakoram. It marks the point where two mighty glaciers, the Baltoro and Godwin-Austen, converge, providing a natural stopping point for climbers intent on ascending one of the mighty summits beyond.

Essential kit

⊕ First and foremost is suitable clothing: **down jacket**, **thermal gloves and hat**, **four-seasons sleeping bag**, and **boots**.

⊕ Take **sunscreen** and a **bottle for water**—drink plenty.

⊕ Essential camera gear includes **wideangle lens**, **telephoto zoom**, and **tripod**.

⊕ Useful filters include **UV** and **81 series warm-ups** to counter the blue cast that you get at altitude with the extra ultraviolet light. **Neutral density filters** will help control exposure variance in high-contrast conditions. Used properly, a **polarizing filter** has benefits too.

⊕ Take plenty of **spare batteries** and **more film than you think you will need**. Take **extra memory cards** for digital cameras.

A legend in the mountains

For trekkers, Concordia is an objective in itself. A ring of formidable mountains surround you, including Broad Peak, Golden Throne, Mitre Peak, Gasherbrum IV (with the rest of the Gasherbrum family lying behind), and the legendary K2, the world's second highest mountain. Wherever you look, there is a scene of extraordinary grandeur. There's no need to rush for the tripod: absorb it all first.

This staggering scenery is the culmination of one of the world's great treks, taking around eight to ten days, from the village of Askole, beyond the Karakoram Highway. You begin your trek through hot, barren terrain. But that changes when the trek reaches the Baltoro Glacier. As you walk further up the Glacier, the enormous mountains start to close in around you, and their names are among the most evocative of the Karakoram: Trango Towers, Lobsang Spires, Cathedral Tower.

The light for photographing these mountains is best at dawn and before dusk, when the granite peaks glow yellow-orange. However, when summits

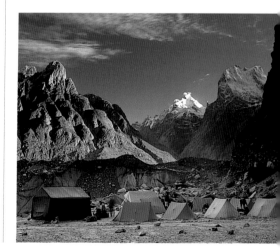

above | The gray, pointed form of Mitre Peak makes a stark contrast to the pale blue water of the glacial stream flowing across the foreground of this picture.

right | A campsite on the Baltoro Glacier lies in shade while the sun lights up the granite face of Uli Biaho.

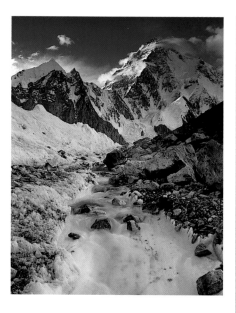

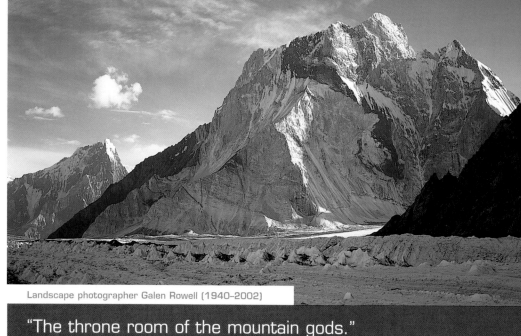

Landscape photographer Galen Rowell (1940–2002)

"The throne room of the mountain gods."

Essential picture list

✛ The obvious images are those mountains nearest to you, notably **Broad Peak**, **Mitre Peak**, and **Gasherbrum IV**.

✛ Take some **wideangle shots of Concordia** with your campsite and the mountains behind in order to show everything in context.

✛ Look at the **glacial streams and edges** of the **Baltoro** and **Godwin-Austen Glaciers**. See how they can work as foreground to mountain images.

✛ For the best **views of K2**, make an excursion to **Broad Peak base camp**.

✛ Concordia is completely surrounded by magnificent mountains, so why not make a **360-degree view** by taking a series of pictures from one spot, moving around in a circle, being careful to overlap slightly. Digital scans can be stitched together using PhotoShop, or your camera may have its own supplied software to do this.

are getting the first or last light, the lower slopes and valleys are in shadow, so there will be a wide variance in exposure readings for the scene.

Upon reaching Concordia, trekkers can make trips to the base camps of Broad Peak, K2, and Gasherbrum, for more spectacular views. Broad Peak base camp gives the best views of K2. Try using a wideangle lens and find foreground interest to lead the eye to the mountain in the top half of the shot.

Mitre Peak

It might sound absurd to single out a mountain to photograph in Concordia. Mitre Peak, at 19,770ft (6,025m), might be a midget compared to K2, but its close proximity to Concordia and distinctive summit gives it a far more imposing presence to capture on film.

above left | A stunning view up a meltwater stream on the Godwin-Austen Glacier to the summit of K2.

above | The mighty Marble Peak towers above the Godwin-Austen Glacier. Mitre Peak is on the left.

Historical background >>> Rising 12,000 feet above the wide Concordia glacial field at the head of the Baltoro Glacier is K2, the world's second highest mountain. It is the only major peak to have the surveyor's original notation as its common name. The mountain was first surveyed in 1856 by T.G. Montgomerie, a young lieutenant in the Royal Engineers, who was responsible for organizing Britain's survey of Kashmir. He first saw K1, the 'K' standing for Karakoram, which later became Masherbrum, the local Balti name for the mountain. K2 was the second peak listed in the Karakoram by Montgomerie, and although the Balti called it Chogori, K2 has survived as the name of choice. After failed attempts in 1902, 1909, 1934, 1938, 1939 and 1953, K2 was conquered in 1954 by two Italian climbers.

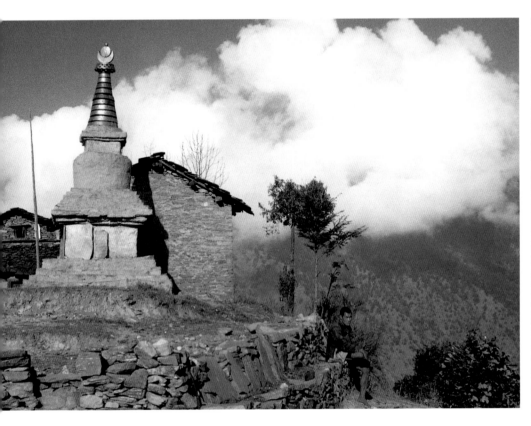

Essential picture list

⊕ The view of **Mt Everest from the top of Kala Pattar**, rising above the formidable peaks of Lhotse and Nuptse, is a must.

⊕ Opposite Tengboche Monastery rises the sublimely beautiful mountain of **Ama Dablam**. Wait till late when it is catching the last light of the day.

⊕ Include **examples of Tibetan Buddhism**, such as chortens, prayer flags, and mani stones, as compositional elements or as individual subjects.

⊕ Commercial treks employ many **porters and Sherpas**, as well as yaks. Together they form a long line of support down the trail as you trek. Frame this scene to show the size of the undertaking, and take some group portraits too.

⊕ The **Middle Hills**, with their lush forests of rhododendron, churning mountain rivers, and village life, provide a great contrast to the high-altitude scenery.

chapter three: natural wonders: landscapes

"Because it's there." That was British mountaineer George Mallory's explanation in 1924 to explain his reason for climbing Mt Everest. Mallory never got to the top—he perished on the mountain's northeast ridge—but his succinct summation of the motive that draws people to the slopes of the world's highest mountain is now entrenched in the climber's lexicon. Even though it was conquered in 1953, the lure of the Everest has not weakened. Every year, thousands of people trek through the hills and valleys of Solu-Khumbu to glimpse its legendary form—because it's there.

When Sir Edmund Hillary and Sherpa Tensing Norgay became the first people to reach Everest's summit in 1953, they could not have known how their deed would transform the fortunes of Nepal. Up till then, the mountain kingdom was virtually unknown to the outside world. Today, such is the popularity of trekking to Everest Base Camp that the main trail through central Nepal is jokingly referred to as "the Solu-Khumbu Highway."

Starting the trek
For most people, the Everest trek begins at Jiri, a small village easily reached by bus from Kathmandu, Nepal's capital. Others cut six days out of the trek by flying to the short-takeoff-and-landing (STOL) airstrip at Lukla, but the price of such convenience is to miss out on many remote villages and a

top left | Buddhist stupas and lines of mani stones become a familiar sight the further you venture into the Khumbu.

right | The impressive sight of Mt Everest, the goal of thousands of trekkers who walk the "Solu-Khumbu Highway" each year to see the world's highest mountain.

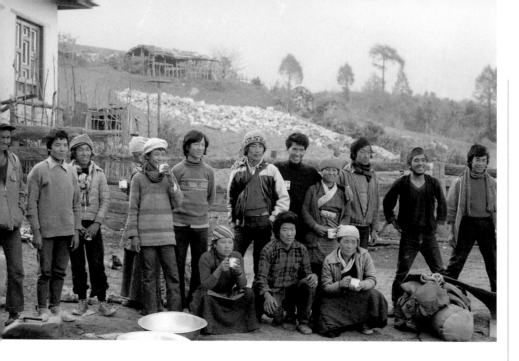

stunning variety of scenery. While it is possible to make this trek individually, carrying your pack on your back and staying at the numerous teahouses and lodges that line the route, most people choose to join a commercial trek from Kathmandu. Teams of porters carry the trekkers' loads as well as other equipment needed for the journey, leaving you free with your daypack of camera gear, clothing, and water, to enjoy the diversions and experiences of what lies ahead.

above | A party of Sherpas and Sherpanis enjoy a drink after completing another successful Everest trek. Trekking is the mainstay of the local economy in Solu-Khumbu.

"Mt Everest is very easy to climb, only just a little too high."

André Roche (1953)

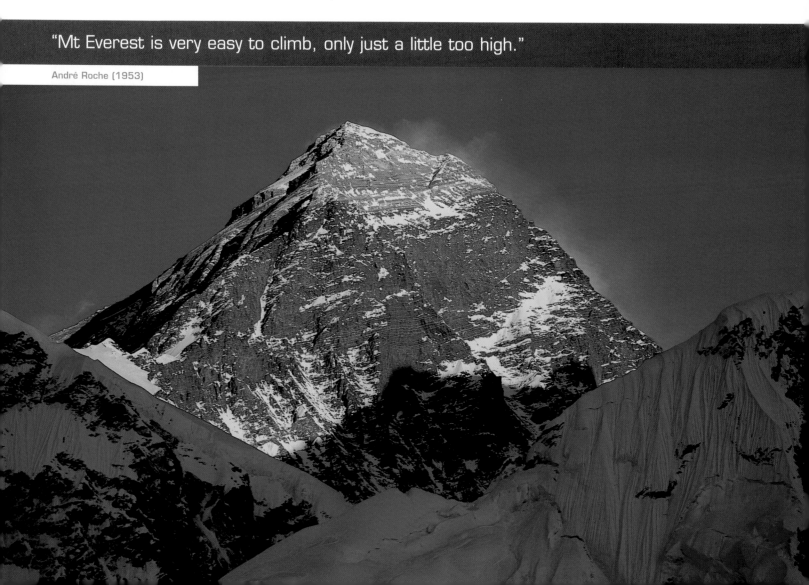

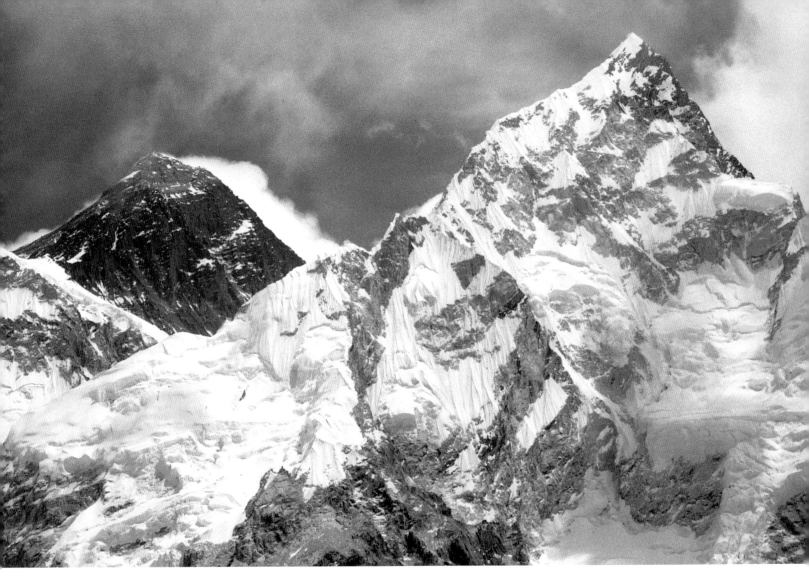

Although modest in height, the constant routine of ascents and descents while crossing the Middle Hills is perfect preparation for the higher climbs to come. The landscape is lush, with great forests of fir, bamboo, and spruce. One of the most memorable sights of this region occurs in early spring, when forests of rhododendron burst into flower, many of the trees up to 30ft (9m) high. With the snowmelt, the rivers churn with white water. This land is home to mountain clans such as the Tamang, Rai, Gurung, and Chetri, and their villages cling to the hills with slopes of terraced fields growing crops of corn, millet, barley, and buckwheat.

At Monju, the trail enters the Sagarmatha National Park, and by this point you are in Khumbu, homeland of the Sherpas. The forests begin to thin out and the trail becomes punctuated by Buddhist chortens (reliquaries), mani stones carved with prayers, and prayer poles. From this point, you may get your first glimpse of Everest.

Just out of the village of Jorsale is the Dudh Kosi River and the Hillary Bridge, the longest suspension bridge in the Khumbu. On the other side, the trail leads downhill before changing direction abruptly and ascending steeply to the Sherpa "capital" of Namche Bazaar.

Because Namche is near the landing strip at Lukla, it serves as a terminus for trekkers in the Khumbu. The influence of Tibetan Buddhism is everywhere, from the architecture of the houses and lodges to the colorful prayers flags and chortens that hang from poles and lines suspended between buildings. The flags feature the five elemental colors of Tibetan Buddhism: blue for air, white for water, red for fire, yellow for earth, and green for consciousness.

Closer to Everest

From Namche, the scenery develops a dramatic intensity that rises with the proximity of the mountains. A favorite stop of many trekkers en route to Everest is Tengboche Monastery. At an altitude of around 14,000ft (3,270m), it sits beneath Ama Dablam, one of the most beautiful mountains in Nepal. You are also much closer to Everest, with a clear view of its pyramidal head rising above the Lhotse-Nuptse face. At this height, altitude sickness begins to have an effect on expedition numbers, forcing some trekkers to stay behind and

recover in the sanctuary of Tengboche while their colleagues continue to Everest Base Camp's city of tents.

The high point for most trekkers is the view of Everest from the summit of Kala Pattar. At an altitude of 18,192ft (5,623m), Kala Pattar is considerably higher than anything in Europe, but compared to the surrounding peaks of this part of the Himalayas, it is an unattractive pile of rock and scree. However, the views are truly spectacular, and with a modest telephoto zoom you can make frame-filling shots of Everest and its neighboring giants of Nuptse, Lhotse, and Pumori. From Kala Pattar, it is a short walk to Everest Base Camp and the treacherous Khumbu Glacier. This is as close as you can get to Everest without actually climbing the mountain.

opposite page top | Everest (left) as seen from the summit of Kala Pattar. The mountain in the foreground is Nuptse.

opposite page below | Three Sherpanis rest on Kala Pattar.

above | Yaks resting in the grounds of Tengboche Monastery, before rejoining a trek in the high Himalayas.

Essential kit

⊕ Do not burden yourself, because the thin atmosphere in the higher altitudes of the Solu-Khumbu will sap your strength. Pack a **single camera body** and **a few lenses**. Zooms will give you most flexibility. Include a **telephoto zoom** for the high peaks, but a **wideangle** is likely to get most use.

⊕ **Lens hoods** will help cut flare.

⊕ Strong **walking boots**, **thermal, windproof outer clothing**, **hat**, and **water bottle** are essential.

⊕ Take **glacier glasses** for the highest parts of the trek to avoid snow blindness.

⊕ **Fine-grained film** and a **lightweight carbon-fiber tripod** are advisable.

⊕ Essential filters to take include **UV**, **polarizer**, and **ND graduates** (0.6 if you were to single out one).

Historical background >>> The Himalayas mark the point of contact of two colliding continental plates, and the mountains are still rising as a result. Since 1999, Everest's official height has been 29,035ft (8,850m). The mountain is named after Sir George Everest, the 19th-century British surveyor-general of India, but the Sherpa name, Sagarmatha, and the Tibetan name, Chomolungma, are gaining favor in the West. The first attempts on the summit were made in the 1920s. Solu-Khumbu is an abbreviation for two neighboring regions of Nepal taking in the highest part of the Himalayas and stretching south to the Middle Hills of central Nepal. Tengboche Monastery is the most important religious site in the region. In the mid-17th century, a Buddhist high priest, Lama Sangwa Dorje of Khumbu, declared Tengboche to be a religious site that would one day be the site of a monastery. It was not until 1923 that a reincarnation of the llama built the monastery at the confluence of the Dudh Kosi and Imja Khola rivers. The current monastery was rebuilt after a fire in 1989.

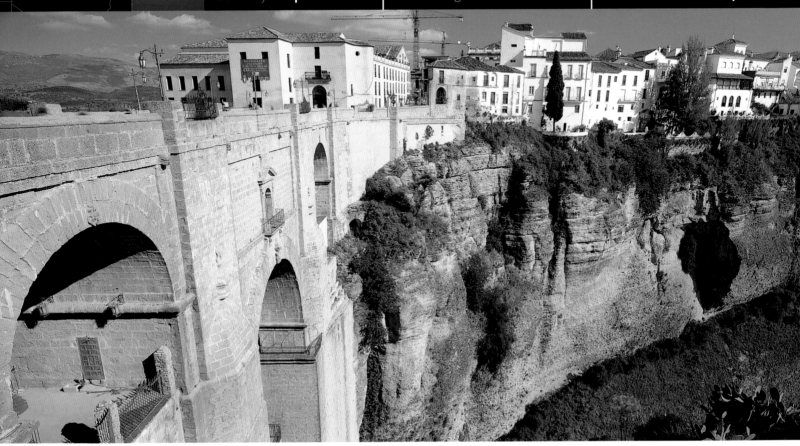

Andalucia is the southernmost region of Spain. Its landscape was shaped by the Moorish settlers who came to Spain in the eighth century. The Moors irrigated Andalucia's dry terrain and created sumptuous water gardens in every city and town that they conquered. Their legacy can be seen across this region in the wonderful blend of architecture, olive groves, and vines.

With one of the sunniest climates in Europe, the play of light on land and building makes Andalucia a wonderful place for photography. There's no better place to start than the heart of Moorish Spain: Córdoba. The city's principal monument is La Mezquita (the Great Mosque), built by the Moors soon after their arrival in 711CE, but converted

above | In the province of Malaga lies Ronda, a fine example of how Andalucia's towns and villages have been shaped by a variety of influences. Here, the Puente Nuevo makes a dramatic viewpoint.

Historical background >>> The most profound influence on Andalucia began in 711CE, when the Moors, a mixed race of Berbers and Arabs, invaded southern Spain from Morocco. For the next 700 years, they ruled over most of the country until they were ousted by the Christian reconquests in 1492. Much of the Moors' architectural legacy survives in the mosques, palaces, and gardens of Andalucia's major cities of Granada, Córdoba, and Seville. The term *mudéjar* refers to Spanish buildings built by Christians or Jews in a Moorish style, sometimes long after the defeat of the Moors. Another long-lasting legacy of Moorish Spain is the irrigation channels that give life to the fruit trees, olive groves, and vines that color so much of Andalucia's landscape.

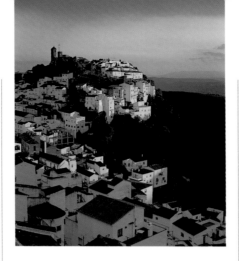

into a cathedral following the Christian reconquest in the 13th century. Inside, the atmosphere of the former mosque still resonates thanks to the white and red marble arches and columns.

For many, the archetypal Andalucian landscape consists of a whitewashed village (pueblo blanco) nestling on a hilltop in the Sierra de Ronda, in the southwest of the region. Ronda is dramatically divided by the Gualalevin River and is perfectly situated for visiting the towns of Olvera, Grazalema, and Setenil. Amid the neat rows of olive groves and orange trees, these towns provide a splash of concentrated white on a sunburnt landscape.

Olvera is notable for its large church, which forms a pinnacle over the town; Grazelama from a distance looks like a tangle of terracotta roofs tumbling down the hillside; and Setenil dazzles with its whitewashed walls and windows forming rickety lines along twisting alleys. East of the Sierra de Ronda, near Antequera, fields and hillsides are covered in patterned rows of almond, avocado, olive, and orange trees.

West of Granada rises the mighty Sierra Nevada mountains. Trevélez is the highest village in Andalucia. Behind it rises Mulhacén, Spain's highest mountain. Locals claim that on a clear day you can see Morocco from its summit. Such a view serves as a fitting reminder of the source of much of Andalucia's cultivated beauty.

Essential kit

⊕ Light is plentiful in this part of Spain, so low ISO ratings on digital cameras and slow film stock—ISO 50 or 100—will be ideal.

⊕ Use a tripod wherever possible.

⊕ Your main lens selection will range from wideangle through to short telephoto.

⊕ Essential filters include neutral density graduates, a polarizer, and 81 series warm-ups.

⊕ The wide vistas of the Andalucian landscape make it a wonderful location for panoramic cameras.

Essential picture list

⊕ The mosque of La Mezquita in Córdoba is a reminder of the architectural aesthetic that the Moors brought to Andalucia.

⊕ In the Sierra de Ronda, photograph the white towns of Olvera, Setenil, and Grazalema from a distance so that you can place them in the context of the surrounding countryside and farmland.

⊕ Look for rows of olive groves, orange trees, and other fruit trees and use these parallel lines as lead-in lines for your pictures.

⊕ The Sierra Nevada is the backdrop to many Andalucian landscapes. Trevélez is the highest village in Andalucia and Mulhacén the highest mountain in Spain.

⊕ South of the Sierra Nevada is another mountain range, Las Alpujarras, where unspoilt villages are still linked by centuries-old mule trails.

above | Casares, lit by the setting sun.

below | Rows of olive groves near Olvera.

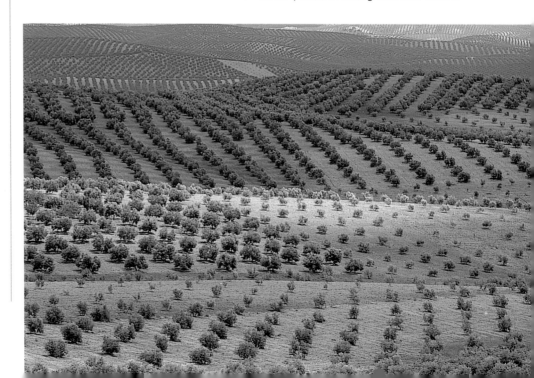

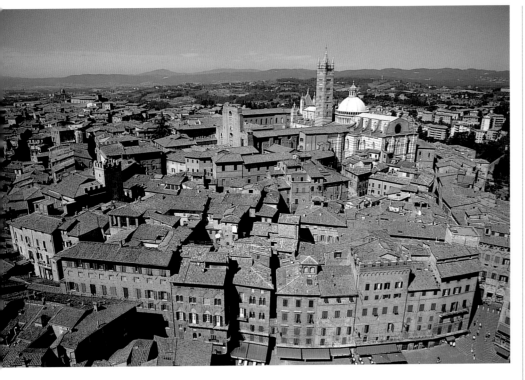

Essential picture list

⊕ Making a picture that depicts the shape and size of Siena's main square, the **Campo**, isn't easy, but the view from the Palazzo Pubblico bell tower is well worth the climb.

⊕ **San Gimignano**, **Montepulciano**, and **San Miniato** are among Tuscany's finest hilltop towns. Each has a distinctive architectural feature, making them visible for miles around.

⊕ For one of the most famous dawn views in Tuscany, head to the **Val d'Orcia**.

⊕ **Florence** is one of the most photogenic cities in Europe.

The Tuscan landscape has entranced artists for centuries. The undulating hills, narrow winding roads, hilltop towns, olive groves, vineyards, and sentinel-like cypress trees create a harmonious scene without equal in Europe. Here, the impact of humankind has been sympathetic to nature; farm buildings of local stone and terracotta roofs match the earthen colors of the land, which is prized more for its arable qualities than as a site for development.

The towns of Tuscany are rich in Renaissance art, history, and architecture; Florence, Siena, Lucca, Montepulciano, and San Gimignano all have enormous appeal for the photographer, the more so since severe restrictions were imposed on the movement of cars in their historic centers.

Siena and San Gimignano

For a city of its size, Siena is remarkably well preserved. The great rival to Florence as Tuscany's most influential city at the time of the Renaissance, Siena has changed little since medieval times. Its main square, the Campo, is dominated by the grand 14th-century Palazzo Pubblico (Town Hall) with its 320ft (97m)-high bell tower. The Campo is a huge space; standing in the center, looking out at the substantial facades of the surrounding buildings, feels like being in an amphitheater. In a way, you are; twice a year, in early July and mid-August, this square becomes the setting for the famous Palio, a horse race that has taken place for centuries with representatives from the city's 17 districts vying for victory.

left | A view over Siena, from the top of the Palazzo Pubblico bell tower.

below | The cypress tree, such as this pair in farmland near Montisi, has become an iconic feature of rural Tuscany.

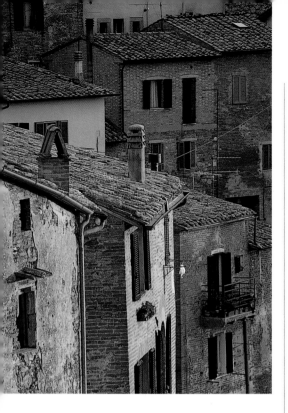

above | **Rooftops in a Montepulciano street are lit by the last rays of the day.**

below | **Farmland just before sunset.**

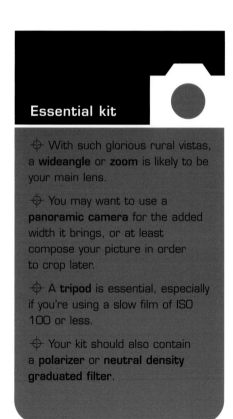

Essential kit

⊕ With such glorious rural vistas, a **wideangle** or **zoom** is likely to be your main lens.

⊕ You may want to use a **panoramic camera** for the added width it brings, or at least compose your picture in order to crop later.

⊕ A **tripod** is essential, especially if you're using a slow film of ISO 100 or less.

⊕ Your kit should also contain a **polarizer** or **neutral density graduated filter**.

San Gimignano is probably the most famous of Tuscany's hilltop towns. As you approach, its bold stone towers break the skyline and fascinate the viewer more the closer you get. The narrow cobbled streets, formidable walls, and stone buildings have stood for centuries, the only change being the fashions of the tourists who flock here. For uninterrupted shots, either visit out of season or arrive in the first hours of morning when the light adds warmth to the fabric of the town.

May and September are the most pleasant months to visit Tuscany. In May, the landscape is blooming, trees are fully leafed, and the meadows sprinkled with poppies. September retains the warmth of summer, but adds the rich colors of the harvest.

The Val d'Orcia

One of Tuscany's most famous landscape views is to the south of Siena: the dawn vista across the Val d'Orcia, near Bagno Vignoni and San Quirico d'Orca. Here, the combination of cypress trees, morning mist, and a perfectly positioned hilltop residence known as The Belvedere, provide a quintessentially Tuscan scene, a favorite for many professional photographers.

location > **Varanasi**

country > **India** when to go > **Mar–Jul** focus on > **Hindu ritual**

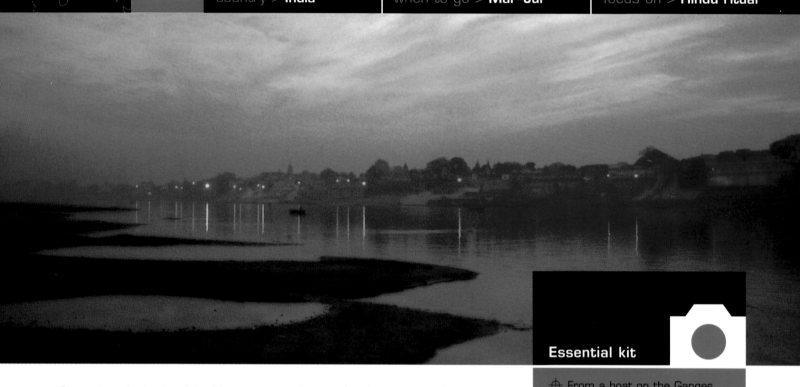

chapter four: spiritual centers

Situated on the banks of the River Ganges, the most sacred river of the Hindu faith, Varanasi is visited by millions of pilgrims each year, who come to worship and cleanse themselves in the muddy waters. They also come to die—a fact that confronts the visitor seeing for the first time the constantly smoking funeral pyres of the cremated.

Varanasi hugs a three-mile (5km) stretch of the Ganges, with hundreds of ghats (steps) leading down to the water's edge from the crowded maze of narrow alleys, guesthouses, and temples. From sunrise, people edge

down to the ghats, to pray, bathe, and wash their clothes, or even to drink the waters. For Westerners, such a sight is hard to comprehend, as Varanasi's drains and sewers flow freely into the river, which also bears the occasional corpse on its journey to the next life.

A river journey

The best way to see life on the Ganges is to hire a boat and row downstream, looking across to the ghats. Sunrise is the best time for photography, with the rising sun casting a warm orange light onto the temples by the river, the light

top | As evening falls on the River Ganges, the lights of Varanasi are reflected on broad expanse of India's holiest river.

left | A man washes in the river at one of the city's ghats.

Essential kit

⊕ From a boat on the Ganges, **telephoto zoom lenses** are ideal for photographing the sunrise and all the activity around the ghats. A suitable focal range would be 75–300mm.

⊕ In the city streets and alleys, you will need to switch to a **fixed wideangle** or **zoom lens** of around 21–35mm.

⊕ An **81a** or **81b** warm-up filter will make colors a touch richer, while a **neutral density graduated filter** helps to reduce the glare of a burnt-out sky in a high-contrast scene.

⊕ The air is full of dust and smoke, so pack **lens wipes** to clean your camera and lenses each day.

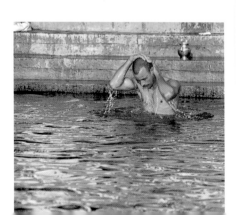

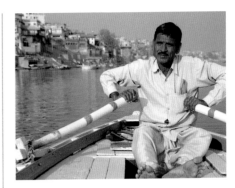

Historical background >>> Varanasi is one of the world's oldest cities, having been the site of continuous habitation for 4,000 years. It is also known as Benares, a name that was dropped when India gained independence from Great Britain in 1947. Varanasi's name is derived from two rivers, the Varuna and the Asi, which flow into the Ganges nearby. The city has always been pivotal to the Hindu faith, primarily because it is believed that any Hindu dying within its precincts will be released from the eternal cycle of reincarnation.

softened by mist and smoke in the early morning air. From the vantage of a boat, you can photograph the sunrise to the east and then look directly onto the golden ghats in the west. A telephoto zoom is ideal for picking out details, composing portraits, and recording social tableaux. Working from a boat means having to handhold the camera and therefore using a fast enough shutter speed, to avoid camera shake.

You should be aware that the ghats have different uses. Some are used for bathing, and some are "burning ghats," where cremations are performed. Photography of this ritual is forbidden.

The Old City

Away from the river, the Old City, known as Vishwanatha, is riddled with narrow, winding alleys, and packed with markets and stalls. Space is at a premium and the pace here is totally different to a

languid boat journey on the river. Pilgrims flock here to visit the Golden Temple, dedicated to Shiva.

Within the Old City's crowded streets, candid photography is an obvious recourse—look out for the colorful produce and saris of the female market traders. Wideangle and standard zooms come to the fore here.

A six-mile (10km) drive north of Varanasi is Sarnath, where Buddha began preaching around 1,400 years ago. Buddhists travel here to worship at the temples that stand adjacent to two stupas, which are said to mark the spot where Buddha gave his first sermons.

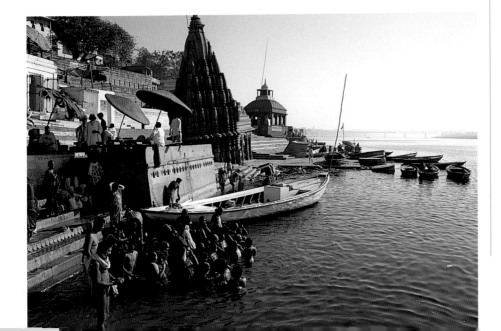

top | The best way to see life on the ghats at Varanasi is to hire a boatman to row you up and down the river.

left | The ghats on the river Ganges.

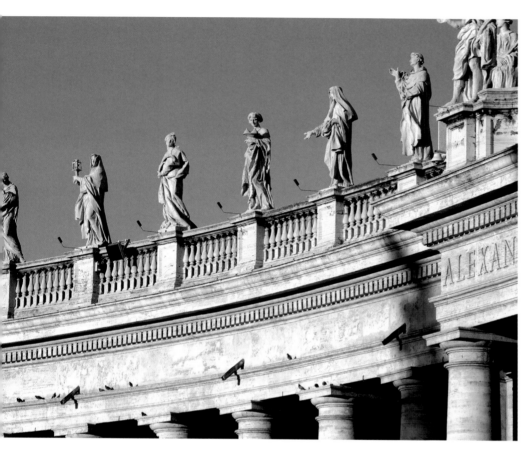

Essential kit

⊕ Take a basic kit of a **single camera body** and a **few lenses from wideangle to telephoto**. This will cover all options from vistas to candid shots.

⊕ **Fast film**—ISO 400 or 800—is necessary for The Vatican Museum and inside St Peter's, where tripods are not allowed.

⊕ Pack your **tripod** anyway; you will need it for night shots of Rome's beautifully floodlit monuments.

⊕ The city's cobblestones, steps, and stairways means that **comfortable shoes** or **trainers** are vital.

⊕ Carry your gear in a **backpack** and take some **bottled water**.

Wherever you go in Rome, there are reminders of the city's extraordinary history; there seems to be a piece of ancient Rome around every street corner. However, major sites such as the Colosseum are rarely free of crowds and to have any chance of "people-free" photography, you need to set the alarm clock very early.

As with any great city, it is easy to find yourself going only to the major sites, but Rome also offers many back streets and alleys that are home to unsung churches and piazzas. You stand more chance of getting unhurried and atmospheric photographs in these quieter locations.

top | The art and architecture of the Vatican is both lavish and glorious. These statues designed by **Carlo Maderno** decorate the facade above the entrance to St Peter's Basilica, the spiritual center of the Roman Catholic Church.

left | Wherever there is a Roman ruin, you will find broken marble columns, either upstanding or fallen to the ground. This detail is from the Forum, the great public square of ancient Rome.

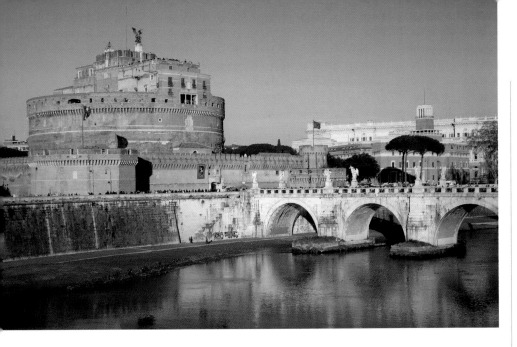

The Vatican

No trip to Rome is complete without visiting The Vatican, a separate state within the city, and home to the Roman Catholic Church. It is from the piazza that you get the best views of St Peter's Basilica and its magnificent dome, designed by Michelangelo. No tripods are allowed inside, but with fast film or a higher ISO rating for digital cameras, photography is still possible; a workable setting is ISO 800. Your best chances are in areas with the most light, such as directly beneath the dome. Look straight up and frame the dome as best you can. Alternatively, set the camera to self-timer and place it on the floor pointing up to the dome. It may not be dead center, but the camera will be perfectly still, ensuring a sharp image.

The Vatican Museum is worth queuing for; photography is allowed everywhere except the Sistine Chapel, although tripods and flash are forbidden. There is no shortage of potential subjects, but one of the most intriguing is the double spiral staircase designed by Giuseppe Momo. The classic view is taken from the top looking down to the stairs spiraling ever-inward below. A glass dome directly overhead means that there is plenty of light for photography.

left | The formidable Castel Sant' Angelo was built in 139CE as a mausoleum for Emperor Hadrian. In the 13th century, it was connected to the Vatican so the Pope could escape in time of political unrest.

above | The magnificent interior of the dome of St Peter's, designed by Michelangelo.

Essential picture list

⊕ Rome has too many ancient sites to cover in a single visit, but the **Colosseum** has to be seen for its breathtaking scale.

⊕ The **Forum** is a wonderful collection of excavated ruins including temples, monuments, and statues.

⊕ **St Peter's Basilica and piazza in the Vatican** are worth a whole day. It's not the easiest of subjects, but hugely enjoyable. Don't miss the **Vatican Museum** either.

⊕ For candid shots, as well as being a subject in its own right, spend some time at the **Trevi Fountain**.

⊕ Another good location for candids is the **Spanish Steps** in the Piazza di Spagna.

Historical background >>> According to legend, Rome was founded in 753BCE by the twin brothers Romulus and Remus, who were the sons of Mars, the god of war. They were raised by a she-wolf after being abandoned as babies. When the boys grew up, Romulus killed his brother and gave his name to Rome. It was several centuries before the birth of the Roman Empire, arguably the greatest and most influential empire that the world has seen. At its height, the empire covered the whole of mainland Europe (going as far north as Hadrian's Wall on the English–Scottish border), most of North Africa, and the Middle East. Since the fall of the Roman empire in the 5th century CE, Rome has evolved into one of the world's primary centers of culture, art, and religion.

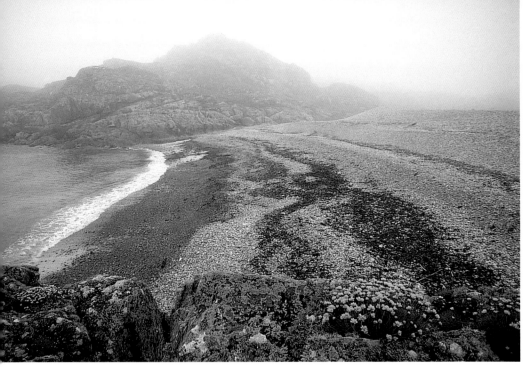

The tiny Hebridean island of Iona, only three miles (5km) long, has been a place of pilgrimage for centuries.

In 563CE, an Irish monk, St Columba, landed on the island and proceeded to convert pagan Scotland and much of northern England to Christianity. Iona then became the most sacred religious site in Europe and a center of the arts. Resident monks produced illuminated manuscripts, carvings, and Celtic stone crosses.

The present-day focus for the island's Christian community is Iona Abbey, built in the 13th century on the site of Columba's original chapel, but left in ruins after the Reformation in the 16th century. The abbey was rebuilt in the early 20th century and within its grounds is Reillig Odhrain, the sacred burial site of 60 kings of Scotland, Ireland, and Norway. St Columba's tomb lies within a small chamber adjacent to the main entrance of the abbey. You can get a view of the whole abbey complex by walking to the top of Torr an Aba, a small hill opposite the entrance.

above | St Columba landed on this beach in 563 CE. The coastal scenery of Iona has changed little since.

below | Every year thousands of people come to Iona to worship and find sanctuary at the abbey, seen here in the distance.

Essential kit

◈ The west coast of Scotland is notorious for its changeable weather, so make sure you've got a **waterproof layer** handy and a **bag** or **backpack** for your camera.

◈ Take a **tripod** and a **couple of zoom lenses**.

◈ In case of overcast conditions or mist, take a **faster film** or use **ISO 400** for digital cameras.

◈ Useful filters will be **polarizers** and **81 series warm-ups**.

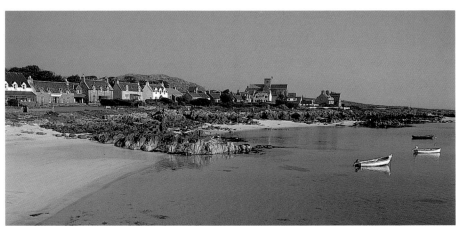

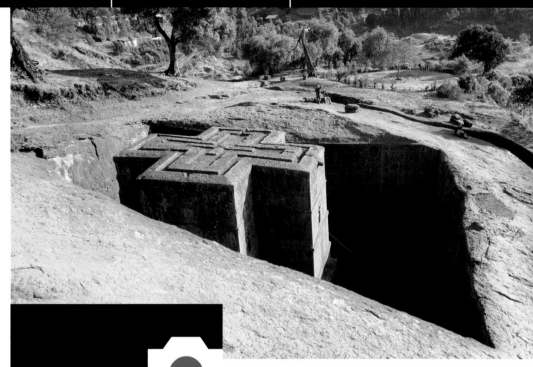

The churches of Lalibela are renowned for their austere beauty. Their origin is uncertain, but many historians have credited their construction to King Lalibela in the 12th century.

The churches were hewn out of solid rock beneath the ground, their exteriors cut and shaped first. Then, doorways and windows were carved into the new fascia, before the interiors were hollowed out of the solid structure, some several stories high.

The largest church is Bet Medhane Alem (House of the Emmanuel), and the smallest is Bet Danaghel, constructed in honor of 50 Christian nuns murdered by the Romans in the 4th century. Bet Giorgis, regarded as the most beautiful, is named after St George, the patron saint of Ethiopia. The churches receive pilgrims from all over Ethiopia and hold regular services. At Bet Maryam, the sound of monks chanting from within the earth in the darkness before sunrise is a ritual that has remained unchanged for 800 years. Each January, the festival of Timkat (Epiphany) is celebrated with a colorful festival through the streets—definitely an occasion worth photographing.

The church interiors are dim, but closer scrutiny reveals profiles of icons etched into the rock, while some walls have even been painted on. Photography in such conditions is difficult without ultra-fast film of ISO 1600 or 3200. Outside, Bet Giorgis offers the most promising image; by standing near the edge of the 40ft (12m)-deep courtyard you can look down on its cross-shaped roof and, with an ultra-wideangle lens, capture the full depth of the structure

Essential kit

◈ With deep courtyards, narrow entrances, and tunnels, you will need an **ultra-wideangle lens** for photographing in the church precincts.

◈ Inside the churches, f**ast film** (or an ISO rating for digital cameras) of **ISO 1600** or even **3200** is advisable as light is mostly from candles.

◈ Consider using **black and white film** for accentuating the mysteriousness of the atmosphere.

◈ Outside, the colors of priests' and pilgrims' robes stand out from the rocky gray and pink churches, and these can be accentuated with an **81a** or **81b warm-up filter**.

above top | Dedicated to St George, the patron saint of Ethiopia, Bet Giorgis was said to have been carved out of solid rock in the 12th century by King Lalibela and a company of angels.

above | A priest in the town of Lalibela during the Timkat (Epiphany) festival.

More than 3,000 years old and an important center for three religions, Jerusalem is a city that has been mired in conflict throughout its history. Today, the popular image of Jerusalem is of conflict, violence, and terror, yet it is home to a wealth of historic religious sites beyond compare.

The focus for most travelers is the historic Old City, East Jerusalem, where Jews, Muslims, and Christians come to worship at places of huge significance for their faiths. East Jerusalem is heavily policed, although restrictions on

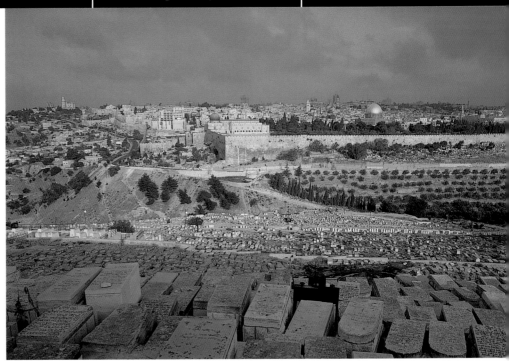

Essential kit

<div>

⊕ East Jerusalem is small enough to walk around, so do it comfortably by wearing **trainers** and not overloading yourself with camera gear.

⊕ **Wideangle** and **telephoto zoom lenses** are essential.

⊕ Pack **plenty of film or memory cards** and **spare batteries**.

⊕ Much of the city is built from pale limestone, so take **81 series filters** to add subtle warmth to the surfaces.

⊕ A **polarizer** is useful too, especially at the Dome of the Rock where its golden sphere and polished tiles are highly reflective.

</div>

movement are not as severe as those in force on the West Bank. However, that situation can change rapidly.

The Dome of the Rock

The Old City is less than a third of a square mile (1sq km) in area, and the dazzling sphere of the Dome of the Rock dominates the skyline. Built nearly 1,500 years ago on Temple Mount, the Dome of the Rock and Al Aqsa Mosque are among the most important religious sites in Islam. The blue tiled exterior walls and the brilliant gold dome give a conspicuous splash of color to the surrounding pale limestone buildings. Consequently, it is almost impossible to take a general view of the Old City without including this beautiful structure as the focal point.

The Dome of the Rock was built on the site of the first temple, erected by King Solomon when he established Jerusalem as the center of Judaism.

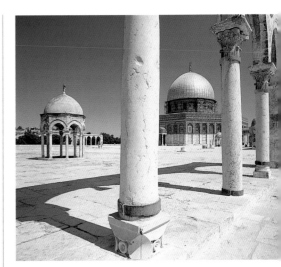

top | The wall of the Old City and the brilliant Dome of the Rock are clearly visible from the Mount of Olives.

above | The Dome of the Rock framed by arched columns on Temple Mount.

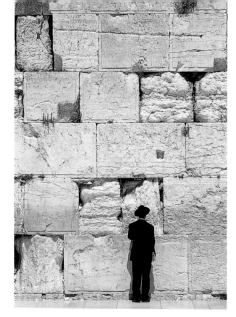

above | The Wailing Wall, the most important place for worship for Jews, is all that remains of the third temple destroyed by the Romans nearly 2,000 years ago.

below right | Even at dusk, when the heat of the day has filled the air with haze, the Dome of the Rock is recognizable from its distinctive silhouette.

Essential picture list

⊕ The **Dome of the Rock** is the most conspicuous and striking landmark in Jerusalem. Whether up close or from a distance, it makes a wonderful subject.

⊕ The views of the Old City from **Temple Mount** or the city walls are wonderful. Use a telephoto zoom to include more detail in the picture.

⊕ Walk around the **Via Dolorosa** and its adjoining streets, or the **souks in the Muslim quarter** where haggling Arab traders provide a lively scene.

⊕ Of the several old gates into the Old City, **Damascus Gate** is one of the most impressive.

Historical background >>> In Biblical times, Jerusalem was first populated by the Canaanites, and named the City of David after its capture by King David around 1000BCE. Later, King Solomon built the first temple, extended the city walls and established Jerusalem as the center of Judaism. After the temple was destroyed by Nebuchadnezzar, a second temple was built on the ruins of the first in 537BCE. The city was conquered by Alexander the Great in 333BCE and successively occupied by the Egyptians, Syrians, and Romans. In the fourth century CE, the mother of Emperor Constantine, a Christian, had a church built on the site of the crucifixion, establishing Jerusalem as the center of Christianity. In 637CE, Jerusalem was conquered by the Muslims, led by Caliph Omar, who built the Dome of the Rock on Temple Mount, the site of the first and second temples. The city remained under the control of Islam until its capture by the Crusaders in 1099. Over the next 400 years, control of Jerusalem swung between Muslims, Crusaders, and Mongol invaders until the Turks captured the city in 1517. The city remained part of the Ottoman Empire for 400 years until 1917, when British and Arab forces drove out the Turks. A UN mandate over the sovereignty of Palestine led to war between the Arabs and the Jews in 1948. The Jews were victorious, thereby securing the future of the new state of Israel, but the eastern half of Jerusalem, the Old City, remained occupied by Jordan, one of the major forces in the Arab alliance. In 1967, it was recaptured by Israel in the Six Day War.

At the foot of Temple Mount is the Western Wall, the only structure standing from the third temple destroyed by the Romans in 70CE. Popularly known as the Wailing Wall, this is the most important place for prayer in Judaism.

Christians pay pilgrimage along the Via Dolorosa, the street through which Jesus carried his cross before being crucified on a site now covered by the Church of the Holy Sepulcre.

The Old City

With three great religions sharing priceless heritage in such a small area, there is a diverse mix of people frequenting the Old City. Many are pilgrims from abroad, and while there is great potential for making candid images, you should be mindful of the religious and political sensitivities of the people around you. The Old City is divided into separate Armenian, Jewish, Christian, and Muslim quarters and each has a distinctive character.

The Muslim quarter is a maze of narrow streets and covered souks, while the Jewish quarter is a quieter, mostly residential, area. The walls enclosing the Old City were built by Suleiman the Great in the 16th century and provide an excellent vantage point for photographing views of the city. The walls can be accessed from several points, including Damascus Gate—an impressive structure that is also worth a few frames in its own right.

The Imam Square

For sheer scale, nothing compares to the Imam Square. Measuring 1,640ft (500m) by 525ft (160m), it is one of the world's largest squares. It was built as a venue for festivals, markets, and the Emperor's polo matches. The original goal posts can still be seen at opposite ends of the square.

Long walls line the four sides of the square, each marking an entrance to another prominent landmark. On the north side is the entrance to the Great Bazaar; at the south is the Imam Mosque; to the east is the Mosque of Sheikh Lotfallah; and on the west is a gateway to the Ali Qapu Palace.

Isfahan lasted only a century as an imperial capital, before an Afghan invasion forced the court to flee to Shiraz in the 18th century. However, the city built by Shah Abbas remains largely intact and is relatively unexplored by photographers.

Essential kit

⊕ The Imam Square is a vast open space, so use a **telephoto zoom** to make selective compositions instead of trying to convey the whole space.

⊕ A **polarizer** will reduce glare from the highly reflective tiles on the mosques.

⊕ Use a **tripod** wherever you can, but check whether there are any restrictions, particularly near the mosques.

⊕ An **81a** or **81b warm-up filter** will counteract any bluish cast from the tiles and add warmth to harsh shadows.

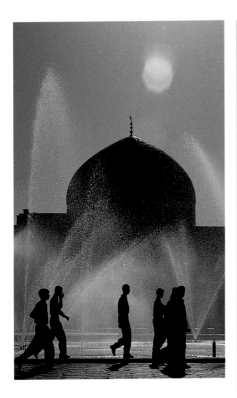

In the middle of Iran lies the former Persian capital of Isfahan. This city occupies a large oasis of trees and magnificent gardens—a striking contrast to the parched and barren landscape that lies beyond it.

Isfahan's magnificent mosques, palaces, and bridges are the work of Emperor Shah Abbas the Great, who made the city his capital in 1598. The city is fed by a river, the Zayandeh Rud, and the bridges across it are stunning examples of Islamic architecture.

above | Fountain spray creates a veil of water between a group of young men and the dome of the Sheikh Lotfollah Mosque.

right | The gateway to the Imam-e Mosque, considered to be Isfahan's greatest building, makes a magnificent study under moonlight.

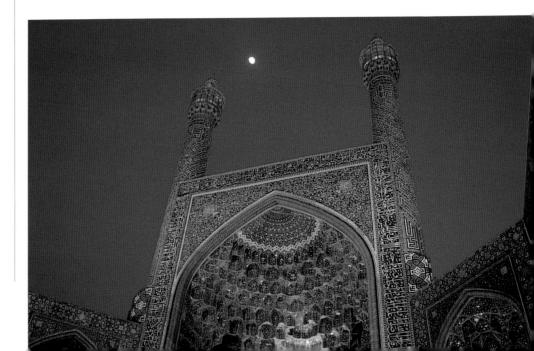

The legend of Timbuktu and the animist traditions of the Dogon people are the primary reasons for the growth in tourism to Mali. But for those who venture a little further into the country's interior, the Grand Mosque at Djenné generates the greater number of superlatives. Situated on the floodplains of the Niger River, downstream from the large town of Mopti, Djenné is home to the largest mud-brick building in the world. It may not sound like an edifying description for a mosque, but this World Heritage Site is a grand construction in every other sense.

The original mosque was built in the 13th century by Koy Konboro, the first Islamic ruler of Djenné. According to legend, he destroyed his palace and built a mosque on the site as an expression of commitment to his new faith. This building stood for 600 years until political and religious strife led to it being abandoned and falling into ruin.

The current mosque was built in 1906, based on the original design. The spikes protruding from the exterior walls are part of the framework supporting the mud bricks and give the mosque a surreal appearance. The smooth layer of mud covering the bricks is renewed after every rainy season.

Although non-Muslims are not allowed inside, the mosque looks spectacular from any part of town. Djenné is at its most lively and colorful on Mondays—market day. As well as being an alternative source of images, the market creates a great foreground to the mosque for a wideangle view.

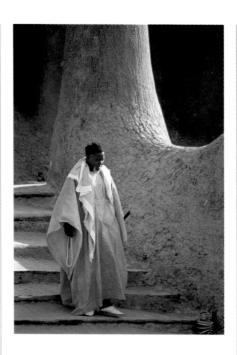

above | **A worshiper, beads in hand, leaves the mosque after prayers.**

below | **The Monday market makes a colorful foreground to the Grand Mosque.**

Essential kit

⊕ A basic kit of **one camera** and a couple of lenses—**wideangle** and **standard zoom**—will cover most possibilities.

⊕ A **polarizer** will help cut down glare and saturate the strong primary colors of the sky and the mosque exterior.

⊕ An **81b** or **81c warm-up filter** will emphasize the earthen walls while helping to retain shadow detail.

⊕ There is plenty of light for **fine-grained film** (**ISO 50** or **ISO 100** setting for digital cameras).

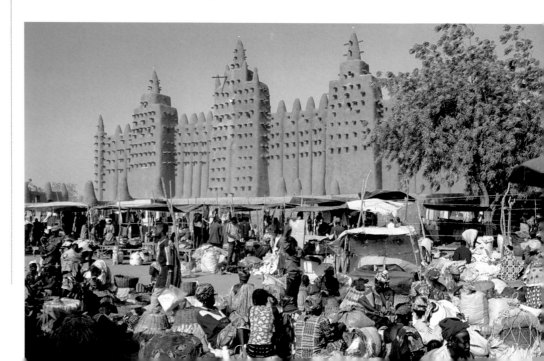

The sight of the holiest of Sikh temples casting a gilded reflection on an open pool of water more than lives up to its name. The Golden Temple (Darbar Sahib) is steeped in legends as brilliant as its exterior. The temple was built on this site because of the water's reputed healing powers. The pool is known as the "Pool of Nectar." According to the Hindu epic tale the *Ramayana*, a jug of nectar descending from heaven at this site restored to life Lord Rama's army after it had been destroyed by his twin sons, Lava and Kusa.

A shrine was built by Guru Amar Das, the third guru of Saint Nanak (The founder of the Sikh faith), on the site of this pool. It soon became a center of pilgrimage and worship and, in 1577, Guru Ram Das, the fourth guru, made his home by the pool and began construction of the current temple in the center of the pool. The task was completed by his son and successor, the fifth guru, Arjan Dev. By this time a whole new town, Amritsar, had grown around the holy site. The lavish marble inlay, gilding, and gold leaf responsible for the temple's popular name was added in the 19th century.

A place of refuge

The Sikh faith is renowned for its tolerance, and people of all faiths are permitted to reside in Amritsar. As a result, the Golden Temple has become a place of refuge as well as a center of pilgrimage. For this reason, it has a more relaxed atmosphere than other temples of the world's great faiths.

It is possible to walk right round the sacred pool to admire the exterior of the Harmandir Sahib (Inner Sanctum), so at any time of day you will be able to shoot a side that is directly lit. Even so, early morning and late afternoon produce the best lighting conditions.

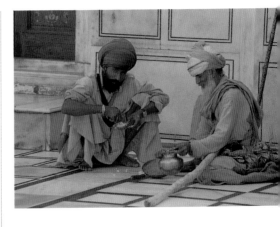

above | Two Sikhs prepare a meal on the marble court near the temple.

left | The Golden Temple photographed in the early afternoon.

Essential kit

⊕ A **polarizer** will temper any glare reflected off the water.

⊕ A **standard focal length lens** will give you the right balance of water to temple to sky.

⊕ With pilgrims, local visitors, traders, and refugees on the temple precincts, there is no shortage of human activity to photograph; a **short telephoto lens** is ideal for this type of work.

⊕ Take **plenty of film** or **memory cards** and don't forget the **tripod**.

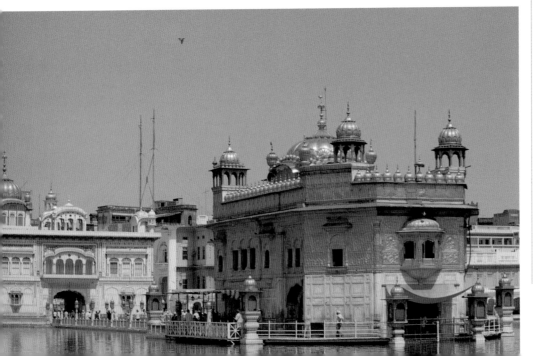

On a major bend of the Irrawaddy River in central Myanmar (previously known as Burma) lies Bagan, one of the most important Buddhist centers of Southeast Asia. The sight of this fertile floodplain, dotted with hundreds of Buddhist stupas, temples, and monasteries, is breathtaking, and the image of spiritual calm is at odds with the oppressive military dictatorship that rules this desperately poor country.

Stupas on the plain

A thousand years ago, Bagan was the capital city of the first Burmese kingdom, founded by King Anawrahta (1044–77CE). It was a thriving spiritual, cultural, and political center for 300 years. There are 2,230 buildings and mounds scattered across the Bagan plain; all were built for religious purposes except for the wall that used to surround the royal enclave.

The oldest stupas and temples are closest to the river; most were constructed in the 12th century by Anawrahta's successors. The most famous stupa at Bagan is the Shwezigon, one of five stupas built to mark the boundaries of the city. One of the king's successor's, Kyanzittha, became a builder of impressive temples, one of which, the Ananda, has been in constant use since its construction.

The surrounding countryside is flat, so the only way to obtain an elevated position to get a wide view of the temples and stupas is by climbing the steps of one of the larger buildings, such as the Dhamma-yazika stupa.

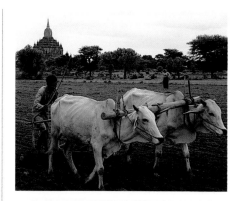

Essential kit

⊕ Bagan lies in an area of Myanmar known as the "dry zone." The weather is mostly hot and dry, so one of your main priorities will be to stay cool and hydrated—carry plenty of **bottled water**, wear a **hat**, and travel light.

⊕ The sites are scattered over a vast area and will entail a lot of walking; wear comfortable **walking boots** or **trainers**.

⊕ Pack a **polarizing filter** to reduce glare and **neutral density graduate filters** to balance exposure variance between the bright sky and shadow areas on the stupas.

⊕ Use a **tripod** wherever possible and **fine-grain film** (or **ISO 100** or less on digital cameras).

left | Myanmar is a peasant economy, and the sight of ox-plows is as much a fixture of this landscape as the Buddhist temples of Bagan.

below | To appreciate the number of stupas and temples spread across the flat plains near the Irrawaddy River, climb the Dhamma-yazika stupa for this view.

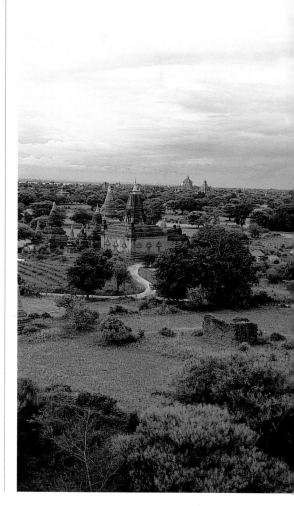

Kyoto is a 1,200-year-old city and the former capital of Japan. In the modern age, which began with the Meiji Restoration in 1868, the city's role has been redefined as the spiritual heart of the country.

There are so many temples, gardens, and shrines that choosing which ones to see depends on the time you have available and the season of your visit. During spring (particularly in April, when the cherry blossom is in bloom), the temples with the grandest gardens and displays of blossom should take priority. Between the Shishigatani Canal and the hills that flank the eastern end of the city is a wonderful path lined with blossom that stretches from the Zen temple and garden at Nanzen-ji, north to the Honen-in Temple, and on to the garden at Ginkaku-ji.

below | The annual flowering of the cherry blossom makes spring a wonderful time to see Kyoto. The combination of rich pink and red colored flowers and acutely angled pagodas leads to imaginative compositions.

Essential picture list

◈ Whatever the season, the **Kinkaku-ji** (Temple of the Golden Pavilion) is well worth visiting. Can you ignore the iconic view of the pagoda reflected in the lake?

◈ Kyoto was a royal city for nearly a thousand years, so spend some time at the **Old Imperial Palace**. The grounds alone are worth a visit.

◈ **Ginkaku-ji** (Temple of the Silver Pavilion), the Zen temple of **Nanzen-ji**, and **Honen-In** temple and their gardens can all be seen on the same walk.

◈ The Zen gardens at **Ryoan-ji** and the **Tofuku-ji Temple** should not be viewed in haste, but in a relaxed state of mind and with time to spare.

◈ Other temples and shrines of note are **Yasaka Shrine**, **Heian Shrine**, **Myoshin-ji**, and **Kennin-ji**.

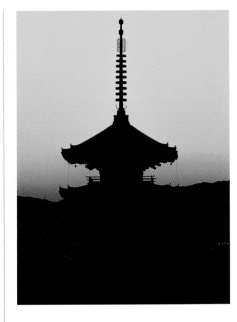

Another garden with an abundant supply of cherry trees is the Heian Shrine, a few blocks west of Nanzen-Ji. This colorful walk passes numerous tea rooms and inns popular with the Japanese, who travel from miles around to enjoy "golden week" with celebratory drinks and all-round bonhomie, so there is a good chance for capturing candid images of the Japanese.

One of the most photographed temples of Kyoto is the Kinkaku-Ji, better known as the Temple of the Golden Pavilion. It is worth visiting at any season, but in winter a fresh covering of snow on the pagoda roof complements the gold facade to produce an almost fairytale finish.

above | The Yasaka Pagoda makes a beautifully proportioned silhouette at dusk.

right | The colors of fall complement the brilliant exterior of the Golden Pavilion.

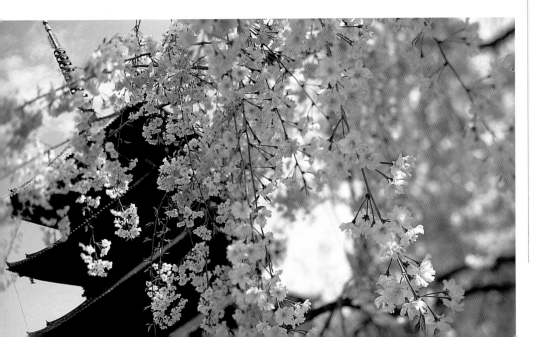

⊕ For photographing the gardens, or the temples in their garden settings, a **tripod** is vital, as most gardens are shaded and exposures are likely to be long.

⊕ Use a **skylight filter** to reduce any blue cast in shadow areas, or boost the warmth of your pictures by adding an **81a**, **81b**, or **81c filter**.

⊕ A **standard zoom lens** from wideangle to short telephoto will cover most options; use a **superzoom** if you want to have a longer focal length without having to change lenses.

⊕ **Good walking shoes** and a **backpack** will help make walking around the many gardens and paths a pleasurable experience.

Historical background >>> Kyoto was founded in 794CE and served as Japan's imperial capital from this time until the 17th century, when the seat of power moved north to Edo (Tokyo). The founding of Kyoto coincided with the arrival of Buddhism in Japan. Kyoto is now regarded as the center of Zen Buddhism in Japan. Many Japanese traditions either originated or developed most strongly in Kyoto. The famous tea ceremony was introduced in the 16th century, and Kyoto is revered as a seat of learning for this and other traditions including calligraphy, woodblock printing, and music. The Zen garden of Ryoan-Ji, built around 1500, is the oldest in the country.

Zen gardens

Kyoto is bordered on three sides by hills and mountains, and it is on these fringes that most of the city's gardens and temples are located. Kinkaku-ji is on the northwest edge of the city, a favored location in fall for the striking colors that burst through the evergreen pines and firs. Nearby is the Ryoan-ji temple, site of Japan's oldest and most important Zen rock garden. Compared with Kyoto's other parks and gardens, Ryoan-ji is a study in minimalism. It is no less beautiful, however.

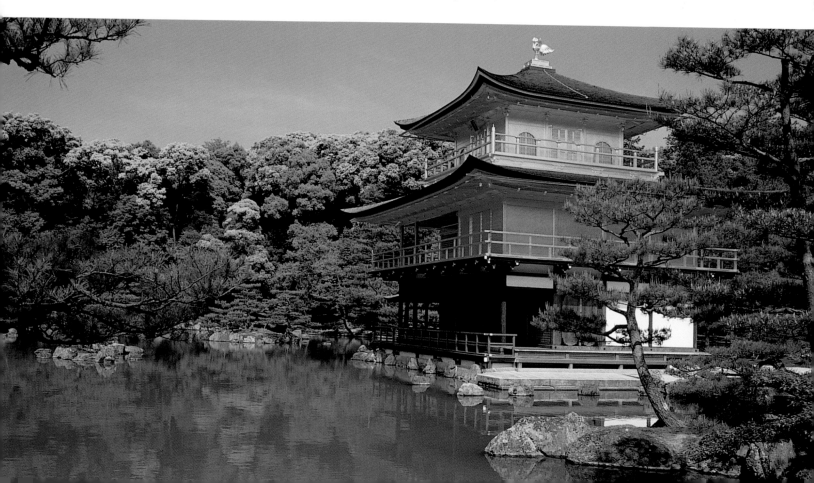

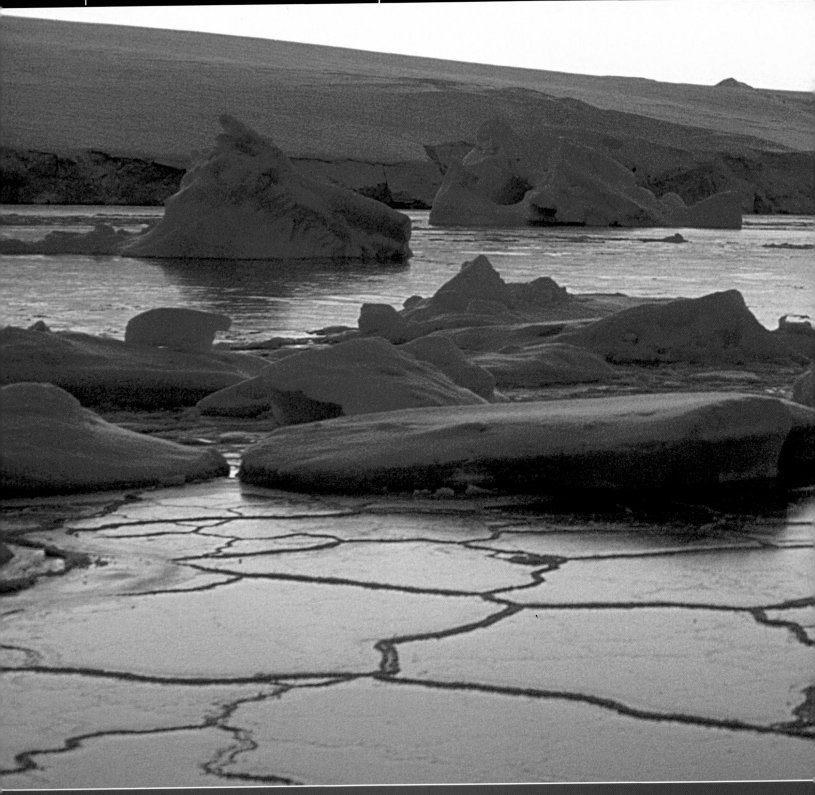

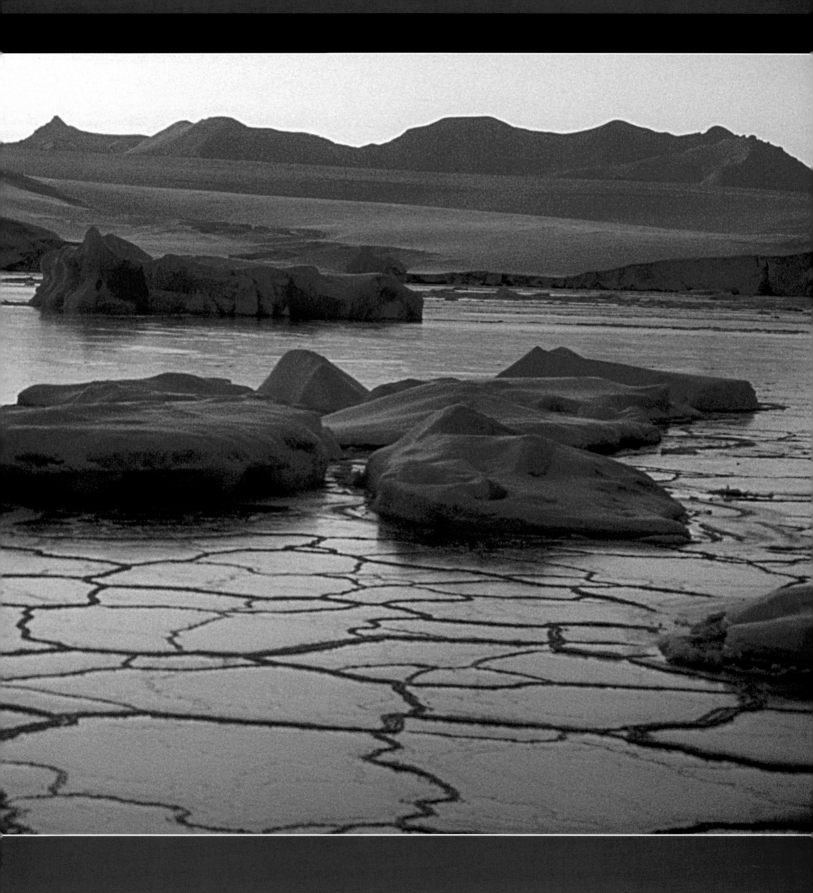

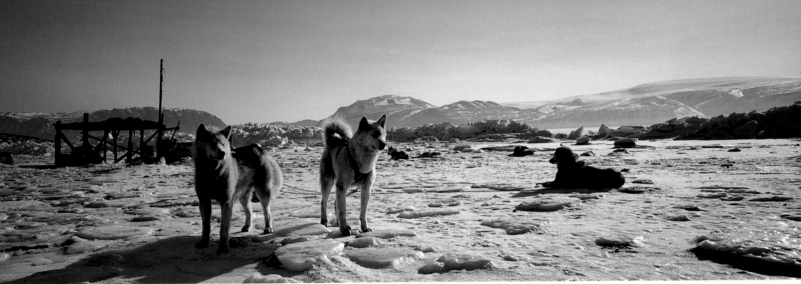

chapter five: countries that defy description

Glimpsing the Greenland coast for the first time as the plane descends to the runway at Narsarsuaq has most people staring in wide-eyed amazement. Icebergs are scattered in every inlet, jagged granite peaks rise steeply above the coastal fringe, while the interior of the country is one giant block of scourged ice. Straining your eyes, you can just make out a few tiny roofs, but otherwise this seems to be a land devoid of human habitation.

There are, in fact, barely 60,000 people living in a country three times the size of Texas. But then Greenland is not the easiest place to live—90 percent of the landmass is solid ice, up to three miles (5km) deep, an inhospitable and barren interior that is the source of much of the country's powerful beauty. The scenery along the west coast, where glaciers from the ice shelf grind their way between granite peaks to calve yet another giant iceberg of white and blue is truly humbling.

Most of Greenland's settlements are located along the west coast, including the capital city, Nuuk, Umanak, and a

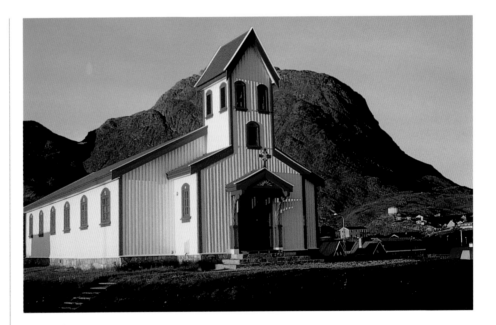

cluster of towns on the southwest tip including Narsaq, Qaqortoq, and Nanortalik. In the far northwest is Thule, a long-established Inuit settlement, and Etah, the starting point for many of the legendary polar expeditions that took place during the 19th and early 20th centuries.

top | On the north and east coasts of Greenland, husky dogs are an important means of transport.

above | Late afternoon sun strikes a church in Narsaq, on Greenland's southwest coast.

Historical background >>> The Inuit have lived in the Arctic regions of Greenland, near Thule and Etah in the northwest, for hundreds of years. The first Europeans to attempt to colonize Greenland were the Vikings, who visited the southwest tip of the country during the 10th century. The Norse ruins of Brattahild, near Qassiarsuk, are the site of the first European settlement, created by Erik the Red. In 1888, Norwegian explorer Fridtjof Nansen became the first man to cross the Greenland ice cap, a feat many had deemed impossible. In 1951, the Inuit "capital" of Thule changed forever when the US Airforce began construction of a huge airbase there because of its strategic position in relation to Murmansk, the major nuclear and naval base of the former Soviet Union.

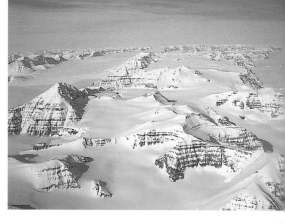

The southwest

Most visitors stick to the southwest tip during the short summer season from June to August, when the channels and fjords aren't completely choked by ice, and a few grassy meadows burst with the brilliant yellow of buttercups. There are no roads or railways linking the towns and settlements, so transportation anywhere in this part of the world is exclusively by open boat.

As well as being the only way to travel, it is also the most spectacular way of seeing the dramatic coast at close quarters. Even during the summer, icebergs are a constant fascination, with their fantastic shapes, cool shades of blue, and the sheer immensity of their form.

Travel is slow, determined by the amount of ice in the coastal channels. Greenland's towns are small, yet colorful, with most buildings constructed from painted timber planks or corrugated iron, in a style similar to the coastal villages of Scandinavia. The most prominent and photogenic buildings are the churches, reflecting the deep faith as well as the stoicism imbued in generations of Greenlanders.

above | An aerial view of mountains breaking through a blanket of snow and ice in east Greenland, the country's least populated region.

left | Summers are brief in Greenland, particularly in the far north, where fresh grass from the receding snow attracts musk oxen to graze on coastal pastures.

below | Greenland boasts a large number of towering mountain peaks, many of them unclimbed. Here, a lone skier is dwarfed by two granite pillars as he makes his way on the sea ice of an east-coast fjord.

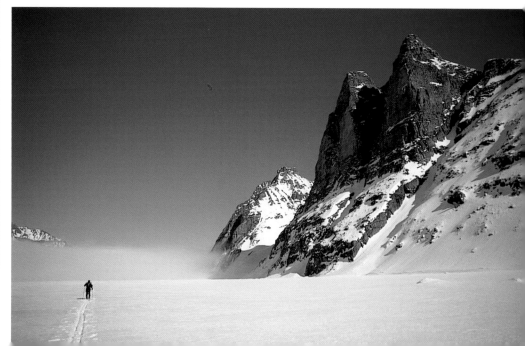

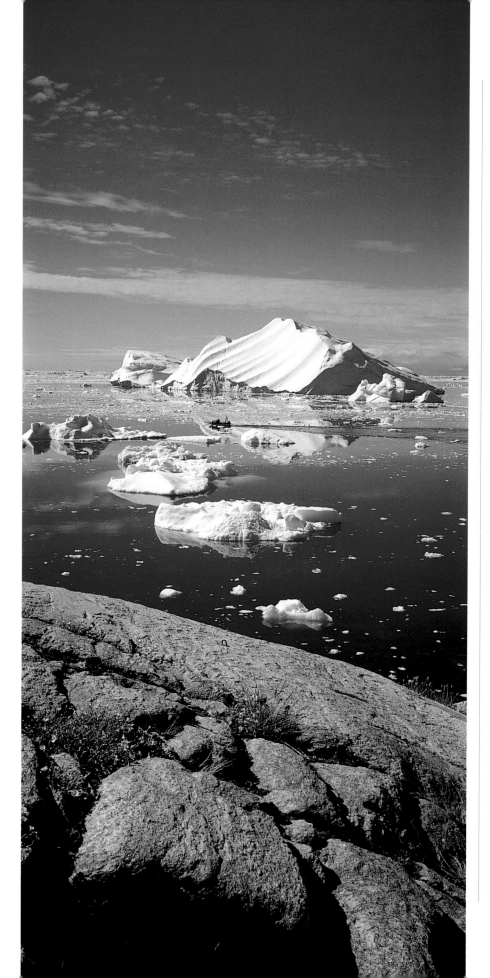

The Nordic influence has lasted a millennium, since Erik the Red gave the land its misleading name in a blatant attempt to persuade his fellow Vikings to settle there. Today, the country is a self-governing part of Denmark. For some young Danes, a summer in Greenland is a rite of passage, but there is little obvious integration with the Inuit culture and Greenlanders now conduct practically all the administration and government of their land.

left | The dominant features of Greenland's landscape are ice and granite. Massive icebergs fringe the granite shoreline all year, but are most spectacular in the summer, when the sea ice thaws and new icebergs break off from the coastal glaciers.

Essential picture list

✦ Wherever you go, there are plenty of **icebergs** and the variety of their shapes and sizes never ceases to astound. Some of the biggest are in **Disko Bay**, near Umanak.

✦ The **jagged granite peaks** are at their most spectacular near **Nanortalik** on the southwest tip of Greenland

✦ Don't miss the dramatic scenery surrounding **Tunugdliarfik** (Erik's Fjord), named after Erik the Red

✦ If you become overwhelmed by too much stunning natural scenery, spend some time photographing **the villages and the residents** going about their daily lives.

✦ Visit the **east coast at Ammassalik** in late winter to go **dog sledging** across the ice. This is a terrific chance for action shots on the move and a glimpse of the "true" Greenland.

Dog sledging trips

Winter lasts eight to nine months in Greenland, and for this reason the country has worked hard to increase the number of visitors from outside the peak summer months. Joining an Inuit dog sledging trip is an opportunity not to be missed. Dog sledges are the traditional means of transport in the less populous east coast. Riding on the back of a sledge hauled by a team of huskies across the frozen harbor of Ammassalik is a thrilling experience.

In Greenland, even in the towns, you are never far from feeling what it's like to live directly off the land, making the most of what nature provides. In most settlements you will see the skins of freshly killed polar bears stretched out on fish racks to dry, or a woman and her daughter gutting a seal on a boulder near the shore.

Essential kit

◈ The weather varies enormously, particularly in summer, so pack plenty of **warm and waterproof clothing**, including thermal socks, hat, and gloves.

◈ **Snow goggles** or **glacier glasses** are advisable, particularly in winter when the sun's high reflectance can cause snow blindness.

◈ Use a **UV filter** on your lenses at all times and a **polarizer** wherever it's going to make a difference.

◈ Take **plenty of film** or **memory cards** and **spare batteries** because stocks are limited and prices high.

◈ Take **enough lenses** to cover you from **wideangle to telephoto**.

above | In Narsaq, a woman and her daughter skin a pair of freshly killed seals. No part of the animal is wasted—the meat is eaten, the blubber is used for heating and cooking, and the skins turned into clothes, boots, and dog-sledge reins.

below | A deckhand watches for submerged ice as a boat is steered slowly through a coastal channel near the southwest town of Nanortalik.

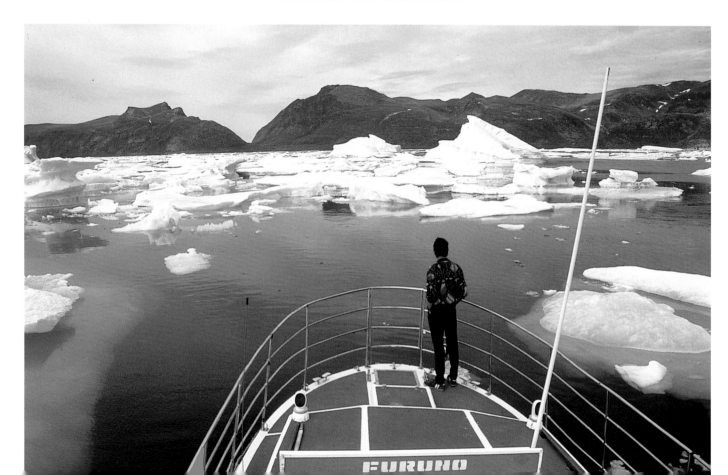

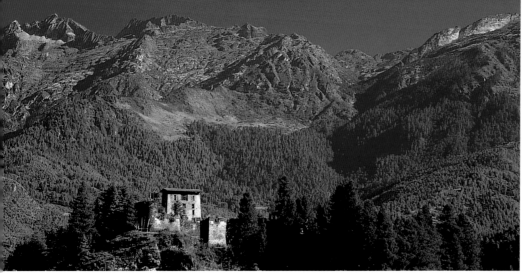

Essential picture list

⊕ The gravity-defying setting of **Taktsang Monastery** has to be seen to be believed.

⊕ Bhutan's only airport is near **Paro**, a beautiful town in the heart of the lush Paro Valley with a patchwork of rice paddies, wheat fields, and trout-filled streams.

⊕ Schedule your visit to coincide with one of the many **Buddhist festivals** that take place in Bhutan. These are a rich source of pictures and are hugely enjoyable.

⊕ Photograph the physical **elements of Buddhism** such as lines of prayer wheels, colorful dzongs (monasteries), and prayer flags.

⊕ Look out for any **archery contests**. This is the national sport and is practiced in every village. A large archery field lies near the main square of Paro.

An ancient mountain kingdom wedded to the rites and beliefs of Buddhism for more than a thousand years, Bhutan remains largely mysterious to the outside world. It has preserved a way of life without being tainted by Western-style development, a fact partly due to a government policy that restricts the number of outside visitors to just a few thousand each year. The rugged Himalayan scenery, lack of motorized transport, and all-pervasive Buddhist culture, make an intoxicating blend for the travelers who are allowed in.

above | **A classic Bhutan scene of steep hills and a stone-walled monastery.**

below | **A monk spins his prayer wheels.**

Buddhist festivals

For the people of Bhutan, life and religion are inseparable. Every village is emblazoned with colorful prayer flags blowing from buildings, temples, and stupa; prayer wheels spin; and the chants of monks and nuns echo from local monasteries. In the hills, most people wear traditional dress and their

Historical background >>> A mountain kingdom bordered by Tibet, China, and India, Bhutan owes its name to the great 13th-century explorer Marco Polo, who called it "Bootan" in the Roman alphabet. Buddhist culture has flourished here since the 7th century, and Bhutan avoided any further Western contact until the latter half of the 20th century. Then, in 1974, the royal government allowed organized tourism for visitors from abroad. It has since maintained a cautious approach to development by restricting visitors to around 6,000–12,000 people a year. Tourism was privatized in 1991 and all visitors must arrange their passage through one of 33 registered tour operators. On matters of foreign policy, Bhutan follows the guidance of India.

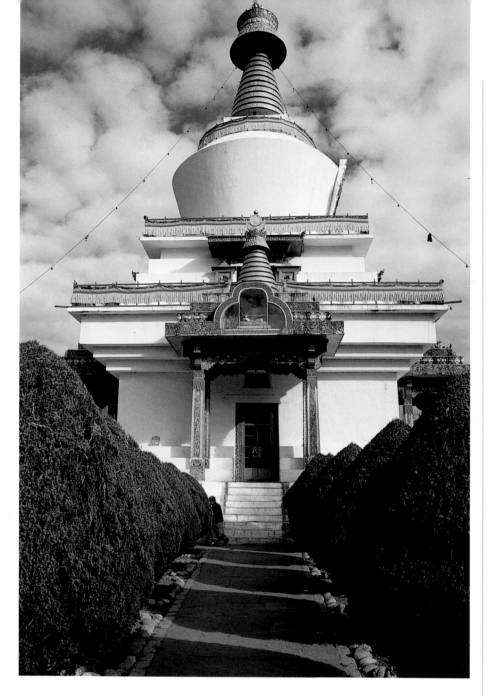

⊕ Bhutan's mountainous terrain demands that you travel light, with a basic kit of **one camera body** and **several lenses**, preferably zooms ranging from **wideangle to telephoto**.

⊕ A **carbon-fiber tripod** will keep the weight down, although a **monopod** that doubles up as a walking pole is also worth considering.

⊕ **UV or 81 series warm-up**, **polarizer**, and **ND graduates** will all be useful filters.

⊕ Carry your kit in a **backpack**. Proper **walking boots**, **sunhat**, **bottled water**, and **sunscreen** are all strongly recommended.

left | In the hills surrounding Thimpu, Bhutan's capital, is the Memorial Chorten, built in honor of the country's late king.

below | Taktsang Monastery clings to a cliff-face hundreds of feet high.

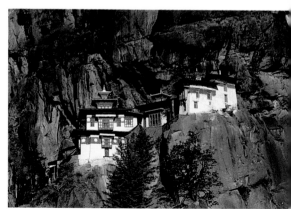

lives follow a calendar of Buddhist festivals. People travel from neighboring mountain villages to participate in these spectacles, where symbolic dances in honor of Buddha and the country's past gurus are the highlight. These festivals are spectacular events for photography. They last for several days and are as much a social occasion as a religious celebration. Bhutan's national sport of archery is also very much in evidence at such events and merits another set of images.

Taktsang Monastery

The most famous site in Bhutan is Taktsang Monastery, perched near the top of a cliff near the town of Paro. According to legend, it is here that Guru Rinpoche brought Buddhism to Bhutan, landing on the back of a flying tiger in 747CE. The monastery makes a remarkable subject for the camera.

Since the end of civil war in 1996, Guatemala has become a popular travel destination. From Mayan ruins and active volcanoes, to colorful festivals and sleepy colonial towns, there is a huge diversity of subject matter to keep the photographer happy.

Most journeys begin at the capital, Guatemala City. It is a place best left alone, with a poor infrastructure and high levels of poverty and crime. Once you have ventured beyond the city's precincts, the tension subsides and the slow, easy rhythm of the country and outlying villages begins to take hold.

Antigua and Lake Atitlan

Guatemala's old capital of Antigua is an elegant old colonial town with cobbled streets and ruined buildings. It has a memorable location in the highlands between three volcanoes. From here, you can take a guided walk up the Pacaya Volcano and peer into its still-smoking crater.

below | **Antigua is full of colonial architecture and wonderfully painted single-story houses.**

Lake Atitlan is another premier site. Framed by three volcanoes, this broad expanse of water is fringed by 13 towns and villages, home to predominantly Mayan populations with their ancient traditions and beliefs. Panajachel is the largest of the towns and, while not overly pretty itself, it offers some spectacular views across the water.

Mayan and Latin fusion

Nearly half of Guatemala's population are of Mayan descent. They are predominantly poor and have a long history of being repressed. A good introduction to Mayan culture is through

Essential kit

⊕ Unless you're photographing wildlife, you can cover most of Guatemala's attractions with the **standard range of lenses** from wideangle to short telephoto.

⊕ The climate is tropical and the roads dusty, so take extra **silica gel** in your backpack and use **wipes or a lens cloth** to clean your camera and lenses each day.

⊕ Take a **tripod** and a selection of lenses such as a **polarizer** and **ND graduates**.

⊕ Carry plenty of **bottled water** and wear a **sunhat** as it is hot and humid in the lowlands.

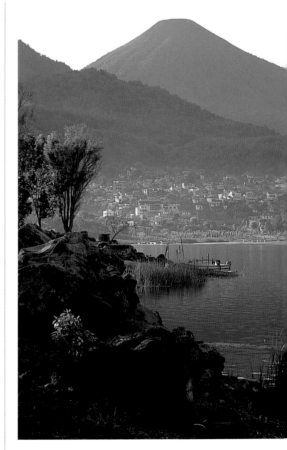

above | **The village of Santiago Atitlán has two stunning volcanoes for a backdrop: San Pedro Atitlán and Toliman.**

opposite page left | **Transport in Antigua varies from chicken buses to traditional horse and cart.**

the lively markets on Fridays and Sundays in the town of Santiago Atitlan. Mayans in traditional clothing and jewelry flock here to trade gossip as well as merchandise. Be careful about photographing the Mayans—they are very photogenic, but many of them

Essential picture list

✦ Only an hour from Guatemala City, the former capital of **Antigua** is a charming and colorful old town with fine examples of colonial architecture.

✦ The climb up **Pacaya Volcano** can be arduous, but the views are breathtaking and the smoking slopes and crater offer a rare experience.

✦ Explore the shores of **Lake Atitlan** for scenes of the surrounding volcanoes and nearby towns and villages for images of Mayan life.

✦ The **Petén rainforest** is the place for wildlife photographers. This wild expanse of jungle is home to jaguars, tapirs, macaws, toucans, and monkeys.

✦ Arguably, the best Maya pyramids are at **Tikal**. Stay overnight so you can get the best light at dusk and dawn and hear the wildlife noises of the jungle.

✦ **Chichicastenango** is a picturesque highland town with colorful Mayan markets held on Thursdays and Sundays.

Historical background >>> More than half of Guatemala's population is descended from Mayan Indians who first settled along the coast around 4,000 years ago. The predominant religion is Catholicism, into which many Indians have incorporated traditional forms of worship. Though the official language is Spanish, it is not universally understood among the indigenous population. The Mayan civilization was already in decline when the Spanish conquistador Pedro de Alvarado seized control of the country in 1524.

Guatemala's first colonial capital, Ciudad Vieja, was ruined by floods and an earthquake in 1542. Survivors founded Antigua, the second capital, in 1543. In the 17th century, Antigua became one of the richest capitals in the New World. Always vulnerable to volcanic eruptions, floods, and earthquakes, Antigua was destroyed by two earthquakes in 1773. The third capital, Guatemala City, was founded in 1776, after Antigua was abandoned. Guatemala gained independence from Spain in 1821 and briefly became part of the Mexican Empire. From the mid-19th century until the 1980s, the country passed through a series of dictatorships, insurgencies, coups, and military juntas.

dislike having their picture taken, so seek permission beforehand and expect to pay a tip for the privilege.

Guatemala's mix of native and Latin culture is further expressed through the many religious rites practiced by the predominantly Catholic population. Typical of these is the Semana Santa festival the week before Easter. This is a good time to visit as the festival coincides with the dry season (November to May).

Other festivals include the colorful Day of the Dead on 1 November. In early December, the pretty town of Chichicastenango celebrates the Burning the Devil festival with music and fireworks.

right | The waters of Lake Atitlán appear to change from blue to gray and then to green as the day wears on.

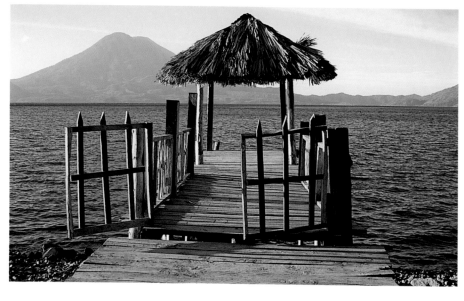

Essential picture list

⊕ The **Antarctic Peninsula** is the primary destination for most cruises and features a mountainous coast, penguin colonies, and plenty of icebergs.

⊕ **Paradise Harbor** on the Antarctic Peninsula is a wonderful location for witnessing icebergs calving off the glacier at the head of the harbor.

⊕ Among the South Shetland Islands is **Deception Island**, a collapsed but still active volcanic caldera. At **Pendulum Cove**, the volcanic activity heats the water enough for bathing. In fact, near some thermal vents the water is boiling hot.

⊕ On Ross Island lies **Scott's Hut**, which has stood since the fatal 1911–12 South Pole expedition. Inside, the furnishings, food stores, books, and possessions remain as Scott and his party had left them.

⊕ **Lemaire Channel** ("Kodak Alley") is a wondrous location. High cliffs line the shore and impressive icebergs fill the water.

chapter five: countries that defy description

Strictly speaking, Antarctica is not a country. There is no capital city, or national flag, and no indigenous population. Antarctica is a continent that belongs to the world.

Tourism is growing as people are attracted to Antarctica's spectacular geography and untainted wilderness. The promise of beautifully shaped icebergs, snow-covered coastal mountains, massive glaciers, and penguin colonies draws around 12–15,000 visitors every summer. There are no tours during the winter, when pack ice extends hundreds of miles into the Southern Ocean during winter, making the continent unreachable by ship.

Travel to Antarctica is expensive and usually takes the form of a cruise from the southernmost ports of Chile (Punta Arenas), Argentina (Ushuaia), New Zealand (Dunedin), Australia (Hobart), South Africa (Cape Town), and the

Falkland Islands (Port Stanley). The pack ice breaks up from October and summer sailings usually begin in November, the peak months being December and January. High on people's lists of sites is the hut that Captain Robert Falcon Scott and his men built for staging their attempt in 1911 to be the first people to reach the South Pole. Situated at the tip of Hut Point Peninsula, on Ross Island, the hut is open for guided tours.

The Antarctic Peninsula is the most visited destination due to its proximity to the South American mainland, the sub-Antarctic islands, and the diversity of landscape and wildlife. It also has the most moderate climate—in January, temperatures along the coast will average just below freezing.

A typical cruise lasts a fortnight or three weeks and will include visits to one or more of the South Atlantic islands, weather permitting. The

above left | A dog sledge team pause to ponder the beauty of an Antarctic sunset. For his 1911–12 South Pole expedition, Scott used ponies rather than dogs.

right | During the Austral summer, the sun never sets. Scientists spending the winter in Antarctica do so in months of continuous darkness.

Historical background >>>

Although Captain James Cook was the first to circumnavigate Antarctica in the 1770s, he never sighted land. Other sailors and explorers discovered various sub-Antarctic islands, which were later frequented by visiting seal hunters. Whaling stations were established on South Georgia and other outlying islands to plunder the Southern Ocean's whale stocks. By 1840, surveyors concluded that Antarctica was a separate continent, and during the rest of the 19th century, expeditions sought to venture further south and fill the gaps in the coastal map. The 20th century began with a spate of expeditions to reach the South Pole. Separate attempts by Captain Robert Falcon Scott (1902–03) and Sir Ernest Shackleton (1907–09) came close, before Scott and Norway's Roald Amundsen raced each other to the Pole, Amundsen reaching the point 23 days ahead of Scott on 14 December 1911. Scott and his party perished on the return journey. Although seven countries—Australia, Argentina, New Zealand, Chile, France, Norway, and Great Britain—have territorial claims, the Antarctic Treaty signed in 1959 establishes the legal framework for the management of Antarctic between the 45 member nations.

Essential kit

⊕ In this extremely cold and hostile environment, the right attire is critical to your comfort and safety. A **waterproof and windproof jacket** are essential, and **thermal gloves** are also advisable. It is better to wear a series of thin layers rather than thick, bulky items.

⊕ The hole in the ozone layer covers most of Antarctica during the Austral summer, letting in more ultraviolet (UV) light, so wear plenty of **sunscreen** and **UV-filtering sunglasses**. Use a **UV filter** with your lenses and also add a **polarizer** to reduce glare in bright conditions. **Lens hoods** will also help.

⊕ Metering off a small **gray card** will make it easier to attain an average light reading.

⊕ A long **telephoto or zoom** is essential to get closer shots of penguins and seals of sea ice

deserted whaling stations of South Georgia are a popular destination, while other favored anchorages include the South Shetland Islands, Deception Island, and the South Sandwich Islands, home to around two million chinstrap penguins, one of the largest penguin colonies on earth. All penguin species are found in the Southern Hemisphere, with the greatest concentration on the Antarctic coast and sub-Antarctic islands. Large colonies of Adelie, gentoo, and chinstrap penguins are found on the Antarctic Peninsula, while the colorful king penguin breeds in large colonies on the sub-Antarctic islands. The largest species is the emperor penguin, which forms colonies on sea ice at the edge of the continent and breeds during the winter.

Most Antarctic cruises attempt to sail through the Lemaire Channel, a stunning narrow passage between the Antarctic Peninsula and Booth Island.

below | A whale skims the ocean surface near a flotilla of icebergs.

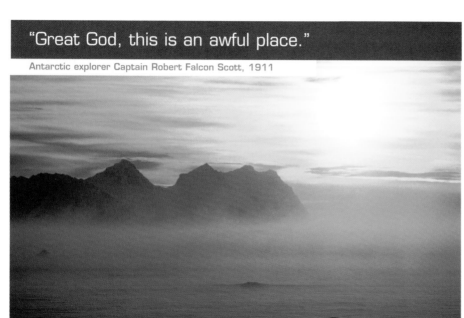

"Great God, this is an awful place."

Antarctic explorer Captain Robert Falcon Scott, 1911

Madagascar is a country that defies comparison with any other. It is one of the largest islands on earth, with a myriad of ecosystems and climate zones that are home to hundreds of unique plant and animal species.

Antananarivo is the capital of Madagascar and the starting point for every visitor. It is a bustling, overcrowded, decaying, and polluted town of half a million people, and many visitors can't wait to leave it. For the photographer, however, there is much to appeal. Roadside stalls, street markets, and rickety public transport provide fascinating tableaux.

A wildlife paradise

Madagascar is a wildlife photographer's paradise. There is an extensive network of national parks, reserves, and protected forests throughout the country. The ring-tailed lemur is probably Madagascar's most famous animal, but it can be found only in the drier forests in the far south of the island. One of the best places for seeing them is the Berenty private reserve. Large family groups thrive in the forest here, and they have grown accustomed to having camera lenses aimed in their direction. Ring-tailed lemurs also spend most of their time on the ground, which makes them easier to photograph.

Berenty and the surrounding spiny forests also support a sizeable population of Verreaux's sifaka, another photogenic lemur that performs a

right | A carpet of water hyacinths provide a striking contrast to the distant statuesque boab trees near Morondova on the west coast of Madagascar. Boabs are considered sacred by the Malagasy.

chapter five: countries that defy description

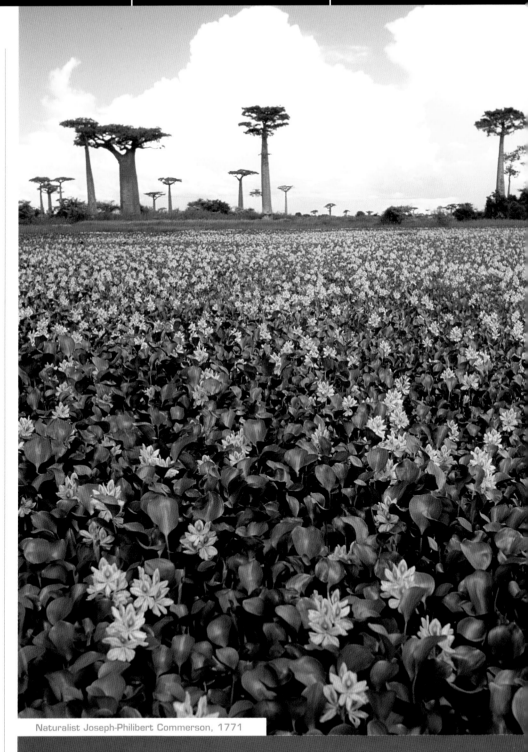

Naturalist Joseph-Philibert Commerson, 1771

"Here Nature seems to have created a special sanctuary where she has withdrawn to experiment with designs different from any she has created elsewhere."

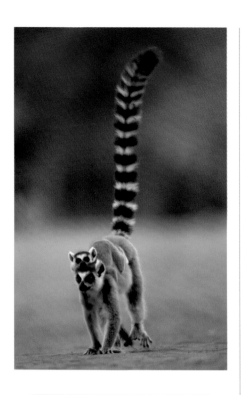

delightful scampering dance on its hind legs when running across the forest floor from one tree to the next. If you're quick, you can capture this endearing and amusing side of lemur behavior.

The far north of Madagascar contains the greatest variety of landscape and forests. In a 100-mile (160km) radius around the northern town of Ambanja there is temperate forest, tropical rainforest, highlands, and dry deciduous forest, as well as a spectacular coastline.

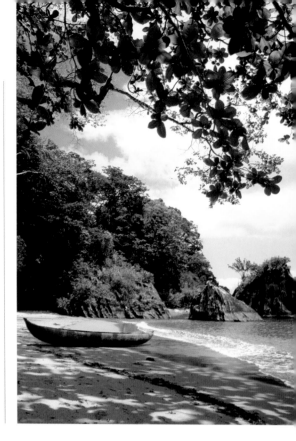

Essential picture list

⊕ The nearest national park to Antananarivo is **Andasibe-Mantady**. **Indri and other lemurs** live here along with chameleons and other rainforest animals.

⊕ For **boab trees** photographed against the setting sun there's no better place than the **Kirindy Forest**, north of Morondava.

⊕ **Berenty private nature reserve** in the far south is the best place for photographing the beautiful and approachable **ring-tailed lemur**.

⊕ For landscapes of Madagascar's highlands, head to **Isalo National Park** in the southwest of the country.

⊕ Madagascar's capital **Antananarivo** is not a pretty town, but it is full of life and color. There are numerous **markets** that never seem to close.

top left | Ring-tailed lemurs spend much of their time on the ground.

top right | A fisherman's dug-out canoe on a secluded bay on the island of Nosy Mangabe.

above | With branches like cactus, these octopus trees reach out in a green tangle of thorns. Part of the *Didiereaceae* family of spiny trees, their entire world range is in a small area in the southwest of Madagascar.

Historical background >>> Around 160 million years ago, Madagascar split from the east coast of Africa. Consequently, its plants and animals have evolved in splendid isolation with some engaging and spectacular results. The human population is more recent; the Malagasy are a mixture of Asian, Arab, and African settlers who had lived here for around 1,500 years before the arrival of the Portuguese (the first European settlers) in the 16th century. Madagascar became a French colony in 1898 and attained independence in 1960, but soon afterward slipped into a spiral of economic decline, political upheaval, and environmental destruction. In the last decades of the 20th century, Madagascar became notorious for the destruction of its rainforest. However, with financial backing from France and the United State, the government has embarked on a programme of economic development including the promotion of eco-tourism through its extensive range of national parks and reserves.

At Montage d'Ambre National Park, you can expect to see other species of lemur as well as impressive mountain scenery and waterfalls.

If lemurs are the iconic wildlife image of the country, then the bottle-shaped trunk of the boab tree is its landscape equivalent. Some of the most striking and accessible examples can be found just north of the western coastal town of Morondava in the Kirindy Forest. It may have been done many times before, but the sight of rows of boab trees silhouetted against an orange sky as the sun's yellow orb drops to the horizon makes an irresistible photograph.

Essential kit

- For general scenic and travel imagery, you can happily get by with **one camera body** and **two or three zoom lenses** from ultra wideangle to telephoto.

- Many animal species, such as chameleons, geckos, and frogs are small, so a **telephoto macro lens** is worth packing.

- The rainforest is dark beneath the canopy, so pack some **ISO 400 film** or take a **flash** to use as fill-in.

- For the most comfort, carry your gear in a **backpack**.

- Few filters are used for wildlife photography, but a **polarizer** is handy for reducing glare and reflections.

- For photographing lemurs, you will need at least a **300mm telephoto lens**. For added magnification, a **1.4x teleconverter** will save on weight and cost.

- A **beanbag** and **tripod** should also be in your kit.

- Much of Madagascar is tropical and hot, so take plenty of **water** and wear **a hat**.

Rainforest treasures

For chameleons, geckos, and other colorful reptiles and amphibians, travel east. Andasibe-Mantady is the nearest national park to Antananarivo, and one of the best for experiencing the wildlife of the rainforest. Here, chameleons can be spotted despite their extraordinary ability to change color. It is best to search for them with a torch at night when their bodies stand out in the torchlight against the darkness. You will need to use flash for photography, but the problem is getting close enough without scaring them away.

Andasibe-Mantady is renowned for being the stronghold of another species of lemur; the indri. This treetop dweller is one of the largest species of lemur found in Madagascar, and has a distinctive and piercing cry.

Coastal villages

Madagascar's coastal villages are also a rich source of subject matter, particularly the fish markets, where the daily catch is a study of tropical colors and textures. If you're on the west coast, you can marvel at the additional color supplied by the setting sun.

opposite page left | Boab trees are synonymous with Madagascar. They grow mostly in the western coastal regions.

top | The star-shaped angraecum orchid is native to Madagascar. This specimen was photographed in Mantadia National Park.

above | Marojejy National Park is one of the most inaccessible rainforests in Madagascar, but the early-morning view from the campsite makes the four-hour walk into the park well worth the effort.

right | A golden-crowned sifaka, one of the 25 rarest primates in the world.

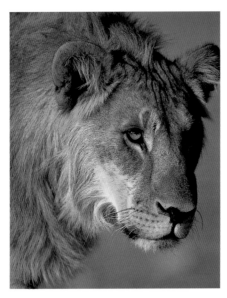

For much of the year, water is in short supply in the 8,000 square miles (20,700sq km) of Etosha National Park. The terrain is flat, featureless, and intimidating, with an 80-mile-long salt pan (Etosha Pan) at its heart. During the dry season, the pan crumbles to white dust, with only a series of waterholes and springs on the periphery to sustain the animals that live here. But there is a wet season, when enough rain falls to replenish Etosha Pan and attract flamingos and pelicans.

More than 300 species of bird are found here, but it is the big game species that make Etosha one of the best locations in Africa for seeing wildlife. During the dry season, rhino, lions, giraffe, leopards, and Africa's tallest elephants are drawn to a network of waterholes, providing photographers with a perfect vantage to train their lenses.

A road along the southern shore of Etosha Pan links three rest camps, Okaukuejo, Halali, and Namutoni, which provide the only accommodation within the park. Each of these rest camps is next to a waterhole; these are floodlit at sunset so visitors can witness animals emerging from the scrub to drink.

Okaukuejo is one of the best places to view elephants and black rhino. Although the lights stay on all night, the game, including nocturnal species, have grown accustomed to their presence. For the photographer, the best time to shoot is when there is still color in the sky from sunset. Find a position where the twilight will fill the background.

Namibia used to be a German colony, and evidence of its past can be found at Namutoni rest camp, where an impressive imperial fort is now home to a museum and provides good views

Essential picture list

⊕ First stop should be **Okaukuejo**, the first rest camp upon entering the park. Its floodlit waterhole is a prime site for wildlife and the twilight sky makes a colorful backdrop.

⊕ Depending on the length of your stay at Etosha, it may be possible to photograph Africa's three big cats— **lion, leopard, and cheetah**. Lions are the most visible.

⊕ The northernmost point of the park is the **Andoni Plains**, where elephants come to drink and have a dustbath. The grassland here offers your best chance to see **cheetah**.

⊕ The imperial German fort at **Namutoni** is an interesting diversion and offers good views from its ramparts.

⊕ Beyond the rest camps, waterholes that are well frequented by wildlife include **Goas, Chudob, Klein Namutoni, Batia, Oliphantsad,** and **Fischer's Pan.**

i

Historical background >>> In the early 20th century, when Namibia was known as German South West Africa, the governor of the day made an area of nearly 38,600 square miles (100,000sq km) of northern Namibia a game reserve. It became popular with hunters, but two world wars and other political changes culminating in Namibia's independence in 1975 have seen the original game reserve shrink to its present size of 8,880 square miles (23,000sq km). Today, Etosha National Park is one of Namibia's major economic and environmental assets. It is home to nearly 90 different types of mammal and 340 bird species.

above left | As in the rest of Africa's savannah and high plains, lions are the dominant predator in Etosha. In recent years, they have increased their range, at the expense of cheetahs. This young male circled the photographer's vehicle before stepping up on the rear bumper and staring at him through the rear window.

from the ramparts. There are several waterholes around Namutoni, which are good for giraffe, lions, black-faced impala, springbok, eland, and kudu.

Halali rest camp lies between Namutoni and Okaukuejo. The nearby Goas waterhole is visited by lion, zebra, giraffe, and other plains animals, and the discipline here, as elsewhere, is to stay in your vehicle and wait for the animals to come. Early morning and sunset are the best times, as the animals are more likely to stay under cover during the heat of the day.

It's worth driving to the Andoni Plains, where the road ends. The waterhole here is popular with elephants and birds, and the huge expanse of open grassland stretching into the distance is one of best places to see the elusive cheetah.

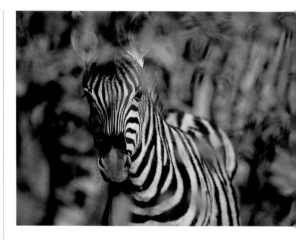

above | Zebras are part of the staple diet for lions, leopards, and cheetahs. They use their camouflage to take cover in bushes when they sense danger.

below | When the floodlights come on at the Okakuejo waterhole, the orange sunset makes a lovely backdrop for photographing elephants and other animals.

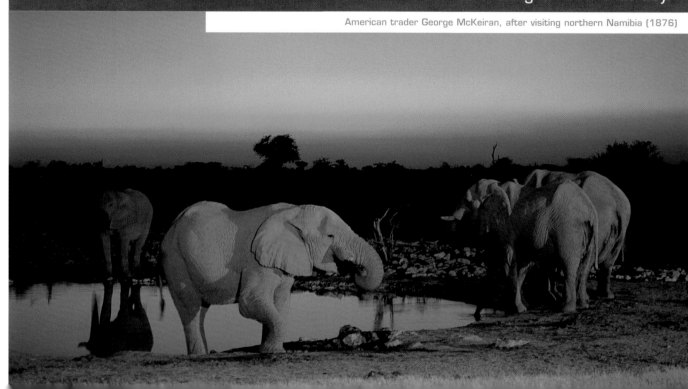

"All the menageries in the world turned loose would not compare to the sight I saw that day."

American trader George McKeiran, after visiting northern Namibia (1876)

The Mara-Serengeti is one of Africa's greatest locations for viewing wildlife. The name is an abbreviation for two protected wildernesses: the Masai Mara National Reserve in Kenya and Tanzania's Serengeti National Park. Together, they comprise a plain nearly 6,500ft (2,000m) above sea level, straddling the Kenya–Tanzania border but free of fences or other obstacles that might impair the movement of wildlife. It is the wildlife that people from all around the world come to see.

Essential picture list

⊕ People visit the Mara-Serengeti to photograph the wildlife. **Giraffe**, **elephants**, **lions**, **zebra**, and **impala** are among the more common animals to be seen.

⊕ Head toward the Mara River during the dry season (July–October) to witness the **annual wildebeest migration** from Serengeti National Park to the Mara.

⊕ Two of Africa's most high-profile species on the endangered list are the **black rhino** and the **cheetah**. If you see either, take plenty of pictures.

⊕ Africa's highest mountain, **Kilimanjaro**, is also one of the most beautiful. It is an extinct volcano and makes a wonderful backdrop to any wildlife pictures.

⊕ The statuesque **Masai** herd cattle all through this region and make wonderful subjects with their brightly colored clothes and jewelry.

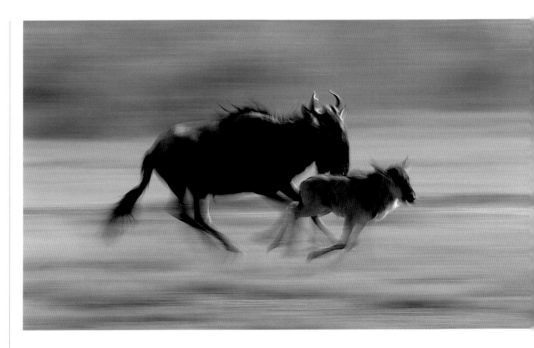

above | White-bearded wildebeest sprint across the Serengeti plain during their annual migration across the Mara River and into Kenya.

The safari experience

Covering several thousand square miles, these plains are home to more than a million wildebeest and hundreds of thousands of zebra and Thomson's gazelle. With such an abundance of herbivores, there are sizeable populations of lion, leopard, cheetah, and other predators. All year round, 4x4 vehicles criss-cross the plains carrying visitors intent on experiencing the meaning of safari and coming back with the pictures to prove it.

The prime viewing time is during the dry season (July to October), when more than half a million Serengeti wildebeest move north in their annual migration across the Mara River and

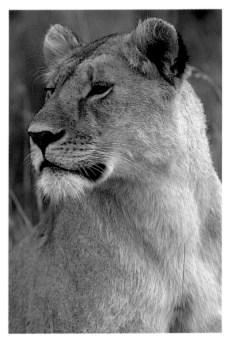

above | A lioness surveys her domain in a shaded spot in the Serengeti.

Historical background >>> The Serengeti Plain lies to the west of Mt Kilimanjaro, once an active volcano and the source of ash that made up the fertile soils feeding the area's vast grasslands (savannah). Kilimanjaro is part of the eastern perimeter of the Great Rift Valley, which cuts through eastern Africa from the Red Sea to Mozambique. It was formed around ten million years ago, when a great slab of land subsided between two continental plates. It was on the savannah in northern Tanzania that anthropologists believe humankind evolved. Here, in 1959, Louis and Mary Leakey found human skull fragments nearly two million years old, at that time the oldest such discovery ever made.

- Most professional wildlife photographers working in the Mara use a **500mm telephoto** as their stock lens. If such a lens is beyond your means, you could always add a **1.4x or 2x teleconverter** to your current telephoto or zoom lens.

- If working from the window of a 4x4 vehicle, rest the lens on a **beanbag** on the edge of the car window—tripods are not practical.

- Light is plentiful, so **fine-grained film** or a setting of **ISO 100** for digital SLRs will suffice, providing that you keep your lens steady.

- Pack **lens wipes** and a **blower brush** to clean the day's dust from your gear.

- A **polarizer** and **81 series warm-up filters** are worth taking too.

- Wear a **sunhat**.

right | The gray crowned crane is one of the bird species found in the Serengeti.

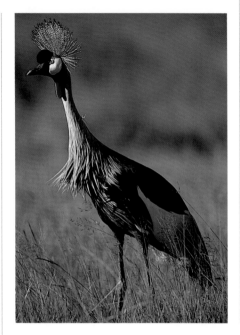

into Kenya. At the height of the migration, the river and its muddy banks become jammed with the thundering hooves of wildebeest.

Of the big cats to be seen here, lions are the most abundant and easily approached, but don't expect them to be on the move—a pride will spend most of the day asleep in the shade or long grass. Leopards are even more elusive, preferring wooded areas and a perch in a tree, where their spotted coat acts as superb camouflage.

On the Tanzania side of the border, the spectacle of elephants and giraffe moving across the plain dotted with acacia trees and the snow-capped Mt Kilimanjaro rising in the distance is one of the iconic images of East Africa.

Bird photographers will have plenty of subjects to shoot; more than 500 species are found in this part of Africa. But the biggest photographic prize is the black rhinoceros. Should you see one, count yourself lucky—there are only around 3,000 left in the wild in the whole of Africa, with only a few dozen roaming the Mara-Serengeti.

below | As the sun descends, a female cheetah prowls for prey.

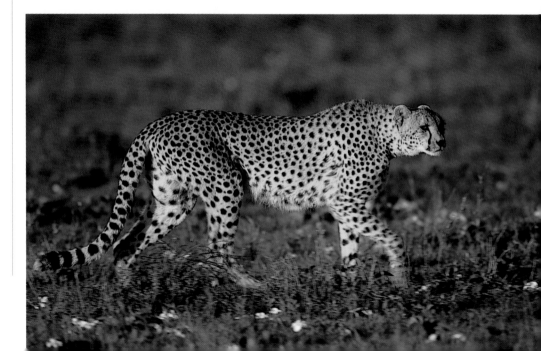

Many photographers rate the Ngorongoro Crater as one of the best locations in Africa for viewing wildlife. The reasons are due to the crater's unique geography. It was formed when a volcano collapsed, creating a vast, sunken plain 13 miles (21km) across and surrounded by the old crater walls nearly 2,000ft high (610m).

A unique topography

Ngorongoro is a unique ecosystem and is much studied by environmentalists and biologists. It even has its own climate: thick mist clings to the trees, hiding the top of the caldera, while rain clouds often drop down into the crater, dissipating local showers.

For the wildlife photographer, the area provides many of the animals for which Africa is famous, accessible within a contained habitat. The rich volcanic soil means that there is ample open pasture to feed the herds of gazelle, zebra, buffalo, and wildebeest, while the caldera rim is heavily forested.

Ngorongoro's caldera rim has made it virtually impenetrable to species outside, while also making many of the animals inside "captive." This is good news for the endangered black rhino—the 30 or so here are the largest concentration in Africa—but has proven something of a drawback for the lions, which are inbred. You will also find elephants and ostriches.

Of course, the caldera wall is no obstacle to birds, and many of the birds common to the neighboring Mari-Serengeti National Park can also be seen here. In the middle of Ngorongoro, thousands of flamingos congregate on the shores of Lake Magadi, a favored spot for their annual migrations. Filling the frame with dozens of these

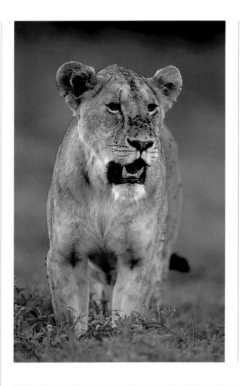

Essential picture list

✛ There are healthy populations of **lion, elephant, buffalo, wildebeest,** and **zebra**. None is difficult to approach.

✛ Although endangered, there are healthy populations of **black rhino** in Ngorongoro, although they can be difficult to see in the long grass.

✛ Head down to **Lake Magadi**, where thousands of flamingos congregate.

✛ Look out for the **Masai people**, who venture into Ngorongoro with their herds of cattle to graze.

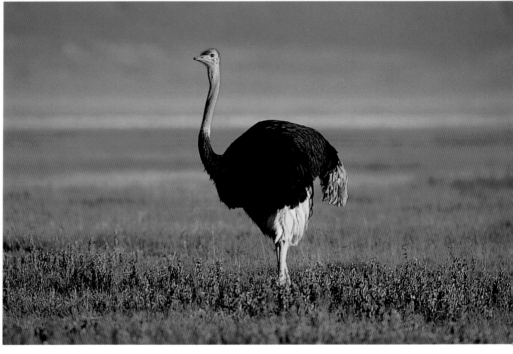

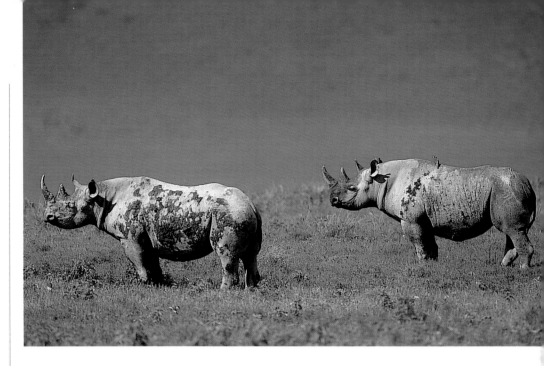

Essential kit

- ✛ A good pair of **binoculars** is indispensable on safari.

- ✛ As you will be shooting from the back or roof of a 4x4 vehicle, a tripod isn't practical, so use a **beanbag** or two to rest your lens.

- ✛ **Long telephoto lenses** are the order of the day, but also use a **zoom** to give you maximum flexibility and fewer lens changes.

- ✛ A **1.4x or 2x teleconverter** is also useful.

- ✛ Lighting conditions tend to be more overcast in the caldera, so a **medium-fast film or ISO setting** might be needed, say ISO 200 or 400. However, contrast levels are lower, so exposures will be more consistent.

- ✛ Take plenty of **spare batteries**, as the nearest electrical store is days away.

top left | The lions of Ngorongoro are inbred, because the crater walls keep the population contained.

left | The rising walls of the crater make a uniform background, ideal for shooting animals such as this ostrich in isolation.

top right | Ngorongoro Crater is one of the last strongholds of the black rhinoceros.

right | In the middle of the caldera is Lake Magadi, a favorite watering hole for thousands of lesser flamingos.

fluorescent pink birds is one of the most colorful images you can make on safari in Ngorongoro.

The crater is well served by lodges on the north and south rims, and visitors are allowed down the steep trails to the caldera floor after dawn. With a safari guide leading the way on a 4x4 vehicle, you will be able to get quite close to the lions and other animals, which are habituated to vehicles.

It is worth trying some shots that show the caldera rim. Not only will this place the shot, it also makes a good background for studies of elephant, ostrich, or other animals in isolation.

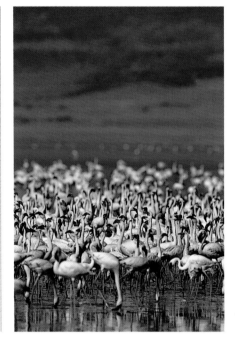

Historical background >>> Many scientists believe that before it erupted, the mountain that used to be the Ngorongoro Crater was taller than Mt Kilimanjaro, the highest point on the African continent. Two million years ago it blew apart, leaving a flat plain inside a 12 mile (20km) wide caldera with walls 2,000 feet (600m) above the crater floor. Around 30,000 animals live in this natural enclosure, the largest intact volcanic caldera in the world. Ngorongoro Crater is just a small part of the Ngorongoro Conservation Area which includes other volcanic features, including Olmoti Crater, Empakaai Crater, and Ol Donyo Lengai, an active volcano that the Masai believe is the home of their god.

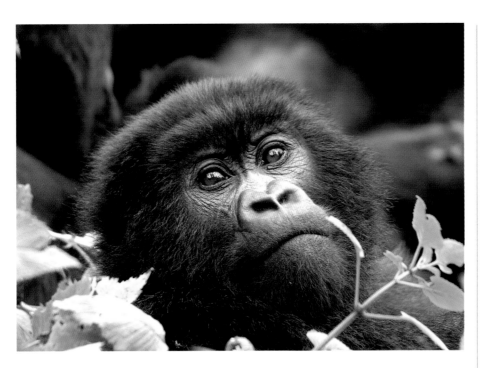

Essential kit

⊕ Wildlife photographers working in tropical rainforest environments were among the first to use digital cameras, which give you the advantage of being able to change your ISO setting for every exposure. With so little light getting through to the jungle floor, 35mm SLR users will have to load a **fast film**.

⊕ If you think a tripod will be too awkward and time-consuming in the jungle, consider taking a **monopod** instead.

⊕ Pack extra **silica gel** in your camera bag to soak up the humidity.

⊕ Don't forget **extra film** or **memory cards**, and **spare batteries**.

In the mountains and dense forests where the border of Rwanda meets Uganda and the Democratic Republic of Congo (DRC), the magnificent mountain gorilla continues to defy the odds in its struggle for survival. Despite poaching, civil wars, and genocide in these countries in the late 20th century, gorilla numbers have increased. According to a census conducted in 2003, there is a population of 380 animals, up from 324 in 1989. The growth of gorilla-watching trips has contributed to this, bringing valuable tourist revenues and employment to the countries that protect them.

The best-known location for seeing mountain gorillas is in the Parc Nacional des Volcans (Volcanoes National Park) in Rwanda. This was Africa's first gorilla-watching destination and covers an area of 48 square miles (125sq km), including five of the eight Virunga Volcanoes—the other three being across the border in the DRC. These mountains range in height from 11,400ft (3,475m) at Gahinga to 14,790ft (4,507m) at the summit of Karisimbi. They provide four major vegetation zones on their slopes, including the bamboo forests and hagiena woodlands that are favored by the gorillas.

Gorilla viewing is possible all year round in the Parc Nacional des Volcans, although the high altitude means that it is quite cold. Generally, the odds of seeing gorillas and photographing them at close range are very good, although it can be more arduous during the dry season, as the animals tend to climb higher at this time of year.

above left | A young mountain gorilla peers out from a patch of undergrowth in the dense tropical forest of the Volcanoes National Park. Even though poaching remains the major threat to their survival, it is possible to get quite close to these amazing creatures.

Katmai National Park owes its existence to a cataclysmic eruption in 1912. Novarupta Volcano deposited ash 100–700ft (30–210m) deep, across an area of 40 square miles (104 sq km) on the Alaska Peninsula. Preserving the affected area—known as the Valley of the Ten Thousand Smokes—was the primary reason for the creation of the Katmai National Monument in 1918.

Today, the preservation of 2,000 brown bears is the primary focus of Katmai's existence, and over the years the boundaries have been extended to preserve more of their habitat. Designated a national park in 1980, Katmai encompasses enormous lakes, imposing volcanic peaks, island-studded bays, hundreds of miles of unspoilt coastline, and salmon-rich streams.

Bear viewing

These streams provide the location for one of the greatest annual wildlife spectacles in North America. Every July, during the peak of the world's largest sockeye salmon run, dozens of bears

right | **An estimated 2,000 brown bears live within the boundaries of Katmai. Mature animals such as this specimen weigh up to 900lbs (400kg).**

below | **Every July, the sockeye salmon run at Brooks River turns into a veritable smorgasbord for the bears.**

gather above the falls at Brooks River to gorge on the fish returning to their spawning grounds. Photographers are well catered for by the provision of bear-viewing platforms along the river close to the visitor center at Brooks Camp. These are accessed by narrow dirt paths, a floating bridge, and elevated walkways, and it is not uncommon to encounter bears along the way. Sensibly, the bears, weighing up to 900 pounds (400kg), have right of way…

Essential kit

⊕ The positioning of the bear-viewing platforms at Katmai makes photography a joy. You're given a stable base for your **tripod** and you are near enough to get a series of frame-filling shots with **long telephoto lenses**.

⊕ If your longest lens is more modest, use a **1.4x or 2x teleconverter**. The resulting drop in shutter speed can be countered by using a faster film or ISO setting.

⊕ Contrast is rarely a problem here, as days are mostly cloudy when it isn't raining, but a **skylight** or **81a filter** will take any glare off the water and add warmth to shadows.

⊕ Katmai is a muddy place, so wear strong **walking boots** and a **waterproof** in case it rains.

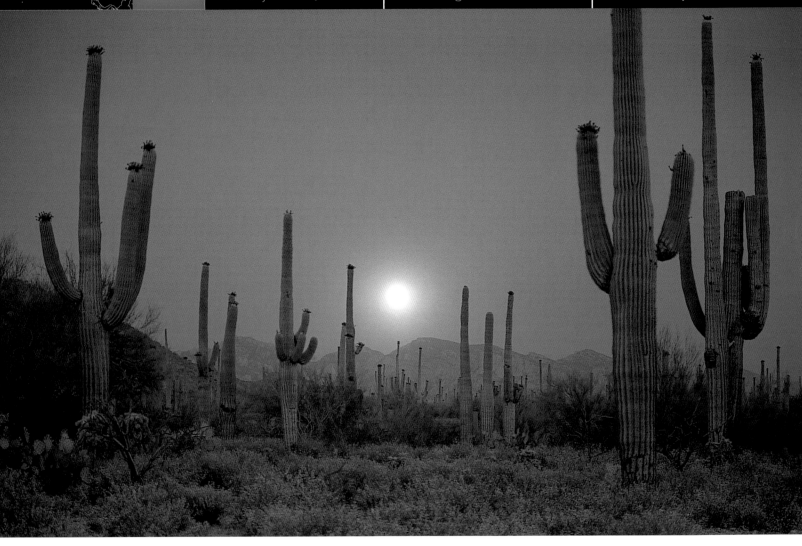

Although one of North America's lesser known deserts, the Sonoran has the reputation of being the hottest. Yet in some parts it is quite lush, supporting an extraordinary array of plant species and producing spectacular wildflower displays after the winter rains. The Sonoran Desert covers 120,000 square miles (192,000sq km) of southeastern California and southwestern Arizona, and spreads across the border into Mexcio's Baja California and Sonora provinces.

Flowers in the desert
What makes the Sonoran unique compared with other deserts is that it has two distinct wet seasons; from December to March, and from July to September. Depending upon which part of the desert you're in, annual rainfall varies from 2in (5cm) to 12in (30cm). It is the winter rains that trigger the enormous flowering displays that carpet the desert floor for miles. There are dozens of species with names as colorful as the flowers themselves.

above | The eerie saguaro cactus under the light of a full moon.

below | Saguaro cactus in flower.

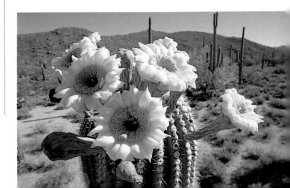

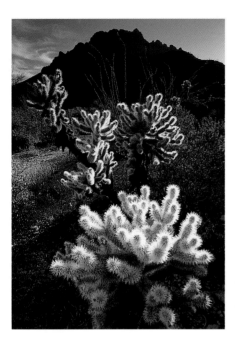

above | Flowering ocatillo and cholla cactus bring color to the desert.

These include Desert marigold, London rocket, Mexican golden poppies, brittle brush, owl clover, fairy duster, desert rock pea, Bladder pod, and popcorn flower. The intense colors make the flowers an attractive subject for close-up images and the keen macro or flower photographer could spend a whole day making frame-filling studies.

Alternatively, a carpet of natural color across the desert floor makes a wonderful foreground to the tall, gangly, and prickly forms of the giant saguaro cactus plants scattered in the distance.

Generally, the western part of the desert receives higher winter rainfall than the east. Conversely, the summer rains are more plentiful and sustained in the east than the west. In the north into the uplands of southwest Arizona, the rain distribution is more even throughout the year, but the driest and hottest region is in the south, in the lower Colorado River Valley into Mexico where summer temperatures often reach 50°C. Even here, with barely 2in (2.5cm) of rain a year and areas of sand dunes, there is plant life in the form of thorny, drought-tolerant shrubs and ground-hugging cacti. Though harsh and inhospitable, the landscape is undeniably beautiful.

Essential picture list

⊕ For its classic shape and height, the **saguaro cactus** has to be at the top of the list. These cacti make a perfect silhouette against the setting sun.

⊕ With two distinct wet seasons, you have a good chance of photographing some of the dozens of species of **desert wildflowers** when they come into bloom.

⊕ The **cacti spines and their flowers** make wonderful macro studies. Species include fishhook barrel, cholla, saguaro, and hedgehog cactus.

⊕ In Mexico, to the east of the Colorado River, is the **Gran Desierto**. It is the hottest and driest part of the Sonoran, but the terrain is truly beautiful.

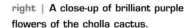

right | **A close-up of brilliant purple flowers of the cholla cactus.**

Historical background >>> Stretching from southwest Arizona, to southeast California and across the border to Mexico, the vast expanse of the Sonoran Desert has been inhabited for thousands of years. Scientists estimate that the arrival of the first peoples, the Hohokam, occurred up to 25,000 years ago. They built villages and irrigation channels that made North America's hottest desert habitable. However, by the 14th century they disappeared from history and were followed by the Pima and Papago peoples whose descendants still live here. The greatest impact on the Sonoran came from the Spanish who arrived in the 16th century. Their language, culture, crafts, and religion are clearly evident in the region and have survived the arrival of peoples from the east since the 19th century.

The Southeast Asian island of Borneo contains rainforests that are home to plant and animal species found nowhere else. Borneo is also a large island—so large, in fact, that it is shared by three countries; Indonesia, Brunei, and Malaysia. Political boundaries do not always respect environmental needs and sometimes the preservation of a species can depend on which side of a border it resides.

Many wildlife photographers choose the Malaysian state of Sabah, occupying the northernmost section of Borneo, as their preferred location for observing the island's wildlife. In Sabah there are numerous well-managed protected areas and a workable infrastructure for

getting around, but where exactly you choose to go will depend on the species you hope to see.

Kinabatangan River

One the best locations for wildlife watching is the Kinabatangan River. This is Sabah's longest river and winds its

way through some of the most pristine rainforest in Asia. It is also a prime habitat for the proboscis monkey, a species found only in Borneo and famous for its extremely large nose.

The best way of seeing the monkeys is by taking a boat to search the forest edges along the river. You will usually

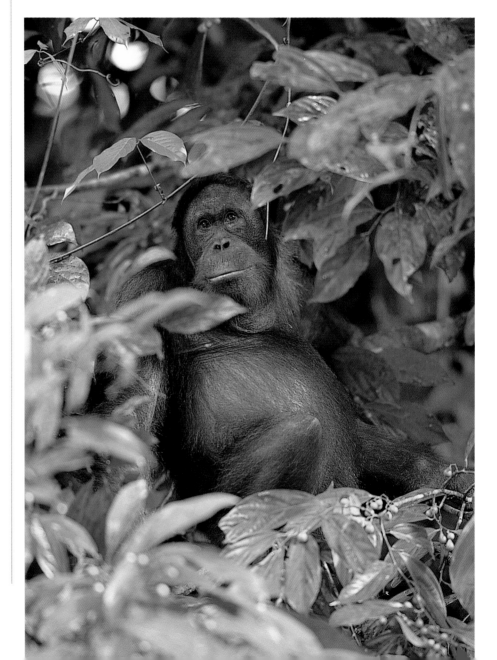

Essential picture list

⊕ The top attraction for most travelers is the **orang-utan**. Kinabatangan River and Danum Valley are two of the best locations for seeing truly wild specimens.

⊕ Although without the iconic appeal of orang-utans, troupes of **proboscis monkeys** leaping through the trees make an equally strong impression.

⊕ **Early morning by the Danum River**, when all before you is pristine rainforest with trails of mist rising off the water, makes an evocative landscape image.

⊕ Other species to look out for include the **Bornean elephant, pig-tailed macaques, slow loris, Bornean gibbons, maroon langurs,** and **rhinoceros hornbills**.

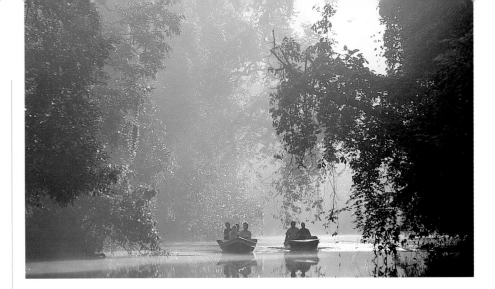

⊕ Borneo demands a wide range of gear, particularly if you want to photograph a variety of subjects. A solid **tripod** is essential, especially as so little light penetrates the rainforest canopy to ground level. For this reason, **fast film** of ISO 400 is another necessity. Digital camera users have more freedom to adjust ISO setting according to the available light.

⊕ To photograph orang-utans and other primates by day, a **300mm or longer telephoto** is required. Pack a **1.4x teleconverter** for flexibility.

⊕ A **macro flash** and **TTL flash** (with off-camera lead) is handy for photographing smaller creatures.

⊕ Rainforests are wet, so take **rain guards**, **waterproof sealable bags**, and **waterproof camera backpacks**.

⊕ Pack extra **silica gel** to save your gear from possible damage caused by the high humidity.

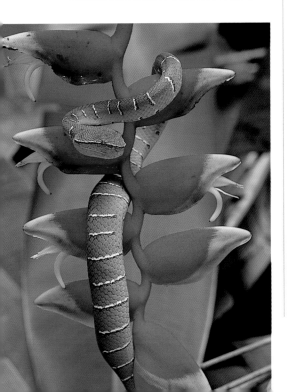

opposite page | A wild male orang-utan spotted in the rainforest canopy of the Danum Valley.

above | Early morning mist rises from the Menanggol River near Sukau, as a wildlife-watching group set out to see the animals of Sabah's rainforest.

below left | A Wagler's pit viper rests on the vibrant blooms of a heliconia flower.

hear the monkeys before you see them, such is the density of the forest undergrowth, but whole troupes are known to jump across the river from low-hanging boughs to the opposite bank. There are other primates in this jungle, such as long-tailed and pig-tailed macaques, and even orang-utans, Borneo's greatest attraction. The little-known Bornean elephant is another resident of this jungle, as are numerous snakes, frogs, and birds.

Danum Valley

The Danum Valley is another great wildlife location. It covers an area of 154 square miles (400sq km) set aside as a reserve in a forest concession; a network of trails makes passage easier and quicker. The greatest obstacle to seeing any wildlife is the cloud of thick mist that rises from the Danum River in the morning. It clears eventually, revealing dense undergrowth, and visitors have a good chance of seeing Bornean gibbons, maroon langurs, and a number of spectacular birds with equally spectacular names, such as the great argus pheasant and the rhinoceros hornbill.

Danum Valley is home to a healthy population of orang-utans, which are usually seen foraging in the branches of fruit trees. Their human-like features and expressions are captivating.

Historical background >>> Diplomatic and trade links have existed between China and the island of Borneo since 700AD when the area now known as Sabah, Sarawak and Brunei was part of the kingdom of Brunei. Through its traders Islam arrived in Brunei and the kingdom became the centre of the faith in South East Asia. Brunei's decline coincided with the rise in interest from European traders, most notably the British and Dutch. During the 19th century large areas of the north Borneon coastline were either leased or ceded to European trading companies and in 1882 the British North Borneo Chartered Company was formed. Six years later North Borneo (Sabah) became a British protectorate and Sandakan its capital. In 1963 Sabah gained independence from Britain and joined Sarawak and Malaya to form the new nation of Malaysia.

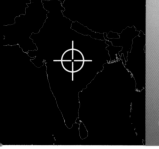
The tiger, the largest of the big cats, has long symbolized strength and power, qualities aspired to by emperors and conquering generals. However, man's desire to replicate the qualities of the tiger through the consumption of its bones and other body parts, or to prove his virility by hunting tigers, means that tiger numbers have plummeted.

It is estimated in 1900 that there were around 100,000 wild tigers in Asia, including 40,000 in India. Today, it is thought that 5,000 tigers are left, with India accounting for up to 3,000 of these. It wasn't until 1970 that India outlawed tiger hunting and the sale of tiger skins. Gone are the days when Maharajahs led lavish tiger-hunting parties and took aim from the back of an elephant. Today, some Maharajahs' hunting grounds are tiger reserves and people take aim with telephoto lenses.

Project Tiger

Two major tiger-spotting locations in India are Ranthambhore National Park in Rajasthan and Bandhavgarh National Park in Madhya Pradesh. Both national parks are Project Tiger reserves, part of India's co-ordinated effort to save its

right | Understandably, tigers are the main focus of attention for photographers to Ranthambhore and Bandhavgarh, but both parks support healthy populations of other mammals and birds. The chittal, or spotted deer, is a favored prey of tigers and are frequently spotted in the forest or near water. These colorful birds are known as tree-pies, and are often seen feeding off the coat of the deer.

below | With eyes fixed straight ahead, a mature tiger walks along a track used daily by visitors to Ranthambhore National Park in Rajasthan. Tiger numbers are small but sightings are frequent.

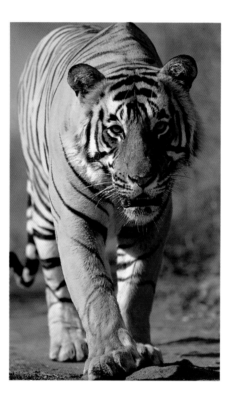

Essential picture list

⊕ Of course, **tigers** are the primary objective for any trip to Ranthambhore or Bandhavgarh, but there is no guarantee that you will see one. Should you be fortunate, keep a cool head and remember the fundamentals: focus on the eyes, keep your camera and lens steady, and use the fastest shutter speed available to you.

⊕ Both national parks are rich in bird life and animals such as **chital**, **sambar**, and **red deer**, which are part of the tiger's staple diet.

⊕ In Ranthambhore, the view of the **ruined old fort** standing over one of the park lakes makes a lovely landscape composition, particularly late in the day.

⊕ If you do see a tiger, chances are that you will be joined by other jeeps. Get a shot of **the tiger and jeeps together**, to show how tourism is creating a new set of pressures.

chapter six: natural wonders: wildlife

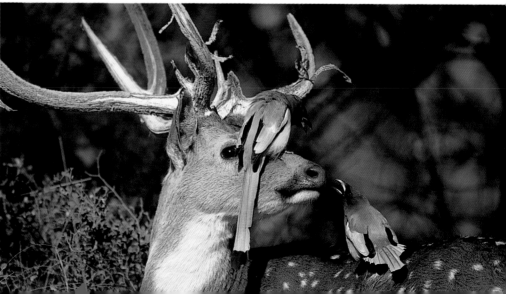

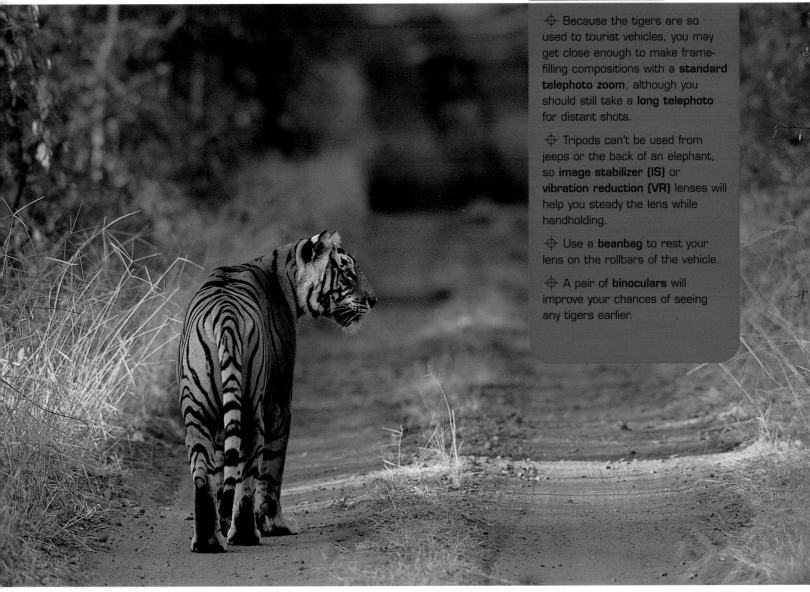

◆ Because the tigers are so used to tourist vehicles, you may get close enough to make frame-filling compositions with a **standard telephoto zoom**, although you should still take a **long telephoto** for distant shots.

◆ Tripods can't be used from jeeps or the back of an elephant, so **image stabilizer (IS)** or **vibration reduction (VR)** lenses will help you steady the lens while handholding.

◆ Use a **beanbag** to rest your lens on the rollbars of the vehicle.

◆ A pair of **binoculars** will improve your chances of seeing any tigers earlier.

remaining wild tigers by preserving these habitats and protecting the populations from poachers. Ranthambhore is the nearest Project Tiger reserve to India's capital New Delhi. Consequently, it faces the greatest pressure from visitors, who are guided along fixed routes in convoys of people-carriers.

above | A tigress ambles along a forest track in Ranthambhore. Because of its proximity to India's capital city, Ranthambhore's tigers are subjected to the greatest number of tourist vehicles.

right | The shade of a bamboo grove makes a perfect setting for this portrait of a resting tiger at Bandhavgarh National Park in Madhya Pradesh. With an estimated 700 animals, Madhya Pradesh has India's greatest population of tigers.

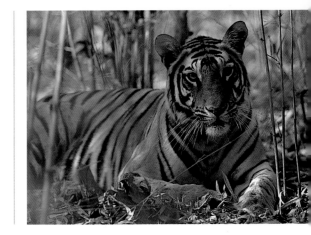

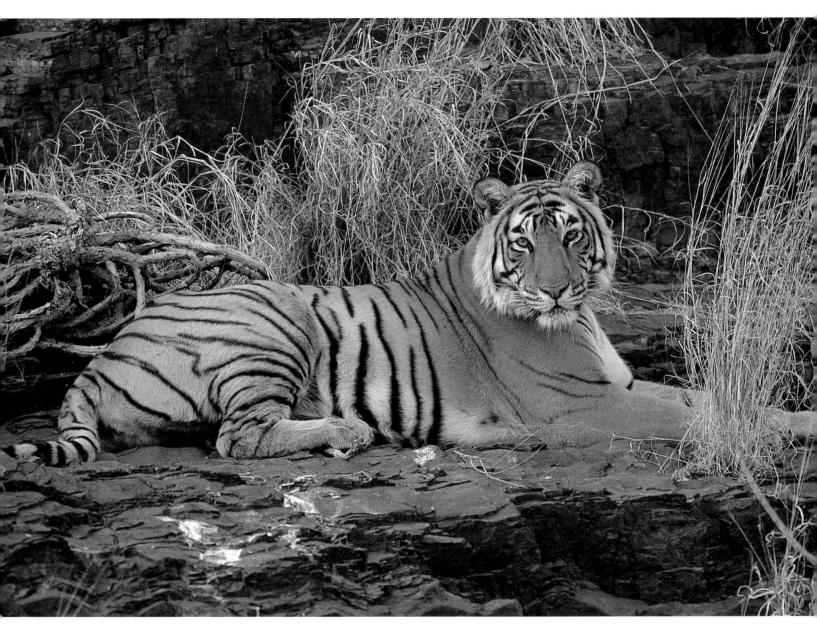

above | This image of a beautiful tigress resting in the undergrowth fulfills many people's ideas of the classic tiger picture. Most tigers at Ranthambhore and Bandhavgarh have become accustomed to the constant fleet of visitors' vehicles, so there is a good chance of getting a frame-filling shot such as this. However, long lenses are still recommended and a beanbag is useful for resting your lens on the roof of your vehicle.

Historical background >>> India became the first country to protect tigers by law in 1970, when then prime minister Indira Gandhi led the push to ban tiger hunting and the sale of tiger skins. It was almost too late. A census of the tiger numbers two years later found that there were barely 1,800 animals in the whole of India. In 1973, the Indian government launched Project Tiger and, with the co-operation of neighboring tiger countries Bhutan, Nepal, and Bangladesh, habitats were selected for protection. There are now 27 Project Tiger reserves in India. Although tiger numbers have recovered, they are still uncomfortably low. The animals continue to be poached, primarily for the supply of bones for Chinese medicine.

Ranthambhore's tigers suffered badly from poachers in the early 1990s, but their numbers have recovered and your chances of seeing a tiger during a stay of a few days are very good. This is certainly one of India's most attractive national parks, with a 1,000-year-old fort of crumbling red sandstone overlooking one of the park's three lakes. Every photographer dreams of getting photographs of a tiger with this scene in the background.

Bandhavgarh is one of three Project Tiger reserves in Madhya Pradesh, the state with the greatest number of India's tigers—approximately 700, according to 2002's official census. This national park covers 17 3 square miles (448sq km) and used to be the hunting grounds of the Maharajah of Rewa. As with Ranthambhore, it can become crowded with vehicles and hired guides, but the tigers in both these parks have become well habituated to the presence of vehicles. One famous male tiger, Charger, became so used to the convoys that he would regularly charge vehicles along the route. Charger died in 2000, aged 17—a very old age for a wild tiger.

An elephant's view

At Bandhavgarh you can experience the lofty perspective enjoyed by the Maharajahs of the past, by tracking tigers from the back of an elephant. It is debatable whether your chances of seeing a tiger will be improved, but the higher position gives you a more distant view and makes it easier to see some of Bandhavgarh's colorful bird life.

below | Snarling a warning to visitors, the greatest danger for the future of this tiger cub is from poachers, who continue to kill tigers to satisfy China's illicit trade in tiger bones for aphrodisiacs.

bottom | A female sambar deer and her calf feed on weeds and grasses by a stream in Ranthambhore.

The Galapagos Islands owe their fame to the groundbreaking evolutionary biologist Charles Darwin. His trip to the islands in 1835 led to the publication of his revolutionary book, *On the Origin of the Species*, and since then the islands have become one of the world's most celebrated wildlife habitats.

The Galapagos comprise 13 major islands, eight smaller islands, and 40 rocky islets. While supporting a population of more than 12,000 people and thousands more visitors from overseas, the human impact on the Galapagos has been minimal. Many of the creatures that inhabit the islands and the surrounding waters are faring better now than they did in the 19th century, when the exploitation of the Galapagos brought creatures such as the giant tortoise, fur seals, and sperm whales to the brink of extinction.

Access to the islands is rigorously controlled; the best way to get there is by joining a short cruise, which lets you explore various islands by day before returning to sleep aboard at night. This way, you can see the marine iguanas, sea lions, lava lizards, frigate birds, and blue-footed boobies in an environment as unspoilt as it was in Darwin's day.

If you want to see the iconic Giant Tortoise, you need to go to the island of Isabela and hike for several miles up a volcano. Otherwise, on the main (human)-inhabited island of Santa Cruz, they can be seen in semi-natural surroundings on "tortoise ranches" or in captivity at the Charles Darwin Research Center.

Essential kit

⊕ You'll never be far from water, so constant use of a **polarizer** is likely to reduce glare on the water's surface and to give more form to any clouds.

⊕ Walks on the islands are strictly controlled and no one is allowed to walk off the marked trails, but **boots** are recommended. Protect yourself from the sun by wearing a **hat**, **sunscreen**, and drinking **plenty of water**.

⊕ A **lightweight backpack** is the best means for carrying your gear, but use a minimum of kit: **one camera body** and two or three lenses, including a **wideangle**, **standard zoom**, and **telephoto**. Most animals, including breeding birds, iguanas, and sea lions are easy to approach, so it is possible to get in close (as long as you do not cause disturbance). **Medium telephotos** are ideal for isolating subjects, and a **macro lens** is useful in all sorts of ways.

⊕ Take plenty of **spare film**, **memory cards**, and **batteries**.

left | Galapagos sea lions on Santa Fe Island.

above | A land iguana basking in the sun.

The Great Barrier Reef is the largest coral reef in the world and ranks as one of the most important ecosystems on earth. It shadows the length of the state of Queensland from Torres Strait south to the coastline around Mackay, a distance of more than 1,240 miles (2,000km).

The Reef is a popular vacation destination, but the vast majority of its 600 or so islands are deserted. People are drawn to the turquoise-blue waters, beaches of white sand, and the pristine rainforests that grow on some of the larger islands. But the greatest attraction lies underwater, where corals of extraordinary shapes and colors fill the seafloor. This coral comprises the entire length of the Reef, and is home to hundreds of species of fish, many with outrageously brilliant colors.

above | **A kaleidoscope of color exists beneath the surface of the water; here, schools of orange basslets swim among an outcrop of hard coral reef.**

Experiencing this living wonderland is easy—you don't even have to stay on one of the island resorts. Cruises sail daily from Cairns, Port Douglas, and Gladstone to the smaller islands, or cays, where you can snorkel on the water's surface, gazing down at the sea life beneath you. The shallower the water, the better the colors (and your pictures) will be—but don't get too close, as some of the hard corals can be sharp enough to cut you.

Essential kit

⊕ To get pictures below the sea's surface, you will need an **underwater camera**. The most common makes are Nikonos and Sea & Sea. Alternatively, you could try an **underwater housing** for your existing camera.

⊕ Objects underwater look bigger than they really are because light refracts in water, magnifying the image. Using **flash** with your underwater camera will improve results, showing up more of the colors.

⊕ Keep the camera tied to your wrist with a **rubber strap or cord**, so that you don't drop it while swimming.

below | **Like a flowering bush, a glimpse of coral that is the color of lavender.**

Off the coast of Borneo there is a small dot of reef circling a tiny tropical island that is consistently rated as one of the best diving sites in the world. That island is Pulau Sipadan.

It takes just 45 minutes by boat from the coastal town of Semporna, on the east coast of Sabah, in the Malaysian part of Borneo, to reach Sipadan. The island is small but is well equipped with professional diving companies, comfortable accommodation, electricity, food, and water. A beautiful white sandy beach encircles the island, but people don't generally come here to lie in the sun—they are intent upon seeing the amazing colors of the marine life below the surface of the sea.

A rainbow underwater

Prime attractions include the huge variety of soft and hard corals and the reef fish of wondrous colors and shapes. The warm tropical waters are home to hundreds of species of fish

with descriptive and playful names like clown, angel, damsel, and butterfly. Every color of the spectrum is visible.

Sipadan is also a favored egg-laying ground for the green and hawksbill turtles. From April to September, encounters with these large and gentle creatures while diving are inevitable as they swim toward the shore in droves to lay their eggs in the soft sand of the beaches. As well as a healthy population of turtles, these waters are also home to huge groupers, barracuda, lobster, and sometimes sharks. Visibility underwater is extremely good, ranging from 60 to around 200ft (18–60m), making the natural colors of the coral and marine life stand out even more. Some dive spots have gained reputations for attracting particular species and have been named accordingly, such as "Barracuda Point" and "Turtle Cavern."

The diving season lasts nearly all year in Sipadan, from mid-February to mid-December. There is no shortage of

Essential picture list

⊕ The whole underwater world here is essential. It's a case of choosing which **amazing colors of coral and tropical fish** to photograph first.

⊕ **Green and hawksbill turtles** look magnificent swimming underwater. Contrast this with their slow, purposeful movements on shore as they lay their eggs.

⊕ The **undersea caves, canyons, and walls** provide a dramatic backdrop and are covered with corals, shells anemones, and other species.

below left | **A parade of yellowback fusiliers head over a crop of coral toward the rim of Sipadan's reef.**

below | **In a seascape of abundant color, this longnose hawkfish finds perfect camouflague in the form of this soft coral to hide from predators. A burst of flash brings out of all of Sipadan's extraordinary range of colors.**

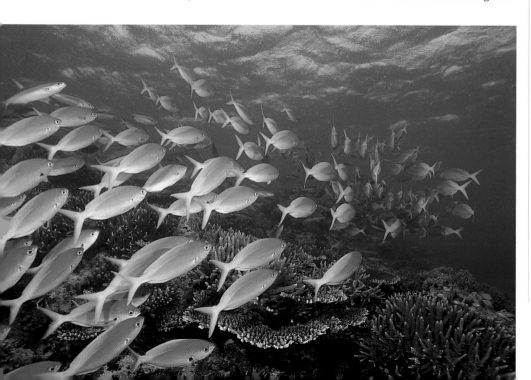

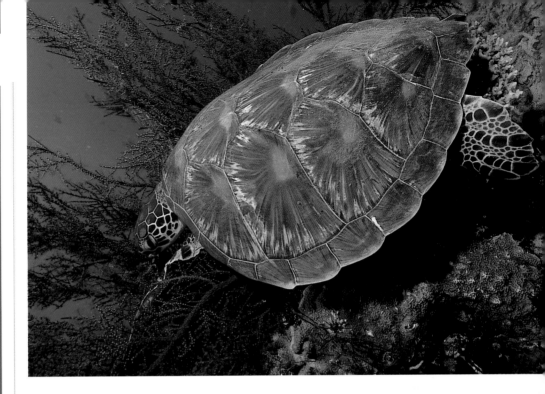

Essential kit

⊕ To take photographs underwater, you need to have qualified instruction and examination in scuba diving. A **specialist underwater camera**, such as a Nikonos, is the obvious requirement. Alternatively, you could get an **underwater housing** for your existing film or digital camera.

⊕ The water may be remarkably clear, but firing **flash** is advisable to maximize the colors of the fish and coral.

⊕ Keep the camera tied to your wrist with **a rubber strap or cord**, so you don't drop it while swimming.

underwater attractions, such as undersea caves, walls, overhangs, plateaux, and other geological features. Back on terra firma, birdwatchers will find that Pulau Sipadan is also a sanctuary for hundreds of sea eagles, frigates, gulls, and terns. After a day of diving among the turtles and corals teeming with fish, Sipadan has one more colorful moment to offer on shore: a blazing red sunset in the equatorial sky.

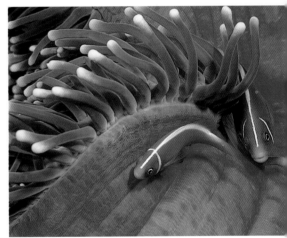

left | An oyster covered with sponges, seasquirts, and corals. With such an abundance of undersea life, it is not surprising that Jacques Cousteau achored longer at Sipadan than anywhere else.

top | Sipadan supports a healthy population of green turtles, which lay their eggs on the island's beaches. Underwater encounters are common between April and September.

above | The beautiful pink anemone fish is one of hundreds of species of tropical fish to be found in these waters.

Historical background >>> Legend states that the renowned oceanographer, diver, and explorer Jacques Cousteau was so entranced with Pulau Sipadan that his ship *Calypso*'s anchor lay here longer than on any previous expedition. The World Wildlife Foundation followed his assessment by rating Sipadan one of the world's best coral areas in 1978. One reason why Sipadan is so outstanding is that it is not connected to the continental shelf; instead, it lies in the Sulu Sea as the peak to a massive submarine mountain rising 2,000ft (600m) on a limestone pinnacle that mushrooms at the surface, supporting a ring of coral.

Pantanal is the world's largest wetland, stretching 50,000 square miles (140,000sq km) across southwest Brazil and over the border into Bolivia and Paraguay. In the wet season, with the floodwaters of the Rio Paraguay at their peak, the Pantanal covers nearly 75,000 square miles (200,000sq km) and there's no escaping the huge acreage of water that spreads over this flat and largely featureless landscape. It is not surprising that Pantanal means "swamp" in Portuguese.

In terms of wildlife, this is an extremely rich environment, with more than 650 species of birds, 80 mammals, 50 reptiles, and around 250 species of fish. There are giant river otters, caiman crocodiles, toucans, howler monkeys, hyacinth macaws, tapirs, yellow anacondas, and even the elusive jaguar, although you are more likely to see the ocelot, a predatory cat that has a coat like a jaguar's, but that is much smaller.

The Pantanal has good accessibility, particularly during the dry season (June to September), when the main road (Transpantaneira) that snakes across the marshland is at its most passable. This is also the best time of year to see wildlife, as a greater concentration of animals congregate at the shrinking waterholes, and predators lie in wait.

Cars and 4x4 vehicles can be hired at Cuiaba, the nearest main town. It is possible to explore the region on your own, but joining a guiding company will greatly improve your chances of seeing animals. Hiring a camper van is a good idea, as it allows you to be self-sufficient and to spend more time in the heart of the marshland without having to worry about where to sleep or eat.

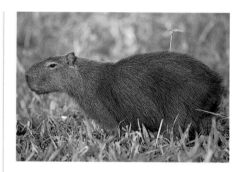

above | With nose, ears, and eyes close to the top of its head, the capybara is able to smell, hear, and see perfectly while swimming in the caiman-filled waters of the Pantanal.

below | Pantanal caiman lying still in the waters at twilight.

opposite page | The powerful bill of the toco toucan can break any nut.

"The Pantanal has the greatest concentration of fauna in the Americas."

Dr Maria Tereza Jorge Padua, former Director, Brazil's National Parks

Essential picture list

⊕ The Pantanal is one of the last strongholds of the **hyacinth macaw**. Its dazzling violet-blue plumage has made it a favorite with illegal collectors.

⊕ **Caiman crocodiles** look their most sinister when submerged in a river, the surface broken only by numerous pairs of nostrils and eyes, watching for prey.

⊕ To convey the vast area of this wetland, make a **wideangle view of an expanse of water** stretching out to a distant feature, such as forests or a hill.

⊕ There are 650 species of birds in the Pantanal. Some of the more common varieties are **toucans**, **egrets**, **storks**, **spoonbills**, **ibises**, and **jabiru**.

⊕ The greatest prize of all is the **jaguar**. The are very elusive and mostly active at night, making sightings rare. The **ocelot** is smaller but more active by day.

Dawn and dusk are the times of the greatest animal activity and they coincide with the best light. One of eeriest spectacles is the eyes and nostrils of caiman crocodiles just breaking the calm surface of the water nearby. They are virtually silent, and you could easily miss them, but scan the water's surface with your binoculars and you will be surprised how many are lurking, waiting for their moment.

The other large occupant of the rivers and marshes is the giant river otter. These are very quick, so don't hesitate to fire off a burst of frames should you see one.

Working from a vehicle rules out using a tripod, but you can obtain suitable support for long lenses by simply resting your lens on a couple of beanbags propped on the windowsill. In this position, you can maneuver the lens smoothly and quickly, but most of the time you will be waiting, quietly and patiently, for something to happen.

Essential kit

⊕ It may not be Africa, but a trip to the Pantanal should be treated like a safari. Take your **longest telephoto lens** and a **1.4x or 2x teleconverter** for added magnification.

⊕ Digital SLR owners using **35mm format lenses** will have an advantage, as the lenses will deliver greater image magnification than their nominal focal length.

⊕ A couple of **beanbags** are ideal for supporting a telephoto lens on the edge of a car door window.

⊕ Take a pair of **high-magnification 10x50 or 8x42 binoculars** for spotting potential subjects.

⊕ Pack **spare batteries** and **enough film** or **memory cards** to last your whole journey.

Historical background >>> Originally inhabited by Indian tribes, the Pantanal became the focus of attention for hundreds of gold miners and slave hunters when Portuguese Brazilians arrived here in the early 18th century. The Indians were driven from the region, and the new settlers lived by hunting, cattle raising, fishing, and farming. This continued well into the 20th century without much effect on the region, but in recent times more intensive agricultural and mining practices, coupled with irrigation and drainage schemes, have increased the pressures on the Pantanal.

Big Island is the largest island of the archipelago of Hawaii, and is home to some of the most active volcanoes on earth. The Hawaiian Islands were formed as volcanoes emerging from the Pacific Ocean floor 70 million years ago. Over time, the volcanoes on the northwest islands, including Kauai and Maui, became extinct, but Hawaii sits over a "hot spot" where magma constantly rises from beneath the seafloor to feed Big Island's volcanoes.

Mauna Loa is the most famous volcano. At 30,000ft (9,140m) from ocean floor to summit, it is the biggest single volcanic structure on earth. However, the most active of Hawaii's volcanoes is Kilauea, on the southeast coast. It frequently erupts molten rock from the summit caldera and bleeds lava through fissures from its flanks to the ocean. These lava flows produce huge quantities of steam as they hit the water, and hydromagmatic explosions caused by seawater entering the hot lava tubes are common. All this volatility does not deter visitors from taking guided walks through the lava fields to witness nature at its most formative.

For photography, nightfall is the best time to visit, when the fiery red glow of the lava is at its most conspicuous, but there are certain risks attached to any field trip. It is imperative to stay upwind to avoid the poisonous plumes of gas, and strong walking boots must be worn. Don't stand for too long in one place— even solidified lava feels hot underfoot.

If there is still light in the sky, metering off some clouds and adding a stop more exposure should produce an accurate result. When it's completely dark, it is best to meter directly off the lava and compensate by a stop and a half. Bracket your exposures in both situations. You will need a tripod, as shutter speeds will be slow.

The Hawaiian Islands are also very wet, and heavy downpours veritably sizzle on the lava fields. As one of the

wettest places on earth, with a mountainous terrain and rich black volcanic soil, the rainforests are lush and verdant and home to many rare species of plants. Although volcanic eruptions can destroy areas of vegetation, the lava fields of Hawaii's Big Island provide a glimpse into how plants take root and regenerate on newly formed land. Photographing a bare landscape of ash and fine lava soils is like seeing the surface of another planet, or looking back to the time before earth bore life.

Essential picture list

⊕ The **Hawaii Volcanoes National Park** is the main attraction of the Big Island. Here you will find **Kilauea**, with its famous lava fields, which are best photographed at dusk.

⊕ Follow the Chain of Craters Road and see the **Halema'uma'u Crater** and **Ka'u Desert**.

⊕ The Saddle Road is the unforgettable link between Hawaii's two highest peaks, **Mauna Loa** and 13,796ft (4,200m)-high **Mauna Kea**, the highest peak in the Pacific and the site of the famous internationally operated astronomical observatory.

⊕ For a cooler and calmer landscape, take a hike through the **tropical forests on the Hamakua coast** of the Big Island or the **cloud forests on the slopes of Kilauea**.

above | Molten rock explodes in a night-time hydromagmatic explosion, caused by ocean surf breaking through the roof of a lava tube.

left | The rainforest canopy screens out most of sun, leaving the forest floor cool and damp.

Historical background >>> The Hawaiian islands are among the most isolated islands in the world, being more than 2,000 miles (3,000km) from the nearest continent. The islands were first settled by Polynesians, who arrived around the 3rd century CE. The first European visitor was Captain James Cook who "discovered" the islands on his third around-the-world voyage in 1778. The natives turned against Cook and killed him during a dispute. Hawaii became part of the United States in 1898, and the bombing of Pearl Harbor, home of the US Pacific fleet, by Japan in 1941 precipitated America's entry into World War II.

below | With a torrent of steam rising from the sea, orange and red rivers of molten lava pour through lava tubes over the coastal edge. Eventually, the lava will cool and solidify, creating new land on Hawaii's volatile coast.

Essential kit

⊕ When the heat and poisonous gases won't allow you any closer, a **telephoto lens** will give a closer view of the lava flows.

⊕ For twilight visits, don't forget your **tripod**, as exposure times will be long.

⊕ Wear strong **walking boots** and don't stand too long in the same place—that goes for your tripod too!

⊕ Carry plenty of **drinking water**, an **umbrella** in case of tropical downpours, and a **torch** for getting back to the road in the dark.

The Solomon Islands have long been a favored haunt of Western scuba divers, and the capital Honiara a popular port for holiday cruises of the western South Pacific. There are six major islands in the Solomons, and nearly a thousand smaller islands, atolls, and reefs, many of which are uninhabited. The Solomons enjoy a more comfortable climate than other tropical islands, with fairly consistent temperatures all year round.

Humidity is less of a burden because the southeast trade winds keep the temperature down during the dry season from April to October.

The islands stretch across nearly 900 miles (1,450km) and support a population of around half a million people. Island life is determined by the ancient customs still widely practiced in thousands of villages. Indeed, the Solomons are said to have a greater

above | In the shallow waters of the Lau lagoon, a man uses a long, flexible pole to punt his vessel forward. With hundreds of islands and atolls comprising the Solomons, populations are scattered over a wide area. Every family has at least one canoe, which is used for transport, fishing, and even taking children to school.

above | Two boys sail on their makeshift raft near their coral island house on the Lau Lagoon. There are more than a hundred manmade coral islands on the Lau Lagoon.

below right | A family from the artificial island of Ferasabua pose for the camera.

Essential picture list

⊕ The capital and port of **Honiara** is the picturesque arrival point for most travelers to the Solomons.

⊕ **Guadalcanal** has the most historic interest, as it was the site of a major naval battle during World War II. The waters of Iron Bottom Sound are the resting place for many sunken ships and their crews.

⊕ The seas surrounding the Solomon Islands are rich in **coral and marine life** and are a favorite destination for scuba diving.

⊕ On any of the islands, you're likely to find that the **people of the local villages** make ideal subjects for the camera, particularly in traditional dress and jewelry.

variety of island traditions than any other nation in the Pacific. This adherence to local customs proves fascinating to many Western visitors.

For example, in the Lau Lagoon of the northeast tip of Malaita Island, the people have a centuries-old tradition of building artificial islands from coral. Today, there are more than a hundred coral islands stretching around 50 miles (80km) along the length of the lagoon. The largest island, Sulufou, is also the oldest and supports a population of nearly a thousand people.

179

Historical background >>> The origin of the Melanesian people who make up more than 90 percent of the Solomons' population is uncertain, but archeologists believe that the islands have been settled for around 5,000 years. The first European to sail here was the Spanish explorer Alvaro de Mendana in 1568. He discovered gold on Guadalcanal and, believing that he might have found the source of King Solomon's wealth, named the islands the Isles of Solomon. Despite the discovery, the Spanish and other Europeans left the islands alone and they remained "lost" for several hundred years. They rose to prominence again in World War II during the battle of Guadalcanal, a pivotal naval conflict during which many American and Japanese ships were sunk. More recently, the islands descended into economic chaos and social unrest following a coup in 2000. Order was restored when an Australian-led security force landed at Honiara in mid-2003.

Approaching Bora Bora by air gives you one of the most dramatic introductions to any Pacific island. From the air, you see an island of emerald green in the middle of a stunning turquoise-colored lagoon, surrounded by a string of motus (islets) and coral reefs. There is only one navigable passage through to the main settlement of Vaitape, and visitors arriving by plane to Bora Bora need to take a catamaran to reach Vaitape from the airport.

The lush vegetation of the main island gives way to the steeply rising, black basalt slopes of Mt Otemanu. Bora Bora is less than 20 miles (32km) around, small enough to explore on foot or bicycle. A partially sealed road circles the island, passing through ancient temples, colourful villages and large guns abandoned by the US Navy at the end of World War II.

The lagoon and reef are popular spots for divers, thanks to the crystal-clear waters, which make it easier to view the colorful array of marine life. There are also rays and reef sharks in the lagoon waters; if you don't fancy snorkeling among these creatures, you can always go shopping for the area's famed black pearls.

below | One of the most stunning aerial views of the world—the main island of Bora Bora emerges from the deep blue lagoon fringed by a coral reef that has only one navigable entrance.

Essential kit

⊕ Bora Bora is a tropical island so pack extra **silica gel** to prevent any damage caused by the humidity and keep your camera in your bag or backpack when not in use.

⊕ Don't forget **lens wipes** for cleaning saltwater spray off your camera and lenses.

⊕ **Two or three zooms** will cover most of your needs.

⊕ Essential filters are **ND grads** for balancing exposure variance between the bright skies and dark green vegetation and a **polarizer** for reducing surface glare off the water.

⊕ Take plenty of **film** or **memory cards** and **spare batteries** as prices in French Polynesia are high.

Located on the northeast tip of the Caribbean, the British Virgin Islands (BVI) is a relatively undeveloped archipelago of more than 60 coral cays, rocky islets, and verdant tropical islands surrounded by beaches of fine white sand. Many remain unpopulated, visited only by the international yachting fraternity, who have made these islands their playground for decades.

Tortola's principal attractions—beaches, sun, and azure seas—are typical of what the rest of the BVI holds,

and with names such as Smuggler's Cove, Apple Bay, and Cove Garden Bay, one can get a hint of a romanticized history waiting to be explored. Road Town is the capital of BVI, but given that the entire population of the islands is about 21,000, it is a small and relaxed settlement, with plenty of activity around the shops and markets to keep your shutter firing. Everywhere you look there is color, from the tropical produce and primary color-painted houses, to the vibrant sarongs and dress fabrics hanging on racks on the street.

It is the natural color that leaves the greatest impression: the clean white sands, lush green rainforests, and cobalt-blue skies won't need any further enhancement through PhotoShop when you get home. There is additional pleasure in traveling from island to island by boat, enjoying a slower pace that gives you time to really think about that next shot instead of rushing it.

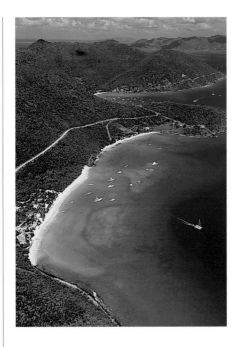

above | **Aerial view of yachts at anchor in the turquoise waters off Tortola.**

below | **One of the many pretty cays that attract sailors to the British Virgin Islands.**

Essential kit

◈ Pack all the gear you need, because you won't be able to buy anything apart from basic color print film in the BVI. Remember to take **spare batteries** and plenty of **film** or **memory cards**.

◈ A **basic SLR** camera system including a couple of **zooms** will suffice.

◈ A **polarizer** is very useful, along with a **skylight filter** and a range of **ND grads**.

◈ Don't forget your **tripod**, although, for shooting from a boat, an **image stabilizer** or **vibration reduction** lens will be more effective at keeping things steady.

◈ Pack a **chamois cloth** for wiping away seaspray.

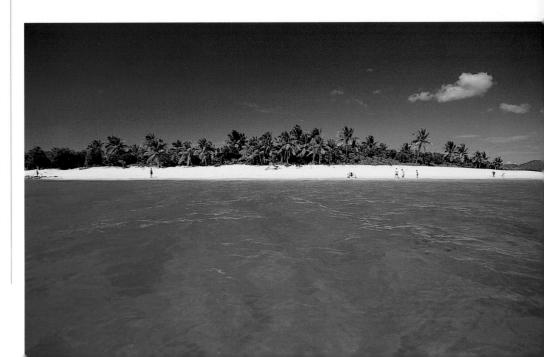

There are dozens of islands surrounding the British mainland, and among the best-known are the Isles of Scilly. Lying 28 miles (45km) southwest of Penzance, just five of the islands are inhabited: St Mary's, St Agnes, St Martins, Tresco, and Bryher. Of these islands, Tresco is the most diverse, with long sandy beaches, wind-beaten granite headlands, Bronze-age burial sites, and a couple of ruined castles from the 17th-century English Civil War. There is also a celebrated garden unlike any other in the United Kingdom—Tresco Abbey Gardens. Many of the subtropical plants that fill the gardens were purchased from sailing ships returning to Britain from the Caribbean, South Africa, and the Canaries. With majestic pines, cedars, and palm trees, the gardens give Tresco an almost Mediterranean ambience.

Sometimes the tide is low enough to allow you to walk across the narrow channel that separates Tresco from the neighboring island of Bryher. Bryher is smaller than Tresco, with barely 40 residents. The aptly named Hell Bay is worth visiting to fully appreciate the power of the ocean breakers, but high winds make it difficult to photograph even if you're using a robust tripod.

You can escape the tempest by crossing Shipman Head Down to the opposite shore with a wonderful view over New Grimsby Harbor to Tresco. Also visible is the tower of Cromwell's Castle, built on the shoreline in the mid-17th century after the Roundheads had destroyed nearby King Charles Castle during the English Civil War.

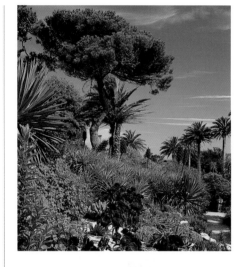

top right | The Tresco Abbey Gardens contain many exotic plants collected from South Africa and the Caribbean.

below | Looking across to Cromwell's Tower and the island of Bryher.

Essential kit

⊕ A **full lens range** from wideangle to telephoto will get plenty of use, such is the variety of coastal scenery to be found on the Isles of Scilly.

⊕ A **macro lens** and/or **extension tubes** for life-size close-ups of flowers and plants will get plenty of use at the Tresco Abbey Gardens.

⊕ Because of the high winds that strike unexpectedly, particularly in the winter, a **heavy metal tripod** will dampen vibrations better than a lightweight carbon-fiber model.

⊕ A **spirit level** slotted into your camera's hotshoe will help keep the horizon level.

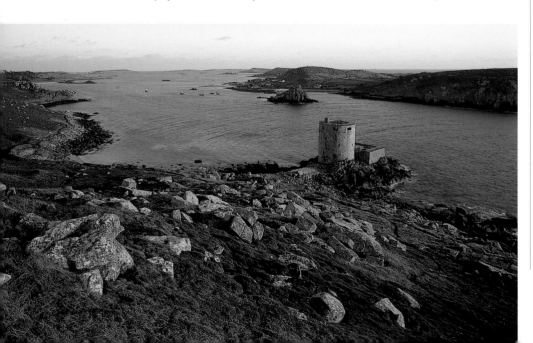

The coast of the Norwegian mainland is renowned for the beauty of its fjords and mountains, particularly in the summer when cruise ships sail north to the land of the midnight sun. Along this coastline, approximately 120 miles (180km) north of the Arctic Circle, are the Lofoten Islands—for many, the most beautiful location in Norway.

In summer, the landscape is a photographer's dream, with jagged mountains reflected in deep blue fjords and picturesque villages adding patterns of color along the shore. The Lofotens are renowned among the climbing fraternity for their challenging rock stacks. One of the most famous is called the Goat of Svolvaer, rising above the village of the same name, with a summit capped by a pair of fingerlike rocks. Reaching the top is traditionally celebrated by leaping from the tip of one rocky finger to the other.

Mountains and villages

Although Svolvaer has an airport, most visitors arrive by ferry from the mainland ports of Narvik or Bodo. As with the rest of Norway, the high living standards of the Lofotens are reflected in their well-maintained villages. Most houses are made of wood and are immaculately painted rust-red, green, orange, or brown, with white frames and eaves. Reine, on the southernmost island of Moskenesoy, is perhaps the prettiest village, but also worth visiting is Henningsvaer, home to a large and colorful fleet of cod fishing boats, which are at their busiest during the winter. Come the summer, and the boats are tied up, making an attractive subject with the mountains in the background.

The midnight sun can be seen from April until mid-July in the Lofotens, so light will not be in short supply.

Essential kit

⊕ Take **plenty of film** and/or **memory cards**. With so much light around during the summer season, you're bound to take more exposures. Also, prices in Norway are steep.

⊕ With so much light, color, and water around, a **polarizing filter** will prove indispensable.

⊕ With such stunning vistas, a **wideangle lens** will get plenty of use.

⊕ If your **tripod** doesn't have a built-in **spirit level**, then purchase a separate one to slot into your camera's hotshoe. This will help you keep the horizon and water's surface perfectly level within the viewfinder.

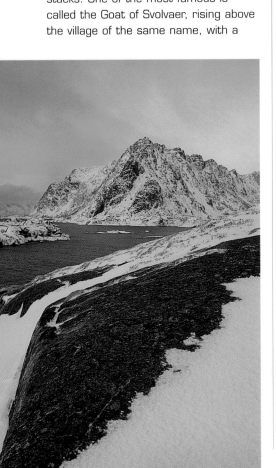

left | As dusk descends, the sky takes on a threatening mood as a storm approaches the coast near Henningsvaer, home to the islands' cod fishing fleet.

right | The pretty symmetry of Vågan church in Kabelvåg and its magnificent setting help to explain why many visitors consider the Lofoten Islands to be the most beautiful location in Norway.

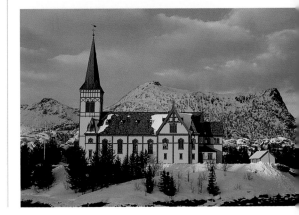

Very few people visit St Kilda. This small group of islands is one of Europe's loneliest outposts, eight hours' sailing due west from the Isle of Lewis (weather permitting). No-one has lived there since 1930, when the last St Kildans were evacuated to the mainland after their once-thriving community had dwindled to just 36 people.

Today, a small Ministry of Defense base on the main island of Hirta is staffed throughout the year, and during the summer months the National Trust for Scotland leads half a dozen work parties to the islands for archeological

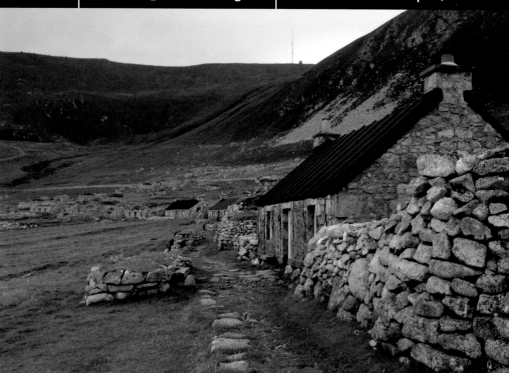

Essential kit

✛ There are no shops or supplies on St Kilda, so take **plenty of spare film, memory cards**, and **batteries**.

✛ The weather is inclement with plenty of dull days; pack some **fast film** (digital cameras should be set to **ISO 400**).

✛ You will need plenty of **lens wipes** to clean off the salt spray, and a **long telephoto** or **zoom lens** to get closer views of the more inaccessible scenery.

✛ Other essentials include a **tripod, binoculars, windproof clothing**, and a **warm hat**.

✛ As a precaution, take **anti-seasickness pills** for the sailings.

and restoration projects. Throw in cruise ship visits and private sailings, and the islands receive fewer than 2,000 visitors each year.

Seabird haven
The islands' isolation and lack of human impact have made St Kilda one of the most important environmental sites in Europe. The four islands of Hirta, Soay, Boreray, and Levenish support the world's largest colony of gannets and Britain's biggest breeding colony of fulmars. There are also puffins, great skuas, guillemots, seals, and flocks of wild Soay sheep, the latest generations of the flocks kept by the St Kildans and left here after the evacuation.

Being exposed to the worst of the North Atlantic's weather systems, it is a wonder that the islands supported a human population for so long. But the evidence is there to see as you walk

top | The last St Kildans were evacuated in 1930, but their houses have withstood the worst of the North Atlantic weather. Every summer, work parties visit the main island of Hirta to continue restoration work on the remains of this community.

above | The unpolluted waters of St Kilda support an abundance of marine life.

ℹ

Essential picture list

⊕ The only landing point in St Kilda is **the jetty at Village Bay** on the island of Hirta. From here you can see and explore the remains of the settlement.

⊕ As well as the **houses on the "main street,"** don't forget to photograph some of the 1,400 **cleits**— small turf-roofed storage huts scattered all over the islands.

⊕ Behind the village rises the steep slope of **Conachair**, with a spectacular view across Village Bay and to the island of Boreray.

⊕ Try to get some shots from the boat of St Kilda's enormous **sea stacks and cliffs**. At 1,400ft (427m), Conachair is the highest sea cliff in Britain.

⊕ If you can dive, St Kilda provides some of the **best dive sites in Europe**.

Historical background >>> The discovery of burial sites on St Kilda suggests that the earliest known settlers were Bronze Age travelers from the Western Isles some 4,000 to 5,000 years ago. In more recent times, Norse explorers are known to have visited, and the name St Kilda is a corruption of the Norse word *skildir*, meaning "shields," a reference to the shape of the islands when viewed from the sea. There were around 180 St Kildans in 1697 who rented the land from the Macleods of Dunvegan, on the Isle of Skye. The people were of Hebridean stock, spoke Gaelic, and were resolutely self-sufficient. They kept sheep and cattle, hunted seabirds, and wove garments from their wool. In 1852, 36 St Kildans emigrated to Australia and this, plus acute food shortages in 1876 and 1912, began the slow decline in the community's numbers and morale. Regular summer sailings and the delivery of food by naval supply vessels during World War I eroded the islanders' self-sufficiency and encouraged more of the young people to travel to the mainland, never to return. By 1930, the remaining population demanded evacuation, and on 30 August that year the last islanders sailed from Village Bay. St Kilda was sold to the Marquis of Bute the following year, and he bequeathed the islands to the National Trust for Scotland in 1957.

below | One of Europe's most important sites for seabirds, the giant sea stacks and cliffs of St Kilda support the world's largest colony of gannets as well as thousands of puffins, guillemots, great skuas, and fulmars. In days gone by, the St Kildans were expert at free-climbing these cliffs for birds' eggs and puffins.

down the village street of Hirta, a narrow grassed path lined on either side by stone walls and the roofless remains of abandoned houses.

Underwater treasures

St Kilda is also popular with divers who come here for the islands' clear waters and fantastic array of submerged caves, tunnels, gullies, and arches. There is a diverse range of marine life here, with colors as brilliant as those found in any tropical reef. Close-up lens attachments and flash are essential accessories to use with your camera when photographing underwater.

"The future observer of St Kilda will be haunted the rest of his life by the place, and tantalized by the impossibility of describing it, to those who have not seen it."

James Fisher, naturalist, visitor to St Kilda in 1947

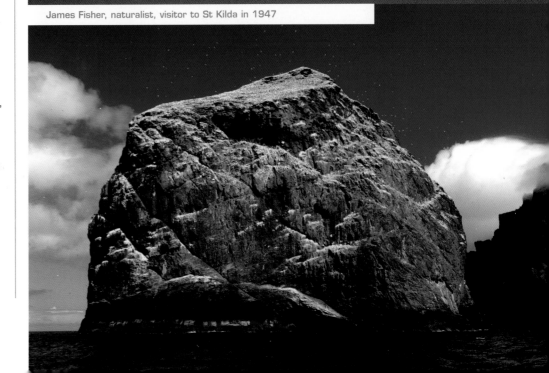

In the middle of the Indian Ocean, stretching north from the equator for more than 500 miles (800km), is an archipelago of 1,200 tiny islands laden with elegant palms and fringed by white sandy beaches. The Maldives, once a country of subsistence fishermen, is now a favorite destination for tourists seeking a tropical paradise.

The islands are formed into 26 atolls, each enclosed by a coral reef with a few deep navigable channels for access. The Maldives were formed when coral started growing on the peaks of undersea mountains, creating beaches of white coral sand leading down to shallow lagoons of crystal-clear water. With no hills or mountains, there are no rivers or streams either, and the soil is poor. Consequently, the picturesque coconut palms are the most common food trees to be found on the islands, along with banana, breadfruit, mango, and cassava.

Riches of the sea

The greatest natural diversity is found in the sea, where coral atolls provide a rich habitat for hundreds of species of fish. An identifying image of the islands is the dhoni, the traditional sailing boat made of timber from the coconut palm. These distinctive boats, built by hand, require skills that are passed on from one generation to the next.

right | One of the 1,200 islands in the archipelago that makes up the Maldives. From the air, the coral reefs surrounding each island can be clearly seen.

below | The distinctive hand-built dhoni, the local vessel made of timber from the coconut tree.

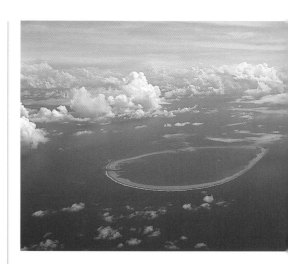

Essential kit

⊕ Take extra **lens wipes** for cleaning saltwater spray off your camera and lenses.

⊕ Keep your camera in a bag when not in use and remember to pack extra **silica gel** to prevent any damage caused by the humidity.

⊕ Pack a **polarizer**, but fight off the temptation to use it at full effect.

⊕ **Two or three zooms** will cover most of your needs.

⊕ Even if you don't dive, at least **snorkel** on the surface and be amazed at what you will see.

⊕ Take **plenty of film** and **spare batteries**.

The Seychelles have long been the first-choice destination for advertising photographers shooting products ranging from swimwear to suntan lotion, sunglasses to sandals. The rest of us have got in on the act, and these islands have become one of the most desirable holiday locations on earth.

The palm-tree paradise

There is a wonderful blend of natural beauty and human influence on the Seychelles; nothing has been spoiled. Even the capital city, Victoria, on the island of Mahé, is small and contained. But touring these islands is about finding the best beaches. Anse Lazio, on the far north of Praslin Island, is one. The sand is white and soft, the

Essential kit

⊕ As with any hot and sandy environment, keep your camera gear sealed in a **shoulder bag** or **backpack** when not in use.

⊕ Clean your lenses at the end of each day with **wipes** and a **blower brush**.

⊕ Useful filters include a **polarizer**, **skylight**, and **81 series warm-ups**.

⊕ **Fine-grained, slow-speed film** is best; on a digital camera, use an **ISO setting of 50 or 100**.

⊕ The horizon out to sea will feature in many images so to avoid it sloping, use a **tripod with a spirit level**.

water turquoise-blue, and the palm trees bend with a degree of elegance that fulfills the image of paradise.

An identifying feature of some beaches, including Anse Lazio, is the occasional large lump of granite, weathered to a smooth, rounded shape, surrounded by white sand. They make excellent foreground-filling subjects for views of the beach and sea. However, the largest beach on the Seychelles, Beau Vallon, on Mahé, is relatively free of boulders. Situated just two miles (3km) from Victoria, it is the most accessible beach and has platforms in the ocean that you can swim out to.

Far more secluded are the beaches on the west of the island, such as the palm-fringed Anse Soleil. The snorkeling here is a highlight. Topside naturalists should join a tour of the nature reserve on Cousin Island, an important breeding ground for seabirds and turtles, and with thick forests that are home to several endangered species.

left | Coconut trees are well adapted to the climate of the Seychelles. On the beach at Anse Georgette, a sapling germinates on the white coral sand.

right | White sandy beaches and tranquil waters beckon through the fronds of coconut palms on the island of Praslin. The Seychelles have a tropical climate that supports lush green rainforests extending right to the water's edge.

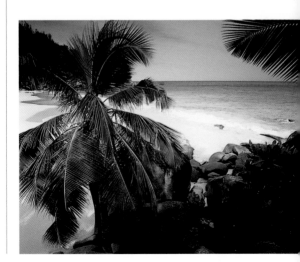

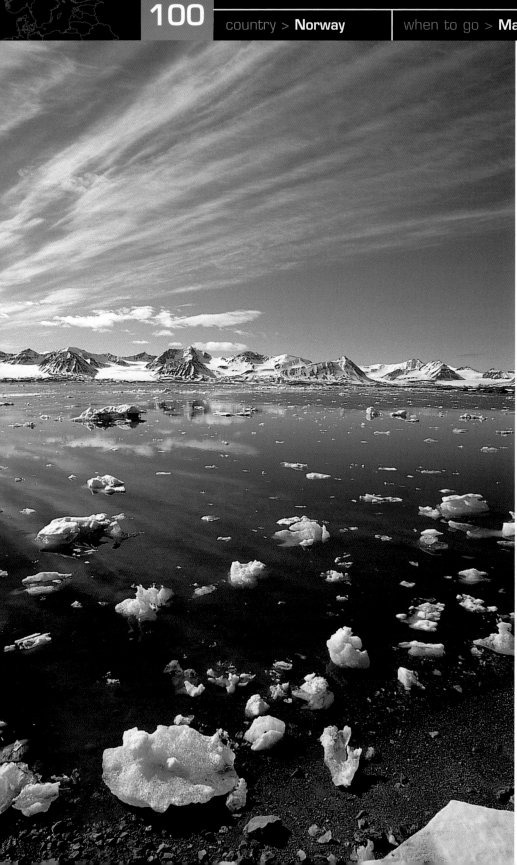

The frozen islands of Svalbard lie deep inside the Arctic Circle above the northernmost coast of Norway. For centuries they have attracted the attention of explorers, sailors, settlers, and governments, and for a variety of reasons, but in each case, the harsh climate and geography has been the greatest determining factor in the success of any quest.

left | Small blocks of ice litter the tranquil surface of Kongsfjorden during the Arctic summer.

Essential picture list

⊕ From the deck of a boat or ship, you have an excellent view of **crushing blocks of glacial ice** meeting the deep waters of the fjords.

⊕ Spitzbergen is the only island of Svalbard open to tourism. **Longyearbyen** is a small but colorful settlement in a spectacular setting.

⊕ The **west coast of Spitzbergen** features many jagged mountains of granite, which create dramatic reflections in the sea. Newton Peak is the highest point.

⊕ For the natural history photographer, summer is the season for flora and fauna. Animals include **Arctic fox, musk ox, and seals. Polar bears** are sometimes to be seen: note that they are protected and very dangerous—they should never be approached.

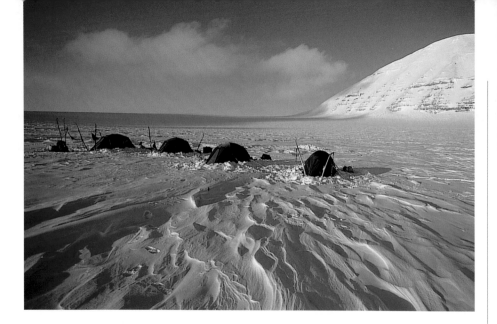

Svalbard is best known for its largest island, Spitzbergen, which has been a home base for many polar expeditions. The island's northern coast lies just 620 miles (1,000km) from the North Pole, and around 80 percent of its surface is covered with snow and ice up to 328ft (100m) thick. Glaciers snake down from the higher peaks and grind their way through freezing valleys to the Arctic Ocean. The year-round average coastal temperature is –6.5°C, reaching a few degrees above freezing in July.

An Arctic landscape

Spitzbergen is the only island in the group open to tourists, and during the brief summer season, cruise ships bring visitors to witness the beauty of the western coast. From the vantage of a deck on a slow-sailing ship, you can witness an extraordinary Arctic landscape of iceberg-sprinkled waters, granite peaks, and craggy glaciers spilling into deep fjords. The air is pure, and on a cloud-free day the skies are cobalt blue with a clarity that allows you to see far into the distance.

The Svalbard archipelago is spread between the 74° and 81° parallels, which means that from 21 April to 24 August the sun never sets. This protracted period of midnight sun is another major draw for cruise ships, which anchor at the coastal settlement of Longyearbyen, Spitzbergen's "capital."

Arctic wildlife

Summer represents a brief season of opportunity for the wildlife photographer. Dozens of bird species return from their winter migration and the soil near the coastal areas thaws enough to allow lichens, ferns, grasses, and wildflowers to thrive. More than 150 different plant types have been recorded here. Animal species such as Arctic fox, hare, seals, musk ox, and the odd polar bear may also be sighted.

above left | In a landscape this vast and empty, a campsite can be very welcoming or very lonely.

Historical background >>> Norway's historical ties to Svalbard go back to the 12th century, but it wasn't until the Dutch explorer Willem Barents "rediscovered" the islands in 1596 that people considered exploiting its natural resources. Whalers and sealers from Norway, The Netherlands, France, England, and Denmark all fought to secure a stake in the islands. However, interest began to wane with the rapid depletion of whale and seal stocks. The discovery of coal on Spitzbergen rekindled international interest, and in 1920 Norway's administration of the islands was formally recognized, although other European nations were permitted "economic access." Even during the Cold War, the existence of Soviet miners on Norwegian territory (Norway is a member of NATO) was never threatened. Spitzbergen has always been regarded as neutral territory, although its strategic position above Europe and between Russia and North America led to it being occupied by Germany during World War II.

191

index

In a book as ambitious as this there are many people who contribute to its success. Full credit must go to Kylie Johnston, commissioning editor at RotoVision, who came up with the original idea and had confidence in my ability to fulfill her vision.

Also at RotoVision, I give warm and heart-felt thanks to April Sankey, whose mastery of gentle but forceful persuasion left me in awe at the end of each phone call and e-mail. Also special thanks are due to Nicola Hodgeson for her masterful editing and proofreading. The wonderful design of this book is the creation of RotoVision art director Luke Herriott, and Balley Design. Thanks guys.

Of course, this book would not have been possible without the generous support of all the photographers who contributed such a stunning selection of images. I hope you find this volume worthy of your efforts and time. A big hug to my editorial team at *Outdoor Photography* and *Black & White Photography*—thank you for keeping me going when I didn't know if I was shot or fish poisoned…

Finally, to my wife Pamela and daughters Elizabeth and Olivia—I owe you a debt that will require a lifetime to repay. May the rest of our journey together be as memorable as the roads we have already taken.

Keith Wilson

Ingrid Abery (50, 181); Niall Benvie (103 (top), 183); Simon Booth (62, 98–99); John Brown (Front cover flap (Sonoran Desert), 44 (top & middle), 45 (bottom), 80–81, 117, 160–161, 187); Sean Burke (Back cover (Giza), 31, 63, 64, 65, 106); Ian Butterfield (66); Chris Caldicott (186); Gary Cook (46, 48–49, 51, 68–69, 129); Paul Harcourt Davies (122–123); Steve Day, C/o Sue Walker (24 (bottom), 25, 32–33, 37, 43, 90–91); Luke Duggleby (12–13, 21 (bottom), 55, 131); Tom Owen Edmunds (Back cover (Kashgar), 20, 22–23); Tewfic El-Sawy (125); Simon Fraser (Back cover (Svalbard), 18–19, 45 (middle), 67 (bottom), 71 (bottom), 87 (bottom), 99 (top), 102, 103 (bottom), 116 (top), 124, 134–135, 137, 144–145, 176–177, 188–189); Nick Garbutt (Back cover (Madagascar), 16–17, 146–149, 154–155, 156–157, 162–163, 165 (bottom), 168); Daisy Gilardini (86); Nick Gray (21 (top), 54); Tracy Hallett (142–143); Mark Hamblin (Front cover (Grand Canyon), 6–7, 79 (top left), 82 & 83); Paul Harris (94–95); Martin Hartley (Back cover flap (Eastern Pamir), 73, 107); Kari Herbert (136 (top), 138); Jon Hicks (Back cover (Manhattan), 10–11, 24 (top), 26 (top), 28–29, 30, 35, 36, 40–41, 67 (top), 71 (top), 74–75, 76, 79 (bottom), 111 (bottom), 114–115, 126–127, 132 (bottom)); Nigel Hicks (Back cover (Great Wall of China & Guilin), 4–5, 14–15, 34, 44 (bottom), 56–57, 60 (top), 61 (bottom), 70, 104–105, 132 (top), 133, 182 (top)); Paul Kay (174–175, 184–185); Andy Latham (108–109); Adam Long (77); Malcolm MacGregor (92, 99 (bottom)); Andrew Marshall & Leanne Walker (178–179); Tim McKenna (180); Terry Middleton (38 (top), 39 (bottom)); Clive Minnitt (38 (bottom), 39 (top), 78, 79 (top right)); James Osmond (26 (bottom), 27, 116 (bottom)); Pete Pattisson (128); Gerry Pearce (158); David Plummer (96); Robert Preston (120–121); Sue Scott (169, 170–171); Charlie Waite (88–89, 97, 140–141); David Ward (52–53, 72, 93); James Warwick (152–153, 164, 165 (top), 166–167, 172–173); Chris Weston (98, 159); Keith Wilson (42, 47, 87 (top), 110, 111 (top), 112–113, 130, 136 (bottom), 139, 182 (bottom)